PARISH CHURCH
TREASURES

Bloomsbury Continuum
An imprint of Bloomsbury Publishing Plc

50 Bedford Square 1385 Broadway
London New York
WC1B 3DP NY 10018
UK USA

www.bloomsbury.com

First published 2015

British Library Cataloguing-in-Publication Data
A catalogue record for this book is available from the British Library.

Library of Congress Cataloguing-in-Publication data has been applied for.

ISBN: HB: 9781472917638
 ePDF: 9781472917652
 ePub: 9781472917645

2 4 6 8 10 9 7 5 3 1

Printed in China by RRD Asia Printing Solutions Limited.

To find out more about our authors and books visit www.bloomsbury.com. Here you
will find extracts, author interviews, details of forthcoming events and
the option to sign up for our newsletters.

PARISH CHURCH
TREASURES

The Nation's Greatest Art Collection

JOHN GOODALL

With photographs by **Paul Barker** from COUNTRY LIFE

BLOOMSBURY

LONDON · OXFORD · NEW YORK · NEW DELHI · SYDNEY

CONTENTS

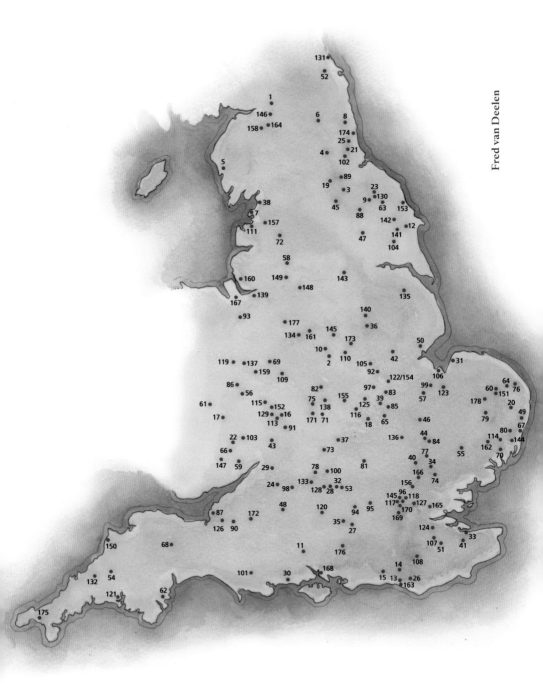

Fred van Deelen

CHAPTER 5 – The Tudor Reformation, 1536-1603

CHAPTER 6 – Protestant England, 1603-1699

CHAPTER 7 – The Anglican Church, 1700-1799

Introduction

Our parish churches constitute a living patrimony without precise European parallel, their architecture and fittings the product of sustained patronage that, in some cases, demonstrably extends back well over a millennium. The cumulative product of that investment is a physical palimpsest of almost unbelievable complexity and interest. Their cultural riches are astonishing not only for their quality and quantity but for their diversity and interest as well. Fine art and architecture here combine unpredictably with the functional, the curious and the naïve, as a complementary backdrop to the life of the local church.

In this sense these buildings effectively form an unsung national museum that, unlike all its institutional rivals, presents its contents in an everyday setting without curators or formal displays. The objects themselves also preserve an unrivalled authenticity of place. There are many exceptions and complications to the rule, but the contents of parish churches often remain in the building for which they were first created. That continuity links us directly with those who created them, sometimes across enormous periods of time. Properly interpreted, therefore, parish churches tell from thousands of local perspectives the history of the nation, its people and their changing religious observance.

This book is an attempt to celebrate these riches in a way that is at once accessible, delightful and thought-provoking. It has developed from the seed of a weekly series entitled 'Parish Church Treasures' published in *Country Life* since the autumn of 2012. Each week this presents a short, focused article on a single object in a different parish church. Brought together within the pages of this book are about 170 'treasures', each individually photographed in location by Paul Barker and assembled within a series of nine

chapters. These are prefaced with short introductory essays that tell within an overarching chronological structure the story of the parish church from the remote past to the present day.

The selection of treasures that form the backbone of this book deliberately looks beyond objects of merely marketable value. In part this is because valuables, such as church plate, are necessarily locked away, and I wanted to celebrate things that can be seen on a day-to-day basis. It would be rash to make promises for the future, but most parish churches are accessible through no more than a preparatory telephone call. Some may lament the fact that the doors of some churches are often closed but this accessibility remains extraordinary. In any case, sometimes it is not even necessary to go through the door to enjoy something unexpected and truly exceptional.

But this focus was not dictated merely by practicalities. People are normally well aware of things that are worth large amounts of money and accord them respect (recent history has also shown that an awareness of value can encourage parishes to sell the objects that make them special). By contrast, the invaluable – or at least the inalienable – are regularly overlooked, almost regardless of their beauty and importance. The local communities that proudly maintain churches are usually only concerned incidentally with their history. They can also find it hard to grasp the full significance of objects that have become familiar.

Why in particular should this matter now? The answer is because parish churches are currently undergoing a massive and collective change as congregations seek to modernize their interiors. As a background to this, moreover, communities are struggling to maintain buildings that, because of their quality, are costly to repair. In scale and significance these transformations will have a physical impact that easily matches that of the great nineteenth-century restorations that created many of the interiors we see today.

To posterity, the present reordering boom will merely be one more episode in the long and eventful history of these buildings. Yet, as with all moments of change, it entails real dangers to the fabric of churches and their contents. Outstanding among these dangers is the possibility that things will be neglected or even destroyed because a parish – lulled by familiarity into indifference or intoxicated by an enthusiasm for change or simply because of a preoccupation with other, more pressing priorities – grossly undervalues them. What better moment, therefore, to highlight the significance and diversity of such cultural riches?

No less important is the need to champion at this critical moment the unique character of these buildings as places that transcend familiar concepts of ownership and use. For as centres of religious life, parish churches are more than just historic monuments; as village or public buildings they are more than simply the possession of their congregations; as works of architecture and receptacles for art they are more than sheds for worship; and in some cases as buildings – or at least sites – of breathtaking antiquity, no one generation has unquestioned rights to do as it pleases with them (though each generation must necessarily take

complete responsibility for them and can expect no help from the past or posterity in the burden it carries).

All the objects covered in this book remain in, or form part of, consecrated buildings presently used as parish churches. These include former collegiate and monastic churches turned to parish use at the Reformation as well as redundant buildings in the hands of the Churches Conservation Trust, which now heroically maintains more than three hundred buildings. The lion's share, moreover, is in the care of the Church of England, a natural reflection of the numerical preponderance of historic buildings maintained by the established church. That said, a limited selection of objects in Roman Catholic churches also feature in the later chapters of this book, an acknowledgement of the fact that there has been a revived system of Catholic parishes across the kingdom since the 1850s. There is no reference to the chapels of Nonconformist groups, however, which are not strictly parish churches. Nor to historic parish churches that have been elevated to cathedral status, such as Leicester, Southwell or Newcastle-upon-Tyne.

In geographic terms, all the churches covered in the book – with the exception of four buildings along the Welsh border – are in England as it is geographically defined today. On one level, this is a great regret to me. My ideal would have been to look at parishes across Ireland, Scotland and Wales. Their history forms a fascinating counterpoint to that of English buildings both Catholic and Protestant. Omitting them for the sake of space has involved some painful

exclusions, such as the Sir John Lavery triptych in St Patrick's, Belfast; Alfred Webster's glass at Kilmun in Argyll and Bute, and the interior of the Church of Our Lady, Star of the Sea, Amlwch, Anglesey, to name but three.

It was originally intended that the selection of treasures be representative rather than encyclopaedic. Yet at a relatively early stage it became apparent that even this relatively modest sounding aspiration was overambitious. Rather, I hope this book will serve as a taster for what remain the inadequately charted cultural waters of the parish church. This may seem a very surprising thing to say about a popular subject that has long garnered so much attention, and upon which there has been so much interesting work in recent years. Nevertheless, it's worthwhile to realize in statistical terms just how limited our knowledge of these buildings really is.

While churches – including a handful of cathedrals – constitute 45 per cent of all Grade I listed buildings (that's a corpus of over 4,000 buildings) and a further 20 per cent of all those designated Grade II and II*, the scholarly examination of the vast majority goes no further than a straightforward description of their appearance and list of contents. Of the 9,000 or so medieval buildings in this group, for example, fewer than half have even been surveyed and, of the resulting plans, a substantial portion have never been published. Our archaeological understanding of these buildings, meanwhile, is limited to full excavations on less than a dozen sites. Even the photography of churches in this digital age is painfully inadequate: try finding a

publishable photograph of an object in your own local church.

To compound this problem, most gazetteers and guides continue to draw heavily on antiquarian scholarship. And perpetuated by this are certain assumptions that distort our perception of these buildings. Outstanding among these is the belief that the parish church is chiefly interesting as a monument to medieval religious life. This is despite the fact that many medieval parish churches have served as places of Protestant worship for as long as – or longer than – they were Roman Catholic. No less frustrating is the Victorian obsession with cataloguing parish churches and their contents. This is usually done according to the four styles of medieval architecture – Romanesque, or Norman, Early English, Decorated and Perpendicular – first devised by Thomas Rickman in 1817. There is nothing wrong with using these terms or applying them to features and furnishings, but it is no more than a basic starting point in their analysis.

Finally, there remains a deep-seated determination, born of romantic sensibility, to present these buildings as expressions of rustic culture and piety. Yet the reality is that, like all buildings, parish churches were expensive to create, furnish and maintain. It's true that we do not always know the names of those who paid for or designed them in the Middle Ages (though this information

is not nearly as difficult to infer as is popularly supposed), but this ignorance is a comment on our imperfect knowledge. It says nothing about the sophistication or motives of those who created them.

These cumulative faults seem all the more grievous, since recent work that has been done on parish churches has been so extraordinarily insightful. This is particularly true in the study of the Reformation, for example, and also the course of the Gothic Revival in the nineteenth century. The debate, too, over the origins of parish churches in the Anglo-Saxon period has generated an enormous amount of fascinating information. I hope that some of the contextual detail in this book will help people realize how much can be known or discovered even about medieval objects.

The readers who enjoy this book will, I hope, not only have their appetite whetted to enjoy for themselves some of the objects it presents. They will also be inspired to go out and look afresh at churches and chapels of all denominations, local and distant, new and old, great and small, familiar and little known, rural as well as urban. If they do so, I am not only confident that every visit will reveal some furnishing, ornament or work of architecture that could have graced the pages of this book. They will also derive from the experience more delight and information than from any book I could ever produce on the subject.

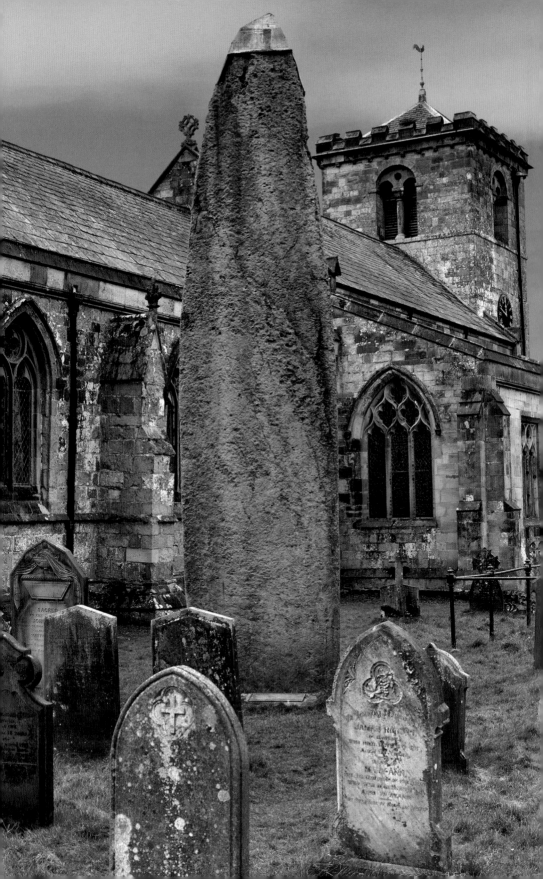

1 Inheritance, Before the Year AD 1000

On Easter Day, 12 April 627, Edwin, King of the Northumbrians, was baptized in a hastily constructed timber church dedicated to St Peter the Apostle at York. This decisive moment in the evangelization of medieval England brought to a close a protracted struggle not merely for the king's religious allegiance but for that of his subjects as well. Writing about the event in his *Ecclesiastical History of the English People* completed in 731, the monk and historian Bede described Edwin's conversion as the combined product of political, marital and divine agencies. Nevertheless, it was not a decision that the king took alone. Edwin insisted that this step must be discussed with his chief advisers and friends in council. The scene of this debate as related nearly a century after the event cannot be read as a detached account of what happened. Yet it carries conviction as more than a merely literary creation.

The central role in the deliberations was taken – appropriately enough – by the figure of the pagan high priest in Edwin's circle, a man named Coifi. He was the first to offer his thoughts on the new religion to the council and king. Then, following the intervention of one of the king's 'best men', who drew an analogy between the life of a man and the fleeting passage of a swallow in flight through the king's hall, Coifi called for further information about Christianity.

Satisfied by what he heard that the new religion was better than his own, he made a dramatic renunciation of the gods that he had so long venerated. Then, as a man forbidden by his priestly office either to ride a horse or bear arms, he left the council in a manner calculated to astonish:

> Girded with a sword and with a spear in his hand, he mounted the king's stallion and rode up to the idols. When

The great Neolithic standing stone at Rudstone, Yorkshire

the crowd saw him, they thought he had gone mad; but without hesitation, as soon as he reached the shrine, he cast into it the spear he carried and thus profaned it. Then, full of joy at his knowledge of the worship of the true God, he told his companions to set fire to the shrine and its enclosures and destroy them. The site where these idols once stood is still shown, not far east of York, beyond the river Derwent, and is known today as Goodmanham. Here it was that the Chief Priest, inspired by the true God, desecrated and destroyed the altars that he himself had dedicated.

The village of Goodmanham today is not a place that it is easy to imagine as a setting for high drama. Yet the events that Bede describes can probably be precisely located within its modest extent across the vast chasm of nearly 1,500 intervening years. Rising on a low eminence from amidst the roofs of this small settlement is the stumpy tower of the parish church that overlooks a landscape rich in prehistoric burial mounds. At Goodmanham, in other words, the likelihood is that the church inherited its naturally prominent position from the pagan shrine that Coifi desecrated. It must be stressed that this conversion of a site from pagan to Christian use was probably not immediate. Certainly, Bede's account makes no mention of a church on the site. Nevertheless, the seat of one religion has, over time, become the home to another.

What the example of Goodmanham illustrates is that the story of the parish church, a building type that properly emerged from the ninth century onwards, is inextricably rooted in the deeper past.

It is a commonplace in a landscape so anciently occupied as Britain's that new buildings, institutions and settlements are reared on inherited foundations. In some cases this continuity is conditioned by such unchanging practical concerns as water supply, communication or defence. But, not exclusive of the force of such practical concerns, the reoccupation of particular sites can also be driven by an explicit desire to appropriate the past to present needs. Indeed, early missionaries to England were directly encouraged to turn pagan sites to Christian use by no less a figure than Pope Gregory the Great. In a letter of 601 he wrote:

> … we have been giving careful thought to the affairs of the English, and have come to the conclusion that the temples of the idols among that people should on no account be destroyed. The idols are to be destroyed, but the temples themselves are to be aspersed with holy water, altars set up in them, and relics deposited there … in this way, we hope that the people, seeing that their temples are not destroyed, may abandon their error and, flocking more readily to their accustomed resorts, may come to know and adore the true God.

Pope Gregory was probably misled by his Roman surroundings as to the sophistication of English 'temples'. Contrary to what he supposed, Celtic paganism – as far as it can be understood from the evidence available – was primarily associated with the worship of natural things and places (notwithstanding Coifi's idols). Nevertheless, the widespread appropriation of sacred sites by

Christians might explain, for example, the large number of ancient yew trees in English churchyards. The age of these trees is not always clear but some are old enough to have been venerable long before the neighbouring parish churches existed.

Similar continuities may also be expressed in the proximity of springs and wells to many parish churches. These, indeed, were perhaps commonly used for baptisms since England strikingly lacks the baptistery buildings that form such a distinctive element of important Christian sites in contemporary Gaul. Regardless of this detail Christianity was – and is – manifestly fascinated by places. Through the association of particular locations with miracles and legendary stories it supplied the landscape with explanatory myths that effectively related the deep past to the present. In other words, it is reasonable to suppose that many parish churches, regardless of the date of their standing fabric, connect the modern visitor to a sacred topography more ancient than Christianity. And however exiguous the evidence, where it exists such continuity is itself a quality to marvel at.

This is not to imply that Christianity as represented by these buildings merely overlaid or extended paganism. The Roman Church – the particular confession of Christianity that eventually came to dominate the whole of the British Isles through the Middle Ages – brought with it a completely fresh package of belief and ritual practice. This was informed, moreover, by another distinct inheritance of defining importance to medieval society and thought: the legacy of Rome. From Rome, the Popes not only exercized authority as heirs to St Peter, but they assumed the prestige and authority of that city's great former empire. And their church revived imperial traditions across medieval Europe. The appeal of Rome to the travelled and educated of Anglo-Saxon England can scarcely be exaggerated, nor can the profundity of its influence.

In architecture its effects are particularly clear. To an English audience of the seventh century, Roman ruins constituted the largest man-made structures in the landscape. They were also built of masonry, a material that had almost completely passed out of current architectural use (in favour of more easily worked timber). Small surprise, therefore, that English churchmen now consciously sought to revive the tradition of Roman building, constructing churches of masonry with detailing copied or stolen from the ruins of Antique buildings. These are properly the first works in the architectural style called the 'Romanesque'. And their enthusiasm did not finish there. Listen, for example, to Bede's description from another work, *The Lives of the Abbots*, describing the construction from 674 of his own monastery church at Wearmouth by its first abbot, Benedict Biscop:

> Only a year after work had begun on the monastery, Benedict crossed the sea to France to look for masons to build him a stone church in the Roman style he had always loved so much … He was untiring in his efforts to see his monastery well-provided for: the ornaments he could not find in France he sought out in Rome. He returned [from Rome] with a great mass of books … an abundant supply of relics … the chief cantor of St

Peter's [called Abbot John, who] … taught the monks at first hand how things were done in the churches in Rome … a letter of privilege from the venerable Pope Agatho … and many holy pictures of the saints to adorn the church of St Peter he had built … Thus all who entered the church, even those who could not read, were able … to contemplate the dear face of Christ and His saints.

Monastic foundations, of which Wearmouth was an unusually important example, were the most significant institutions of the early English medieval church. Moreover, some monasteries also became the seats of bishops. It was to bishops that the duty of pastoral care fell. Such evidence as we have for this activity is largely anecdotal and based on miracle stories. Characteristically, bishops are presented as riding round their dioceses seeking out obscure spots for preaching and performing christenings and confirmations. The invariable implication is that they worked out of doors. Perhaps bound up in some way with this type of pastoral care was the tradition of erecting carved monoliths and high crosses. It may be related to the absence of parochial church buildings that the celebration of the Mass is not usually listed among the bishops' services to the laity.

It remains an open question, therefore, just how far the ideas and practice of Christianity penetrated to the grass roots of society in its first centuries of development. What does seem clear, however, is that at least some of those at the lowest levels of society were sufficiently affected by the new religion to feel aggrieved by its impact on their life and traditions.

Bede in his *Life of St Cuthbert*, for example, relates an altercation between the young Cuthbert and a group of peasants at the mouth of the Tyne in about 650. The peasants were jeering at an unfortunate group of monks stuck on a raft that was being driven out to sea by the wind. When Cuthbert reprimanded them they replied, 'Let not God raise a finger to help them! They have done away with all the old ways of worship and now nobody knows what to do' (chapter 3). Whether or not anyone had actively proselytized among these peasants or served their pastoral needs, Christianity was certainly noticed by them and resented.

Whatever the role of monasteries described by Bede in serving the pastoral needs of the population as a whole, the Christian hierarchy familiar to him was soon to be overwhelmed. Famously, in 793 the great monastery of Lindisfarne was sacked by the Vikings. The attack sent shock waves through Europe, but it was to prove only the harbinger for more sustained raids. There followed full-scale invasions and then the permanent settlement of large tracts of northern England. Resistance in the south of England led by King Alfred of Wessex (reigned 871–99), however, proved more successful. In the context of this struggle, and in circumstances that remain poorly documented and in many points obscure, a new church structure augmented and developed the old. It's to this structure, with its network of local churches, that we must next turn our attention.

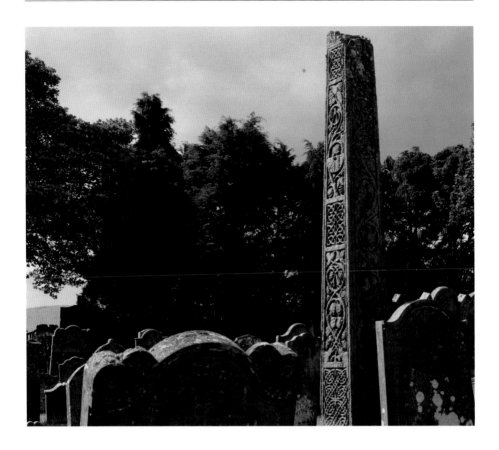

1 Riddle of the runes
The Church of St Cuthbert, Bewcastle, Cumbria

In 1742, *The Gentleman's Magazine* published an article on cryptography, illustrated with an engraving of a runic inscription on this great monolith in the graveyard at Bewcastle. It was reproduced in the hope 'that some gentleman who understands the language ... [will] give us the explanation'. The church is unforgettably set beyond Hadrian's Wall, within the enclosure of a hexagonal Roman fort. The stone shaft was carved in about 700 and was, presumably, surmounted by a cross – although it may, alternatively, have come to a point – and is carved on each of its four sides. Shown here to the right is one face carved with a representation of a vine filled with birds, a decorative motif drawn from Roman or Byzantine art. On the left face are further vine-scroll panels alternated with interlace, a decoration familiar from such manuscripts as the Lindisfarne Gospels. All this carving may originally have been painted. There is also a semicircular sundial, the earliest to survive in location on a freestanding object in Britain. The weathered runes of the principal inscription on the far side of the stone still defy epigraphers. One possible reading runs: 'This token of victory, Hwaetred, Waethgar set up in memory of Alefrid ... Pray for them, their sins and their souls.'

2 Mercian Mary
The Church of St Mary and St Hardulf, Breedon-on-the-Hill, Leicestershire

This bust, which probably dates to about the year 800, is one in an exceptionally rich collection of Anglo-Saxon sculptural panels preserved in the walls of the parish church at Breedon-on-the-Hill. The image is thought to depict the Virgin and is framed by a double arch supported on columns. The figure wears a rigidly folded costume including a veil and her eyes are arrestingly depicted as deep sockets. One hand is raised in blessing and the other holds a book. It is not clear what the original context of the panel was, though it has been compared both to images in contemporary manuscripts, such as the Book of Kells, and carving on the Hedda Stone, a surviving stone shrine cover at Peterborough. The prominent hill on which the church stands – much of which has now been quarried away – was the site of an Iron Age hill fort and chosen as the site of a monastery in the late seventh century. It was an important foundation within the kingdom of Mercia and one member of the community, Tatwine, became Archbishop of Canterbury in 731. The sculptural panels in the church today, including several ornamental friezes carved with details possibly inspired by Syrian textiles, are all that remain of the Anglo-Saxon building.

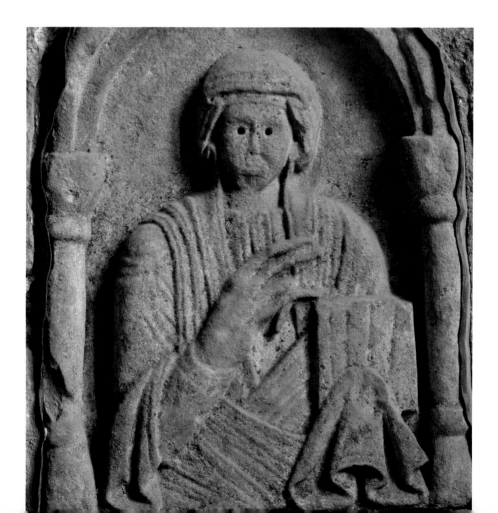

3 Viking Yorkshire
The Church of St Thomas, Brompton-in-Allertonshire, North Yorkshire

During the restoration of Brompton in 1867, several ancient sculptural fragments were discovered built into the fabric of the church. Among them was a set of ten so-called hogbacks, one of the largest collections of these enigmatic objects known at any one site. This photograph shows details from three that remain at Brompton (five others are at Durham Cathedral).

These large carved stones are specifically associated with the Viking settlement of northern England and those at Brompton all date to the early tenth century. They take the form of miniature houses – perhaps after the example of early shrines – and, in this case, are set to either end with the figures of muzzled bears. The surfaces are covered in geometric patterns and panels of lattice decoration. It is assumed that they served as grave markers but, if so, none has ever been found in direct association with a burial. Nor is it known whether they originally formed part of a larger monument. Although earlier sculpture in the region is generally associated with monastic sites, the distribution of hogbacks suggests that they were created for the laity. In support of this idea, some carved details have been interpreted with reference to Norse myth, although the detailing is so rugged that iconographic readings can differ sharply. The concentration of hogbacks at Brompton may imply that this was a centre of their production.

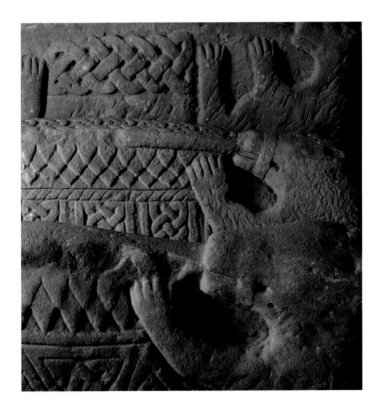

4 Bede's world
The Church of St John the Evangelist, Escombe, Co. Durham

This is a detail of the inner face of the chancel arch of the ancient church at Escombe, which was probably built in the late seventh century from recycled Roman material. The wall painting and plaster is all that remains of the medieval decoration of the interior. Its date is uncertain but the swirling pattern of red lines may be inspired by the tendrils of vines, a common motif in Anglo-Saxon sculpture. The church stands in a circular graveyard, almost certainly evidence that it occupies the site of a prehistoric monument. It's a small structure that is very tall in relation to its plan. The walls are built out of Roman masonry taken from the nearby fort of Binchester (Vinovia). As originally laid out, the building comprised three rooms or cells. That to the west was demolished around 1700. The church was turned to parish use by the twelfth century but no reference to it has been identified in Anglo-Saxon texts. It's presumed that it was originally served by a monastic community. Certainly, a sundial set in the south nave wall that divides the day into four parts would have served the needs of such a community well. The church became semi-ruinous in the mid-nineteenth century and was restored in 1879. It's an extraordinary survival: a building created more than 1,300 years ago in the age of the Venerable Bede.

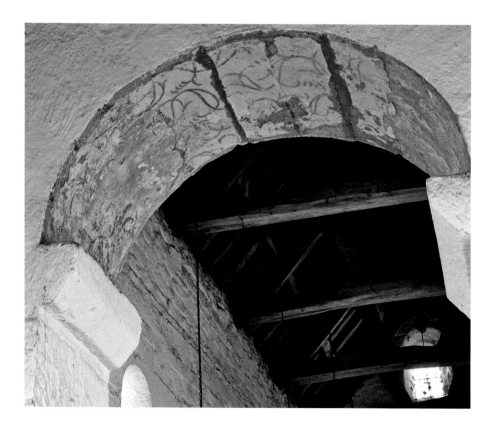

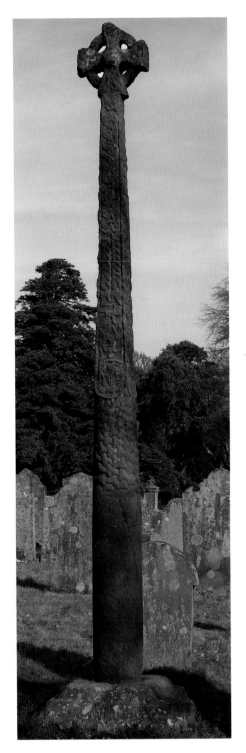

5 Viking Christianity
The Church of St Mary, Gosforth, Cumbria

In the graveyard at Gosforth there rises
a thin monolith of pink sandstone 15ft
high. This is a completely preserved cross,
a relic of the Viking Age that has stood
here for more than a thousand years. It
originally formed one in a small group,
but its last companion was removed to
make a sundial in 1789. The cross rises
from a circular base, but its section
gradually becomes squared. From this
point upwards, the surface is carved
with decorative patterns interspersed
with small scenes. The iconography
of the cross is impossible to unravel
with certainty, but it clearly combines
Christian and pagan imagery drawn from
Scandinavian myth, perhaps with specific
reference to the concept of Ragnarok,
or *The Doom of the Gods*. On the east
face, for example, there appears the
Crucifixion, but above it is the avenging
figure of Odin's son, Vidar, and the
dragon. Overall, might the theme of the
carving represent the end of the old world
order and the beginning of the new? It
is possible that the decorative panels
also had significance. The cross head is
small and ringed with ornament. The
church otherwise preserves an impressive
collection of stone sculptures from the
Viking period.

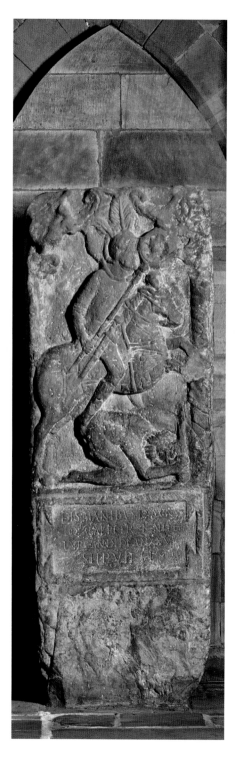

6 Barbarian conquest
**Hexham Abbey, Hexham,
Northumberland**

In 1881, during excavations on the
former site of the abbey 'slype' (a covered
passage) at Hexham, this large tombstone
was discovered. It stands about 9ft high
and commemorates one Flavinus, the
twenty-five-year-old standard-bearer of
the crack Petrian cavalry regiment, or
ala Petriana. He is shown on horseback
with a high plumed helmet and a long
cavalry sword. Behind him is visible the
outline of a tall oval shield and in his right
hand he holds a standard with a face in
its central roundel. Trampled beneath
him is the figure of a naked and bearded
barbarian, who cowers in terror with a
sword in his hand. The scene is framed
within an arch. Flavinus served with his
regiment for seven years. It was based
in nearby Cobridge (Coria) from AD 79
and this stone presumably came from
the cemetery there. Several military
tombstones in the first century AD bear
similar imagery. The tombstone is part
of a large collection of Roman masonry
incorporated in the buildings at Hexham
since the Anglo-Saxon period. All of this
came from buildings and forts along the
line of Hadrian's Wall, which offered
a useful quarry for medieval builders.
From the late nineteenth century some of
the best pieces have been redisplayed in
niches throughout the modern nave.

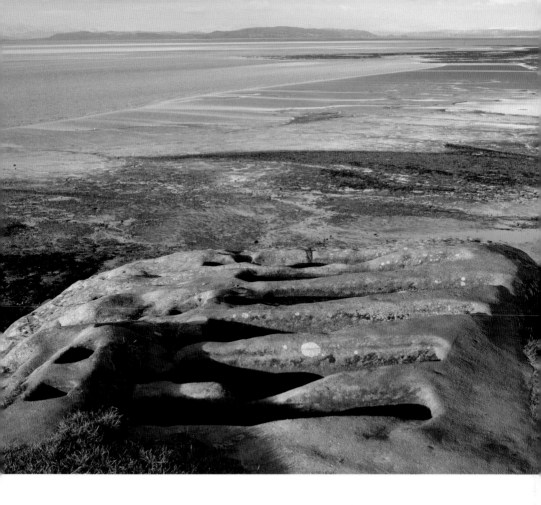

7 The prospect of eternity
St Patrick's Chapel above St Peter's Church, Heysham, Lancashire

Sheltering the graveyard immediately to the west of Heysham parish church is a high outcrop of rock crowned by a ruined chapel. Together the church and chapel possibly formed part of an Anglo-Saxon monastic settlement. Archaeological excavation of the latter in the 1970s suggests that the building was in use between the eighth and eleventh centuries. Shown here are a series of graves cut into the living rock immediately beside the chapel. These are all carved in roughly the shape of a body, though they are in fact just too small to receive one comfortably. This has led to the suggestion that they were receptacles for relics. At the head of each grave is a socket for a headstone. The extraordinary view they enjoy over Morecambe Bay must explain the position of the burials and suggests that important individuals were laid to rest here. In its earliest form the adjacent chapel is also known to have been externally plastered. This would presumably have made it visible from a long distance and created a landmark. Today this is one of the most evocative spots on the Lancashire coastline. It seems to encompass the entire history of the region in a single vista: depending on where you look it is both majestically beautiful and aggressively industrial.

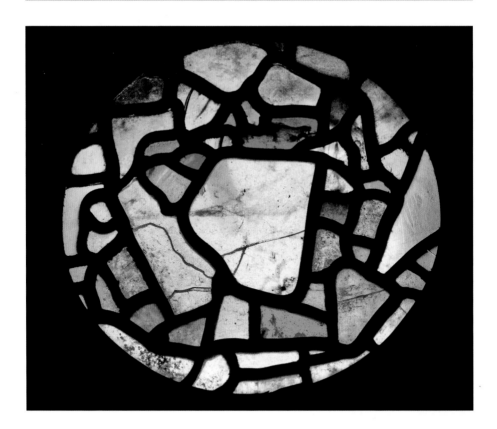

8 Glass from Gaul
St Paul's Monastery, Jarrow, Tyne and Wear

This is a detail of reset seventh-century glass from the parish church at Jarrow, a modest but extraordinary survival from the dawn of English church architecture. A monastery was founded here in about 681, part of a double foundation with nearby Wearmouth. These two institutions enjoyed a European reputation and were the home of the monastic historian and writer Bede (d.735). He records that the first abbot, Benedict Biscop, brought many international craftsmen to work on his buildings. Among these were glaziers from Gaul, who educated the English in this unknown art. Over the last 50 years archaeological excavation at both sites has revealed more than a thousand fragments of window glass. None of them is painted but there are many pieces in green, amber, yellow, red or streaked colour. It seems that the glass was set in lead to form mosaic panels: the first English stained glass. These were mounted in stone frames inset within the window arch. In this case a circular opening is punched through the frame for the glass. The window survives in the modern chancel, which incorporates the remains of one in a pair of Anglo-Saxon churches that formerly stood on the site. Another church, on the site of the nave, was destroyed in the eighteenth century.

9 Words from a sundial
St Gregory's Minster, Kirkdale, Yorkshire

The removal of plaster from the modest exterior of Kirkdale church in 1771 revealed this sundial cut in a 7ft-wide stone above the south door. In the centre is the dial itself marked out as a semicircle with eight divisions and the fixing for a gnomon (the part of the sundial that casts the shadow), now lost. The uniquely informative Old English inscriptions suggest the importance of measured time to the church. Across the top of the dial are the words 'This is the day's sun's marker' and in the semicircle 'at every time'. Beneath is the maker's inscription: 'Haward me wrought and Brand, priests'. Finally, within panels to either side is the text 'Orm Gamalsson bought St Gregory's minster when it was all broken down and fallen, and he had it built anew from the ground for Christ and St Gregory in the days of Edward the King and in the days of Tostig the Earl'. These figures date its creation between 1055 and 1065 and the language demonstrates a strong Scandinavian influence. Prior to its ruin during the Viking invasions, the minster at Kirkdale had been an important site. Orm's purchase and restoration of the church may illustrate wider patterns of private noble patronage in the mid-eleventh century. Unfortunately, nothing is known of the subsequent history of the minster prior to the twelfth century.

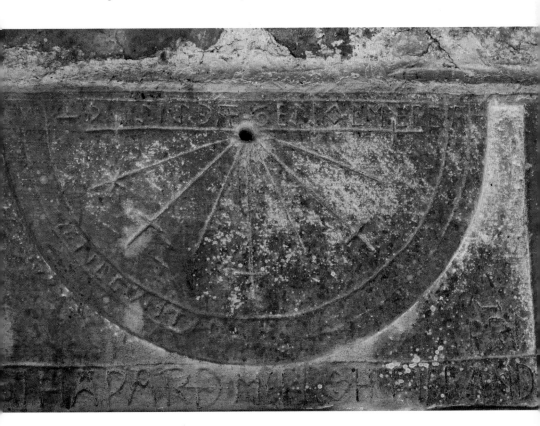

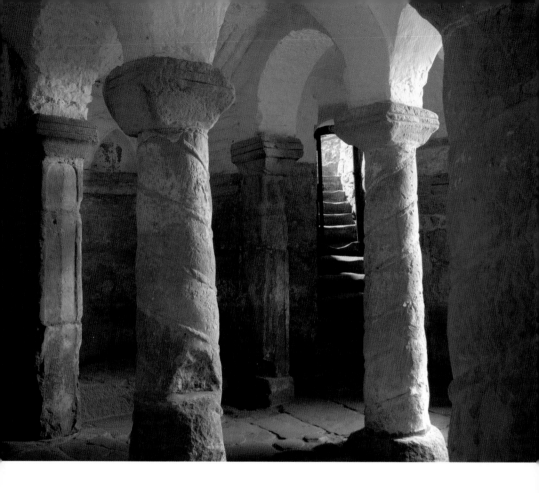

10 Royal mausoleum
The Church of St Wystan, Repton, Derbyshire

The Anglo-Saxon crypt at Repton was a mausoleum of the kings of Mercia. It may have been built in the early eighth century for King Æthelbald (d.757), but was later adapted to its present form. This incorporates four central columns decorated with spiral patterns supporting a stone vault. The treatment of the columns is presumably inspired by the baldachin raised by the Emperor Constantine over the tomb of St Peter in Rome. This was similarly supported on spiral columns. At Repton, however, it is likely that the columns and vault were erected to dignify the burial place of St Wystan, or Wigstan, who refused the Mercian crown and was later murdered, in 849. His tomb probably sat within the central space defined by the spiral columns and vault (effectively a baldachin). The arrangement would have allowed pilgrims to the then monastery at Repton, who had access to the crypt via two stairs extending diagonally from its western corners, to circulate round his shrine. Repton is one of a small group of surviving Anglo-Saxon crypts – including those at Hexham and Wing – apparently inspired by Roman or continental example. They are testimony to the international outlook of the Anglo-Saxon church. St Wystan's body was later translated to Evesham by King Cnut, who ruled from 1016 to 1035.

11 Christ the King
Romsey Abbey, Romsey, Hampshire

Set in the external transept wall of Romsey is this monumental figure of Christ crucified. It is over a thousand years old. The sculpture comprises three massive pieces of limestone arranged in the form of a cross: two blocks for the arms and one about 7ft long for the central figure. Christ stands on a shallow projection with arms outstretched and eyes open in dignified and commanding repose. The blessing hand of God descends from a cloud above. Christ's head is deliberately flattened at the top, probably evidence that the figure was crowned. Such ornaments are documented elsewhere. When King Cnut (1016–35) gave his crown to Old Minster Winchester, for example, it was placed on the brow of the crucified Christ in the church. It is likely that the cross was formerly flanked by additional figures of the Virgin and St John but these were probably lost when the crucifix was reset in its present position within the nuns' cloister in the late twelfth century. Of its original location – perhaps above a door or chancel arch – nothing is securely known. Various details of the figure may be paralleled in Anglo-Saxon manuscript and ivory images that collectively suggest a date for the sculpture in the tenth century.

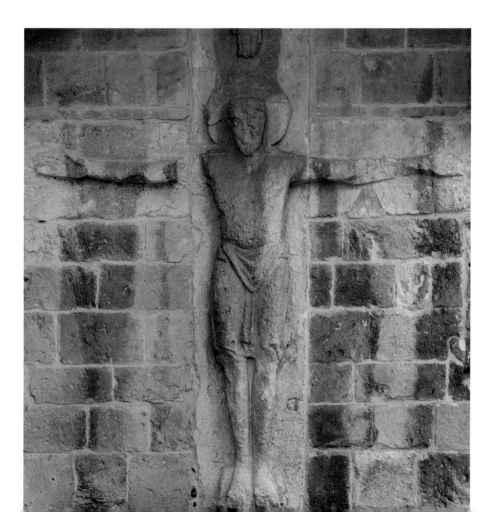

12 Pointing to the past
The Church of All Saints, Rudstone, Yorkshire

Immediately beside the church in the graveyard at Rudstone is the largest surviving monolith in Britain. It stands a majestic 6ft wide and 29ft tall. A lead cap now protects the tip of the stone but its gritstone surface has been worn by millennia of rain. The stone was presumably brought from the nearest natural outcrop of gritstone at Cayton Bay about ten miles away. It was probably erected between about 2500 and 3000 BC and forms part of an extraordinary concentration of Neolithic monuments in the chalk uplands of the Yorkshire Wolds. This comprises long and round burial barrows, a henge named the Maiden's Grave, numerous pits and five linear earthworks termed cursuses (the largest is just under three miles long). These follow the valley of the Gypsy Race, suggesting that the river had some special significance. The monolith may have been an anchor for this entire landscape, standing above a sharp bend in the river. With the advent of Christianity, this sacred topography was overlaid and the stone appropriated to the use of the new religion as a high cross: the name of the village literally means 'rood (or cross) stone'. It's likely that the erection of the parish church long follows the first Christian use of the site.

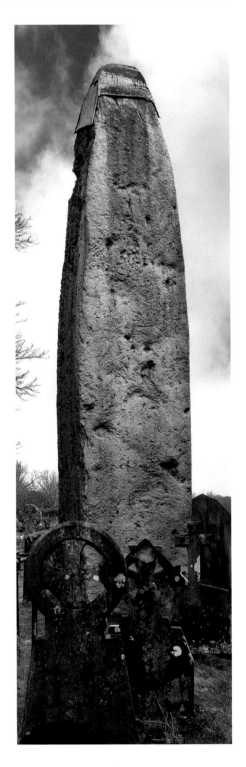

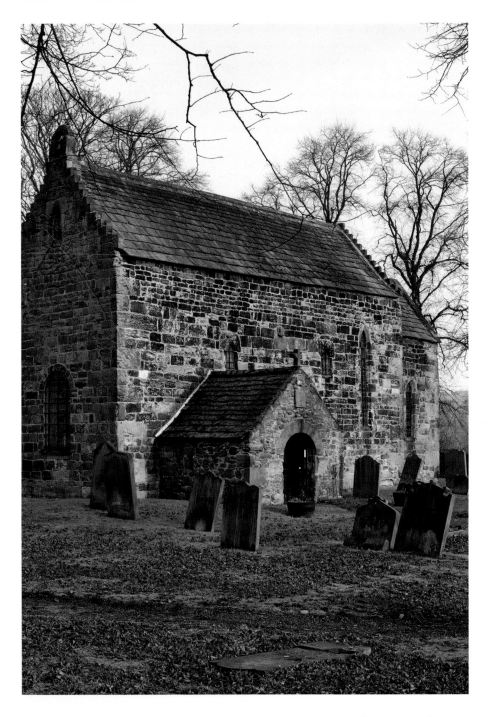

Escombe, Co Durham: the 7th-century church stands in a circular graveyard, evidence that it occupies the site of a prehistoric monument

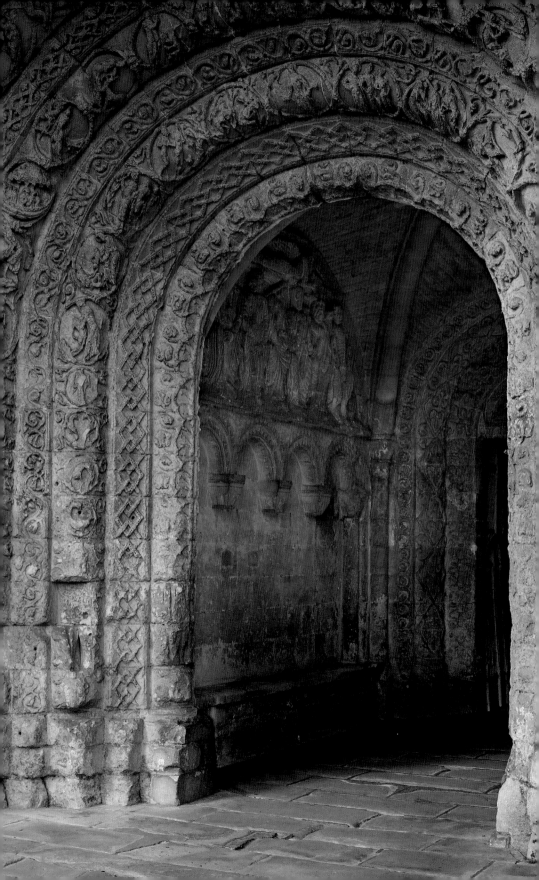

2 Genesis, 1000–1199

That a well-developed parochial system was established across England by about 1100 is universally conceded. Also, that by this date the word 'parish' had come to possess two related meanings: it referred both to a geographically defined locality and the people of all ages and both sexes who lived within it. The universal embrace of the parish – uniting everyone in an area – distinguished parochial churches in villages, towns and cities from all other Christian religious buildings. Indeed, perhaps from any other kind of building at all. It has also guaranteed them an important role in the daily life of ordinary people for more than a millennium.

Opinions vary, however, as to how this system of parishes came into existence. The widely accepted view at present is that it developed from the ninth century onwards out of a network of churches termed 'minsters', the Anglo-Saxon word for *monasterium*, or monastery. Such minsters demonstrably existed over a wide geographic area and their landed endowments are well attested in the documentary record. Commonly these foundations were associated with royal centres, or vills. The boundaries of their responsibility were large, at least the size of many later parishes, and they can sometimes be shown to have been coterminous with those of royal administrative districts. This fact has been cited as evidence that they were created by – and reinforced – the authority of the king.

The actual character of minsters as religious bodies is debated. By this analysis, rather than being contemplative (in the manner of most later medieval monasteries), their religious communities undertook pastoral duties for their local

The mid-12th-century south porch of Malmesbury Abbey, Wiltshire

populations. From the ninth century, however, the pressure of Viking attacks and settlement brought about the fragmentation of this minster system. With the breakdown of effective royal power, combined with a sharp growth in population, noblemen began to build churches on their own estates and these new foundations inexorably established their own integrity and independence. Minsters sometimes preserved some vestigial control over the new buildings within their former territories and their original significance was reflected in the relatively greater scale of their buildings. Nevertheless, they diminished in importance and their pastoral role was usurped and diluted by the interloping and private foundations that sprang up around them.

The present scholarly consensus favours this thesis but it is worth expressing a conflicting interpretation of the evidence, not least because no one single model of change is likely to have applied everywhere. According to this perspective, while minsters loom large in the documentary and archaeological record, their role in parochial care has been exaggerated. Indeed, it has been argued, these institutions were really an integral part of the royal estates they occupied and their religious life was inwardly focused (like later medieval monasteries). Responsibility for the spiritual needs of the population fell on bishops, who were the only people who could ordain priests, consecrate churches or provide chrism for the sacraments.

Bishops in the Anglo-Saxon kingdoms – as this argument runs – managed a clerical hierarchy that was not permanently endowed with lands or property.

Consequently, it is not fully described or represented in the documentary record (in contrast to wealthy minsters). Hitherto, exemplary bishops had travelled across their dioceses to serve their flock, but the Christian life of the population as a whole had – arguably – not been of central importance to the Church. All this changed, however, under the influence of the Carolingian Church reforms of the eighth and early ninth centuries. These put particular emphasis on the appropriate provision of care for the laity, perhaps as an expression of a high purpose on the part of such rulers as Pepin the Short, Charlemagne and Louis the Pious to turn their subjects into a new 'People of Israel'.

As part of this process the Carolingian Church hierarchy was restored and endowed – through state backing – with the universal taxation of a tenth of all produce familiarly known as a 'tithe'. Crucially, this tax did not pass directly from the laity to a single recipient but was divided. One part was retained by the local church, which henceforth, therefore, required geographic demarcation. This was the parish. Another portion was passed to a church with responsibility for several parishes. And this hierarchy was managed by the bishop. In simple terms, it has been suggested that England adopted these Carolingian ideals and church structure from this continental European example. The crucial figure in this process was King Alfred (reigned 871–99), who laid the foundations for the future parochial system as part of his extraordinary reorganization of the administration of the kingdom of Wessex.

From the limited evidence available it seems clear that the physical form of

early parish churches varied considerably. Some assumed the ambitious architectural mantles of minster churches built in stone. A vast number, however, probably began life as wooden buildings. These need not have been simple structures, as surviving medieval stave churches in Scandinavia powerfully illustrate. Only one substantial fragment of an early timber-built English parish church survives, however: the eleventh-century aisle of Greensted-juxta-Ongar, Essex, ruggedly constructed of split oak logs.

Timber continued to be used as a principal construction material for churches in certain areas throughout the Middle Ages. Nevertheless, where the means existed there was from the very first a clear preference for building churches in stone. Their sacred purpose demanded the use of this permanent and prestigious material redolent of Rome. The process by which parish churches were recast in stone must have varied in different regions but it received a particular boost after the Norman Conquest in 1066. Stone quarrying was revolutionized in a technical sense and parish churches were evidently part of the intense building boom that covered Norman England with new castles, cathedrals and monasteries. In the process, the last touches were added to the bones of a parochial system that would survive with little material change into the nineteenth century. By 1200, it is estimated that about 8,500–9,000 parishes existed in England, the vast majority of them served by stone churches.

Detailed evidence about this process of parochial expansion is extremely limited but occasionally we are reminded of the complex human stories that lie behind it. In the 1130s, for example, one Oliver de Merlimont, a steward, received a grant of the manor of Shobdon in Herefordshire. There he rebuilt an existing wooden chapel in stone and gave it parochial status. Oliver then went on pilgrimage to Santiago de Compostela, leaving the consecration of the completed building to his return. During his travels, however, a chance encounter outside Paris introduced him to the monastery of St Victor on the edge of the city.

Having returned to Shobdon and consecrated the church, Oliver decided to found a monastery of his own and wrote to the Abbot of St Victor to supply a founding community. The two

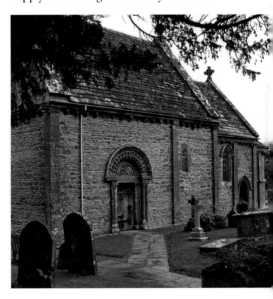

Kilpeck, Herefordshire, was built around 1134 and its Romanesque fabric remains almost perfectly preserved. The church comprises three cells and ends in a curved apse, a typical 12th-century feature.

canons who eventually came from St Victor were provided with a residence at Shobdon but were quickly ejected by the steward's overlord. Thereafter, in very complex circumstances and on a different site, this monastic foundation became Wigmore Abbey. Oliver's story is only known because of a medieval account of the abbey's foundation. Remarkably, fragments of the sumptuous parish church he erected at Shobdon still survive but as a folly; his building was replaced no less splendidly in the eighteenth century.

Regardless of the material in which they were built, parish churches through the vast majority of the period covered by this chapter required just two internal spaces: an area for the altar, termed the chancel, and another for the congregation, the nave. In the simplest church plans the chancel and nave could be accommodated within a single room or architectural volume. This was usually a rectangular building laid out with the altar at the east end and the nave to the west (the almost universal convention for the orientation of churches from the Middle Ages to the present day).

More elaborate buildings, however, were planned on a cellular principle(see opposite). That is to say, they comprised a series of rooms or cells interlinked by internal archways. The most straightforward expression of this idea is the two-cell church, in which the nave and chancel were discrete structures communicating internally through the so-called chancel arch. In yet larger buildings, however, there might be more cells. The most important of these were usually organized in a single line on an east–west axis, but there could be additional cells to the north and south, too. After the

Conquest, as time progressed it became increasingly common for the chancel to end in a semicircular apse. This form permitted the area of the altar to be dignified with a half-dome of stone.

Many larger parish churches from the Anglo-Saxon period onwards incorporated a tower. This could be placed between the chancel and nave to form a central cell within the building. More commonly in parish churches, however, the tower was placed at the end of the nave. In this position, and opening into the nave through an archway, it could form a western or endmost cell to the building. From the generous staircase arrangements and fine architectural detailing of such towers it seems reasonable to infer that in some cases the upper chambers were privileged spaces used perhaps by the patron of the church for watching services.

From the very earliest times bells were hung in parish church towers and constituted a jealously guarded mark of status. For practical reasons a belfry needed to be set as high as possible and its walls pierced with openings for the passage of sound. These considerations imposed upon parish church towers a characteristic design in which architectural ornament was concentrated around the belfry on the top storey of the structure. Low pyramidal spires also sometimes surmounted towers from an astonishingly early date. A unique example dating to around 1000, for example, survives at Sompting, West Sussex.

Roofs – made of thatch, shingles or lead – may also have served as a canvas for decorative treatment. Certainly, the images of buildings on the eleventh-

century embroidery familiarly known as the Bayeux Tapestry show complex roof structures. Another common decoration attested on large buildings from antiquity onwards that may have appeared on parish churches was the weathercock.

It is rare in this period to find an external door in the base of the tower. Where they exist, these were probably processional entrances to the building. The principal door to a parish church was usually on the south side of the nave. In the period covered by this chapter, the door itself was ornamented with ironwork (a treatment which falls abruptly from fashion after 1300). Church doors seem to have been a setting for public ceremonies from a very early date (though documentary evidence for such practices in parish churches prior to the fourteenth century is nonexistent) and presumably for this reason towards the end of the twelfth century richer parishes sometimes enclosed the door within a porch to keep out the weather. Previously, porches tend to be a feature of greater churches including abbeys, priories and cathedrals.

One of the distinctive features of Romanesque churches (that is to say buildings that aped the language of Roman architecture) both great and small is the quantity of architectural sculpture they incorporate. The interest in such detailing may reflect the influence of timber architecture, where it was easy to ornament the architectural elements in this way. Whatever the case, by its subject matter and richness, architectural sculpture was always applied in a way that underlined the relative importance of the different parts of the building. The nave, for example, is often more plainly treated than the setting of the altar in the

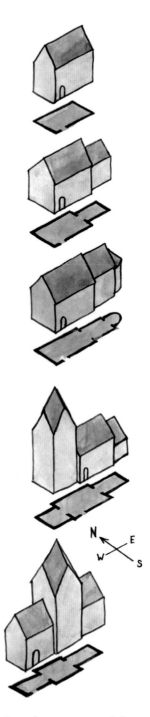

Examples of one-, two- and three-cell parish church designs

chancel and carving is clustered around the outward faces of the principal door and chancel arch.

Dominating the church interior was the main altar, the furnishing on which the priest ceremonially re-enacted the Last Supper in the ceremony of the Mass. This usually sat within the chancel framed by the arch that communicated with the nave (though occasionally it may have stood in front of it). No parochial altars of this period survive but the ideal was for them to be built in stone and fixed in position. To judge from documented attempts by the church authorities to replace wooden altars, however, it's clear that substantial numbers existed in this material too.

In the ninth and tenth centuries it's possible that priests faced their congregations across the altar for the celebration of Mass. Whether and how they were assisted at the altar is not clear. By the twelfth century, however, it was universal practice for the priest to stand with his back to the congregation. From the evidence that survives, it seems that the chancel arch usually stood open with no infilling screen or barrier. This may explain why it was commonly ornamented prior to 1200: a treatment that helped underline the sacred character of the threshold that it demarcated.

The church at Pittington, Co Durham, is a typical example of a building cumulatively expanded over time. The two aisles and tower were added to a rectangular Romanesque nave at different dates.

It's possible that the corresponding tower arch at the west end of the nave framed the only other significant internal furnishing of an early parish church: the font. These objects were in effect expressions of independence, symbolizing the right of the parish to baptize its own population and welcome them into the Christian community. That said, Anglo-Saxon fonts are rare and it is only from the late eleventh century that large numbers of these fittings survive. England is unusual in a European sense for the survival of several regional groups of unusually elaborate carved Romanesque fonts in parish churches.

Parish church windows were generally small and were probably filled with window shutters in a wooden frame rather than glass. An Anglo-Saxon example of such an arrangement with the frame and shutter still in place was recently revealed in the chancel at Boxford, Berkshire. Stained glass was probably rare in parish churches and the principal

form of internal decoration was wall painting. Given the extent of the blind internal wall surfaces, there was space for impressive and large-scale painted cycles. One common configuration was to have the bottom section of the wall painted so as to resemble hanging cloths, presumably a familiar arrangement in grand domestic interiors. The area above was then decorated with tiers of imagery. As with external sculpture, the painting could underscore by its subject matter the function or relative importance of the space it decorated.

Such was the probable form of the early parish church. Yet by the mid-twelfth century these double- or triple-cell interiors were in the process of transformation. From this date forward parish churches began to be expanded with the addition of aisles: long, narrow spaces added to one or both sides of the nave and communicating with it through arcades of high arches. The idea of aisles was already well developed in great churches but various pressures may have encouraged their inclusion in parishes. Burial within a church was proscribed in this period (though it did happen) and aisles may have been seen as a way of creating internalized burial plots. More certainly, aisles also provided space for additional altars that could be used to offer Masses paid for by the laity. Whatever the motivation behind the change, aisle arcades henceforth became a vehicle for architectural display.

As a background to these architectural changes, there was also taking place a transformation in the ownership of parish churches. Some priests were fortunate enough to enjoy their tithe income – the universal tax of a tenth of all produce

paid to the church – directly. They were called 'rectors', a word deriving from the Latin verb *regere*, meaning 'to govern'. Nevertheless, the tithe was technically the property of the local manorial lord. As such, tithes could be inherited or bequeathed (and also divided) by them and this offered a means by which they could be indirectly exploited.

From the late eleventh century there began the widespread assignment of parishes by the laity to monastic communities, who drew on their tithes as an endowment. Since the lay donors could not benefit from the tithes anyway these were relatively easy gifts to make. Over time nearly half of all medieval parish churches were transferred or 'appropriated' in this way. In return, monasteries were obliged to provide a deputy – a vicar, or *vicarius* – to perform parish duties. He received a salary, not the full tithe enjoyed by the rector.

It is a common pattern to see parishes transferred in this way being rebuilt on an extravagant scale as the new monastic owner made tangible expression of their new possession and responsibility. Yet as time went on – or even concurrently – there was a natural tendency for religious houses to treat parishes simply as a source of income. There were widespread complaints of vicars being inadequately paid and, as a corollary to this, insufficiently educated. As early as 1102 a council at Westminster ordered that monks should not 'rob' churches of their revenues so that 'the priests who serve them want things necessary'.

The individual ultimately responsible for policing such difficulties and also overseeing the parochial system in each

diocese was its bishop. One hagiography in particular offers a vivid impression of the issues facing one English bishop in this regard at the end of the eleventh century. This is *The Life of Wulfstan*, a text written in the early twelfth century by the monk chronicler William of Malmesbury (but based on an earlier and lost text written in English). It narrates the life of its eponymous hero, who became Bishop of Worcester in 1062 and died in 1095.

To a quite remarkable extent Bishop Wulfstan was apparently absorbed in preparing new churches for use. There is mention, for example, of 'a journey devoted to the dedication of altars' (iii.15) and, more explicitly, the claim that: 'Through all his diocese he built churches on lands that were in his jurisdiction, and pressed for such building' (iii.10). Presumably some of these were new parish churches. Nor was the bishop the only builder of such structures. One narrative, for example, tells of a certain '… Ælfsige, who had been a thegn of King Edward', who invited Wulfstan to dedicate a new church he had built 'at his vill of Longney on the Severn'. Upon arrival Wulfstan ordered that a nut tree in the churchyard should be cut down to give space and light to the new building. When Ælfsige refused – he enjoyed playing dice beneath its branches – Wulfstan cursed it and the tree died (ii.17).

As William of Malmesbury portrays him, Wulfstan was 'assiduous in travelling through his diocese, giving infants any sacraments they lacked and spurring the faithful to good works' (i:15). Wherever he journeyed large crowds evidently came to hear him preach. But, curiously, we are nowhere told of the laity attending Masses celebrated by him, a reflection perhaps of the relative rarity with which they witnessed this ceremony. Indeed, the whole question of how regularly the laity came to their parish church or what they saw once they came is frustratingly uncertain.

His parochial duties aside, Wulfstan was also a man, as Ælfsige discovered, prone to curses and visceral responses. There is a description, for example, of him grovelling in the dust wearing his episcopal robes in an attempt to settle a blood feud (ii:15) and the famous story of his treatment of a rich woman who persistently attempted to lure him into bed. At last Wulfstan

'… could stand it no longer. He interrupted her in full flight, and crossing himself said, "Away with you, and take with you the hatred you deserve, you tinder of wantonness, daughter of death and vessel of Satan." These admonitory words were followed by a slap, which he, in his zeal for chastity, administered to the face of the gabbling woman with such force that the smack of his palm could be heard right through the door of the church [of Worcester]. The story went the rounds of the city … (i:6)'

Grovelling and blows are behaviour that's very hard to imagine of an exemplary clergyman even a generation later. For the church was growing and changing very fast indeed. In this new and flourishing institution there was no space for blunt and bullish men of Wulfstan's mould. The next generation of churchmen were to carry themselves with more self-conscious dignity, intensely aware of the authority of the anointed cleric. As we shall see in the next chapter, their churches great and small would grow in scale and ornament to reflect that fact.

13 A sculpted font
The Church of St Nicholas, Brighton, East Sussex

Beneath the tower of the medieval parish church of Brighton is this remarkable font carved with four scenes in low relief. Shown here is a striking representation of the Last Supper. Christ, with a cross inset in his halo, is shown centrally. He lays his hand on a loaf of bread and blesses a goblet of wine. The Apostles – only six can be squeezed in – each raise a hand in response. An elegantly pleated cloth is laid over the table. There are bands of geometric and floral decoration around the rim and lower register of the font. The other carvings represent the baptism of Christ, an obvious subject for a font, and what are probably two miracles of St Nicholas, the patron of the church. One of these latter shows the bishop rescuing pilgrims from a storm on a boat. To judge from the style of the carving, the font was probably made in the late twelfth century. Prior to the virtual reconstruction of the church in 1853–4, it stood in the centre of the nave and drawings show its lower section encircled by a ruggedly constructed wooden bench. This addition is probably dated by a former inscription on a band beneath the carving that read: 'H. Stanbrig and W. Buckoll C[hurch] Wardens 1745'.

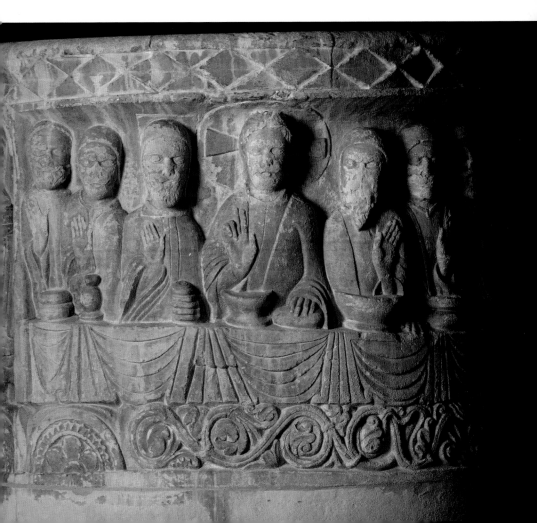

14 Painted splendour
The Church of St John the Baptist, Clayton, West Sussex

At Clayton it's still possible to imagine something of the impact of a grand Romanesque parish church. The interior, originally lit by small windows, displays an impressive and coherently executed wall-painting cycle that probably dates to about 1100. Shown here is the chancel arch with the seated figure of Christ supported by angels at its apex. To either side are Apostles, part of a Last Judgement scene that runs round the upper register of the flanking walls. On either side of the arch in the lower decorative register are two further images of Christ. To the left he gives St Peter the keys of Heaven and, to the right, St Paul the new law. Inspiration for this iconography and the stylistic treatment of the figures suggests a Byzantine influence. It's possible that the scheme was complemented from the first by a crucifixion or rood fixed within the arch. The paintings were first discovered in the 1890s and conserved in the 1960s. At that time further traces of contemporary wall painting were revealed in the chancel. Four other local churches in the area have – or had – similar wall paintings of about the same date, though the character of the connection between them remains contested.

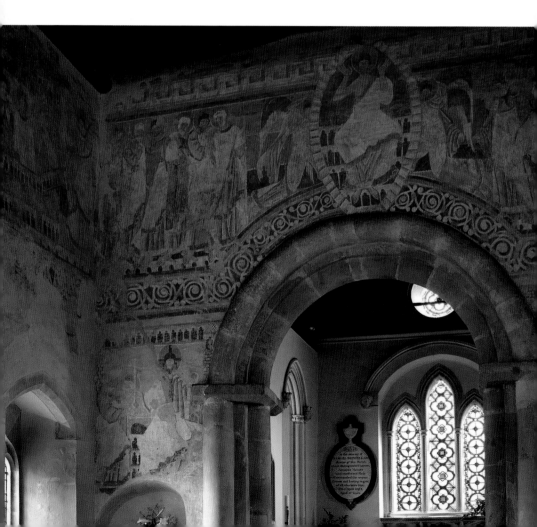

15 Groaning under the load
**The Parish Church at Coombes,
West Sussex**

This is a detail from the fragmentary
wall-painting scheme dating to the
decades around 1100 and uncovered at
Coombes in 1949–52. The figure appears
within the spring of the chancel arch and
is wittily shown grimacing to support
it. This conceit of a figure bearing an
architectural load has a long history in
Western architecture running back to
the caryatids of classical temples. It was
widely popular in Romanesque art in both
France and England. The cartoon-like
treatment of the figure was partly dictated
by the rapid technique of its creation.
For this painting is a true fresco with the
paint worked into the surface of the wet
plaster before it had dried (though some
detail could be over-painted later). There
is evidence for incisions made in the wet
plaster by the painters to guide their work.
Coombes is one in a group of five Sussex
churches (with Clayton) that possess – or
are known to have possessed – roughly
contemporary wall-painting schemes
(two schemes were destroyed in the
nineteenth century; a salutary reminder of
how vulnerable wall paintings are during
internal works to buildings). As is often
the case in parish churches, the pigments
used were cheap and locally available: red
and yellow ochre, lime white and carbon
black.

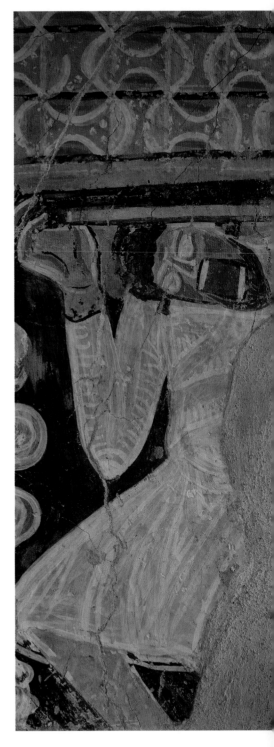

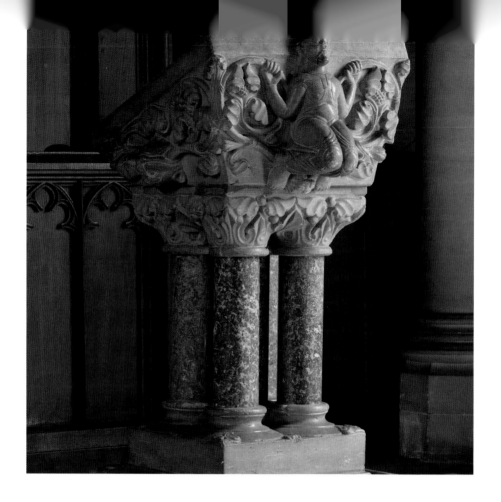

16 In honour of the rule
The Church of St John the Baptist, Crowle, Worcestershire

Facing the congregation of Crowle church is this astonishing medieval lectern carved from polished limestone. Its upper section, supported on a cluster of foliage capitals, is strikingly decorated: a kneeling man dressed in a gown grasps at the surrounding scrolls of leaves and vines that emerge from the mouths of lions. The style of the carving and the architectural detailing of the lectern suggest that it was created in about 1200. The origins of this remarkable object are obscure. It was reputedly brought into the church from the graveyard in 1841 and then restored in its present form with polished shafts in about 1845. The lectern probably comes originally from a monastery. Indeed, a similar one decorated with a figure of an ecclesiastic, now a few miles away at Norton, was dug up in 1813 near Evesham Abbey. Freestanding stone lecterns were a particular feature of chapter houses, where the business of the daily assembly of monks was prefaced by a reading from the Rule of St Benedict. In this context, the lectern underlined by its size and beauty the importance of the text it physically supported. The representation of a man either sustained – or perhaps entrapped – by foliage could also read as a metaphor for the importance of the rule as a means to virtuous life.

17 The snares of sin
The Church of St Mary Magdalene, Eardisley, Herefordshire

This is a detail of the vigorously carved font at Eardisley probably dating to around 1140. It shows two fighting figures, one of whom has just passed his spear through the leg of his opponent. The font is in the shape of a goblet with a bulbous body set on a base with a narrow stem. On the opposite side of the font is the figure of a lion and – probably – a scene representing the Harrowing of Hell, the moment at which the resurrected Christ breaks the bonds of sin. In this image Christ is shown dragging Adam out of Hell. He appears with what are presumably the other figures of the Trinity: on his arm is a dove (the Holy Spirit) and beside him another haloed figure (God the Father). Running behind the figures and intertwining with the limbs of the fighting men is a trail of foliage. This may be an emblem of worldly ensnarement. If so, the font promises salvation to those baptized within it, but it also warns them of the dangers of sin. The Romanesque church for which this font was created has disappeared. Nevertheless, the style of the carving suggests that it was created by a group of masons who worked on a number of other Herefordshire churches in this period, including Kilpeck.

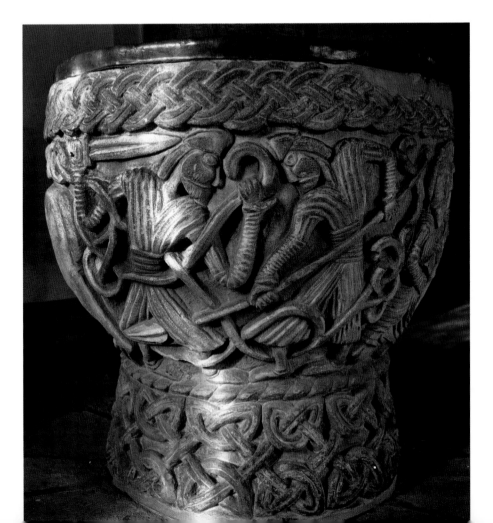

18 A thegn's tower
The Church of All Saints, Earls Barton, Northamptonshire

This tower at Earl's Barton probably dates to about the year 1000. It stands four storeys high, each storey, like the sections of a telescope, being slightly smaller than the last. The uppermost level is a belfry and is opened out with arcades supported on bulbous columns. Above this are fifteenth-century battlements; the original form of the roof and parapets is uncertain. Possibly there were gables and a low spire. Externally, the tower is ornamented with projecting strips of masonry laid in patterns. These may evoke in stone the appearance of contemporary timber frame structures, a vanished corpus of architecture. Running up the angles of the tower are alternately placed deep and narrow stones, a typical feature of Anglo-Saxon masonry termed long and short work. A large door at ground level led into the building and another – visible beside the clock – opened into the air. Was this a balcony? Of the original form of the Anglo-Saxon church nothing is securely known. It seems likely that the tower was a nave and opened into a lost adjoining chancel. The tower stands immediately beside the residence of a lord or thegn that was adapted after the Norman Conquest into a castle. The assumption is, therefore, that the Anglo-Saxon church was privately constructed as an estate church.

19 Coloured glass
The Church of St Agatha, Easby, Yorkshire

In the shadow of the abbey ruins at Easby there stands a small parish church with an unexpectedly rich collection of medieval sculpture and painting. Easily overlooked within it, however, is this fragmentary survival of a late twelfth-century stained-glass figure of St John the Evangelist. St John was conventionally represented in the Middle Ages as a beardless youth – in contrast to virtually all other male saints – and is shown here with one hand raised in a gesture of grief. This is evidence that the panel originally formed part of a Crucifixion scene in which standing figures of St John and the Virgin flanked Christ on the cross. The surrounding red and blue glass is modern and one piece of late medieval glass has been awkwardly used to repair damage to the torso. Otherwise the figure is remarkably well preserved. Particularly fine are the flowing folds of St John's gown and the bold stylization of his face. The panel has been dated to around 1180–90 by comparison with glass at York, which is both technically and stylistically similar. It is rare to find such early stained glass in a parish church, where this medium only seems to have become widespread in the thirteenth century. The glass may originally have come from the neighbouring Augustinian abbey.

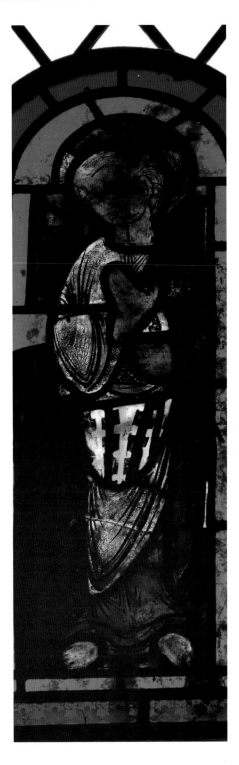

20 Commanding the threshold
The Church of St Mary, Haddiscoe, Norfolk

Enclosed within the fifteenth-century porch at Haddiscoe is this twelfth-century doorway. It's a relatively modest creation distinguished by two exceptional associated elements. Over the door is an enthroned figure in the vestments of a bishop, set within its own decorated niche. He holds up objects like sceptres and above him hovers a dove, presumably the Holy Spirit. This might represent a bishop or a more evocative subject such as the Old Testament priest and king Melchisedech, a figure closely associated with Christ. There is also preserved on the surface of the door – itself remade in the nineteenth century – the reorganized and restored remains of decorative ironwork dating to around 1100. Dominating the pattern is a central cross. Today the cross has limbs of roughly equal length but originally the base extended down to the threshold of the door. Various details of the ironwork, including its use of interlace, suggest an Anglo-Saxon inspiration for the pattern. Curiously, two immediately neighbouring parishes formerly had similar work, possibly by the same smith. Such ornamentation underlines the medieval importance of the door both as an entrance and the backdrop to public rituals such as oath-taking (including for weddings). The iron cross and enthroned bishop presumably projected the authority of the church over them and into the world beyond.

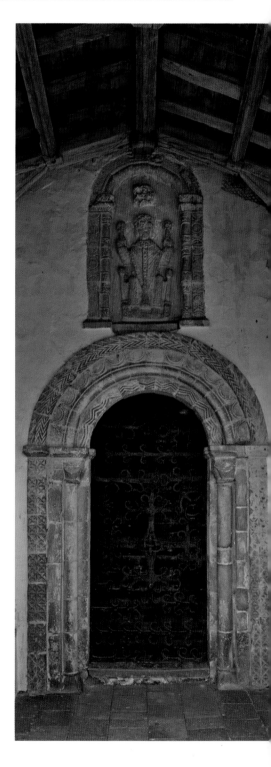

21 The power of the cross
The Church of St Helen, Kelloe, Co. Durham

During the restoration of Kelloe church in 1854, a group of Romanesque sculptural fragments was discovered embedded in the wall of the chancel. Reunited, together the fragments form a superb cross about 3ft high with a wheel-shaped head. It bears the Latin inscription 'in this, victory', a reference to the Emperor Constantine's vision of the cross before his crucial victory at the Battle of Milvian Bridge. The scenes on the shaft, carved in about 1200, refer to the discovery of the True Cross by Helena, the mother of Constantine. At the top, she is visited by an angel in a dream and, at the bottom, she discovers the relic by threatening with a sword the figure – named, by tradition, Judas – to reveal its hiding place. Also shown in this scene is the miraculous resurrection of a dead man by the touch of Christ's cross. The central panel shows Helena and another queen. Blank recesses in the surface of the stone may have been for jewels or their lookalikes. Presumably the whole was also painted. It perhaps explains the richness of this object that, to a northern English audience, Constantine's victory was paralleled at Heavenfield in 635, when the Christian King Oswald set up a cross prior to his defeat of the pagan Cadwallon.

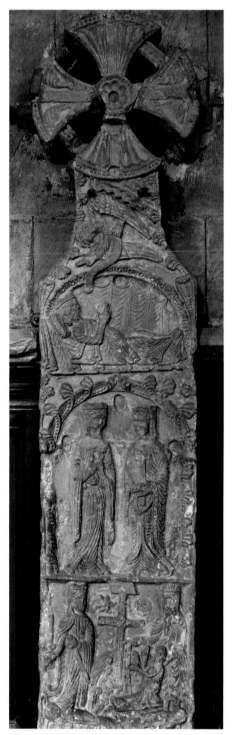

22 An heroic struggle
The Church of St Mary and St David, Kilpeck, Herefordshire

This is a detail of the nave door at Kilpeck. It forms part of an exceptionally well-preserved Romanesque church, the construction of which can probably be associated with a charter of 1134. By the terms of this the local magnate, Hugh FitzWilliam, granted the church and chapel in the neighbouring Kilpeck Castle to the monks of Gloucester Abbey. To either side are columns transmogrified into the writhing figures of dragons, lattices of foliage and the figures of two knights set one above the other. In the archway above are monsters and animals, while the central panel displays a vine in the centre, a reference presumably to Christ. The surrounding images perhaps represent the heroic struggle between good and evil. This door forms part of a sculptural programme extending throughout the nave, chancel and apse. By its subject matter and richness it underlined the function and relative importance of the different parts of the building. In this case, for example, the figures of knights may refer to the use of this door by the laity. By contrast, the chancel arch framing the high altar has similar figures of saints. While the carving at Kilpeck bears comparison to that found in other local churches, its decorative motifs are drawn from across Europe.

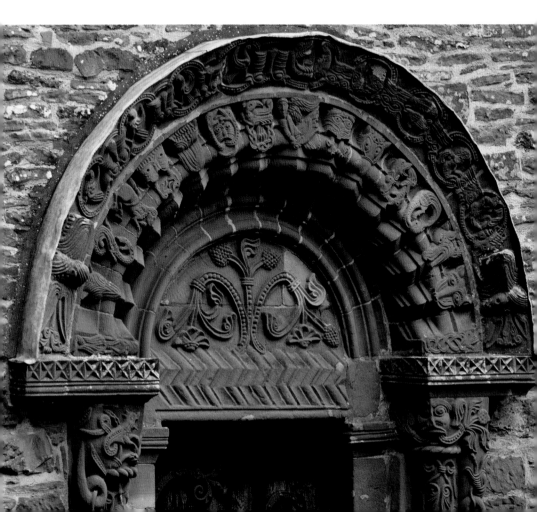

23 Monastic enthusiasm
The Church of St Mary, Lastingham, North Yorkshire

In 1074, a small group of monks set out from Winchcombe and Evesham with the
bold intention of reviving the Anglo-Saxon monasteries of northern England that had
been destroyed by the Danes. One of the remote and ruinous sites they resettled was
at Whitby, North Yorkshire. The community there soon quarrelled, however, and,
in or after 1078, one part of it, led by a certain Stephen, departed for a new home at
Lastingham. This village in the Yorkshire moors was the site of a monastery originally
founded in the 650s by two brothers, Sts Cedd and Ceadda. Stephen's restored
monastery proved short-lived, because the community was offered another home at
York, to which it had moved by 1086. There is, however, architectural testimony to
its brief stay at Lastingham; the eastern arm of the monastic church has survived in
parochial use. It's hard to think of a space that connects a modern visitor so immediately
to post-Conquest England. The most perfectly preserved part of the interior is the
crypt, shown here, which is supported on four rugged piers of stone. The upper church
was restored by J. L. Pearson in 1879 and is vaulted in stone. Technical details of the
design point to a direct connection with Durham Cathedral as rebuilt from 1093.

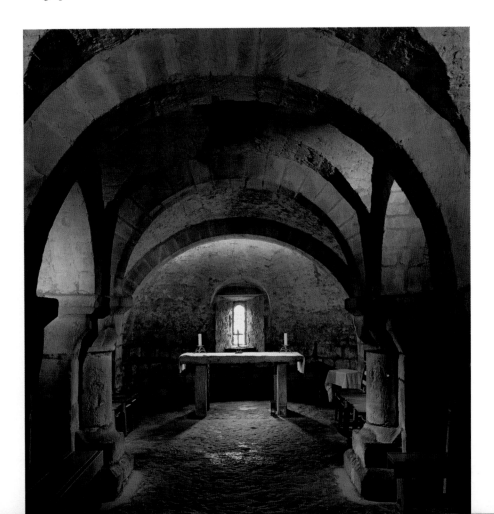

24 Romanesque magnificence
Malmesbury Abbey, Malmesbury, Wiltshire

In about 1530, Malmesbury Abbey was partially ruined by the collapse of its great central spire, a massive and famous landmark. The further ruin of the choir and the fall of the west tower followed the surrender of the monastery to Henry VIII about a decade later. But a wealthy local clothier, William Stumpe, saved the body of the nave, with its spectacular south porch, shown here, for parish use. Probably erected in the 1150s or 1160s, the inner and outer doors of the porch are detailed with multiple broad mouldings that run continuously through the full arc of the arches. Parallels for this bold treatment can be found in south-west England and the Thames Valley. Criss-crossing vine scrolls on the broader orders of the outer archway frame scenes from the Old and New Testaments, including the Creation and a life of Christ from the Annunciation to Pentecost. There is besides a wealth of abstract and foliage decoration. Just visible on the wall within the porch are six large-scale figures of seated Apostles with the figure of an angel floating above them. These elongated figures face a matching panel on the opposite wall. Concentrations of figural sculpture are a rarity in English Romanesque art and the artistic sources for this display are probably French.

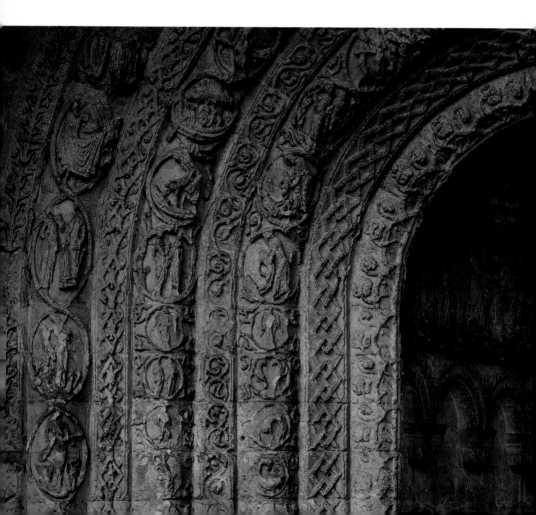

25 Architectural imitation
The Church of St Laurence, Pittington, Co. Durham

Pittington was an ancient property of the cathedral Priory of Durham. This connection must explain one of the most striking features of the parish church. Probably around 1170 this building was extended by the addition of a new north aisle. Many parish churches were undergoing similar enlargement in this period in order to create space for additional altars. In conventional manner the new aisle communicated with the main volume of the nave through an arcade and its structure was encrusted with ornament. Each of the arcade arches was carved with zigzag or chevron and the principal piers were decorated with spirals and vertical flutes. The obvious sources for this treatment are the celebrated piers of Durham Cathedral itself, which are carved on a grand scale with similar abstract patterns. It is unusual to be able to trace the passage of ideas from great churches to parishes with such exactitude, though the phenomenon is commonplace. One likely explanation for this direct quotation is that the patron of the work was a monk of Durham, perhaps even one of the priors. The arcade cuts into the original external wall of the church and fossilized in the fabric above it is a window splay with some fragments of slightly earlier Romanesque paintings of St Cuthbert, Durham's patron.

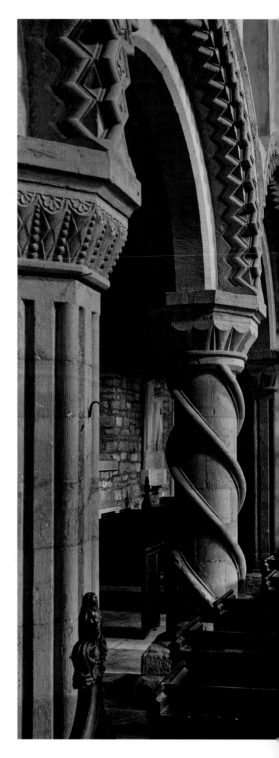

26 A tomb from Tournai
The Church of St John the Baptist, Southover, East Sussex

In the 1070s, one of the outstanding beneficiaries of the Norman Conquest, William de
Warenne, Earl of Surrey, visited the monastery of Cluny in Burgundy with his Flemish
wife, Gundrada. They were inspired to found a daughter house to this great abbey,
the first Cluniac priory in England, beside their new castle at Lewes. Gundrada died
in childbirth in 1085 and her husband died three years later. Both were buried in their
priory, dedicated to St Pancras, at Lewes. St Pancras expanded rapidly and probably in
about 1160, the founders' bodies, laid in lead cists, were reinterred beneath new tomb
slabs in the chapter house. This is a detail of the slab created for Gundrada (William's
is lost). It's cut of highly prized Tournai marble imported from Flanders. The surface
is decorated with leaves springing from the mouths of lions. A beautifully lettered
inscription runs around the slab and down its centre. Significantly, this arrangement
is paralleled on the tomb of William the Conqueror's queen, Matilda, in Caen. Lewes
Priory was demolished in 1538 and Gundrada's slab was evidently cherry-picked for
reuse in a sixteenth-century tomb at Isfield. There it was spotted in 1775. Then, in
1845, workmen building the railway across the priory site also found Gundrada's lead
coffin. Both were reunited in a specially constructed chapel in 1847.

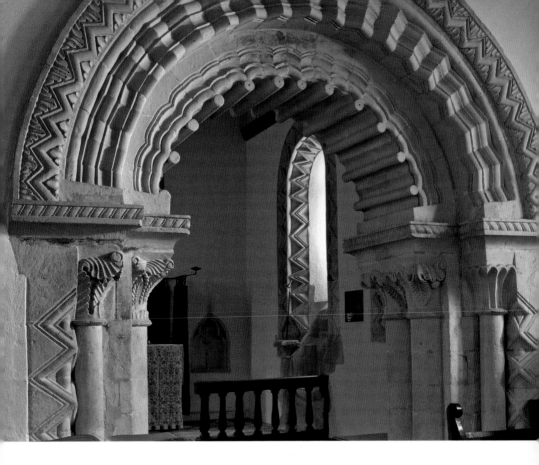

27 Symphony in sculpture
The Church of St Mary, Winchfield, Hampshire

Dividing the chancel from the nave at Winchfield is this spectacular Romanesque archway of around 1150. Its outer face is decorated with three registers of fantastical abstract sculpture. To enrich the design further the inner line of the arch ripples with multiple cusps of stone. No less striking is the treatment of the arch supports: the sturdy cylindrical shafts terminate with capitals of stylized leaves crimped like Elizabethan collars. Beside the shafts are orders of bold zigzag ornament set at right angles to each other. Abstract sculptural ornament of this kind is one of the distinguishing features of European Romanesque architecture. It may be partly informed by the ornamentation of wooden architecture. Whatever the case, such decoration served not only as structural enrichment of a building but as a means of underlining visually the relative importance of the constituent spaces within it and the thresholds between them. At Winchfield, for example, several elements of the modest church structure – including the principal door and the chancel windows – are similarly enlivened with sculpture. The richest decoration, however, is reserved for this arch because it frames the congregation's view of the high altar. In the mid-twelfth century Winchfield manor was owned by Chertsey Abbey. The patronage of this wealthy house perhaps explains the unusual opulence of the carving.

3 The Church Triumphant, 1200–1399

On 19 April 1213, Pope Innocent III declared his intention of holding a great council of the Church in Rome. When it gathered more than two years later in the Lateran Palace in November 1215 there could be no doubting the grandeur or authority of this great assembly. Brought together were delegates representing all the principal dynasties of Latin Europe, about seventy archbishops and patriarchs, four hundred bishops, and around nine hundred abbots and priors. Over the next month they collectively approved a set of 70 decrees that covered an impressive spectrum of concerns, from the governance of the clergy to the obligation of Jews and Muslims to wear distinctive dress.

From a theological point of view, the council's most important statement was its first: an exposition of the dogma of Transubstantiation. This was the assertion that during the ritual of the Mass the bread and wine on the altar – without changing their outward appearance – actually become the body and blood of Christ. This decree, like many others endorsed by the council, articulated long-standing beliefs and opinions. Yet it was the coherent and authoritative promulgation of these ideas

that made the Fourth Lateran Council so significant. Indeed, measured by its future influence, the council decrees make Magna Carta, sealed by King John at Runnymede earlier in the same year, disappear into parochial insignificance.

Events would subsequently prove that the church hierarchy could deliver the decrees of the council to the grass roots of the Christian faithful across Europe. In England, for example, the decrees subsequently served as the foundation for

Sir Simon de Drayton depicted as a donor in around 1317 at Lowick, Northamptonshire

sets of statutes drawn up by bishops to manage their dioceses and clergy. These statutes were enforced by inspection or 'visitation' and laid down clear terms for the operation of parish churches. So, for example, there occurs in the 1217–19 statutes of Salisbury a formal division of financial responsibility for the fabric of these buildings. From this was established the long-standing principle that the recipient of the parish tithes was responsible for the chancel and the laity for the nave (the former the ultimate origin of modern-day chancel repair liability). As a direct consequence, the office of churchwarden – first clearly defined in the 1287 statutes of Exeter – came into existence.

The Lateran Council also materially shaped the intellectual and theological context against which parish churches across Europe would physically develop. At risk of seeming to digress, therefore, it's essential briefly to consider the theological understanding that underpinned the liturgy and architecture of all churches great and small from the early thirteenth century onwards. These ideas would form the basis for the practice of Western Christianity into the sixteenth century and continue to inform the devotions of the Roman Catholic Church to the present day.

In a world that acknowledged God's direct intervention in its daily life, the central role of the clergy was to celebrate Divine Service. Man not only owed God the duty of praise but needed to secure His support and help in daily affairs. Forming the backbone of Divine Service were the so-called Divine Offices or Canonical Hours, eight services of prayers and psalms that took their name

from the hours of the day and night at which they were recited: Matins, Lauds, Prime, Terce, Sext, Nones, Vespers and Compline. This ancient regimen of prayer was monastic in origin but throughout the later Middle Ages parish churches – not to mention the laity, too, privately – aspired to celebrate it with as much dignity as they could afford.

Crucially in this respect, prayer served to benefit not only the living but also the dead. When Adam and Eve ate the apple in the Garden of Eden they rejected the paradise that had been created for them by God. They also bestowed upon all their progeny the legacy of that decision which disposed humanity to evil: Original Sin. Because of this sin Man barred himself from salvation. But God in his mercy became incarnate as a perfect man – Christ. By his sacrifice at the Crucifixion he atoned for humanity's Original Sin and reopened the gates of paradise to the world.

Yet while Christ atoned for Original Sin, the sins that men and women committed in their own lives were the individual responsibility of the perpetrator. Those who died without remorse for their sins, therefore, passed to the fires of Hell. But the repentant could atone for their deeds and come to Heaven. Atonement could be undertaken during life through charitable works and prayer. After death, however, souls still stained with outstanding sin had to be cleansed in Purgatory. This was a celestial zone where souls made satisfaction for their sins in proportion to their enormity.

Purgatory's torments, even if they were experienced with the knowledge of eventual salvation, were believed to be protracted and terrifying. To

those in their throes there existed only one source of succour: the charity of the living in the form of good deeds and prayers undertaken on behalf of a suffering soul. And no action had more potent power in this respect than the celebration of the Mass, a re-enactment of Christ's Incarnation and Sacrifice. The importance and potency of this ritual was enormously enhanced by the dogma of Transubstantiation. It also underlined the special status of priests, the men at whose hands this miracle was performed.

In the aftermath of the Fourth Lateran Council there was a demand for more clergy to celebrate Divine Service and in particular more priests. This demand was driven by the laity, who were eager to secure the benefits of Divine Service for the living as well as the dead. Meanwhile, Christ's real presence in the consecrated bread and wine encouraged the development of new devotions and liturgy. This required specialist furnishings, vestments and instruments. The consecrated host, for example, was used in the Easter liturgy and physically disposed in a tomb or sepulchre on Good Friday to symbolize Christ's death and burial.

Sight of the consecrated host became an important element of all such devotions. During the feast of Corpus Christi (a name literally meaning the 'Body of Christ'), which celebrated the reality of Transubstantiation, the host was publicly paraded with the support of the whole parish. On a day-to-day basis, within the chancels of churches great and small, the transubstantiated host also came to be publicly displayed. It could either be suspended in a tent-like receptacle called a pyx or locked within a fixed structure termed a sacrament house.

In both cases the host itself was made visible, so that the life of the church took place in the literal presence of Christ. Those outside the church could sometimes also see the pyx through specially constructed squints or widows on the outside of the building. These are generally cut through the wall on the inner angle of the chancel, suggesting that the pyx usually hung near the chancel screen. Today, these are often mistakenly described as squints for lepers to watch the Mass.

One striking reflection of the growing number of clergy, meanwhile, was the widespread and concurrent enlargement of chancels. From the late twelfth century these were almost universally rebuilt on a rectangular plan, rather than with a semicircular east end or apse as had been common previously. Rectangular chancels created a more spacious setting for the altar and could accommodate larger windows. When money for the new chancel was provided by a particular patron, it's common from the late thirteenth century to find their tomb built into the wall immediately to the north of the altar. This not only brought them close to the Mass in death (proximity evidently guaranteeing particular benefit from the liturgy) but it involved the donor in the re-enactment of the Resurrection during the Easter liturgy (more of which in the next chapter).

On the form of tombs something should briefly be said. Most people were laid to rest in the graveyard and their disarticulated bones gathered together in an ossuary if necessary as the plot was redug over time. There is no evidence that such burials received any permanent memorial. The wealthy or powerful,

however, could secure burial within parish churches. They could also afford extravagant monuments, which begin to appear in parish churches during the thirteenth century. From the beginning these can be conveniently divided into two broad categories.

The first incorporates sculpted effigies of the deceased depicted in their living estate as knights or ladies (or more occasionally as officials or priests). These are usually carved in stone – though images carved in wood also survive from the fourteenth century onwards – and are set in or against a wall. Regardless of the materials in which they were made such effigies were normally coloured and the most elaborate stood within architectural canopies. These might in turn be richly ornamented and decorated with devotional imagery in sculpture or paint.

To animate effigies, knights were commonly represented drawing their swords and with their legs crossed. (This detail does not, as is sometimes supposed, identify a crusader and it is interesting to note that French effigies, by contrast, are always static and with straight legs.) The cheaper alternative to an effigy was a floor slab laid in the body of the church, the second category of monument. Slab memorials in different forms remained the staple of internal church burials into the nineteenth century. Their popularity is partly bound up with the simple reality that they create a floor space rather than an extra fitting.

From the late thirteenth century one type of slab monument, termed a brass, began to enjoy particular popularity. Brasses comprised a polished slab of dark stone – usually of Purbeck marble – inlaid with engraved plates of a copper alloy to create a figure. These monuments were relatively cheap to manufacture and as a consequence came to be mass-produced in regional centres. They were also sometimes imported. By the late fourteenth century, however, London workshops dominated the entire market.

There is evidence besides for a small number of more unusual monuments in parish churches that also deserve notice. The practice of removing entrails from bodies – a habit dignified by French royal example – sometimes led to the creation of heart burials. It's impossible to know how common these were but there does exist a small group of diminutive images that clearly record such burials. These show the deceased holding a heart between their praying hands. An outstanding example of around 1300, which was attached to the mullion of a window, was tragically stolen in 2012 from Castle Frome, Herefordshire.

This unusual placement of the Castle Frome figure in a window connects it to another important group of memorials. These are monuments with canopies that relate to or incorporate windows. It's to be presumed that the associated stained glass displayed heraldry or devotional imagery that related to the burial. The tombs of such window monuments can be placed internally or externally within niches.

From the mid-thirteenth century onwards chancels were also often provided with a series of three seats for the clergy celebrating the Mass (termed a sedilia with a place for a priest, deacon and sub-deacon) and a basin for washing the

liturgical instruments associated with the Consecration (termed a piscina). Sometimes these were united on one side of the building to create a series of niches on the wall to the south of the altar. These fittings speak of the greater ceremony that was becoming attached particularly to the Mass and the handling of the consecrated bread and wine. As with all significant fixtures and fittings, the sedilia and piscina were usually designed in an architectural idiom.

Architecture, it should be explained, enjoyed a pre-eminent status among the medieval arts. Its beauty was understood to derive from the accurate recreation of the proportions and measurements of God's creation. The principles and forms of architecture, therefore, were assumed within every medieval art form and appear on every scale. Churches were, in effect, full-scale works of architecture furnished with miniature ones in the form of screens, tombs and altarpieces. All shared a common vocabulary of pinnacles, buttresses, tracery and ornamental sculpture. Even goldsmiths' work copied the forms and trappings of architecture on the most miniature and exquisite scale.

To reinforce the division between the nave and the chancel, where the principal parish Masses were celebrated, wooden screens began to be erected for the first time. These were usually placed within the chancel arch. All early surviving examples of such screens have open arcades that permitted the congregation to see the high altar (in the late thirteenth-century example at Stanton Harcourt, Oxfordshire, the devout also informally carved squints through the lower section of the screen so they could see through

it while kneeling). From about 1400 the chancel screen came to be regarded as integral with the sculpture of the crucifixion or rood that dominated the nave from above the chancel arch as well as with a beam for candles lit in its honour; the rood screen, as the whole ensemble was called. We will read more of this in the next chapter.

Screens introduced a new dynamic to the organization of internal space within parish churches. Previously it had been normal for the architectural elements of the building to correspond with its functional divisions; that is to say the chancel and nave were separate structures as well as distinct liturgical spaces. Screens, however, made it possible to divide up a single interior into different areas. They also – eventually – permitted architectural design to be released from the constraints of function. For the future grand spatial effects might coexist with complex internal divisions created by screens.

The determination of the laity to share in the spiritual benefits of the Mass was simultaneously transforming the nave. While the high altar in the chancel remained the setting for the most solemn Masses, it became increasingly common to elaborate the aisles to either side of the nave. In some cases, too, transepts were thrown out to create a building on a cross-shaped plan. Neither phenomenon is well documented but all the evidence points towards a single driving explanation: each aisle or transept provided the setting for additional altars where private Masses could be celebrated. Commonly these altars were patronized by an individual family which would claim proximate burial space. The result is a clustering of

The column with a circular cross-section characteristic of the thirteenth century (above) was replaced in the fourteenth century by the more visually interesting octagonal or hexagonal pier (below). Piers were sometimes decorated with bold geometric patterns.

tombs in these areas, the effigies or slabs usually set in wall niches.

New aisles in parish churches demanded new arcades and there continued from the late twelfth century until about 1250 an extraordinary period of experimentation with the decoration and detailing of these architectural elements. The idea of arcades supported on uprights or piers was borrowed from great church buildings. Yet in the context of these massive buildings piers needed to be designed in aesthetic and structural relationship to the overall structure. This was particularly true if the building supported a vault and two or three upper storeys.

By contrast, most parish churches in the period covered by this chapter were single-storey buildings with arcades that rose to the roof (raised tiers of windows termed clerestories are usually late medieval additions). There was, therefore, no structural or architectural constraint on their design. The overarching trend was to slim piers down and simplify them. The initial result was the cylindrical pier followed by the more visually interesting pier of the fourteenth century with a hexagonal or octagonal cross-section. Such simplification obviously made economic sense. It also served to integrate the volume of the nave and aisles and thereby exaggerate the spatial grandeur of the building.

Another important concurrent aesthetic shift is the movement away from Romanesque abstract architectural ornament and carving. In its place there emerges an interest for mouldings incorporating thin shafts or colonettes (like scaffolding poles) that imply a

subsidiary system of structure and support in the frames of doorways and windows. Such shafts also sometimes appear in particularly richly detailed arcade piers. This change is ultimately connected to French architectural experiments of the late twelfth century and the development of an aesthetic of structure, spatial complexity and light, the so-called Gothic style.

Linked to the Gothic aesthetic was a growing desire to make the structure of buildings read more clearly. The kind of dense abstract ornament that Romanesque masons had crowded on to their buildings fell out of favour. Instead, sculptural ornament was now applied to the building in ways that did not confuse the design. It appeared, for example, on capitals and corbels, the supports for structural elements such as arches, roof timbers and the projecting drip mouldings around windows. Here, it augmented and dignified the architectural composition rather than overrunning it.

Yet perhaps the most important change in the appearance of the parish church related to its windows. From the 1220s, after the example of experiments in great church architecture, these began to expand rapidly in size and were internally divided by decorative lattices of stone, termed tracery. These large, traceried windows came to dominate the visual axes of the church and became the perfect setting, therefore, for displays of stained glass. In the process the most important spaces of the church became suffused with light, an effect enhanced by the relative darkness of the nave (the aisles and tower, where this stood to the west, removed from it all direct sunlight).

By contrast, the chancel was directly lit from the sides and usually incorporated the largest window in the building. This stood in the east gable of the chancel, where it naturally doubled as a backdrop or reredos to the high altar. The east windows of the aisles were likewise relatively large and also therefore effectively formed reredoses to the subsidiary altars of the church. Imagery now began to be sucked into these prominently placed windows and the pressure to enlarge them further grew. Wall painting also began to change in character as a response to the popularity of stained glass.

Painted imagery remained common (indeed, sometimes it supplemented the iconography of the stained glass), but during the thirteenth century by far the most widespread internal painted finish was a structural one termed lining out. This involved whitewashing the walls and painting them with masonry joints to look as if they were built with beautifully cut blocks of stone. Lining out was not a novelty – numerous examples exist from the eleventh century onwards – it simply became even more common than before. Such patterns could additionally be ornamented with flowers or sprigs of foliage. Meanwhile, in a counter-intuitive shift, as aisle arcades were simplified in architectural terms and stripped of carved ornament, their surfaces were painted with bold abstract patterns such as chevrons.

Of the form of seating in parish churches over this period almost nothing is securely known. About the only explicit documentary evidence on this subject derives from episcopal statutes that restrict the use of seats in the chancel

by the laity. The clear implication is that lay grandees normally passed beyond the chancel screen and that their social inferiors were desirous of following them. Presumably these figures sat in choir stalls arranged along the lateral walls of the chancel. The earliest surviving parochial examples of such stalls date to the fourteenth century, but earlier examples doubtless exist based on the example of choir arrangements in cathedral and monastic churches.

As regards ordinary parishioners, it's conventional to assert that surviving stone benches integral with walls and the bases of piers were used as seats. These are, however, rare to find and there is no corroborative evidence for the practice. Meanwhile, some fixed pews have been dated as early as the thirteenth century. Such dating is impossible to substantiate and the vast majority of surviving examples are clearly much later. It has also been suggested that portable stools could have been a common means of seating. If so, no examples are known to survive.

Naves, meanwhile, were themselves evidently put to a wide variety of uses, many of them recorded through the censorious responses of the authorities. In 1363, for example, the Archbishop of York inveighed against those who: '… meet in churches on the vigils of saints, and offend very grievously against God and his saints whom they pretend to venerate, by minding hurtful plays and vanities … and in the exsequies of the dead turn the house of mourning and prayer into the house of laughter and excess to the great peril of their own souls ... We strictly enjoin all rectors etc. that they forbid and restrain all such insolencies and excesses from

being committed in their churches and churchyards.'

One of the practices he is certainly referring to is the ancient habit of holding 'ales' following major celebrations, including funerals and religious feasts (of which more in the following chapter). These were also the object of criticism rather earlier in 1325 when Archbishop Reynolds of Canterbury denounced 'certain sons of gluttony and drunkenness, whose god is their belly, hastily swallow the Lord's body at Easter, and then sit down in the church itself to eat and drink as if they were in a tavern'. There is even occasional evidence of mumming or dancing. In a conflict between groups of 'Northern' and 'Southern' students in Oxford around 1250, for example, the two sides came to be associated with different churches and their activities elicited a ban on 'dancing with masks or any noise in churches and streets'. Plays, too, were widespread throughout this period and as early as 1180 the cleric William FitzStephen noted their popularity in London churches.

Not only pleasurable pastimes, but serious ones, too, naturally took place in parish churches and their surrounding graveyards. It's quite clear from anecdotal evidence, for example, that churches were places where oaths could be taken, courts held and public penances performed. So, too, were these spaces frequently used for markets. In 1236, for example, Henry III forbad the use of the church and churchyard of All Saints, Northampton, during the annual fair. Meanwhile, the anonymous author of the English devotional text *The Lantern of Light*, written around 1400, describes as a literary conceit the use of the sanctuary

of a church as a country market, an image doubtless taken from life.

Information of this kind does help flesh out an impression of parish churches as living buildings. Nevertheless, the medieval life of these buildings and the world view of those that created, served and used them is hard to rescue. To illuminate their religious perspective and experience, however, it's worthwhile briefly reconstructing and analysing an event that took place more than seven hundred years ago in an existing parish church that served an English colony in Wales. Incidentally, nothing could more clearly convey the efficiency of the papal administration than the fact that the texts upon which the following narrative is based are held in the Vatican. They have been translated by Dr Jeremy Ashbee, who generously made them available for me to use.

At sunrise on 6 September 1303 John of Gyffin, the gatekeeper of Conwy Castle in North Wales, discovered the body of a two-year-old boy in the moat beneath the main gate. Descending into the ditch he found the child 'completely stiff and cold, for there had been a frost, and he was completely undressed … His mouth was closed, his spittle was frozen all around his mouth, and his eyes had rolled up so that nothing could be seen of his pupils.' The toddler called Roger, the son of the castle cook, appeared to have fallen accidentally into the ditch, the drawbridge to the castle having been raised during the night. It was a lethal drop of 28 feet on to rock and everyone, including the coroners who inspected the scene, judged the boy to be dead.

Conwy was effectively an English enclave under direct royal administration and one

of the officials present, a burgess of the town called John Syward, was moved to action. Syward had often been to the shrine at Hereford of St Thomas Cantilupe, a former bishop of the see, and was aware of the many miracles performed by him. According to his own account Syward 'took out a silver penny from his purse and made a sign of the cross on the said Roger's brow, and hung the said penny by a thread from his neck, in faith, hope and intention that God, by the grace of Saint Thomas, might restore the said Roger to life'. He then prayed openly and vowed that if the child recovered he and its mother should travel with the penny to St Thomas's shrine in Hereford.

Forcing open the child's mouth with his fingers Syward saw the tongue move. Calling out that there was a sign of life he picked

Conwy Castle, North Wales. The two-year-old boy Roger fell from the level of the wooden balcony visible in the raised gateway of the castle. The circular socket for the hinge of the drawbridge is visible just below it. The mass of masonry to the right formed the head of a bridge causeway to the gate.

up the body and carried it to the house
of Richard le Mercer near the ditch and
warmed it by the fire. At this 'Roger gave a
weak groan and opened and moved his eyes
a little'. He was then returned to his mother,
Dionisia. Having been crazed by grief at
news of her son's death, she tore open her
clothes down to her girdle and pressed Roger
to her flesh to warm him. She then walked
with the assembled crowd through the town
to its parish church of St Mary. There the
Bishop of Bangor was celebrating Mass for
the soul of a recently deceased courtier, Sir
John St John.

Dionisia sat down with her child before the
cross that hung at the division between the
chancel and nave surrounded by about two
hundred people. Having finished Mass the
bishop came to her and made the sign of
the cross on the child's forehead. Dionisia
saw Roger look up in terror at the bishop's
presence and felt him move for the first time.
She cried out first in fear and then in praise
of God and St Thomas. Those present sang
a hymn of praise, the Te Deum, in joy at
the child's recovery. By her report Roger
could stand up and also suckle by vespers
(in the early evening). He could then walk
on the third day after the accident and was
completely recovered within three weeks.

We know about this event in such detail
because it was reported as a miracle and
investigated with meticulous care, the
church authorities interviewing all the
principal figures involved. It's an added
poignancy that the place where the
accident took place is clearly identifiable
today: the outcrop on to which the child
fell is passed by thousands of visitors
every year as they climb up to the castle.
The church, too, greatly reordered
internally, remains in use. Beyond
its compelling human qualities, the

story gives a very rare insight into the
experience and world view of ordinary
people. For our purposes it elucidates
the motive forces behind late medieval
devotion.

First and foremost it reveals the
importance of saints as intermediaries
in the relationship between the world
and God. Standing in the moat,
Syward effectively struck a bargain
with St Thomas. Offering money,
devotion and attendance on his shrine,
he spontaneously secured the saint's
intercession with God for the child's
recovery. The idea that saints could
support you in your daily needs was
central to the practice of late medieval
Christianity. So, too, was the idea
they required honour, attendance and
gifts in return. Hence the ubiquity
and prominence of images of saints in
churches and the offerings made to them.

Of the physical form of the parish
church at Conwy the account makes
one thing clear: that it was dominated
in conventional form by a crucifix hung
above the division between the chancel
and the nave. Certainly, the fact that
Dionisia waited beneath it implies
that it stood at some internal point of
demarcation. Rather more intriguing,
however, is what the account tells us
of the operation of the building: it was
against the backdrop of two very different
ceremonies connected with the dead that
the events at Conwy unravelled.

The first of these was the Mass being
celebrated for the soul of Sir John St
John. He was a courtier with no direct
connection to Conwy and it speaks of
the force of established convention for
devotions for the dead (as well as the

efficiency of the royal administration in organizing them) that his anniversary Mass was being said. This was an official occasion, as the involvement of the bishop testifies, and it attracted to the parish church a congregation that included some of the leading figures in the administration of Wales.

It's remarkable that a large crowd of people could simply march into the building during the course of the service without apparently disturbing anything. Perhaps the grandees attending the occasion were assembled in the chancel. The progress of the Mass, incidentally, was evidently very clear: nearly all the witnesses specifically record that they arrived prior to the Consecration, when the bread and wine became the body and blood of Christ. To dramatize this moment bells were rung and the priest elevated the host and chalice above his head. Presumably, the crowd flooded the nave west of the cross and had a sufficiently clear view of the high altar in the chancel to see the elevation or be aware of its associated sounds.

Yet, curiously, we know this Mass followed another very different devotion to the dead that occupied the whole of the previous night. Roger escaped from his cradle because both his parents had kept a vigil in the parish church for two funerals, one for a servant called Gerard and the other for Cecilia, a lady-in-waiting to the wife of the constable of Conwy Castle. Dionisia had left her house, which was 'a stone's throw from the church', with a maid who had attended Cecilia's last sickness. The two women left three children asleep inside and the door ajar because it had no catch on the outside.

Roger's father, Gervase the cook, met them in the church but twice left the building during the wake to check the children. On both occasions Roger was missing but Gervase assumed he must have gone to a neighbour. Unlike the glittering congregation at Mass next morning, the wake was a gathering of ordinary townsfolk. Not even the parish priest was present. In the church itself there were people clustered together, but it was so dark that Dionisia wasn't certain whether she stood in a group with her husband. There must have been some candles lit, however, because on his second trip to the house Gervase took one with him to help search for his son.

Dionisia, by her own account, left the church before dawn. Tired from the wake and distressed by the unexplained absence of her son, she fell asleep in the house 'for the time it would take to go a mile'. But her husband went at sunrise straight from the wake to work. On his way he was met by his master, the constable of the castle, who ran up to him and sharply demanded where he had been that night. On learning of the vigil the constable gruffly told him that he should keep a better vigil on his son, who had just been found dead in the castle ditch.

When Roger was taken to Hereford a few weeks later by his parents, the constable was one of those who attended the shrine so as to testify to the powers of St Thomas Cantilupe. Given their experience, it's not hard to understand the depth of their gratitude to this figure from the court of Heaven. Nor of the vibrancy of the late medieval church, which we will explore further in the next chapter.

28 Stem of Jesse
The Church of St Helen, Abingdon, Berkshire

This is a detail of the magnificent Lady Chapel ceiling at Abingdon. To either side of a central band of carved panelling are lines of figures standing above the curving branches of a vine; this is a tree of Jesse, a representation of the genealogy of Christ through a line of prophets and kings described at the opening of St Matthew's Gospel. The three panels to the right show an Annunciation scene, with the Archangel Gabriel and the Virgin. To emphasize the fact that God became man at this moment, the pot of lilies conventionally shown in Annunciation scenes is hung with a figure of the crucified Christ.

A painted verse inscription unpicks the history of the chapel. According to it, William Reve founded this 'shrine for the praise of the Virgin'. Reve (fl.1245–88), who lived in Abingdon, is otherwise recorded as a proctor of the town's Guild of Our Lady. A certain William Cholsey (fl.1355–62) is credited with having paid for the repair of the ceiling, and a guild chaplain, Henry Bernyngton (fl.1363–93), with giving vestments and a silver cross to the chapel altar. Finally, Pope Boniface IX is described as offering spiritual benefits to those paying to repair the chapel. This Papal Indulgence, dated 28 February 1391, survives and provides a likely date for the ceiling.

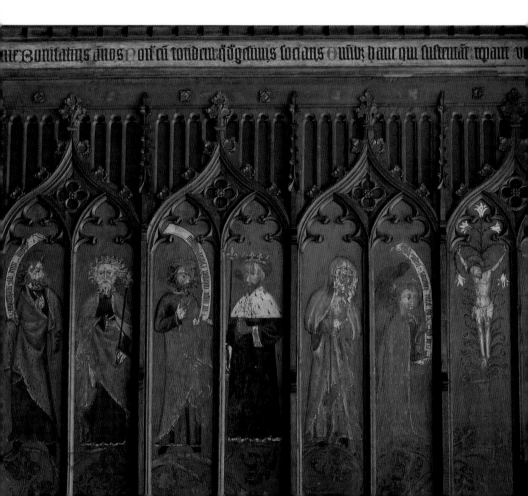

29 A light for the soul
The Church of All Saints, Bisley, Gloucestershire

Among the gravestones in the shadow
of the western tower at Bisley is a
large, squat pinnacle of stone. This is
a monument without exact parallel in
Britain and it's assumed to be a stand
for burning lights in memory of the
dead. Because they drive away darkness,
burning tapers or candles have long been
thought to ward off evil. They have also
been understood as symbols of Christ's
power. Presumably, this stand was used
to light the cemetery in memory of the
recently dead and also on major feast
days, such as All Souls. The design of
the structure is satisfyingly coherent:
its hexagonal shaft is ornamented with
a blind arcade and stands on a circular
base. Presumably, the light or lights would
have been placed within the opening in
the central section of the pinnacle. The
crowning spire has been much restored. It
acts as a visual exclamation mark, drawing
attention to the whole. The architectural
detailing would suggest that it was
erected in the thirteenth century. Until
the proliferation of graveyard memorials
in England from the late eighteenth
century, there would have been few
permanent external monuments around
parish churches. This would have made
this stone pinnacle seem all the more
prominent and striking.

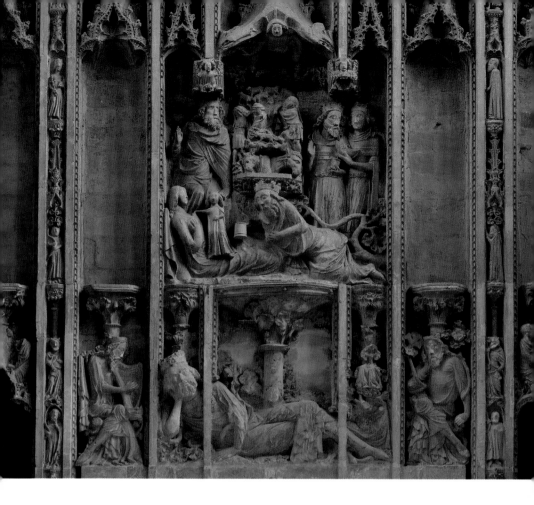

30 A wall of sculpture
Christchurch Priory, Christchurch, Hampshire

This shows the central section of the monumental 1350s backdrop or reredos to the high altar of Christchurch, Dorset, an Augustinian priory converted to parish use following the Reformation. The theme of the reredos is the descent of Christ from Jesse, who is shown recumbent at the bottom of the picture between the seated figures of a prophet and King David. All the foliage in the screen is to be understood as part of a tree that grows from Jesse's loins and links his progeny. Immediately above Jesse is shown the Nativity. Here, the semi-recumbent Virgin and Christ (their faces ruggedly repaired) receiving gifts from the three kings as the shepherds – shown in a central panel above the heads of the ox and ass in the stable – are visited by an angel. The figural sculpture is boldly executed, presumably in order that the iconography is clearly legible from a distance. Freestanding or 'wall' reredoses on a large scale are a peculiarity of English churches and first survive from the 1340s. Curiously, that at Christchurch must have been rebuilt in its present position during the later Middle Ages following the extension of the church. Clearly visible are traces of the colouring that would once have covered the sculpture and niches of the screen.

31 The parish chest
The Church of St Nicholas, Dersingham, Norfolk

Chests were common pieces of medieval furniture and surprisingly large numbers survive in parish churches, where they might be used to store documents or miscellaneous valuables. This photograph shows a detail from the front of an unusually fine fourteenth-century example at Dersingham, which is possibly mentioned in a 1360 inventory of the church. Seen here are two of the four naïvely carved Evangelist symbols – the angel of St Matthew and the lion of St Mark – each carrying an identifying scroll. Above and below are borders of flowers and birds, and over the stubby foot of the chest to the left is a panel of tracery decoration. Fragments of colour show that the chest was painted and some of the background surface of the oak is pounced or stippled for decorative effect. Church chests were often secured with multiple locks (most commonly three). With the keys distributed to different individuals, this arrangement ensured that opening a chest involved public and collective assent. The watercolourist John Sell Cotman drew the chest in 1815, since which time half the lid has been sawn off. It bore lettering including the Latin inscription 'Jesus of Nazareth crucified King of the Jews'. The lid was repaired by Kenneth Bowers in 1984.

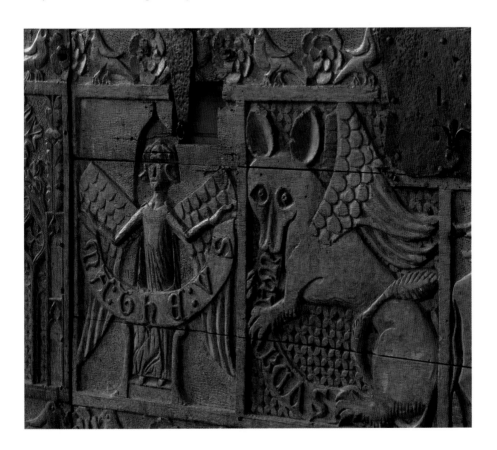

32 Stone and glass
Dorchester Abbey, Dorchester, Oxfordshire

This photograph shows a detail of one of three extraordinary early fourteenth-century windows that overlook the high altar of Dorchester Abbey. Each one presents a distinct iconography in a highly inventive combination of architecture, sculpture and stained glass. Above the altar itself is the Passion of Christ and to its right scenes from the funeral of the local saint, St Birinus. The window shown here presents the ancestry of Christ. At its foot reclines the figure of Jesse. From his loins springs a figurative family tree replete with waving branches of leaves that grow organically through the vertical divisions of the window and connect his descendants: the figures of kings and prophets in stone and glass were once identified by lettered scrolls. The latter figures have been badly damaged over time and are reset in modern quarries, probably replacements of grisaille foliage decoration, that is to say monochrome black decoration on clear glass. Immediately above the figure of Jesse there existed an enthroned figure – probably an image of the Virgin – that has been defaced by iconoclasts. In the window uprights to either side are carved an angel with a censer, and a kneeling figure, presumably the donor of the window. His name is unfortunately not recorded. The Augustinian abbey at Dorchester, founded in 1170, was the successor to a cathedral church. The bishopric was translated after the Norman Conquest to Lincoln.

33 Column altar
The Church of St Mary of Charity, Faversham, Kent

In the north transept aisle of Faversham church is a thirteenth-century column decorated with the principal scenes in the life of Christ. These are arranged in three tiers and run in chronological order from the Annunciation at the bottom to the Resurrection at the top. Shown in this detail is the Crucifixion and the Nativity, the latter clearly identified by the ox and ass peering into the stable and the Virgin and Child from an adoration of the Magi. The lower section of the column is blank, possibly evidence that these images served as the backdrop or reredos to an altar placed against the column. There are examples of such column altars in great churches such as St Albans Abbey. Nothing is securely known about the circumstances in which the paintings were created, although it's very likely that they were commissioned by the Cistercian monk whose kneeling figure appears before the Virgin and Child on the lowest tier of the scheme. His name is unfortunately not given. The paintings are highly accomplished and may be securely dated on stylistic grounds to the late thirteenth century. They compare in detail, for example, with such paintings as the surviving ceiling panels from the Painted Chamber in Westminster, executed by Walter of Durham in the 1260s, and two surviving heads from a wall-painting cycle at St George's Chapel, Windsor, of about 1250.

34 A medieval altar
The Church of St Mary, Great Canfield, Essex

This is a detail of the early thirteenth-century wall-painting scheme exposed in the Romanesque chancel at Great Canfield during improvements in 1877. In place of a central window is a blind arch, the architectural frame for the medieval high altar (and its modern successor). This is filled by a large figure of the enthroned Virgin with one breast exposed to suckle the Christ child on her lap. The image is presumably a two-dimensional representation of a common altar arrangement in the thirteenth-century: rather than a backdrop panel painted with imagery or a retable with folding wings there was a single devotional sculpture. Here the framing arch has been treated like a canopy and is painted with sprigs of foliage. The surrounding walls are lined out to suggest the edges of finely cut masonry blocks. Red and yellow ochre have been used throughout, cheap pigments commonly found in parish church paintings. Beneath the Virgin and Child is a circular panel painted with a cross. This must be a consecration cross, one of the points at which the bishop anointed the fabric of the church during its consecration. Much of the original paint surface has been lost and the figures have been heavily retouched during modern restoration work. It remains, however, a remarkably complete and important survival.

35 Punctuating curves
The Church of St Mary, Hartley Wespall, Hampshire

The west wall of Hartley Wespall church, shown here, incorporates a spectacular early fourteenth-century decorative timber frame. It's conceived in two stages. At the lower level, the massive timbers give the illusion of strength and solidity appropriate to their position in the base of the building. Above, in the gable of the roof, the framing is much lighter and lace-like. Particularly satisfying throughout the design is the way that small decorative projections or cusps are used to punctuate the curving lines of the timbers. There is no clear documentary evidence to date the frame, but the sinuous form of its timbers suggests that it was erected around 1330. This was a period at which the manor was held by the Bishop of Bath and Wells. Indeed, the intersection of the braces bears generic comparison to the great scissor arches erected to support the buckling central tower of Wells Cathedral in around 1338–40. This wall at Hartley Wespall is a reminder that timber never passed entirely out of use in church architecture. Also, that timber buildings in the Middle Ages could be every bit as spectacular as their stone counterparts. Nevertheless, to a medieval audience timber frame displays of this kind were most familiar in grand domestic buildings such as halls.

36 In hope of resurrection
The Church of All Saints, Hawton, Nottinghamshire

Around 1340 money was lavished on rebuilding the chancel of Hawton. As a mark of particular opulence, the new building incorporated a spectacular series of richly carved architectural furnishings. Shown to the right is its so-called Easter Sepulchre. During the liturgical re-enactment of the Crucifixion and Resurrection from Good Friday to Easter Sunday, this recess became Christ's tomb in which a consecrated host – understood literally to be his flesh – and a crucifix were reserved. In reference to the Easter story, the lower register of the sepulchre is carved with the figures of the sleeping soldiers guarding the tomb. In the recess itself, the three Marys are shown encountering the resurrected Christ and across the upper register is an Ascension scene. During the remainder of the year, the small niche within the recess may have served as a sacrament house for the secure display of the consecrated host. The patron of this sumptuous creation wanted to be closely associated with the sepulchre and built a canopied tomb immediately to its left. This proximity associated his body both with the Easter liturgy of the Resurrection and with the presence of Christ in the host. It was thought that the patron was the lord of the manor, but it was more probably a wealthy cleric connected to Southwell or York Minster.

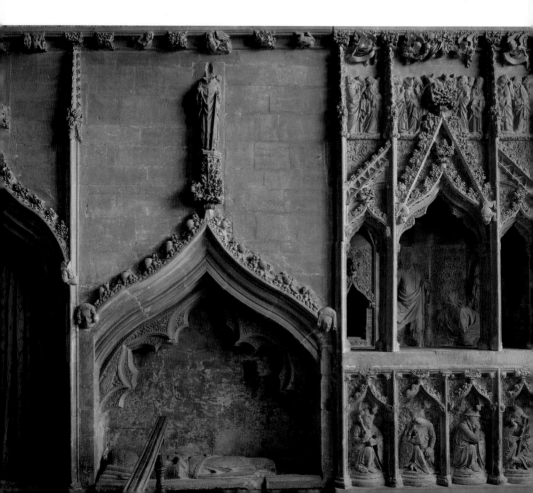

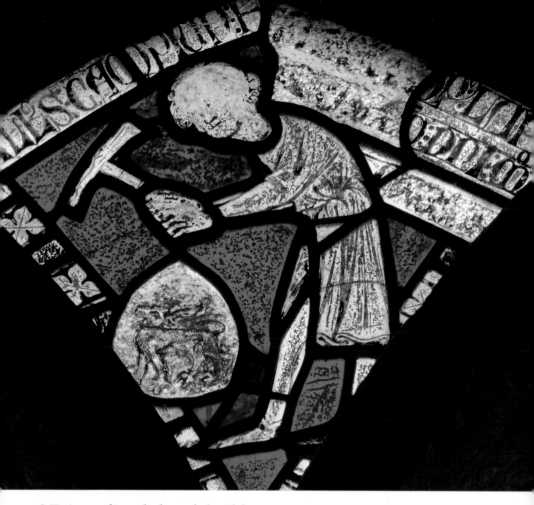

37 A medieval church builder
The Church of St Mary Magdalene, Helmdon, Northamptonshire

This stained-glass panel of a man wielding a pick is a rare surviving depiction of a named medieval mason at work. It fills the apex of a north nave-aisle window at Helmdon and incorporates an inscription that reads 'William Campiun made this work of stone the year of Our Lord 1313'. Campiun probably worked in the limestone quarries that are known to have existed around the village. Unfortunately, it's not clear whether he donated the window in question or was actually employed in working on the church fabric, much of which dates to the early fourteenth century. He might conceivably have done both. Campiun is shown in a yellow tunic, blue hose and fashionable pointed shoes. He stands against a brilliant red background. His name in the abbreviated form – 'Wills Campiun' – is clearly legible to the top left. The beguiling detail of the lion on the block of stone he is hewing is not authentic; rather, it is a medieval fragment of glass inserted into the composition. The panel was restored in 1976–7 and its original lattice of leading, now detached, still survives. Campiun's portrait is a reminder that medieval masons didn't necessarily work anonymously, but, like their modern counterparts – architects – might be both wealthy and desirous of remembrance.

38 Horror vacui
The Church of Mary, Lancaster, or Lancaster Priory, Lancashire

The wooden stalls that enclose the choir of Lancaster Priory are subsumed beneath
a superb array of ornament. This photograph shows a series of the tall gables with
inset arches that rise over every seat. Both elements are fringed by stylized foliage –
including maple and oak leaves – and their structure dissolves into complex webs of
decorative tracery. Choir stalls were a common feature of churches of every scale in
the Middle Ages, although furnishings of this magnificence were the preserve of large
ecclesiastical institutions, such as monasteries and colleges. The clerics who occupied
these architectural structures during Divine Service became, in effect, counterparts
to the saints framed in niches, canopies and window lights in the church around them.
There is no documentary evidence to identify the craftsmen or patron responsible for
the stalls at Lancaster. Nor is it certain that they originally belonged to the church; there
is a tradition that they came here from nearby Cockersands Priory at the Reformation.
Whatever the case, the closest parallels for this type of decoration are to be found in
northern English architecture of the 1330s and 1340s, notably the gabled front of the
Wakefield Bridge chapel. In their present form, the choir stalls have been reconfigured
and restored, but their density and quality of decoration is, nevertheless, arresting.

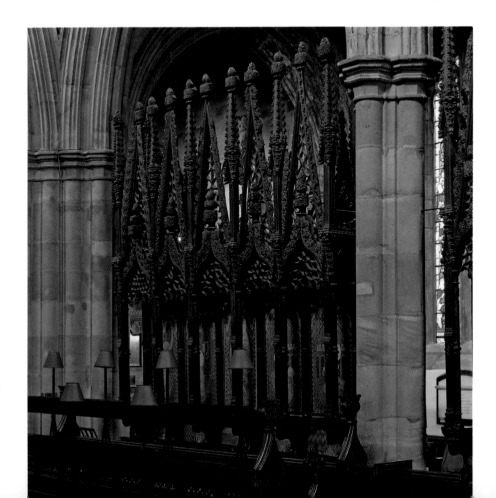

39 Martial piety
The Church of St Peter, Lowick, Northamptonshire

On 5 August 1317, at the request of Queen Isabella, the lord of Lowick manor, Sir Simon de Drayton, received royal permission to endow a priest to celebrate Divine Service in the chapel dedicated to St Mary in the parish church. Later rebuilding has obscured the position and form of this lost chapel, but there does survive a fine series of stained-glass panels that is almost certainly connected with it. The panels were transposed to new windows during the late fourteenth-century remodelling of the church. Among them are figures of eleven prophets and four kings illustrating either the family tree of Christ or the Stem of Jesse, a subject appropriate to a Lady Chapel. There is, besides this, a splendid figure of a knight in full armour devoutly offering up a miniature model of a church or chapel. From a combination of evidence, including the heraldry on the shield and a fragmentary inscription, the knight can be plausibly identified as Sir Simon. He kneels on a lawn but the red background behind, ornamented with bands of roundels depicting lions and eagles, is probably meant to represent a decorative hanging in a richly furnished room. The image perfectly expresses the spirit of militarism and Christian piety implicit in medieval knighthood.

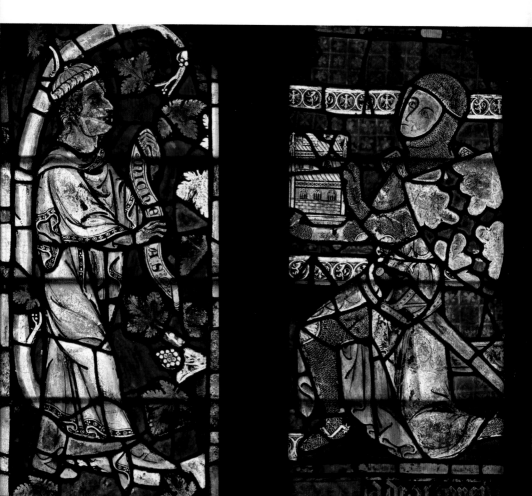

40 Roman pavement
The Church of St Mary, Meesden, Hertfordshire

Around the high altar of Meesden is a sweeping semicircle of early fourteenth-century tiles. These are cut into shapes to form patterns and their upper surfaces are glazed. The intended original effect was of a mosaic floor made from coloured marbles. Four colours – rather than the more usual two – are used in the design (now badly abraded): yellow, brown and two shades of green. Another rare detail is that some of the tiles bear impressed or incised patterns. These include numerous types of flowers and, in the corners of the innermost rectangular frame, two shields emblazoned with the Muchensey arms; the family owned the manor from 1265 to 1313. To judge from its closest surviving parallels, notably the splendid 1324–5 pavement in Prior Crauden's Chapel at Ely, the floor must date to the end of this period. The present configuration and position of the tiles at Meesden is the result of modern relaying, probably around 1877. As originally conceived, the floor would have described a full circle and would have been set further from the altar (probably in the body of the chancel). Mosaic floors were first introduced to England in the late twelfth century and several early examples – without impressed decoration – are known from Cistercian monasteries, as, for example, at Byland Abbey, Yorkshire.

41 The colour of jewels
The Church of St Mary, Selling, Kent

This is a detail of a complete fourteenth-century window above the high altar at
Selling. The five lights are largely filled by clear glass painted with patterns in black,
a treatment termed grisaille. The grisaille in the central three lights describes elegant
foliage patterns around oval frames. In the outer lights, by contrast, it comprises a
grid of smaller diamond quarries. This French treatment sets off the inset coloured
glass to jewel-like effect. Each light is framed by a red and yellow foliage border and
possesses a central panel of a saint framed within a canopy above a coat of arms. The
curving arrangement of the central panels echoes the shape of the window arch and
underlines the importance of the middle light with its image of the Virgin and Child and
the royal arms. The two pairs of flanking lights bear respectively Sts Mary Magdalene
and Margaret over the arms of Edward I's two wives and Sts John and John the Baptist
above the arms of Clare and Warenne. It has been suggested that the window was
commissioned by Bartholomew Badlesmere, lord of Chilham, in memory of Gilbert
de Clare, who was killed at Bannockburn in 1314, and that it formed part of coherent
iconography with surviving wall painting in the chancel.

42 Keeping out the Devil
The Church of St Andrew, Sempringham, Lincolnshire

This magnificent two-leaf door, probably made between about 1330 and 1360, is enclosed inside the south porch of Sempringham church. It hangs within an earlier twelfth-century arch that would certainly have been known to St Gilbert, a reformer closely associated throughout his life with the village and who died in 1189 at the astonishing age of 106. Incorporated in the decorative ironwork that covers the surface of the door are a number of distinct elements. There are four C-shaped hinges, a series of asymmetrically placed crosses and a continuous border. All are enriched with curling fronds of stylized foliage. In the ironwork on either side of the top of the door are the nearly indecipherable remains of a lion and a man with his arms raised. The crosses and figures were probably intended to ward off evil spirits from the threshold of the building. It's probable that the ironwork or door were formerly coloured, a richness of finish appropriate both to the main door of the church and for an object that served as a backdrop to important occasions: porches played an important role in medieval parish life and were used, for example, as the setting for weddings and also sometimes for courts. Doors decorated with ornamental ironwork passed out of fashion in England in the late fourteenth century.

43 Perpetual prayer
Tewkesbury Abbey, Tewkesbury, Gloucestershire

Perched above the ring of chantries and tombs that enclose the high altar within the spectacular choir of Tewkesbury Abbey is this diminutive kneeling figure of a knight in armour. It represents Edward le Despenser (d.1375) and stands over the chapel in which Masses were to be said for his soul in perpetuity. He holds his hands together in prayer and looks towards the high altar. The idea of creating monuments with praying figures has a long medieval – and post-medieval – history. The appeal of such images partly rests on their immediacy: here is no passive figure in timeless repose but a real being. Connected to this is the idea that the effigy literally becomes the person it represents. Here, in other words, through his image, Lord Despenser becomes actively engaged in the devotions of the church. The importance attached to funeral images is sometimes powerfully conveyed in wills of the period. There are requests, for example, for tombs to stand near altars so that the words of the Mass can pass over them. The rich architectural canopy that frames the figure dignifies the kneeling form in exactly the same way as the canopy of a choir stall does its occupant. The monks of Tewkesbury were in this way provided with one additional and perpetual member of their community. And the modern parish has inherited him.

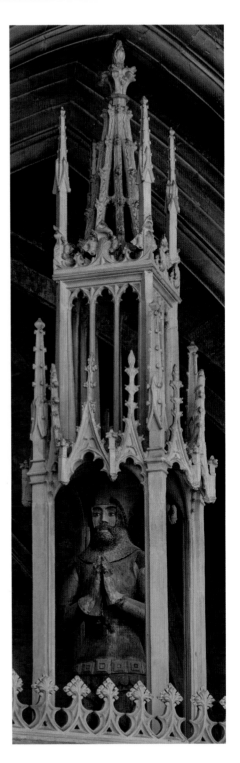

44 Images of brass
The Church of St Mary and St Michael, Trumpington, Cambridgeshire

This is a detail of the funerary brass of Sir Roger de Trumpington (d.1326). It's a marvellous example of a type of monument that begins to appear in English churches from about 1270. The effigy is engraved on a plate of latten (an alloy of copper) and inlaid into a slab of a limestone termed Purbeck marble. When the two materials were polished the effect was of a golden effigy on a marble table, the most costly and prestigious memorial that money could afford. In a brass, however, the effigy was flat – rather than a three-dimensional sculpture – and cost a fraction of the grand funeral monuments it imitated. Brasses became hugely popular and were mass-produced in London, the centre of the tomb-making industry in medieval England. From here they were shipped around the country. Indeed, this monument is London-made. As is typical of medieval monuments, the portrait is not a likeness of the deceased. Rather, it's an idealized image that shows him in the full flush of youth and dressed in armour, a mark of his estate as a knight. In this respect it is curious that the brass seems to have been adapted in the workshop to serve as Roger's memorial after he predeceased his father, its original intended recipient.

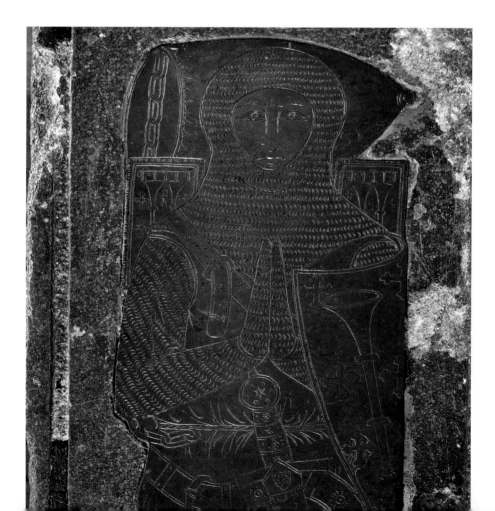

45 Funeral obsequies
The Church of St Nicholas, West Tanfield, North Yorkshire

West Tanfield church stands beside the River Ure in impressive juxtaposition to the neighbouring castle gateway. Among the medieval effigies preserved in the church are these alabaster figures of a knight and his wife on a low tomb. By the heraldry displayed on their clothes, they are probably identified as Sir John Marmion (d.1387) and Elizabeth St Quintin (d.1400). Around and over the monument rises an iron frame with seven prickets for candles. The structure is detailed with miniature battlements and surface ornament. This is a rare surviving example of a medieval hearse. During funeral rites, it was common for the coffin to be placed before an altar and – with the help of a portable frame – draped with a cloth or pall and set about with candles or tapers. In the late Middle Ages, it became popular for the benefit of souls in Purgatory for funeral rites to be re-enacted each year in ceremonies termed anniversaries. These celebrations took as their focus the tomb of the deceased, which was dressed like the coffin for the occasion. In this case, rather than use the parish hearse (presumably a portable object and now long lost), this couple created a permanent one of iron for their own tomb. Its immobility has preserved it to the present.

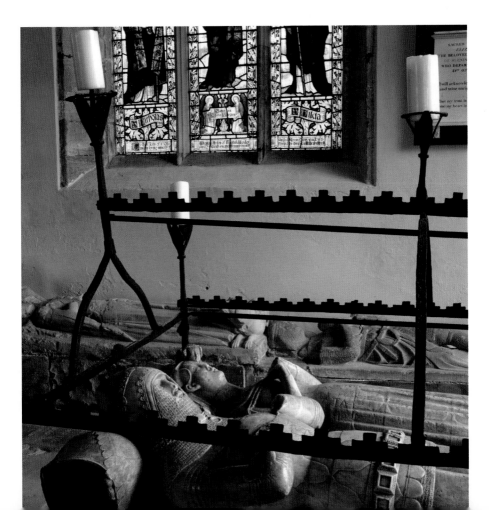

46 The burden of sin
The Church of St Mary and All Saints, Willingham, Cambridgeshire

Above the north nave arcade of Willingham church is this panel depicting the figure of St Christopher carrying Christ. The saint leans on a pilgrim's T-shaped staff and his stocky legs are submerged in a stream of water that teems with fish. To judge from the style of the painting, it was executed in the mid-fourteenth century. According to *The Golden Legend*, a popular miscellany of saints' lives compiled in the late thirteenth century, St Christopher was a giant of a man who sought the most powerful master in the world. Disillusioned with the might of a king and the Devil, he ended up carrying travellers across a treacherous river in an attempt to find Christ through service. One day, a child roused Christopher and demanded passage across the river. Christopher easily lifted the boy on his back, but, as he crossed, his burden grew oppressively heavy. The child then revealed himself as Christ, bearing the sins of the world. For obvious reasons, Christopher became a patron saint of travellers. He was also a protector against misadventure and sudden death. The first reference to an English wall painting of him occurs in 1240, but it wasn't until the fourteenth century that such images became widespread. His figure was commonly painted opposite the principal doorway to churches so as to face entering visitors.

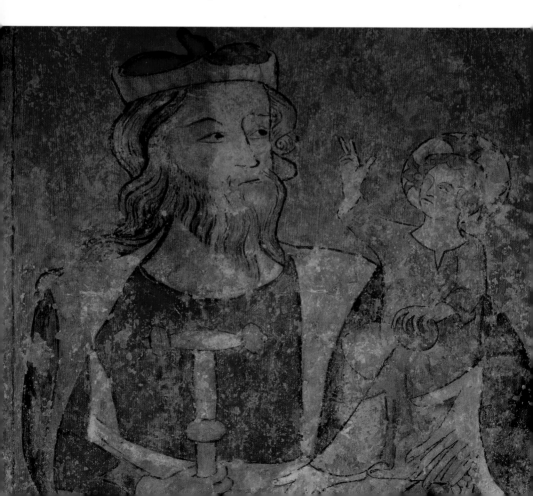

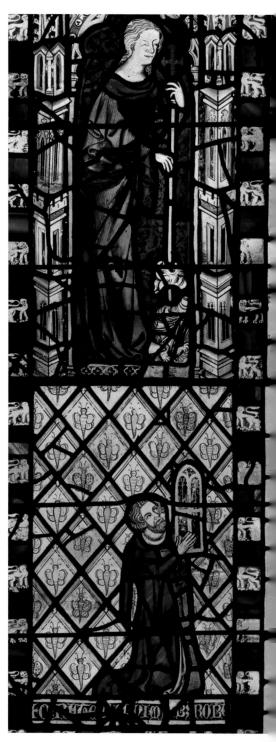

47 Butterflies and lions
The Church of St Denys, Walmgate, York, North Yorkshire

A figure of a kneeling man in fashionable fourteenth-century dress appears in one of the windows of St Denys, Walmgate, York. His hands, clasped in prayer, overlay the image of a window. By this means, he is simultaneously shown in devotion and identified as the donor of the window. A fragmentary inscription below the figure reads 'pray for the soul of Robert'. In the window lights beside him, there also appear images of his wife and son, Johanna and John. Above are large figures of saints in architectural canopies – St Margaret (shown here), the Virgin and Child and St Katherine (now lost) – and a Crucifixion.

The donor is almost certainly the York mercer Robert de Skelton and the glass has been dated, on technical and stylistic evidence, to the 1350s. This was a prosperous decade for de Skelton: he was Chamberlain of York in 1353 and a bailiff in 1353–6. Images of donors presenting windows are very unusual in England (although they do occur in France from the late twelfth century). Nevertheless, this is one of three such depictions to survive in York. Another curious detail is the decoration of the diamond-shaped quarries with butterflies rather than the more usual abstract patterns or foliage. Around the window is a frame of lions, doubtless a reference to the arms of England.

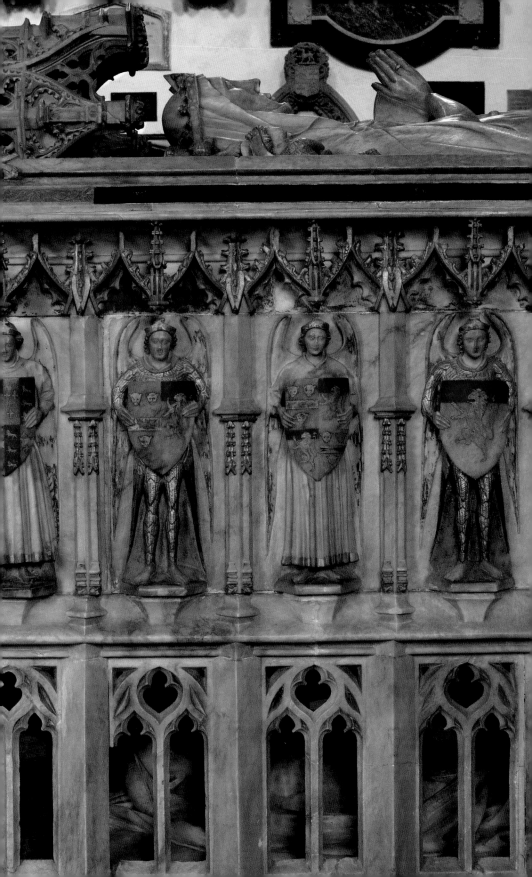

4 The Late Medieval Parish, 1400–1535

The imperative behind the transformation of the late medieval parish church was the determination of people at every level of society to intensify and dignify the celebration of the liturgy. This process was described in countless wills, statutes and other documents as the 'increase of Divine Service'. By this means it was hoped not only to fulfil man's duty of praise to God and to win benefits in life, but also to gain remission for sins in Purgatory. Gifts towards this could come in a bewildering variety of forms, from money for building or the salary of a priest, to bequests of liturgical instruments, books or vestments. All that the donor required was that his or her name was somehow associated with the gift and therefore recollected in the parish's round of prayer. From the proceeds of such generosity even relatively small communities could acquire generous buildings, fine fittings, rich collections of liturgical utensils as well as the clergy to serve their devotional needs.

For the very wealthiest in society, the increase of Divine Service was achieved through the endowment of religious foundations called chantries. The word shares its French root with the word 'chant' and refers to the habit of 'singing' the Mass. Chantries could take a wide variety of forms, all of them intensifications of established liturgical practices. The smallest might simply employ a priest on a fixed salary to say Divine Service and Masses at a particular altar or chantry chapel within an existing church. In so doing they had a particular obligation to remember the name of the patron and their family. The tomb of the patron would often be proximate to the altar or within the chapel, bringing the body and effigy close to the Mass. Besides such duties chantry priests were

The 1470s tomb of Alice de la Pole at Ewelme, Oxfordshire

also sometimes expected to run a school and to partake in the parish liturgy where appropriate.

But the very greatest chantries were perpetually endowed religious institutions. A surprising number survive today in the form of Oxbridge colleges, almshouses and schools. Some of these were attached to existing parish churches, where they took over the duty of celebrating Divine Service. Such colleges always possessed a body of priests, usually 13 after the number of Christ and his Apostles. They might besides support a body of clerks and choristers for performing the complex polyphonic music that was by now a well-established feature of English church life. Surviving music books from colleges at Arundel and Eton give a flavour of that tradition. A college might also incorporate an almshouse or a body of poor men and a school. The governing statutes of these foundations established tailor-made devotions to remember patrons.

Take, for example, the dramatic ceremony each evening around the tomb of Edward, Duke of York, founder of the college at Fotheringhay in 1415. At the end of the final office of the day the whole community of a master, precentor and 11 chaplains, 8 clerks and 13 choristers came to the step of the high altar and genuflected on one knee. An antiphon to the Virgin was then sung and one chorister recited the Hail Mary. There followed a series of prayers that made special mention of 'Edward', humbly stripped of his title. Then the whole community apart from the choristers left the church. The choristers said further prayers before three of their number stood along the length of the Duke's tomb

to sing the psalm 'Out of the depths I cry to you, O Lord' and other petitions and prayers making clear mention of the name 'Edward'. Finally, they passed out of the church addressing various altars on the way 'and then on to supper'.

Chantries were always attached to parish churches in places where the patron's family had a particular interest or connection. In the manner of most noble and gentry foundations, Fotheringhay College stood adjacent to the castle that was the seat of the Dukes of York. Such chantries often attracted generations of family burials and their collections of tombs, which commonly extend straight through the Reformation, can be enormously impressive. One case in point amid the myriad examples would be St Mary's Warwick, the mausoleum of the Earls of Warwick. Bishops and clergy, by contrast, often established chantries in their towns of birth. Higham Ferrers College, for example, supporting a community of priests, an almshouse and a school was founded by Archbishop Chichele in 1422 and acclaimed by the population of the town in 1425. This acclamation was certainly staged but it is a reminder that chantries were not regarded as a form of privatized religion. Rather, they were public benefactions from which the donor profited privately in both life and death.

Perpetual chantries were the preserve of the very rich. Yet the benefits of such foundations were available to people a long way down the social scale through the medium of religious fraternities or guilds. Guilds are first documented during the late fourteenth century, often in the context of towns. Their numbers grew steadily and by the Reformation

London is estimated to have possessed at least 150, King's Lynn over 70 and Bodmin over 40. By this time they existed in rural and urban parishes across the kingdom. Some were connected with the governance of crafts but the vast majority were devotional and might attract very specific groups including merchants, maidens or 'younglings'. A guild typically maintained a light or candle in its parish church to dignify a devotional image and held a communal feast once a year on an appropriate feast day. If it was rich enough it might also support a priest and have weekly or even daily devotions for its members. In addition, guilds offered their members appropriate funeral obsequies.

The medieval liturgy was shaped by the calendar of saints' days and feasts. Most important of all was Easter, in which the events of the passion and resurrection of Christ were remembered and ceremonially re-enacted. The solemnities of 'Holy Week' (leading up to Easter Day) were of such importance that they deserve individual and brief description. They began with Palm Sunday, the celebration of Christ's triumphant entry into Jerusalem. The entire parish, led by its parish priest, would process round the church and make a formal entry into it. This procession often appears to have begun at – or at least incorporated – the raised stone cross that stood by convention on the north side of the church. There followed Maundy Thursday, when the altars in the church were ceremonially stripped and all its imagery was veiled.

The next day, Good Friday, was a day of deep mourning in recollection of the Crucifixion. St John's account of the Passion was read, often with dramatic asides, and the congregation venerated a crucifix, a practice called creeping to the cross. The crucifix and a host consecrated the previous day – no Mass was said on Good Friday – were then placed together in a 'sepulchre' on the north side of the chancel. There they remained under watch through the following Saturday, Easter Eve, to symbolize Christ's death and burial. In some churches the sepulchre was a portable wooden hearse made in the shape of a small house. Some examples of these objects still survive, as, for example, at Cowthorpe, Yorkshire.

But there were permanent alternatives, either purpose-built stone sepulchres (such as has already been described at Hawton, Nottinghamshire) or specially made tombs. Monuments of this kind stand to the north of the altar and generally incorporate a tomb chest without raised effigies. This allowed the crucifix and host to be laid easily on its surface. The involvement of a tomb in the Easter celebrations drew the deceased into the liturgy of the parish and connected them permanently to the transformative events remembered every Easter. Early in the morning on Easter Day, the host and crucifix were removed from the sepulchre in re-enactment of Christ's resurrection. For a short time thereafter, during the celebration of Easter itself, the empty sepulchre remained an object of devotion.

For all the variety of the late medieval liturgy, the Mass retained its pre-eminent importance. It's worthwhile, therefore, briefly describing the form of this ceremony as it would have been familiar in the mid-fifteenth century. It began with the procession of the clergy to the high altar, all of them men (women had no formal role in the liturgy). For a

principal or 'High' Mass at least three clergy needed to be present: the celebrant priest and his two deputies, the deacon and sub-deacon. The latter were also respectively known as the gospeller and epistoller since they were responsible for reading the gospel and epistle during the ceremony. There might additionally be more junior clergy bearing candles, a cross and a thurible for burning incense, not to mention singers and other priests. Leading the procession was the parish clerk or acolyte. Generous seating provision in the chancels of some late medieval churches speaks eloquently of the numbers of clergy involved.

The priest and his two deputies wore vestments derived from late Roman dress. The outer garments usually formed a set and might be a particular colour depending on the day and the wealth of the parish. This gradually formalized into a system, but one that was only properly enforced from the mid-sixteenth century: red or white for major feasts, gold for great feasts, purple for Lent, black for Requiem Masses and green for ordinary or ferial days. Vestments, it should be said, were commonly also decorated with devotional imagery or heraldry. English embroidery, termed opus *Anglicanum*, was particularly prized. The priest's outer garment, a so-called chasuble, was larger and more capaciously cut than that of his deputies. Acolytes and other clergy usually wore white outer robes and, depending on their status, coloured hoods (a form of dress inherited by universities).

Opening the ceremony was the so-called Ordinary of the Mass, comprising the greeting, a confession and absolution from sins, the hymn of praise termed the Gloria and then the Epistles, taken from the New Testament, and the Gospel, from the four Evangelists. This section of the Mass varied greatly day by day, with different readings and prayers. There followed the Offertory, at which the bread and wine were brought to the altar. At the same time the liturgical instruments necessary for the next stage of the Mass were prepared: a disk of metal called a patten for the bread and a chalice of metal for the wine. The latter was mingled with a dash of water in reference to the flow of blood and water from Christ's side on the cross.

The Offertory concluded with two further hymns of praise, the Sanctus and Benedictus. Then came the central and most important section of the ceremony, the Canon of the Mass. This was an unchanging text and the climax of the ceremony, for which reasons it was also known as the Still of the Mass. Incorporated within it was a recitation of Christ's words over the bread and wine at the Last Supper. In the course of speaking them, first the bread and then the wine were elevated by the priest so as to be visible to the congregation. At the priest's words they became the Body and Blood of Christ. A 'sacring bell' was rung to draw attention to the two sacred moments of Transubstantiation, while the deacon and sub-deacon knelt beside the standing priest to draw back his outer vestment.

When multiple Masses were being celebrated at the same time care was taken to avoid simultaneous elevations. This was done by creating squints that allowed the priest at a subsidiary altar to see what was going on in the chancel and delay his elevation if necessary. The Protestant Archbishop of Canterbury Thomas Cranmer would later comment

disapprovingly on the staggering of elevations when he asked:

What made the people to run from their seats to the altar, and from altar to altar, and from sacring (as they call it) to sacring, peeping, tooting and gazing at that thing which the priest held up in his hands, if they thought not to honour the thing they saw? What moved the priest to lift up the sacrament so high over their heads? Or the people say to the priest 'Hold up! Hold up!' …? But that they worshipped that visible thing which they saw with their eyes and took it for very God?

As this account illustrates, for the congregation the Consecration was the focal moment of the Mass. Otherwise this ceremony did not require much response from those who witnessed it. During Mass, indeed, the devout would be engaged in private devotion. The wealthy and literate had devotional books, but the bread and butter of private prayer were the Our Father, Hail Mary (shorter than the modern prayer) and Creed. It was expected that everyone could recite these prayers. As an inscription round the font at Bradley, Lincolnshire, reminds parents and godparents: 'Pater Noster, Ave Maria, Criede/Leren the childe yt es nede'. One widespread devotion that employed them, for example, was the rosary. This comprised recitation of multiples of these prayers which were counted out using beads on a string.

The priest normally took Communion alone, the laity only receiving the sacrament occasionally and after special preparation. In place of Communion the so-called pax circulated round the congregation. This was a disk of wood or metal often engraved with the face of

Christ. It was kissed by all those present starting with the priest, who put it to his lips after first kissing the chalice and patten used in the Consecration. There followed the dismissal and the departure of the clergy. After the Mass it was sometimes the habit to distribute pieces of bread among the congregation from a loaf that had been previously blessed. The ceremony of the Mass was the anchor of the liturgy and was celebrated in parish churches not just on Sundays but every day and – in wealthy parishes – many times a day.

By 1400 a new aesthetic was shaping the form of the English parish church. During the late fourteenth century, within a series of important royal commissions in the south-east of England, and including massive changes to Windsor Castle, a small circle of royal masons formulated a new architectural style: the Perpendicular. It was rapidly disseminated and by the end of the century had currency across the full geographic extent of the kingdom. The Perpendicular was born of French inspiration and the grandest buildings in this idiom were conceived of as cages of stone, their internal surfaces subsumed beneath repetitive grids of decorative panelling. Wherever possible this panelling was opened out to form windows that flooded the interior with light. To these essential characteristics, the Perpendicular added a preference for boxy internal volumes and a delight in fantastical outlines of pinnacles and battlements.

The Perpendicular has a claim to be the longest lived of all English architectural styles, enjoying currency through the events of the Reformation into the early seventeenth century. Its long popularity is fundamentally bound up with an

admiration for the regularity of form and repetitive detailing that were intrinsic to its architectural effects. Ironically, it is the same qualities that have caused some modern commentators to dismiss it as unimaginative, a charge that is as misconceived as it is unjust. And nowhere is its sophistication more apparent than in parish churches. For not only do the vast majority of medieval parish churches bear some stamp of the Perpendicular – from a window to a screen – but the style has in some ways shaped our expectations of these buildings.

Prior to the late fourteenth century, for example, parish churches were usually one-storey structures with the roof over the body of the church falling in a single sweep on either side from the apex of the nave to the eaves of the aisles. From around 1400 this characteristic arrangement began to change. The nave walls above the arcades were now commonly raised up with an additional tier of windows set over the arcades, the so-called clerestory. At the same time, the steep pitches so long characteristic of parish churches began to be flattened out. Low-pitched lead roofs, of course, allowed for the creation of the kind of boxy proportions so beloved of the Perpendicular and the consequent expansion of windows across a maximum area of the wall. With the flat roofs came important changes to the external outlines of buildings. These were made busier than ever before with grotesquely shaped water spouts, battlements and pinnacles.

It should be said that in some regions – notably the south-west – and also in many town churches across the country, another pattern of development was accelerated in this period. This involved the creation of new aisles attached to the body of the church, each with its own altar. These could be crowded on to churches to create naves with two, three or even occasionally four flanking aisles. The chancel, too, might acquire adjunct aisles creating buildings on a rectangular plan and divided through their full length with two or more arcades. A striking example is the five-part interior of St Helen's church, Abingdon, Berkshire.

In the design of towers, too, the Perpendicular had a powerful effect. In different regions there already existed strong preferences for particular tower forms, most obviously those with or without spires. In parish churches both types of tower grew enormously

The familiar outline of the parish church was transformed by the Perpendicular aesthetic. Its preference for boxy volumes and large windows sometimes encouraged the addition of clerestories, changes to the pitches of roofs and also alterations to the belfry stage to the tower. Spires of different materials and proportions also enjoyed popularity in some regions.

in ambition, closing the gap with the structures which dignified great churches. They also began to crowd on additional ornament in a most impressive way, much of it focused on the upper section of the building around the bell frame. Again there are clear regional variations in the way this was done. In East Anglia use was made of knapped flint, but in the south-west there was a whole group of spireless churches that made reference to hugely admired Perpendicular works such as Gloucester Abbey (now the cathedral) and the fantastical outline of its central tower.

Inextricably associated with towers were the bells that hung in them. For the first time in the fifteenth century numbers of parishes began to acquire full rings of bells. These were formerly a preserve of only the greatest churches. Their inscriptions are often composed as invocations that were sung out by the bell when it sounded. In addition, many buildings were also provided in this period with a secondary bell hung near the chancel. This was the Angelus that rang three times every day to call the parish to pray to the Virgin.

The Perpendicular not only changed the familiar configuration and volumes of churches, it also transformed the principal architectural features within them, respectively their arcades, windows and roofs. By the mid-fourteenth century, the arcade arches of parish churches were usually very plainly moulded and separated by pronounced capitals from the circular or polygonal columns that supported them. Now the arches and their supports began to be visually integrated. This was done by running small decorative shafts like scaffolding

poles between the different elements of the arcade and reducing the capitals to a vestigial minimum. At the same time the arcades were substantially increased in height. The shafts applied to them could also be run into the clerestory and up to the principal timbers of the roof to create a notional structural system – a cage – supporting the building.

Arcade piers with integral shafts or colonettes suggested a system of delicate structural support. Sometimes the cross-section was distorted to create a 'lozenge' pier (right). Viewed from the side this gave the illusion of the arcade as a visually insubstantial feature and opened out views across the building.

As an added sophistication, the cross-section of the arcade could be distorted to create piers that were much broader than they were deep. Such lozenge-shaped piers were broad enough to support the weight of the wall but appeared very narrow when viewed across the breadth of the church. As a result, they opened up views through the full volume of the building. Grand spatial effects of this kind, though familiar enough in great churches, were a novelty in parishes. Of course, the use of screens permitted these interiors to be broken up into a myriad of chapels and subsidiary areas.

Meanwhile, the growing scale of windows demanded a completely new

style of glazing. By degrees since the early fourteenth century windows had incorporated growing amounts of clear glass to set off jewel-like panels of densely worked and deeply coloured imagery. Delight in such rich colouring never disappeared and remained the mainstay of costly stained-glass windows. There developed in parallel, however, a much more lightly worked style of glazing appropriate to the task of filling large numbers of openings. This predominantly used clear glass decorated with yellow stain and black paint to create shading and imagery. In large lights the glass was often laid in distinct leaded patterns. Diamond-shaped panels or 'quarries', for example, decorated with letters, initials or small motifs were commonly used as a background to the main imagery. By the late fifteenth century immigrant craftsmen manufactured much of the best English stained glass.

The growth in the scale and number of windows also had an effect on the iconography they presented. Hitherto attention had focused on large windows above the principal altars, where imagery could be marshalled into coherent themes. Now the existence of larger lateral windows – combined with the consequent reduction in the wall space available for painting – encouraged much more complex cycles of imagery embracing the entire church (and famously exemplified in the glass at St Mary's Fairford, Gloucestershire, of about 1500–15). It also demanded a greater quantity of miniature figures or decorative motifs to fill the complex lattice of small openings that were part and parcel of Perpendicular tracery. Figures of saints, prophets and angels were particular staple themes, executed either on a large

or small scale. From the late fourteenth century, narrative windows also began to appear, each scene often accompanied by explanatory verses.

No less striking than the changes to arcades and windows in this period was the treatment of roofs. With very rare exceptions, parish churches in England – though not in continental Europe – eschewed vaults of stone or wood, which remained a distinguishing mark of great church architecture. This preference can be partly explained with reference to the aesthetic preferences of the Perpendicular with its desire for boxy proportions and large windows. Yet it is also testimony to the decorative possibilities offered by timber roofs. In flat structures, the underside might be boarded to create a ceiling that could be painted or decorated. Alternatively, the structural members of a roof could themselves be carved with imagery. No subject was more popular than that of angels, whose figures turned ceilings into evocations of the celestial firmament and the company of Heaven.

It's curious that while patrons were prepared to pay for ever grander buildings, they thought nothing of compromising the architectural logic of the interiors they created with visually intrusive furnishings. From about 1400, for example, the screen dividing the chancel from the nave began to undergo an important metamorphosis. This was now commonly raised up in height and overset with a gallery or loft accessible via a narrow stair. Such lofts were set immediately beneath – and related to – the crucifixion group or rood that by convention was set above the entrance to the chancel. From these lofts it was possible to tend the candles that burnt

in honour of the rood. The maintenance of lights before the rood as well as other images of saints around the church was a major concern of parish guilds. Rood lofts could also serve a wealth of other purposes and there are many incidental accounts of lofts accommodating chapels, organs and seating. At St Andrew Hubbard in London, for example, seating for 'maydens' was made in the loft in 1499–1502.

The rood itself conventionally comprised at least three sculpted figures: Christ crucified with the Virgin and St John standing to either side. By the fifteenth century these figures rarely stood in isolation. Instead the sculptures were set either against a wall – if they were raised above the chancel arch – or a board if they were inset within it. Whatever form it took, this backing to the rood was a perfect surface for painting. To judge from surviving examples, such painting was partly intended to show off the sculpture to advantage. It also commonly incorporated a depiction of the Last Judgement known simply as The Doom. This juxtaposition of images of the Crucifixion and Last Judgement was very deliberate, drawing together the moment of Man's redemption with the end of time. As a final decorative touch, some roods were also overhung with a canopy, or celure. This was normally attached to the roof and often took the form of a richly painted ceiling immediately above the screen. Such celures are also documented over the high tables of great halls from the late fourteenth century. In both churches and halls they dignified the space beneath them.

Meanwhile, the screens incorporated in these elaborate rood compositions could themselves become a canvas for iconography and decoration. Preferences for the form of the imagery varied in different regions but it included the figures of saints, the Doctors of the Church, the Apostles and the Nine Orders of Angels. Visually structured by the architecture of the screen, these iconographies constituted large-scale expressions of orthodox belief beneath the crowning figure of Christ crucified. They would not only have dominated the nave, forming a backdrop to the activities within it, but framed the congregation's view of the high altar. In some cases subsidiary nave altars were also built against these screens. Perhaps the most celebrated examples of such screens are preserved in Norfolk and Suffolk, but there are important survivals in other areas that enjoyed prosperity in the late Middle Ages, such as Devon and Somerset.

In wealthy parishes other church furnishings were similarly aggrandized. Fonts, for example, by convention prominently placed at the west end of the nave near the entrance to the building to underline the role of baptism as a rite of entrance into the church, were an obvious object for ornamentation. Particularly well known are the 40 or so examples of octagonal fonts created from the mid-fifteenth century and carved with images of the seven sacraments: baptism, confession, confirmation, marriage, the Mass, ordination and the last rites. Most of these also survive in Norfolk and Suffolk, an area where the heretical group known as the Lollards enjoyed particular support. It has been suggested, therefore, that the fonts constitute a direct response to that heresy and its attack on the sacramental teaching of the Church. It was possible to dignify fonts

by elevating them on steps but they could be given further visual emphasis through their covers, which were required in order to keep secure the holy water they contained. These could be transformed into vast pinnacles of wood and decorated with imagery.

Pulpits also begin to appear in the naves of parish churches during the fifteenth century (earlier examples are a rarity). They are testimony to the importance and popularity of preaching among the laity. The most common form of medieval pulpit resembles a large goblet with a polygonal or circular vessel raised up on a post to command the church interior. The facets of the pulpit could again be painted with appropriate imagery, such as the Doctors of the Church, or ornamented with carving. These furnishings might be made of either stone or wood. Some pulpits were given further emphasis by the addition of a canopy. One of the most complete examples to survive is at Edlesborough, Buckinghamshire, where the whole is surmounted by an elegant wooden spire.

It's possible that preaching had an impact, too, on the provision of seating in churches. The conventional story of the humble fixed pew is that it emerged over the course of the fifteenth century. Previously, it is argued, the congregation stood in the church during services or the older or more vulnerable 'went to the wall'; that is to say they sat on stone benches around arcade columns or the perimeter of the nave interior. There is in fact very little direct evidence to authenticate or disprove this assertion. What we do know is that fixed benches were widespread by the mid-fifteenth century. Also, that in some parishes there

developed a trade in exchanging seats for money. What this may suggest is that it was a mark of status to sit in a pew and that some positions in the church were more prestigious than others. In other words, the seating of the parish had come to express its social hierarchy. We will see in later chapters how this practice evolved into a full-blown system of pew rental.

It seems to have been a universal practice to separate men and women within the church. The most common arrangement was to place women on the north side of the building. This was usually the side of the building on which the Lady Chapel was set. Men, therefore, sat to the south. Sometimes the decoration of seating further underlines this division. At Wiggenhall St Mary, Norfolk, for example, the northern benches are carved with images of our Lady and those to the south with male Saints. This division of the congregation may be illustrated on funerary monuments and stained-glass windows. These universally show the husband and wife with the figures of sons and daughters respectively kneeling behind them. This may look like an artistic convention but it could be a reference to real life.

Pews only normally extended over a limited area of the nave, for this was otherwise a busy space. There is documentation to show that naves were pressed into use for everything from entertainment to court hearings. The entertainments usually took the form of 'ales'. These were the feasts that we have already heard criticized by Archbishop Reynolds in 1325. They could raise funds for any number of causes – 'church ales' for the building or fabric, 'bride ales' to pay off the costs of a wedding or 'help ale'

to help someone in financial difficulties. Churches were also the setting for religious plays and these might be lavishly staged. In 1470 the churchwardens of St Mary's Redcliffe, Bristol, one of the richest parish churches in the country, took possession of a set for their Easter play. It incorporated:

> a new Sepulchre, well gilt with fine gold; an image of God Almighty rising out of the same Sepulchre … Heaven, made of timber and iron work thereto. Item Hell made of timber and iron work thereto, with Devils the number of thirteen. Item, for knights armed, keeping the Sepulchre, with their weapons in their hands; that is to say two spears, two axes with two shields. Item four pair of angel's wings, for four angels, made of timber and well painted …Item, longeth to the four Angels, four perukes.

Small wonder that the Venetian ambassador, writing a description of England in about 1500, was moved to speak of what seemed to him the extraordinary wealth of England's churches. 'Above all are their riches displayed in the church treasures; for there is not a parish in the kingdom so mean as not to possess crucifixes, candlesticks, censers, pattens and cups of silver … which churches … are not in fine cities'.

But all this was about to change. The parish church, which had for four centuries been a mainstay of local life, was about to be overwhelmed by the Reformation. In less than ten years this prosperous institution was left destitute at the hands of a rapacious and centralized Tudor monarchy.

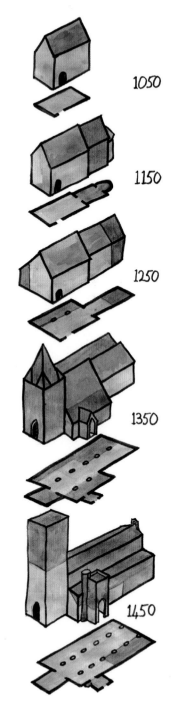

1050

1150

1250

1350

1450

The evolution of a parish church in elevation and plan from 1050 to 1450

48 A mnemonic of mortality
The Church of St Mary the Virgin, Bishops Cannings, Wiltshire

This gargantuan hand is painted on the backboard of what looks like a box pew with a sloping desk. Nothing is securely known about its provenance before the nineteenth century. The hand emerges from a cloud and is entitled in Latin on its red sleeve 'The hand of meditation'. Painted on each element of the hand and at the tip of each digit are small scrolls of text. All are admonitory and reflect upon sin and death. Those on the third finger well illustrate the character of the whole. From the palm, they read: 'To meditate your debts consider that/you don't know to what you will come/you don't know how you will die/you don't know where you will die/the hour of death is uncertain'. Beneath are two further inscriptions respectively held by a white and a black bird (the latter now only a shadow). The former translates as 'In all things remember your end and you will not sin' and the latter is a verse that reminds the reader of their death and its realities. Despite heavy repainting, the character of the image and the texts themselves suggest the hand dates to about 1500. How much of the present pew originally relates to it is an open question.

49 The realms of glory
The Church of the Holy Trinity, Blythburgh, Suffolk

In 1412, the Augustinian priory at Blythburgh received a licence to rebuild the parish church that stood in its shadow. To judge from will bequests, the present church was being completed in the 1460s. This vast building rises as a solitary landmark above the surrounding marshes, but it must once have stood in imposing partnership with the priory. The high roof of the nave is a spectacular creation, its 11 principal beams apparently supported on the backs of paired angels. The figures are depicted from just below the waist and emerge from circles of cloud. Each is clad in feathers and possesses strikingly long wings. They wear crowns over curling hair and clutch shields to their chests. One of the most striking features of the roof is the extent to which the original painted decoration survives. The scheme compares to that found in more fragmentary condition on other roofs in Norfolk and Suffolk. It uses a palette of black, red and green on a white ground as well as alternations of colour and motif to striking effect. Within the geometry imposed by the principal roof timbers, for example, the rafters are painted in blocks with the letters 'IHS' for Jesus and what might be read as a stylized monogram of 'Maria' for the Virgin.

50 Breaking Hell's gates
The Church of St Botolph, Boston, Lincolnshire

In about 1425, work began on Britain's greatest medieval parish church tower, the
'Stump' at Boston. Work was to continue on the building for about a century before
it attained its present height of 272ft. Shown here is the main door to the tower. This
was not the normal entrance to the church, which was through the south porch. It was,
however, used for formal entrances into the building. Perhaps the most elaborate of
these took place on Palm Sunday, the celebration of Christ's triumphant entry into
Jerusalem. Having circumambulated the church in procession, the entire congregation
would have entered through this door, passing beneath an elevated monstrance holding
a consecrated host. They were led into the building by the priest, who struck the door
with the shaft of the processional cross. His action symbolized Christ's forced entrance
through the gates of death and the Harrowing of Hell.

A compressed porch, decorated with battlements, panelling and – formerly – the figures
of saints in niches, dignifies the entrance. The door itself is covered in flowing tracery
decoration like a great window. From the early fourteenth century in England, this
treatment of doors with carved detail replaced the earlier fashion for elaborate ironwork
decoration that had flourished from the Anglo-Saxon period.

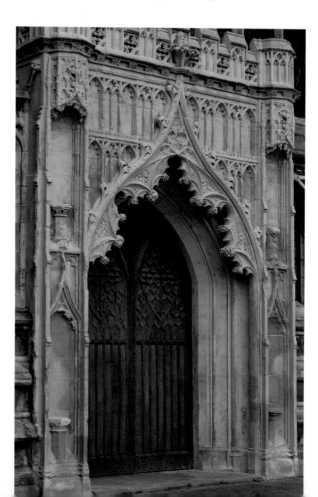

51 Threshold to the grave
The Church of St Peter, Boughton Monchelsea, Kent

It must have been in deference to long-established and widespread convention that the funeral service in the 1549 Book of Common Prayer directed the officiating minister to meet the body of the deceased at the 'church style' and conduct it to the church. Certainly, from the 1480s, there are references to lychgates, a term deriving from the Anglo-Saxon word *lic* meaning a corpse. Presumably, this was the place where the funeral service began. Surviving medieval lychgates are rare and, confusingly, given their name, very few were demonstrably closed by gates. Rather, they generally took the form of an open porch set on the perimeter of the churchyard. A particular concentration exists in Kent. This one at Boughton Monchelsea comprises six timber uprights supporting an internal bench and a roof structure. Applied to the gables are boards ruggedly decorated with cusps. The internal gate is a modern addition. Without scientific analysis this lychgate cannot be precisely dated. The village, however, enjoyed a period of particular prosperity in the fifteenth century (its agricultural economy was boosted by the local quarrying of ragstone, which was used both for building and cannonballs). A number of surviving timber-frame houses were built in this period and the lychgate is probably contemporary with them.

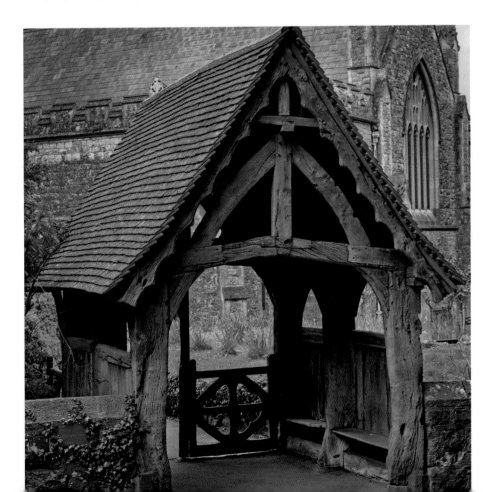

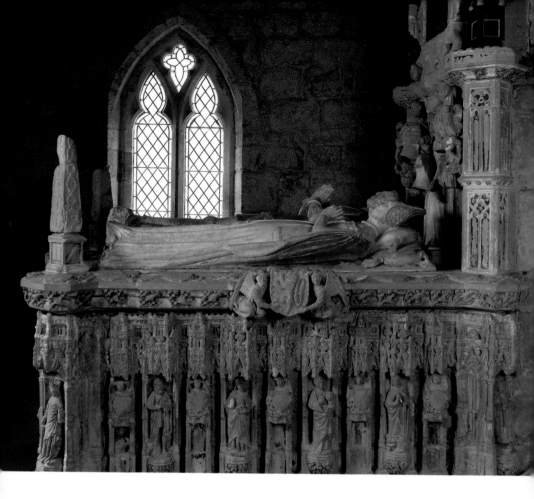

52 Cloaks and ladders
The Church of St Peter, Chillingham, Northumberland

Within a side chapel of the tiny parish church of Chillingham is this grandiose monument to Sir Ralph Grey (d.1443) and his wife, Elizabeth FitzHugh. Sir Ralph was probably the first of his family to own Chillingham Castle. The monument is exceptional for its remarkable state of preservation. Around the base of the tomb are 14 figures of saints, several of whom have explicitly northern associations, such as Sts Cuthbert, Wilfrid and Ninian. Between them are busts of angels emerging from clouds and holding coats of arms. Above the heads of the effigies are the heraldic achievements of the family, with figures of angels raising the souls of the deceased to Heaven in sheets. There is also a full-length figure of an angel holding Sir Ralph's helm. Around the upper rim of the monument are the repeated family emblems of a ladder and cloak. Extensive traces of colour show that the whole monument was formerly painted. It appears to have been designed rather like a four-poster bed with a massive canopy or tester, now lost. In the early seventeenth century, obelisks were added in place of the canopy supports and an inscription was erected over the tomb. The monument was dismantled and restored in 1995–7.

53 Power and piety
The Church of St Mary the Virgin, Ewelme, Oxfordshire

Set between the high altar and the gloriously decorated fifteenth-century chapel of St John the Baptist at Ewelme is one of the most remarkable surviving funerary monuments of the late Middle Ages in Europe: the tomb of Alice, Duchess of Suffolk, the granddaughter of the poet Geoffrey Chaucer. Executed entirely in alabaster, it was probably made in London at her explicit direction shortly before she died in 1475 (probably aged seventy-one). An effigy of the Duchess dressed in robes of estate, and once painted, extends across the top of the tomb. Her distinctive face with its long nose is almost certainly an attempt at a portrait. Over her head is a canopy carved with virtuoso skill from a single block of stone. Ranged around the monument are angels bearing shields that trumpet the Duchess's formidable dynastic connections. Yet the monument has an unexpected and startling secret, properly visible only to those who lie down to view it. Tucked beneath it is a second effigy. Here, the Duchess is shown as a corpse, her funeral shroud parted to display shrivelled breasts and desiccated flesh. The cadaver's half-opened eyes stare in unwavering devotion at a series of paintings executed on the ceiling of the chamber it lies in. This is Alice the mortal woman, piteously seeking salvation.

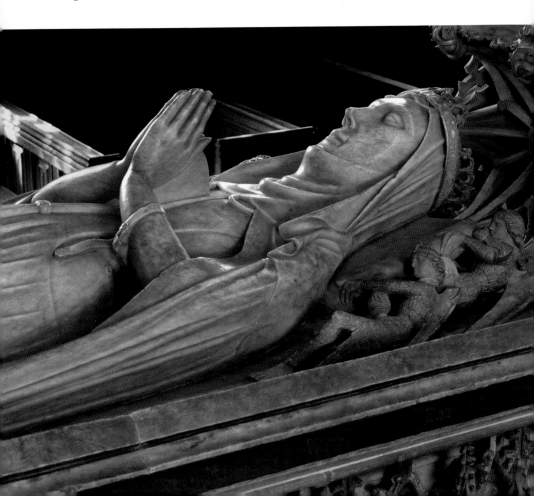

54 Opulence in granite
The Church of St Mary Magdalene, Launceston, Cornwall

Carved across the walls, buttresses and battlements of one of the largest churches
in Cornwall is a fantastical array of low-relief sculpture. It includes stylized foliage,
pomegranates, heraldry and the repeated motif of a tree hung with a shield. An
enclosing grid of blind panelling visually structures the display. Behind the high altar
there also appears a figure of St Mary Magdalene, patroness of the church, attended by
musicians and devotional inscriptions. Over the main porch are figures of St Martin and
St George, the date 1511 and arms of Henry Trecarrel and his wife, Margaret Kelway,
patrons of this astonishing creation. Legend has bestowed a knighthood on Henry
Trecarrel and also a compelling motive for church building, namely the tragic early
death of his only son. In fact, the rebuilding of the church almost precisely coincides
with Trecarrel's emergence as a leading figure in government of the town – of which he
was alderman and later mayor – and also the administration of the Duchy of Cornwall.
The sculptural programme was a means of making the new church, formerly a chapel,
conspicuously opulent. It also made it fashionable: panelled grids are a defining feature
of the Perpendicular style of Gothic. Comparable displays of continuous surface
decoration are also to be found in local Tudor church furniture.

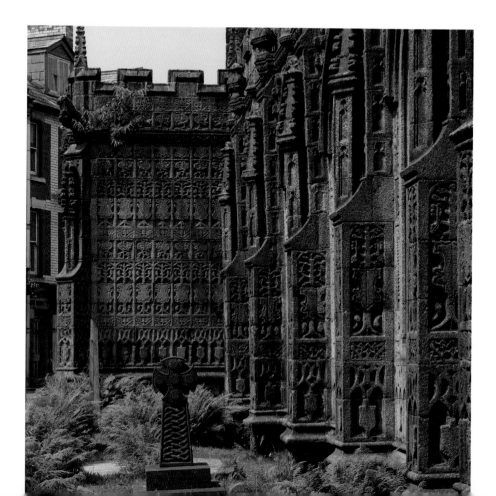

55 Votive verses
The Church of the Holy Trinity, Long Melford, Suffolk

This is a detail of the late fifteenth-century roof over the family chapel at Long Melford built by John Clopton (d.1493), a great benefactor of this wealthy parish. A hand emerges from stylized clouds and grasps the end of a scroll that winds its way around the whole cornice of the interior. It notionally wraps itself around a spiral of intertwined foliage. On each fold of the scroll are verses in English minutely written in a Gothic script. Across the beams of the ceiling are shorter scrolls with the repeated invocation 'Jesus mercy and gramercy'. There also appear phrases from the Litany. Between the beams is a scattering of moulded stars to suggest the celestial firmament. The cornice verses bear a direct relationship to the areas of the chapel they ornament. Those over the altar, for example, speak of the virtues of the Mass. They were written by John Lydgate, a monk of Bury St Edmunds who died around 1450. He was a popular poet during his lifetime and, as the chapel shows, beyond it, too. Verses by Lydgate were elsewhere used in a similar way. The most celebrated was a translation of French texts commissioned around 1430 to accompany a painting of the Dance of Death in the cemetery cloister at St Paul's, London.

56 History and myth
The Church of St Laurence, Ludlow, Shropshire

This is a detail of a window commissioned by the Palmers – or Pilgrims – Guild for their chapel in Ludlow, probably in the 1440s. To the right is shown a gathering in which a guild official, identified by his sash, links the hands of two brothers to take an oath. A harpist plays music and a greyhound, symbolic of aristocratic life, sits on the tiled floor. Above the scene is a fantastical architectural canopy. All the principal figures wear a livery, half blue and half white with stripes and a red hood. The rest of the window ingeniously connects this scene to St John the Evangelist (to whom the chapel is dedicated) and the reputed founder of the guild, St Edward the Confessor. According to legend, St Edward gave his ring to a beggar, who was, in fact, St John the Evangelist in disguise. St John passed it on, in turn, to two pilgrims with the instruction that they return it to the King with a warning of his impending death. This narrative is depicted in the upper register of the window. In the lower register, St Edward is shown to the left granting the guild – in the persons of the two pilgrims (dressed in blue) – its charter of foundation. Then follows the joyous reception of the pilgrims at a city, presumably Ludlow.

57 A susurration of wings
The Church of St Wendreda, March, Cambridgeshire

This is a detail of the celebrated angel roof at March probably completed around 1480. Incorporated in three tiers of imagery is a heavenly host of more than 120 angels fluttering in protection over the assembled parish. Figures of saints and apostles – the props of the Church – are set in architectural niches on the vertical posts supporting the roof. On the first projecting beam above are angels holding the instruments of Christ's Passion. These were doubtless to be understood in relation to the sculpture of the rood or crucifixion above the chancel screen. Angels bearing shields decorate the next tier of beams as well as the collars beams that span the apex of the roof. Further busts appear at the springing of the roof and at the wall head, the former playing musical instruments and the latter with their hands in gestures of adoration. There is besides a wealth of carved decoration in the form of squares and crestings of foliage. Elements of the roof would originally have been picked out in colour. The widespread English fashion for timber roofs ornamented with the figures of angels was inspired by the stupendous example of Westminster Hall, as remodelled in the 1390s. It was fuelled by the late medieval devotion to angels and their perceived role as messengers of prayer.

58 A confraternity of archers
The Church of St Leonard, Middleton, Lancashire

This is a detail of an early sixteenth-century stained-glass window depicting a company of archers. Each is identically dressed in a blue livery with a quiver of arrows and a bow. The name of every one is carefully written along the line of their bow. An accompanying inscription in Latin, now fragmentary, called upon the viewer to 'Pray for the good estate of Richard Assheton and of those who had this window made, the names and images of which appear shown above. The year of Our Lord 1505'. The window has popularly become known as the 'Flodden Window', since Richard Assheton is known to have led a troop of archers to this battle in 1513. Assuming the date on the inscription is correct, however, this image cannot relate to Flodden. Rather, it presumably commemorates a religious confraternity. This would not only explain the relative social modesty of most of those depicted and named but also the inclusion of a chaplain, one Henry Taylor, at the head of the band. He was uttering a prayer, 'Lord have mercy. Our Father'. Several of the figures shown were demonstrably connected with the locality. The window is a powerful reminder of the diversity of religious confraternities and guilds, embracing groups of craftsmen and professionals as well as those with particular devotional interests.

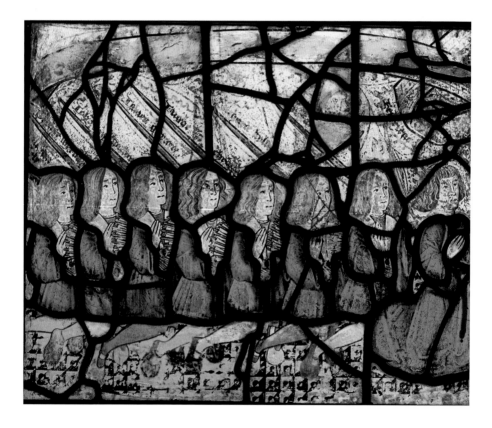

59 Industrial pride
The Church of All Saints, Newland, Gloucestershire

Among the outstanding monuments at Newland is a brass in the south chapel. The damaged figures on the monument are of the luxuriantly bearded Robert Greyndour (d.1443), in a suit of armour, and his widow, Joan. She founded a chantry at Newland in 1446 and probably commissioned this tomb at about this time. The metal inlays of the monument – made from latten – would originally have stood out like gold against the dark, polished Purbeck marble into which they are set. Certain technical details of this brass prove that it was produced by a prolific workshop based in London. Despite its London provenance, this tomb incorporates one arresting reference to Newland's locality, the Forest of Dean, and its long history of iron and coal extraction. Shown here is a detail of a panel depicting Greyndour's crest. Above the helm, with its flowing fronds of decorative cloth termed mantling, there emerges the diminutive figure of a miner. In one hand, he clutches a pick and the pipe-like object in his mouth is a hands-free candleholder. His hair seems to be enclosed by a scarf or cap and there is a hod on his back.

60 Dancing with Death
The Church of St Andrew, Norwich, Norfolk

In 1506, work began on the reconstruction of St Andrew's, the second largest parish church in Norwich. This ambitious project had been anticipated since at least the year 1500 and had already attracted a steady stream of bequests from wealthy parishioners. These included a gift of 50 Marks in 1502 from Nicholas Colich, a grocer and former mayor of the city. Colich's money seems to have been spent on a specific task: glazing the new north clerestory, probably in the 1510s. Here, his merchant mark and the arms of the grocers appeared repeatedly in the context of an arresting cycle unique in surviving English medieval stained glass: the Dance of Death. This presented figures of every degree – emperors, kings, knights, ladies and peasants – led in a dance by Death to their universal and inevitable fate. This photograph shows a detail of the sole remaining panel from this sequence. A bishop in his worldly pomp recoils from the grasp of a shrouded skeleton with a leering and toothy grin. The cycle must originally have comprised more than 30 such panels and was probably based on a printed description of the subject. Depictions of the dance were often accompanied by verses on the transience of earthly glory and the inevitability of death, although no traces of such remain here.

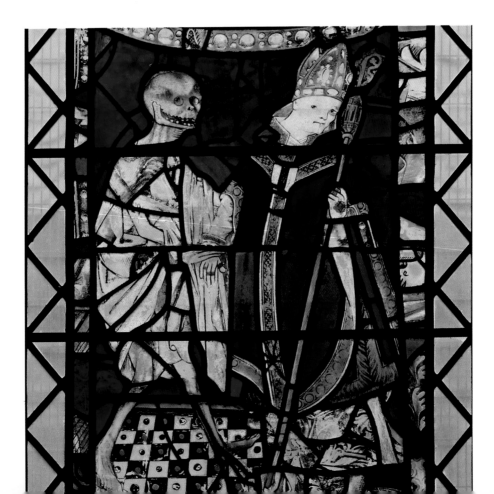

61 Instrument of praise
The Church of St Stephen, Old Radnor, Powys

In 1868, the wealthy clergyman Frederick Sutton published an illustrated account of this remarkable early sixteenth-century organ case at Old Radnor church. It was then stripped of its pipes and mechanism, but remained in its original position to the east of the choir stalls in the chancel. By the late Middle Ages, all great churches and many parishes possessed organs to accompany Divine Service. Fragments of only a handful are known today, however. In his short book, Sutton wanted to draw attention to the only substantial pre-Reformation organ case to survive in the British Isles and to encourage parishes thereby to think more carefully about the placement and decoration of their organs. His study subsequently became a bestseller and, helped by Sutton's friendship with the architect G. F. Bodley, its ideas became influential. The case at Old Radnor was itself restored according to Sutton's direction in 1872 by J. W. Walker, who inserted a modern instrument within the original frame. As well as replacing lost woodwork, some surviving elements of the case were also reconfigured. This photograph shows a detail of the case, which incorporates three projecting boxes of pipes within a five-part composition. Crowning the structure is a spectacular parapet of cockleshell niches, foliage and stylized animal carvings.

62 Devotion in stone
The Church of St John, Paignton, Devon

Separating a small chapel from the body of the church at Paignton is this remarkable late fifteenth-century stone screen. It comprises a matching pair of tombs with effigies (now badly damaged) and tall canopies flanking a central door. The quality of the architectural sculpture – with its intricate detailing, foliage and pendant vaults – is extremely high and compares to that found on several monuments of about 1500 in Exeter Cathedral. Preserved within the screen is an unusual quantity of sculpture. As well as mourners lining the tomb chests, there are figures of the Nine Orders of Angels, the Doctors of the Church, the Evangelists and the Apostles. Such displays celebrated and reaffirmed orthodox beliefs about the hierarchy of the Church and, for this reason, were often employed to decorate the rood screens that divided late medieval churches. To either end of the tomb effigies are large devotional panels. Visible here are the Mass of St Gregory (*left*) and the family of St Anne (*right*). Curiously, there are no inscriptions to identify the date or builder of this outstanding furnishing. It is ascribed to the Kirkham family of nearby Blagdon Manor on the word of the seventeenth-century clergyman John Prince, in his work of historical biography *The Worthies of Devon*.

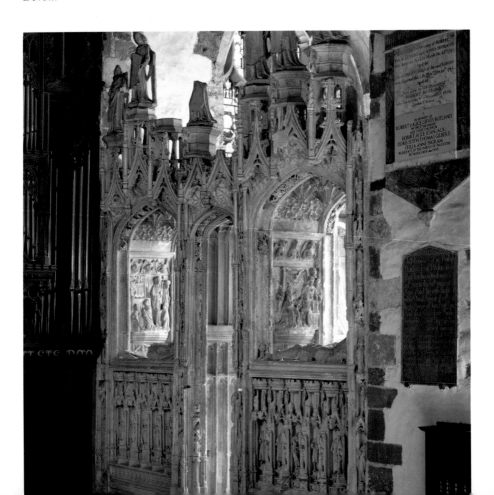

63 Patriotic martyr
The Church of St Peter and St Paul, Pickering, North Yorkshire

A detail of the martyrdom of King Edmund, part of an extensive mid-fifteenth-century
cycle of wall paintings rediscovered in the nave of Pickering church in 1852. It shows
the figure of Edmund tied to a tree in a meadow of flowers and wearing his crown.
Pierced by a multitude of arrows, he seems to be accepting martyrdom at the hands
of the Danish archers with slightly plaintive indifference. St Edmund was the patron
saint of England until St George displaced him in the mid-fourteenth century. To either
side of Edmund's head are scrolls painted with text that issues from the hand of God.
Immediately after their first exposure, the paintings were controversially whitewashed
over, but in 1876–8 they were revealed again and restored to their present condition.
As a consequence, some details, such as the archer to the left of this scene, are distinctly
Pre-Raphaelite in character. Elsewhere in the cycle, there are paintings of individual
saints, such as St George and St Christopher, as well as a narrative of the Passion of
Christ and a depiction of the Works of Mercy: feeding the poor, visiting prisoners and
so on. It has been suggested that the arrangement of the paintings from east to west
within the church is determined by the liturgical calendar.

64 Hierarchy of Heaven
The Church of St Helen, Ranworth, Norfolk

The principal liturgical division of the late medieval parish church was the screen that divided the chancel, with its high altar, from the public nave. Named the rood screen after the image of the crucifixion or rood that surmounted it, these furnishings were often additionally decorated with ranks of saints. This screen at Ranworth, dating to the mid-fifteenth century, is an outstanding surviving example, although its upper section – the rood, a gallery balustrade and candle beam – are lost. On the lowest panels of its central section are depicted figures of the Apostles. To either side of the chancel arch, and demarcated by a low partition with a candle spike, is an altar. Shown here is the Lady Altar, its partition ornamented with St Michael defeating the dragon of the Apocalypse. Over the altar are figures particularly suited for the devotion of pregnant women: the Virgin, St Mary Salome and St Mary Cleophas. The screen figures stand on countercharged patterns of tiles and wear rich silks decorated with animals. Both details are characteristic of a wider group of Norfolk screens attributed to the same craftsmen. In the foreground is a fifteenth-century cantor's lectern, another unique medieval survival. The two ledges for books are at different levels and a painted plainsong setting of a versicle is clearly visible.

65 Pride and her progeny
The Church of St Peter, Raunds, Northamptonshire

This is a detail from the impressive cycle of medieval wall paintings that survive above the north nave arcade of Raunds. It shows Pride, personified as a young woman dressed in fashionable early fifteenth-century dress, being stabbed in the stomach by the grinning figure of Death. Two demons appear to be placing a crown on her head and she holds a wand or stem in each hand, perhaps symbols of vanity. Escaping from her wound – which Pride receives with apparent indifference – are the Deadly Sins she engenders. Each is being vomited up from the mouth of a dragon and is identified by its gestures and attributes. Shown here from top to bottom are Avarice with bags of money, Wrath gashing itself and Envy writhing in anguish. Small identifying scrolls, now illegible, are held by the equally small demons that accompany each figure. The painting is set against a white background decorated with a scattering of red flowers, a painted evocation of a fabric hanging. Such engaging images would probably have been invoked to illustrate sermons and would also have helped parishioners understand rudimentary doctrine. At Raunds, the imagery forms part of a wider scheme that includes a figure of St Christopher and also the painted dial of a clock supported by angels in the internal arch of the magnificent west tower.

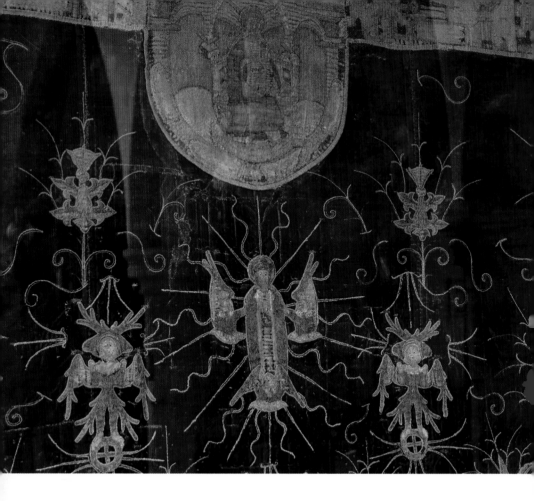

66 The dress of angels
The Church of St Bridget, Skenfrith, Monmouthshire

Preserved at Skenfrith is this splendid late fifteenth-century vestment – a cloak,
termed a cope. Such mantles are worn by priests for processions and ceremony, not
for the Mass. Made of crimson velvet, the cope is ornamented with applied pieces of
embroidery. Now abraded, the whole was originally rich with silver and gold thread
that would have coruscated with light. In the centre of the cope – appearing on the
back of the wearer – is an image of the Virgin being assumed into Heaven by seraphs.
These angels are depicted as figures with six wings standing on wheels. Around these
figures are other motifs including fleur-de-lis and double-headed eagles. A series of
saints in architectural niches form borders, termed orphreys, along the top edge of the
cope. These hung vertically from the front of the collar to the feet of the vested priest.
Among the saints, St Andrew is clearly identifiable by his emblem of an X-shaped cross.
Between the orphreys is a hood bearing the Virgin and Christ. Nothing is securely
known of the medieval history of the vestment. It was spotted in 1846 by a local Roman
Catholic priest, Fr Thomas Abbot, being used as an altar covering. The cope has just
been conserved and was returned to the church for St Bridget's Day, 2013.

67 Jack the Smiter
**The Church of St Edmund,
Southwold, Suffolk**

Set against the tower arch at Southwold
is this engaging figure of a man in armour
holding a falchion and axe. He is carved
of oak and stands just short of 4ft high.
This is a clock jack, an automaton that
was formerly attached to a clock and
chimed the quarters. The form of the
armour suggests that the figure was
made in the late fifteenth century. Of the
original provenance of the jack, nothing
is securely known. It's likely to have stood
outdoors and the asymmetrical posture
of the feet suggests that it was formerly
one of a pair. When the mechanism is
operated today, the figure jerks its head
and strikes the bell with the axe in its right
hand. Another similar figure in armour
survives at nearby Blythburgh, where
it announces the start of services. The
Blythburgh figure may date from as late
as 1682. There is evidence for clock jacks
in England from the thirteenth century,
as, for example, on the steeple of Old St
Paul's in London (although the idea of
mechanical figures attached to clocks has
a much longer history). Perhaps the most
celebrated survival of this kind in England
is the 1390s clock at Wells Cathedral with
its seated 'Jack Blandiver' and jousting
knights.

68 Merchant splendour
The Church of St Peter, Tiverton, Devon

According to an inscription on his tomb, the wool merchant John Greenway founded
a burial chapel attached to the parish church at Tiverton in 1517. Shown here is a view
of the building he created, which is ornamented with a spectacular array of sculpture.
By its intricacy and subject matter, this carving was intended to advertise Greenway's
wealth, his profession and his worldly pretensions. Cut in fragile Beer stone, the
sculptural display of the chapel, and the adjacent porch, has been much restored over
time. Nevertheless, the essential details of the carving remain legible. The external
decoration of the chapel is organized in clearly defined registers, which grow in richness
at each level. At the spring of the window arches, the plain walls are subsumed in a
lacework of blind tracery ornamented with anchors and Greenway's monogram and
merchant's mark. Above this is an ocean bearing galleys, galliases and rambarges, the
latter a type of vessel with oars and sails. These are presumably Greenway's ships and
most are prepared for battle: visible on their decks are guns, archers and bowmen and
the crow's nests are filled with bundles of spears to cast down on enemy ships. Over this
frieze are small scenes depicting the life of Christ. In the next register are Greenway's
arms and those of the Merchant Adventurers and Drapers Company, to which he
belonged. As a final decorative flourish, the battlements crowning the chapel are pierced
through to create a lattice of stonework.

69 Preaching to posterity
**The Church of St Bartholomew,
Tong, Shropshire**

The church at Tong was the dynastic
mausoleum of the Vernon family and is
filled with their tombs. One of the most
delightful is this unusual early sixteenth-
century half-figure of Arthur Vernon,
a priest. It stands in the intimate burial
chapel of his parents, Dame Anne and
Sir Henry Vernon, which was probably
completed by early 1519. Arthur died
in 1517 and, in his will, requested
burial beneath a 'stone', a reference
presumably to an extant funerary brass
in the chapel. It's not clear who designed
this additional monument, perhaps his
father's executors. Arthur is shown within
a richly detailed niche, like a pulpit, with
a pendant base and canopy. Supporting
the canopy are busts of angels holding
family coats of arms and the fan vault
above his head is a miniature version
of that covering the chapel itself. The
sculpture, which shows traces of paint, is
sensitively executed. Arthur holds a book
open before him and gestures with his
other hand (now damaged) as if calling
the visitor to stillness and attention. The
form of the effigy anticipates a genre
of monument later used by Protestant
divines. It's also strongly reminiscent
of contemporary portrait paintings that
place the sitter behind a ledge.

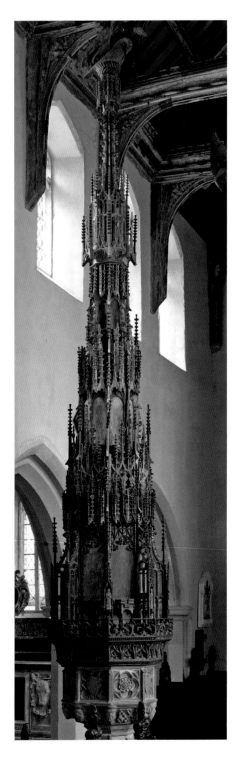

70 Baptismal monument
The Church of St Mary, Ufford, Suffolk

Following a visit to Ufford in about 1620, the antiquary John Weever described its church as 'the most neatly polisht… within the diocese'. Although he admired its angel roof and organ case, the object he particularly singled out for praise was the font. Its cover was 'without compare, being of great height, cut and gloriously depicted with many imageries consistent to the representation of the holy Sacrament of Batisme'. Some of the furnishings Weever saw have disappeared, but the cover survives. It is suspended on counterweights and rises the full height of the nave. Of the medieval imagery, only the figure of a pelican piercing its breast – a symbol of Christ's sacrifice – at the very apex remains. There is also evidence of painted decoration, which has been restored in some areas. The cover probably dates to the last quarter of the fifteenth century. Timber pinnacles were incorporated within medieval church furnishings of all kinds, including stalls, sacrament houses and even pulpits, although this is perhaps the grandest example to survive in a parish church. When the iconoclast William Dowsing came to purge Ufford in 1644, he and his men were denied the keys to the building for a full two hours. The delay probably saved the cover for posterity.

71 Gilded chivalry
The Collegiate Church of St Mary, Warwick, Warwickshire

In the centre of the sumptuous Beauchamp Chapel of the collegiate church of Warwick lies this effigy of Richard Beauchamp, Earl of Warwick, who died in Rouen in 1439. It is made of gilt bronze, a material associated with royal tombs. Several contracts relating to the chapel's construction survive and they demonstrate the surprisingly complex process of producing the tomb from 1447 to 1450. The London founder William Austen cast the effigy from wooden models carved by the sculptor John Massingham, an outstanding sculptor otherwise active in Oxford and Canterbury and the capital. Massingham's models were, in turn, based on designs by an artist called Clare. Four other specialist craftsmen were otherwise involved in the production of the monument, along with a barber surgeon, who possibly gave advice on the effigy's anatomy. The Earl is dressed in a suit of Milanese armour and lies beneath a semicircular cage for supporting a hearse cloth. His head, with its pudding-bowl haircut and outstanding veins, is detailed with startling liveliness. The Earl's hands are parted in a gesture of praise and he stares upwards towards a figure of the Virgin carved on the boss of the high vault above the chapel altar. Behind his head is a helmet with the crest of a swan's head emerging from a coronet.

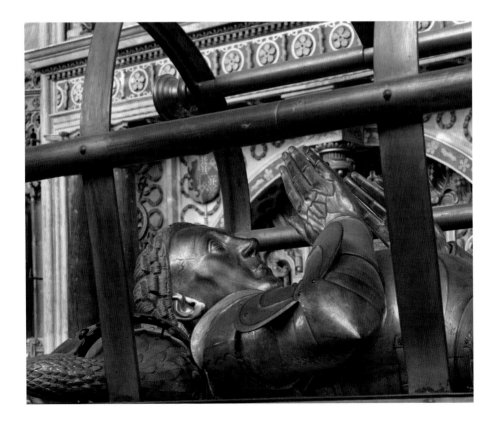

72 Shoeing the goose
The Church of St Mary, Whalley, Lancashire

This is a carving from the imposing set of fifteenth-century choir stalls at Whalley. It shows a blacksmith, his tools visible to the left, attempting to put a shoe on a goose, which is held in a vice-like clamp and tethered (to the right). The expression 'to shoe a goose' meant to undertake some fruitless task and this would help explain the verse inscription beneath the scene. It reads: 'Who so melles hym of that al men dos, let hym cum heir and shough that ghos'. The sense of this is as follows: the man that would meddle in the affairs of other people might as well come here and shoe a goose. The scene is carved beneath a misericord, a ledge on the back of the upturned seat which offered support to the occupant of the stall while standing. These were often carved with imagery that was either playful or absurd (though serious themes do also appear). Those at Whalley form an unusually delightful and varied collection. The stalls were moved to the parish church from the neighbouring Cistercian abbey after its seizure by the Crown in 1537. They are dated by the initials of Abbot William Whalley on one misericord to the years of his rule between 1418 and 1434.

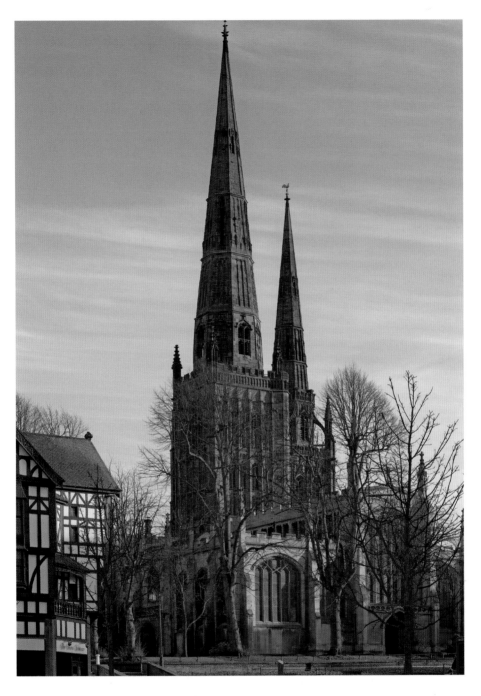

Coventry preserves one of the finest groups of medieval spires in the country. Here is the 237-foot-high spire of Holy Trinity with the great 15th-century spire of the modern cathedral behind.

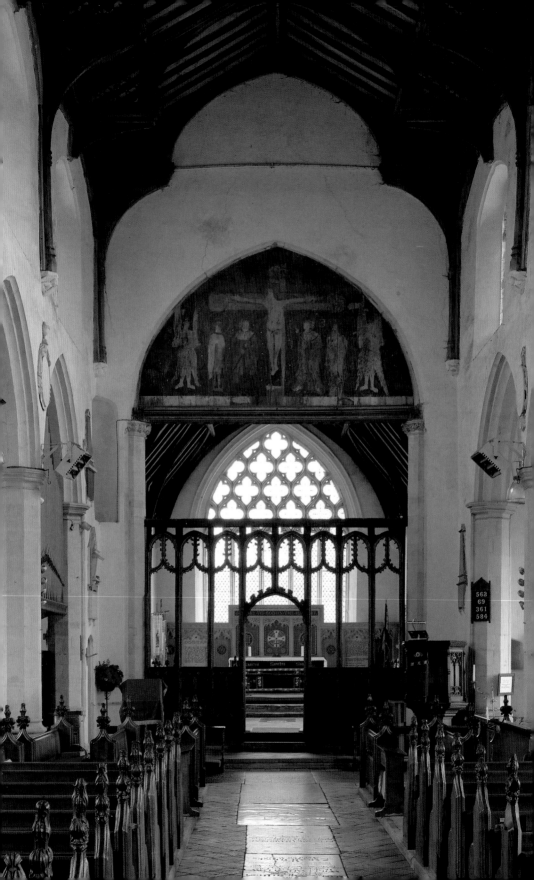

5 The Tudor Reformation, 1536–1603

In the twenty-first century opinion remains as deeply divided as ever about the causes, effects and character of the Reformation. Was the overthrow of Catholicism in England by a new Protestant order imposed from above on an unwilling populace or was it the result of a grass-roots movement? Did the reformers topple a moribund and decayed religious order or take advantage of political change to assault one that remained vibrant and responsive? Is this religious change no more than a manifestation of deeper economic, social and intellectual changes? There are no simple answers to these questions, and such as there are perhaps lie more in people's sympathies than they are willing to admit.

Nevertheless, during the second half of the sixteenth century the religious life of the kingdom underwent a profound change. A liturgy based on ritual and performance, in which actions and the intonation of words had living power, completely disappeared from parish churches. Moreover, everything associated with it – the language of Latin, vestments, rituals and processions – became proscribed in public worship.

So, too, was the devotion to saints, the court of Heaven that interceded with God for the needs of the living and dead. With these things disappeared a whole apparatus of life in which the passage of time was related to the liturgical hours and the annual calendar to the celebration of saints' feasts and holy days. The clergy, too, was drastically reduced in number and its defining late medieval characteristic of celibacy removed.

The rood at Ludham was probably created during the Marian restoration of Catholicism in the 1550s

In its place there emerged a religious observance in which the understanding of the laity was of paramount importance. Faith, not good works, promised salvation. To convey the sense and meaning of prayer, the liturgy was translated into the vernacular. It was also drastically simplified and homogenized. Most ceremonial and all but the simplest music were also suppressed for the sake of clarity. Meanwhile, any inanimate objects used in devotion, aside from an authorized prayer book or Bible, became suspect. Relics, imagery of all kinds, rosaries, holy water and candles – indeed, all things that could be blessed, honoured or mechanically employed for devotional purposes – were condemned as the trappings of superstition or idolatry. So, too, was the central Catholic devotion of the Mass and the dogma of Transubstantiation.

The degree to which Protestantism came to be widely accepted is very difficult to judge. It seems to have set its stamp on the religious life of south-eastern England relatively quickly, though the roots were established more rapidly in towns – and London in particular – than rural parishes. By contrast, its imposition prompted a series of major rebellions in the south-west and northern England into the late 1560s. Even thereafter, reforming bishops in Wales, Yorkshire and Durham were often in despair at the continuing prevalence of Catholicism. What is clear, however, is that by the last quarter of the sixteenth century a growing majority of people felt loyalty towards the reformed Church of England.

It is difficult to exaggerate the scale of physical destruction associated with the Reformation. In parish churches, altars were torn out, images of all kinds were destroyed or whitewashed over, vestments and liturgical instruments sold and books defaced. Others were hidden or taken into private hands. (That said, it's a confusing but important paradox that, despite such destruction, England's parish churches nevertheless possess an astonishing and vast collection of surviving medieval art; one of the largest such, indeed, in Europe. In this sense, the resilient popular belief that the story of British painting can only be told from after the iconoclasm of the Reformation is absurd. It's just that most parish church art isn't – as yet – on the market to flesh out national collections.)

No less profound a change to these churches was their diminished usage. These once dynamic interiors, used throughout the day and sometimes the night, too, now became home to intermittent services. Medieval parish churches were, indeed, only incidentally suited to the religious practice of Protestantism. They could so easily have followed in the footsteps of the monasteries in the mid-sixteenth century and passed with their contents into virtual oblivion. Yet they did survive and this chapter, which traces the history of the Reformation from the end of Henry VIII's reign to the death of Elizabeth I in 1603, seeks to explain why.

While Henry VIII set the ball of the Reformation rolling, his conservative religious views were a constant stumbling block to those attempting to push through a Protestant agenda. Nevertheless, from 1536, and in tandem with the suppression of the monasteries, parishioners did begin to see striking evidence of religious change. That year large numbers of saints' day holidays were erased from

the calendar. Then by the terms of royal injunctions issued in 1538 the cult of saints was effectively proscribed. Pilgrimage was likewise forbidden as was the 'offering of money, candles or tapers to images or relics, or kissing or licking the same, saying over a number of beads, not understood or minded upon'. The same injunctions also silenced the Angelus, the bell rung at morning, noon and evening in churches throughout the kingdom that had called the faithful to kneel in prayer to the Virgin.

In the following year, 1539, the first authorized English translation of the Bible, the 'Great' Bible, began to appear in parish churches. Reading of this volume was officially encouraged. Then in 1545 there appeared the first authorized primer or prayer book in English, known as The King's Primer. These and other changes of practice and use fuelled religious tension across the kingdom, the fortunes of traditionalists and reformers shaped by the factious politics of the court. Nonetheless, the fixtures and fittings of churches were generally only vulnerable to destruction if they were the object of what was deemed inappropriate veneration. The pace of change quickened rapidly, however, following Henry VIII's death in January 1547 and the accession of Edward VI. Now the Reformation of the medieval parish church began in earnest.

In the first year of Edward VI's reign a new set of injunctions was issued. By their terms processions of all kinds were abolished, bells were to be silenced during services (excepting one to announce the sermon on Sunday) and all 'abused' images were to be destroyed. Abuse was now very broadly defined and the types of images specifically referred to

included stained-glass windows. It was also forbidden to burn candles before the rood. Apparent in the injunctions is an explicit criticism of Catholic practices. Any individual was banned from:

> casting holy water upon his bed, upon images, and other dead things; or bearing about him holy bread or St John's Gospel, or making of crosses of wood upon Palm Sunday in time of reading the Passion, or keeping private holy days, as bakers, brewers, smiths and shoemakers, and such others do; or ringing of holy bells, or

Behind the small parish church at Easby, Yorkshire, are the ruins of a Premonstratensian abbey. It was common for religious houses to create neighbouring parish churches so as to keep parochial and monastic life independent.

blessing with holy candle, to the intent thereby to be discharged of the burden of sin, or to bribe away devils, or to put away dreams and fantasies.

The injunctions were aggressively enforced by an exacting visitation – in effect an official inspection of churches – that extended into the following year. There was dissent but deep-seated loyalty to the Crown was evidently an important factor in driving the changes through. Churchwardens' accounts for these years are full of references to the removal of images and the whitewashing of walls. In 1547–8 the roods that had for so long dominated church interiors were dismantled. Raised in their place, either on the boards of the rood or on canvas sheets, were images of the royal arms, the Commandments and other biblical texts in English.

These arms were a powerful reminder that the state and Church had become inseparable from one another. A failure to conform was not heresy, it was treason. Meanwhile, parishes also began to sell valuable furnishings and items of church plate. The latter may suggest growing sympathy with Protestantism but it might equally reflect a need to raise cash for implementing the changes demanded of churches by royal policy, not to mention a prescient awareness that it was only a matter of time before the Crown would help itself to these objects, too.

The visitations coincided with a new act that encompassed the abolition of all chantries on the principle that they related to 'phantasising vain opinions of purgatory and masses satisfactory, to be done for them which be departed'. At a stroke all the supplementary clergy

The nave aisle of Lanercost Priory, Cumbria, became a parish church after the Reformation. The distant monastic choir survives but was stripped of its roof and is now a ruin. The nave was re-roofed in the 18th century.

supported by chantries and guilds were dispossessed and their property seized. This didn't just strike at the celebration of the liturgy, but at lots of social projects bound up with chantry foundations, including schools and almshouses. And yet more radical reforms were in train. Much of the ritual associated with Easter Week was now proscribed, as was the practice of hanging the consecrated host in a pyx. Then, on 19 December 1548, Parliament began to debate the introduction of a new prayer book compiled by the Archbishop of Canterbury, Thomas Cranmer, backed by an Act of Uniformity to clarify practice.

The 1549 Book of Common Prayer was intended to be – as its name suggests – a universal English prayer book. Presented within it are texts for Morning and Evening Prayer as well as 'The Supper of the Lorde and holy Communion, commonly called the Masse'. These texts are like a series of play scripts in which accompanying rubrics – descriptions of actions – serve as stage directions. These ensured that the right things were done in the right way at the right time. To judge from the rubrics the familiar topography of the medieval church was still broadly in place. Morning Prayer, for example, was to be led by the priest from within the choir or chancel speaking in a loud voice. Since this position was necessarily removed from the nave he was additionally instructed to turn towards the congregation for the readings.

By contrast, the priest began his celebration of Mass – the name survived for the present – from the altar and the whole congregation joined him there briefly after the offertory, when the bread and wine were brought forward. There

the congregation were exhorted to place charitable offerings in a poor box. Those who were to receive Communion were instructed 'to tarry still in the quire, or in some convenient place nigh the quire, the men on the one side, and the women on the other syde'.

Also incorporated in the prayer book are a series of occasional services for baptism, confirmation, matrimony, visitation of the sick and burial. In some ways the text drew heavily on the liturgy it replaced, translating sections of it directly and preserving a calendar with a number of saints' and feast days. These were striking departures from wider European Protestant practice, where feasts and saints' days were in many places entirely done away with. Nevertheless, this should not obscure what a radical change the prayer book effected on the hitherto familiar liturgy.

The use of the vernacular would have seemed extraordinary to contemporaries. So, too, would the changes to the Mass, which was scarcely recognizable as the Catholic ceremony of the same name. Language aside, the central episode of the elevation was deliberately stripped of drama. Christ's words over the bread and wine were to be said 'without any elevacion, or shewing the Sacrament to the people'. Incidentally, the bread was to be thicker and larger than a host – the flat wafer used in the Catholic celebration – and had to be placed in the mouth of communicants at Communion so they couldn't carry it away.

At the heart of these changes was a contention about the nature of the Eucharist. Was Christ really made manifest in the bread and wine, as

Catholics maintained, or was this to be understood as a solemn re-enactment of the Last Supper? The former understanding made it appropriate to celebrate the Mass on an altar, with its connotations of sacrifice. But for a communal meal a table was surely the appropriate thing. Among reformers there were many graduations of opinion; nevertheless, the more radical carried the day. In 1550 altars were ordered to be destroyed across the country. The expense was considerable: at Ludlow in 1551 it took two men six days to destroy the altars and four labourers 18 days to clear the church at a cost of 16 shillings. Multiple altars were now replaced by a single wooden table.

Meanwhile, experiments were already under way among reformers as to how the communion table might be arranged. Those receiving Communion needed to be separated from the remainder of the congregation for this solemn re-enactment of the Last Supper, so the table needed to be in a discrete area. The chancel, in this respect, still served well. But there was also a desire to place it close to the communicants so that they could partake in the action and words of the Eucharist. The result was that the table began to be placed lengthwise between the stalls of the chancel.

This arrangement received official endorsement when Cranmer issued a revised version of the prayer book in 1552: the celebrant was ordered to stand at the north side of the table, an instruction that only makes sense if it was arranged lengthwise. The text goes on to say, however, that the table could be placed 'in the body of the church, or in the chancel, where morning prayer and evening prayer

be appointed to be said'. Parishes, in other words, now had a choice. They could use either the chancel or the nave for Communion. There was a good reason for leaving the option open. Chancels were now themselves threatened as priestly enclosures by some reformers. Bishop John Hooper, for example, in a Lent sermon of 1550 called for their universal closure. If he had had his way England's parishes would be like Scotland's, where chancels either disappeared or were transformed into family pews.

The publication of the 1552 prayer book coincided with the confiscation of all the remaining valuables belonging to parish churches (which followed an order given in March 1551). The commissioners were instructed to leave only such items as the prayer book specified were necessary for the celebration of the Eucharist: a surplice for the priest, a couple of tablecloths, a cup for Communion and a bell. This final treasury of the medieval church, an accumulation of five centuries of bequests, was now stripped almost completely bare. All that survived were the buildings themselves and, given the fate of the monasteries and the disapproval shown to chancels, might their fabric not be claimed to fund another ruinous Tudor foreign war or to line the pockets of courtiers?

On 6 July 1553 Edward VI died. Mary was swept to the throne on a wave of popular support and the Mass was restored. Across the country churchwardens' accounts again speak of the restoration of images, of rood lofts, altars, liturgical books and all the trappings of Catholic worship. Given the relative poverty of parish churches it is to be imagined that a great quantity of the

restored objects had in fact been hidden and kept safe over the last decade or so. Yet for parishes, the return to the familiar liturgy proved short-lived. The death of Mary in 1558 after a brief reign and the accession of Elizabeth I brought about a return to Protestantism that, in the light of hindsight, we now know was to be permanent. Contemporaries had no such certainty.

A new Act of Uniformity – effectively the fourth in a decade – promulgated the 1559 Book of Common Prayer. This was based on its predecessor of 1552, though toned down and deliberately ambiguous in some respects to make it more widely acceptable. Yet the precise character of the prayer book is in some ways less important than the longevity of use it enjoyed. For this English rite remained in use until the civil wars of the 1640s and cemented Protestantism into the national consciousness.

Accompanying the restoration of Protestantism was another royal visitation. Its second injunction enquired of the clergy 'whether in their churches and chapels all images, shrines, all tables, candlesticks, trindals or rolls of wax, pictures, paintings, and all other monuments of feigned and false miracles, pilgrimages, idolatry, and superstition be removed, abolished, and destroyed'. Once again came the expense of a complete change to the fittings and liturgical texts, not to mention the religious ceremonies, of the parish.

Since the prayer book rubrics deliberately left space for interpretation, parishes had considerable latitude to restore the authorized Protestant rite – or what might pass for it – after their own liking.

The authorities, moreover, were clearly nervous of anarchic iconoclasm and quickly moved to protect even altars from unsupervised destruction. Tombs, too, were protected from defacement and attack. Gradually, however, the Elizabethan settlement was fleshed out and tightened.

The prayer book, for example, simply instructs that chancels should 'remain as they have in tymes past'. The direction secured their survival but the first clear statement of the form they should take is only articulated in a Royal Order of 1561. This makes it clear that the chancel should be separated from the rest of the church by a screen. Where the rood loft had not been 'transposed' (i.e. removed), it was now to be reduced to the level of the supporting coving or vault and a new

The vast outline of Wymondham, Norfolk, another example of a monastic site that was preserved through parish use. Here the nave is effectively a parish church with its own western tower. The second tower stood over the choir crossing, now demolished.

decorative 'crest' set above it 'towards the church'. The stalls in the choir were to be left as they were.

But if the screen had been entirely 'transposed', continued the order, a 'comely partition between the chancel and the nave' was now to be constructed. The former site of the high altar within the enclosed chancel now became the place where 'the Communion Table shall stand out of the times of receiving the Communion, having thereon a fair linen cloth, some covering of silk, buckram or other such like, for the clean keeping of the said cloth'. Above it should be placed a board of the Commandments.

Another important development that becomes apparent is the creation of a reading desk for the minister beside the chancel screen. An injunction compiled by Parkhurst, Bishop of Norwich, in 1569 neatly describes the problem and the appropriate response:

> in great churches, where all the people cannot conveniently hear their minister, the churchwardens and others, to whom that charge belongeth, shall provide and appoint a decent and convenient seat in the body of the church, where the said minister may sit or stand, and say the Divine Service, that all the congregation may hear and be edified therewith. And that in smaller churches there be some convenient seat without the chancel door for that purpose.

Of the customary structure of services under the 1559 prayer book more will be said in the next chapter but it is worthwhile observing something of the arrangement of the nave in this period. Besides the reading desk, the minister also required a pulpit for his sermon and the congregation seats to listen to it. Fixed seats and pulpits were a commonplace of English parish churches from at least the fifteenth century onwards and there is no reason to expect that there was much need to adapt the fixtures that existed already. Another striking continuity in the fittings of the nave was the position of the font. Whereas some European Protestant churches abandoned fixed fonts altogether, in England they survived, albeit their imagery defaced and the locks that had formerly kept safe the holy water within them broken.

When James VI of Scotland made his triumphant progress southwards to claim the Crown of England in 1603 he did not initiate a transformation of the Church. He was the first monarch in living memory not to do so. Instead, a general synod convened in London consolidated the terms of the Elizabethan Settlement. Its canons, published in 1604, are a complete expression of the constitution of the Church. The same year, at a conference at Hampton Court, the seed was also sown for the translation of the Bible published in 1611 and known after its patron as the King James Version. In these events Protestantism at last began to grow to maturity in England. As it did so, the iconoclasm and destruction that had characterized its advent receded. In the process, the buildings it had inherited from the Catholic past took on a new character and importance. This stimulated, as we shall see, a new period of investment in fixtures and fittings appropriate to a Protestant future.

73 Making the point
The Church of St Mary the Virgin, Adderbury, Oxfordshire

As an appended inscription announces: 'This is the representation of Thomas More Gent: who deceased the 2 day of Ian: 1586. And of Marie his wife daught: to Anthonie Bustard esq: who caused this monument to be made in testimonie and certaine beleefe of the resurrection of their bodies wch are laied hereby'. Painted monuments begin to appear in England during the sixteenth century, but never obtained widespread popularity. The principal panel of this fine example shows Thomas and Mary to either side of a tomb with a skeleton on it. They kneel beneath their respective arms and images of a skull and hourglass. Around them is a series of inscriptions and verses in English and Latin that remind the visitor of the transience of life. A pair of cherubs on the frame around the central verse point towards texts that speak of living and dying piously. They also gesture towards the tip of the frame as if to indicate that this is the 'point' of the whole. To underline the unexpectedly optimistic message of the tomb, the inscription beneath the skeleton reads: 'So far is ought from lasting aye/that tombes shal have ther dying day'. The message is repeated in the Latin text that runs between the figures. It translates as 'fates have also been given to tombs themselves'.

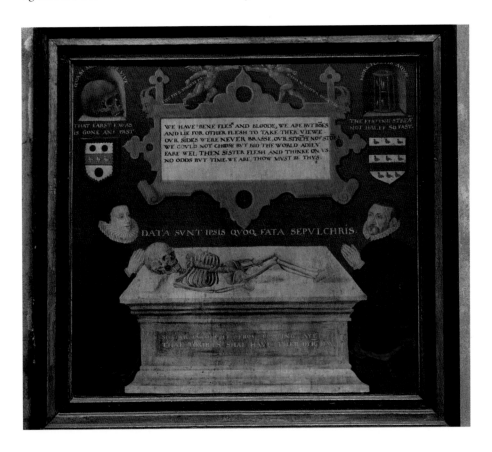

74 The riches of Reformation
The Church of the Holy Cross, Felsted, Essex

This is a detail of the reclining figure of Lord Rich (d.1568) from his fine monument set with columns of brass. He stares abstractedly towards the adjacent kneeling figure of his son. Lord Rich was a notable beneficiary of the Reformation, growing wealthy on confiscated monastic property. Famously, according to Roper's *Life of Sir Thomas More* (c.1556), he also perjured himself to send that Lord Chancellor to his death. Set within the monument are several carved and engraved panels including figures of the virtues and a scene of Lord Rich's funeral. Above it is a trumpeting figure of fame. Curiously, the monument was created nearly sixty years after his death. In his 1568 will, Lord Rich left the manner of his burial at Felsted to his executors. That no memorial had been raised by 1581, however, is shown by his son's will, which requested 'a cumelye and decente tombe according to oure degrees and states' be set up 'for my ffather and mee'. Yet it was not until the death of his son in 1617 that a memorial was built. He charged his executor to erect a tomb for his grandfather, father, brother and himself. No reference to the latter two actually appears, however; possibly the tomb was left incomplete without inscriptions.

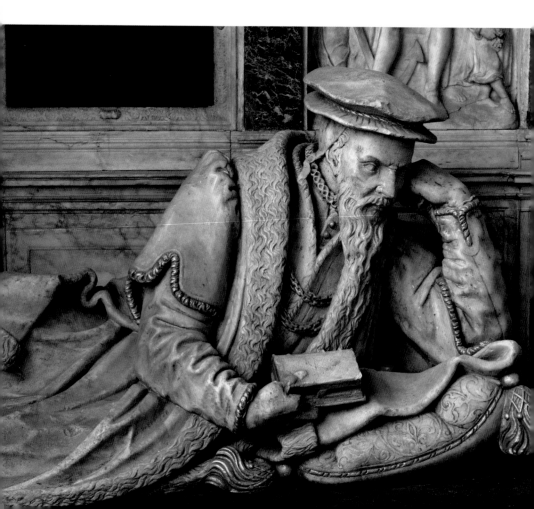

75 A royal welcome
The Church of St Nicholas, Kenilworth, Warwickshire

The west door at Kenilworth looks like a splendid piece of mid-twelfth-century Romanesque architecture. But it is, in fact, a 1570s assemblage of medieval architectural fragments erected to welcome no less a figure than Queen Elizabeth I to Divine Service in the church. The sculptural elements incorporated within the door and its surrounds were almost certainly looted from the ruins of the abbey that once stood immediately beside the church. For from 1570 the Queen's favourite, Robert Dudley, Earl of Leicester, was engaged in preparing Kenilworth for a series of royal visits. A particularly distinctive feature of the door – and difficult to parallel in twelfth-century design – is the way it sits within a rectangular frame. The detail is found, however, in Dudley's works to the castle. It's possible that the reuse of monastic fragments in parish churches was a relatively widespread phenomenon, though, for obvious reasons, it's usually hard to verify. Another remarkable surviving memorial of the Reformation preserved at Kenilworth is a sixteenth-century ingot made from lead that was stripped from the abbey during its demolition. The weight and value of the ingot are punched into its surface. It was overlooked during the clearance of the site and rediscovered when the abbey ruins were excavated in the nineteenth century.

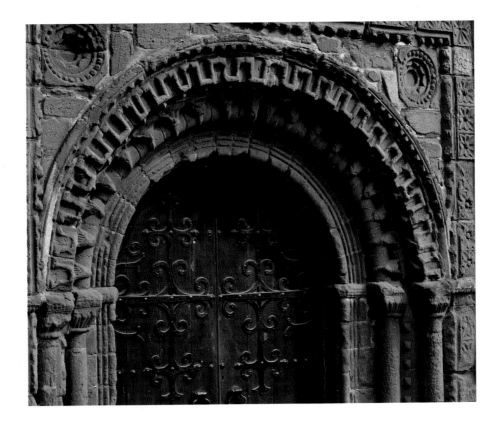

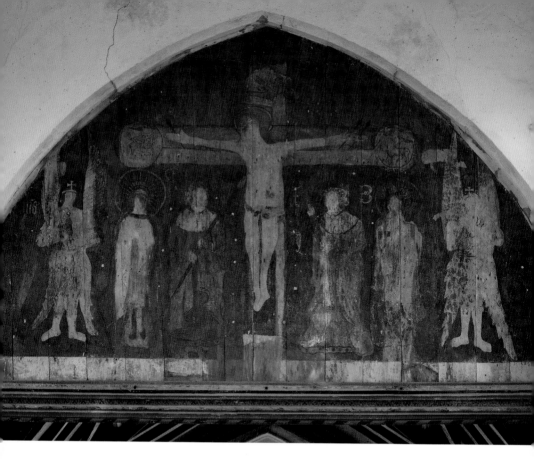

76 Reformation rood
The Church of St Catherine, Ludham, Norfolk

Set in the chancel arch at Ludham is this painting executed on boards. It is a unique surviving example of a mid-sixteenth-century rood, a large-scale scene of the Crucifixion with Christ flanked by the figures of his mother and St John. In this case, the familiar rood composition is augmented by a pair of angels dressed in costumes of feathers and, immediately flanking Christ, two richly dressed figures – presumably legionaries – one of whom pierces Christ's side with a spear. Across the background are letters and devotional monograms and the Beasts of the Evangelists are depicted on the arms of the cross.

Roods set on a beam above the screen that divided the chancel from the nave were once a universal church fitting, yet their figures were usually carved. This fact and the relative crudity of the painting when compared to that on both the supporting beam and 1493 screen below suggest that this example was a makeshift creation. It was probably erected during the Marian restoration of Catholicism because the original rood had been destroyed in the 1540s. The rood was later dismantled and an Elizabethan canvas of the royal arms was erected in its place. However, its constituent boards were discovered in a stair and re-erected in 1890. The royal arms are now displayed on the reverse.

77 Death's inevitable dart
The Church of St Mary the Virgin, Saffron Walden, Essex

This magnificent armorial presides over a tomb of black touchstone in the south chapel of Saffron Walden church. Its verse epitaph begins: 'The stroke of Deathes inevitabl dart/hath now alas of lyfe beraft the hart/Of Syr Thomas Audeley of the Garter Knight/ Late Chancellour of Englond under owr prince of Might/Henry the eight worthy high renown/ and made by him Lord Audeley of thys toun …' Armed with a pliant conscience and astute judgement, and unswerving in his submission to the royal will, Lord Audley rose from humble beginnings to great power. He died in 1544. The tomb was once surrounded by an iron railing and stands on the former site of the chapel altar. Some Protestant reformers placed their tombs provocatively on altar sites in this way to signal the permanent overthrow of the Mass; Lord Audley's sympathies are uncertain. One Cornelius Harman is asserted by several authorities to have made the tomb. If this attribution is correct, he is possibly one and the same man from the Holy Roman Empire who received letters of denization in 1539–41. Foreign craftsmen were increasingly dominating all areas of luxury production in this period. The carving is highly accomplished, though the surface of the stone has suffered from fragmentation.

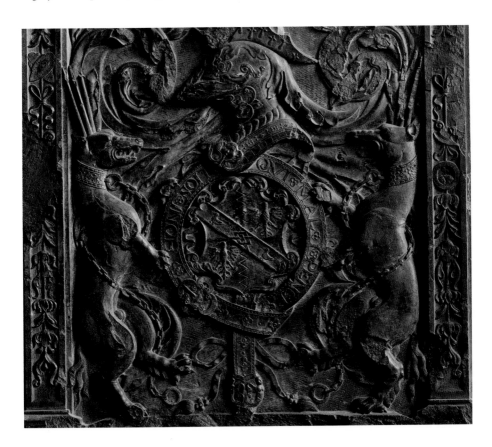

78 From shrine to sepulchre
The Church of St Michael, Stanton Harcourt, Oxfordshire

Just to the north side of the altar at Stanton Harcourt is this remarkable stone canopy.
It's an extremely rare survival of a medieval shrine, part of a fourteenth-century
structure that formerly housed the relics of St Eadburgh – or Edburg or Edburga
– abbess of Aylesbury (or possibly Adderbury), who died in 650. Her reliquary
presumably stood on top of the canopy. The shrine is thought to have been brought here
in the 1530s from its original home in the Augustinian priory at Bicester. It served at
Stanton Harcourt as an Easter sepulchre in which Christ – in the form of a consecrated
host – could be physically entombed and resurrected during the Easter liturgy. The
canopy is raised on a sixteenth-century base. Like all grand medieval furnishings,
it's conceived as a miniature work of architecture. Several Purbeck marble columns
support richly decorated arches and an internal vault. At the corners of the canopy are
full-length figures and around the top is a frieze of male and female heads, perhaps
representing petitioners to the saint. The display of heraldry helps date the monument
to before 1312. Preserved on the stonework are extensive traces of medieval paint.
Other fragments of the shrine survive elsewhere in the church.

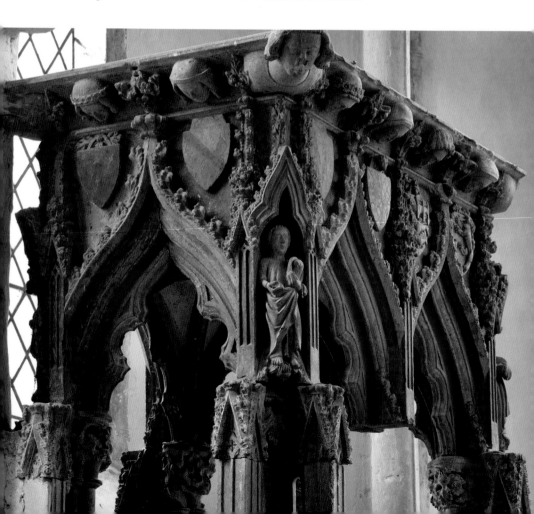

79 In time of peril
The Church of St Margaret, Tivetshall St Margaret, Norfolk

Before the Reformation, a crucifixion or rood always stood over the screen that divided the church nave from the chancel. Indeed, old parishioners at Tivetshall must have remembered such an arrangement when this huge painted board was raised above the former rood screen. It displays Elizabeth I's arms encircled by the Order of the Garter. The arms are surmounted by a crowned helm and supported by a lion and dragon. At the feet of the supporters is an inscription that reads 'O God Save oure Quene Elizabeth' and, beneath this, is a passage from Romans: 'Let every soule submit hym selfe unto the auctorite of the hyer powers/For there is no power but of God/The powers that be are ordered of God' and the date '1587'. It cannot be a coincidence that this enormous exhortation to dutiful loyalty was erected during the national crisis that preceded the Spanish Armada. God himself is decidedly subsidiary to the Queen: a star labelled 'Deus' and two monograms of the name of Jesus are squeezed in at the very apex of the composition. Across the bottom of the board is the text of the Ten Commandments and awkwardly divided to either side of them the note 'Rychard Russel Ieffrye Neve and Ihon Freeman in there tyme they caused this for to be done'.

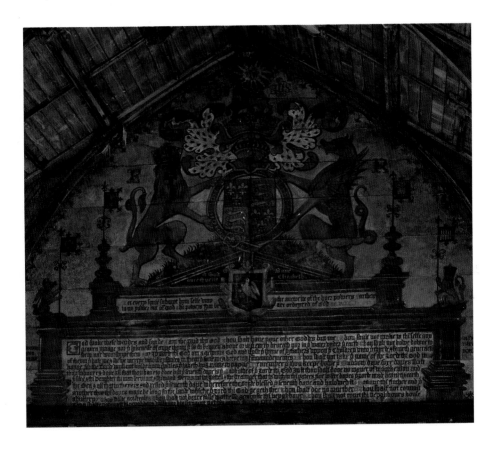

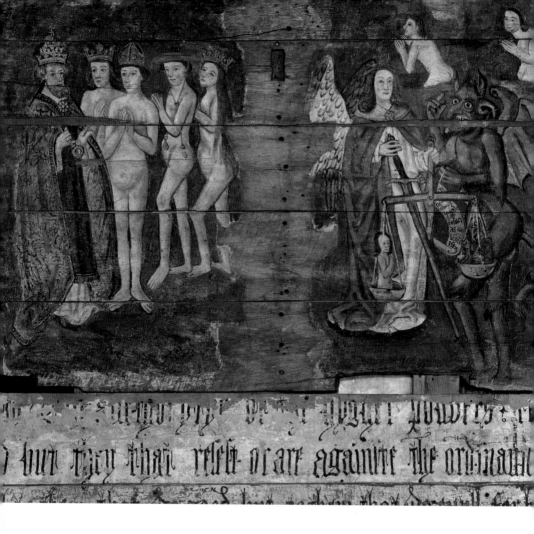

80 A lucky shower
The Church of St Peter, Wenhaston, Suffolk

This is a detail of the Last Judgement scene or Doom that formed part of the rood screen at Wenhaston. The sculpted cross – or rood, from which the screen took its name – and its flanking figures were nailed to this panel and their ghosted outlines are still clearly legible. Shown here is the figure of St Michael weighing souls to the right of the cross. Beside him stands the Devil with a list of bad deeds that are represented in the scales by demons. To the left, St Peter, wearing a papal tiara, welcomes the blessed into Heaven. There is a colourful counterpart scene showing the maw of Hell. Above the arms of the cross is the figure of Christ seated upon a rainbow in judgement, with Our Lady and John the Baptist kneeling before him. The panel was discovered accidentally in 1892 when a whitewashed partition in the church was stripped out. A shower of rain washed clean the discarded boards to reveal the painting. As reassembled, the panel incorporates two boards painted with sixteenth-century texts in English. These relate to a display of the royal arms that was erected in place of the rood after the Reformation.

81 English classicism
The Church of All Saints, Wing, Buckinghamshire

This is the late sixteenth-century tomb of Sir Robert Dormer, which stands in one of the greatest surviving Anglo-Saxon churches in England. The tomb is an imposing structure executed in a strikingly idiomatic Classical style. It comprises a canopy supported on four fluted Corinthian columns. Beneath this is a tomb chest decorated with the skulls of oxen – termed bucrania – linked by swags of fruit. Carved on the panel beneath the central bucranium is the date 1552. In fact, the monument was almost certainly erected slightly later by Sir Richard's son, William. He was related by marriage to the powerful Dudley family and the connection may suggest a provenance for this highly unusual tomb. John Dudley, Duke of Northumberland, sent one John Shute to Italy in 1550 to study architecture. On his return Shute published the first English treatise in his field *The First and Chief Groundes of Architecture*, in which he refers to his study of ancient monuments. The tomb canopy at Wing is of relatively conventional design, but the detailing of the tomb chest implies a personal knowledge of Roman sarcophagi and altars. In short, given the Dudley connection, Shute is a plausible designer for the monument. If so, the inset brasses behind the monument are later additions to it.

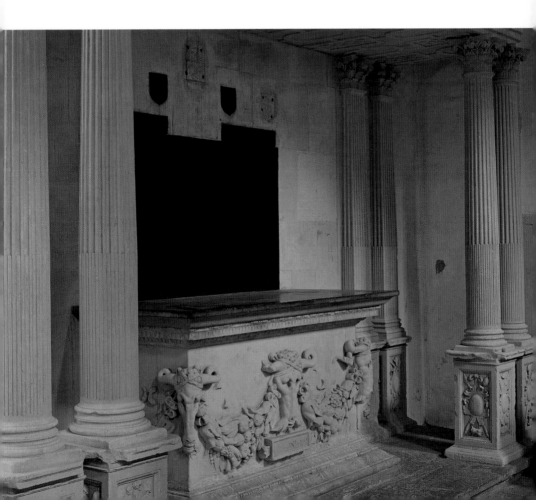

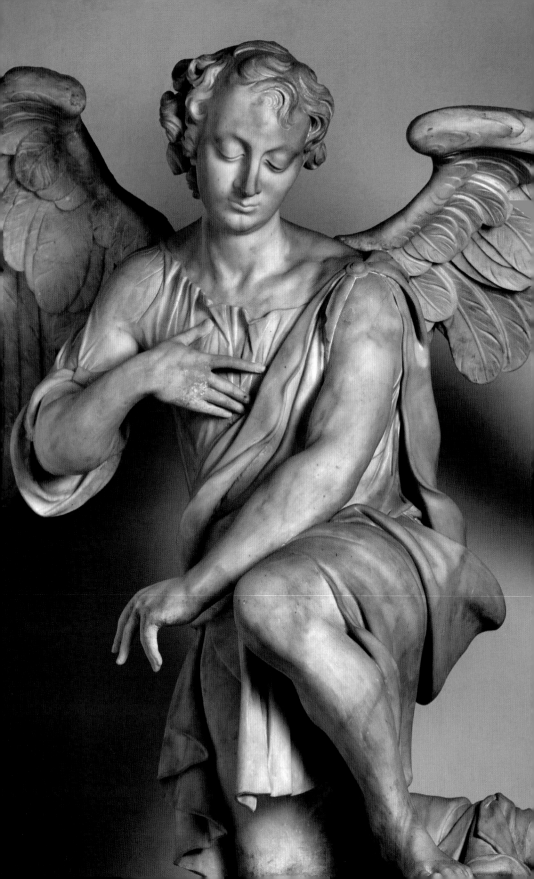

6 Protestant England, 1603–1699

The English Reformation was to have one final violent paroxysm in the civil wars of the 1640s. Yet central to understanding the next wave of religious controversy, as well as the settlement that succeeded it, is the character and rhythm of mainstream Protestant worship in parish churches during the early seventeenth century. For in the last quarter of the sixteenth century, the 1559 Book of Common Prayer did clearly begin to assume normality by virtue of its sustained use. In the process it also began to attract loyalty and affection. Yet its rubrics on some points remained very far from clear. This ambiguity was both deliberate and pragmatic and it lent the Elizabethan settlement resilience. Events of the 1630s and 1640s would prove, however, that the breadth of practice it permitted could be deeply divisive, too, even catastrophic.

As the Catholic liturgy faded out of living memory so, too, did the fragmented and richly decorated parish church that had housed it. The prayer book names just two internal areas in a church: the nave and chancel. Almost incredibly, it makes no explicit reference to the use of either space, nor the location of any essential fitting or furnishing within them. As we have already seen, however, it was an established principle that a screen should divide the nave and chancel and that an image of the royal arms – an expression of the sovereign's authority since the Reformation as 'Supreme Governor' of the church – should hang above this. Also, that the communion table should be stored on the site of the former altar within the chancel, from where it was to be moved to a prominent place for use.

From this starting point it is worth turning to the canons of the general synod convened by James I in London

One of the 1685 angels at Burnham-on-Sea, Somerset

following his accession to the throne and promulgated in 1604 to help flesh out a handful of further details. Canon LXXXII, for example, directs that the Ten Commandments be set up on a board above the stored table 'where the people may best see and read the same, and other chosen Sentences written upon the Walls of the said Churches and Chapels in places convenient'.

Further fittings were few and simple. Again, according to Canon LXXX, there needed to be a prayer book, bible and authorized set of sermons in every church. There was also to be a stone font set in its 'ancient' place (at the west end of the nave near the entrance) (LXXXI), a 'convenient' seat for the minister to read the service (LXXXII), a pulpit (LXIII) and 'a strong Chest ... having three Keys; of which one shall remain in the custody of the Parson, Vicar, or Curate, and the other two in the custody of the Church-Wardens for the time being: which Chest they shall set and fasten in the most convenient place, to the intent the Parishioners may put into it their Alms for their Poor Neighbours' (LXXXIV). There is besides in Canon LXXXVIII an impressive list of prohibited activities, which serve as a reminder of the degree to which the usage of churches had changed since the late Middle Ages: 'no Plays, Feasts, Banquets, Suppers, Church-Ales, Drinkings, Temporal Courts, or Leets, Lay-Juries, Musters, or any other profane Usage to be kept in the Church, Chapel or Church-yard, neither the Bells to be rung superstitiously'.

Parishioners were increasingly accommodated in seats when attending the regular round of church services. These were commonly arranged as a combination of benches – either with doors (to keep out draughts) or without – and large enclosed box pews. Pews built by local gentry were often prominently placed in the church and in some cases were also located in relation to family tombs. It was, therefore, in the company of ancestors that the living landowner appeared before his community. Seating throughout the church was segregated with men, women and sometimes children grouped in discrete areas. This arrangement now had clear social significance, as the specific experience of one church may illustrate.

On 10 August 1634, the entire congregation of Puddletown, Dorset, remained seated in their pews after evening service to hear the churchwardens propose the complete reorganization of seating in the church. Within a year the work was completed but the new arrangements caused dissent and in 1637 the churchwardens drew up a document to clarify the seating arrangements. These made it explicit that everyone had to pay for their seats in church and also that none could lease their seat. It also created a four-part division of the church based on sex and social position. Most of the pews still survive replete with the pegs for hats in the men's pews.

The two manorial lords and their wives sat closest to the pulpit with their maids and children, each in their own block of seating; behind them sat their tenants, again with men and women apart; and cottagers likewise in the gallery. Those too poor to pay for seats had to stand in the tower. Quite apart from the fact that this can hardly have offered much sight of the service, such a small space

simply cannot have been adequate for the numbers of poor in the parish. It's little more than educated guesswork but the whole population of the parish was probably around 580, and the estimates for the seating speak of about 240 people paying five shillings for their places. That would leave about 340 people standing in the tower. Did they all come to church given the social, judicial and economic pressures that could be exerted on them? And if they did, how on earth did they fit in?

The prayer book gives little indication of the behaviour of the congregation beyond occasional directions to stand or kneel. The implication is that these differentiated important moments of the service, for which the default position was sitting. Of their demeanour, however, Canon XVIII of 1604 is clearer: 'No Man shall cover his Head in the Church or Chapel in the time of Divine Service … All manner of Persons then present, shall reverently kneel… [and stand] according to the Rules in that behalf prescribed in the Book of Common Prayer: And likewise when in time of Divine Service the Lord Jesus shall be mentioned, due and lowly Reverence shall be done by all Persons present, as it hath been accustomed; testifying by these outward Ceremonies and Gestures, their inward Humility, Christian Resolution, and due Acknowledgment that the Lord Jesus Christ, the true and eternal Son of God, is the only Saviour of the World, in whom alone all the Mercies, Graces, and Promises of God to Mankind, for this Life and the Life to come, are fully and wholly comprised.' It goes on to say that everyone should be 'in quiet Attendance to hear, mark, and understand that which is read, preached, or ministered; saying in

their due places audibly with the Minister, the Confession, the Lord's Prayer and the Creed; and making such other Answers to the publick'.

Such engagement was made possible through education. As Canon LIX continues: 'Every Parson, Vicar or Curate, upon every Sunday and Holy-day before Evening Prayer, shall for half an hour or more, examine and instruct the Youth, and ignorant Persons of his Parish, in the Ten Commandments, the Articles of the Belief, and in the Lord's Prayer: and shall diligently hear, instruct, and teach them the Catechism set forth in the Book of Common Prayer. And all Fathers, Mothers, Masters and Mistresses, shall cause their Children, Servants and Apprentices, which have not learned the Catechism, to come to the Church at the time appointed, obediently to hear, and to be ordered by the Minister, until they have learned the same.'

The presence of the congregation was policed by the lay officials of the parish. As Canon XC of 1604 explains, the annually elected churchwardens of the parish (also called questmen) and two or three or more 'Side-Men or Assistants ... shall diligently see, that all the Parishioners duly resort to their Church upon all Sundays and Holy-days, and there continue the whole Time of Divine Service: and none to walk, or to stand idle or talking in the Church, or in the Church-yard, or the Church-porch during that Time'. Those who did absent themselves were to have their names read out every six months 'as well in the Parish Church as in the Cathedral Church of the Diocese in which they remain, by the Minister openly in Time of Divine Service upon some Sunday, denounced and declared Excommunicate, that others

may be thereby both admonished to refrain [from] their Company and Society [LXV]'.

Churchwardens might also refer malefactors in their parish to the church courts and the punishments they handed down included public penances. In June 1631, for example, the Dean of Salisbury wrote this unpunctuated direction to the curate of Charminster, Dorset: 'Ursula Greene of your parish is enjoined on Sunday next to come to your parish church porch at the second peal to morning prayer with a white sheet loose about her, her face uncovered and a white rod in her hand of an ell long where she shall stand until you begin service at which time your parish clerk shall lead the said penitent by the hand and place her in the middle alley of the church or against the pulpit where she shall stand until the second lesson be ended.' Then she had to make a public confession 'of the wicked and detestable offence of fornication with Christopher Harbyn', repent of the act, to beg forgiveness and to promise not to repeat it.

As this description makes clear, the minister of the parish had an assistant in the person of the clerk. Canon XCI of 1604 again gives a useful summary of his credentials for office: 'the said Clerk shall be of Twenty Years of Age at the least, and known to the said Parson, Vicar, or Minister, to be of honest Conversation, and sufficient for his Reading, Writing, and also for his competent Skill in Singing (if it may be)'. As this last direction implies, there was considerable scope for singing in Divine Service. In parishes this was generally very simple and limited largely to the Psalms. Settings initially took the form of harmonized

chants based on medieval plainsong that were sung in alternate sections across the church. A metrical version of the Psalms by Thomas Sternhold and John Hopkins first printed in 1562 enjoyed considerable popularity and was commonly bound into the prayer book.

On Sundays and Holy Days the prayer book stipulated the performance of four ceremonies: Morning and Evening Prayer, the Litany and the Communion Service. Morning and Evening Prayer comprised prayers, readings and psalms and were to be conducted by the minister 'from the accustomed place of the churche, chapel or chauncell'. He delivered these from the so-called reading desk, which by this date usually stood in the nave against the chancel screen. The Litany was a series of supplicatory prayers read by the minister with responses by the congregation. It was to be read on Sunday morning and additionally to be said on Wednesdays and Fridays. There is no specified place in the church for reciting the Litany in the prayer book but Canon XV of 1604 directs that the service be held 'in some convenient Place, according to the Discretion of the Bishop of the Diocess, or Ecclesiastical Ordinary of the Place'. Warning of the service was to be given by the tolling of a bell and instruction was given that 'every Housholder dwelling within half a Mile of the Church, to come or send one at least of his Household fit to joyn with the Minister in Prayers'.

Communion was a variable service depending upon – confusingly – whether there was Communion or not. The prayer book states that those who wished to partake of it were meant to give advance notice of the fact. Celebration of the

Eucharist only took place, however, if '… there be a good number to communicate with the priest … And if there be not above twenty persons in the parish of discretion to receive the Communion, yet there shal be no communion excepte four or thre at the least communicate with the priest.' It also imposed an obligation to communicate at least three times a year, one of those occasions being Easter.

Yet the Catholic practice of taking Communion only once a year at Easter evidently died hard. The canons of 1604 make complaint of the reluctance to take Communion and even in London parishes during the early seventeenth century monthly celebrations only gradually became normal. In rural parishes Communion, therefore, was presumably a rarity. Two things followed from this. First, that the communion service was usually celebrated in a truncated form – as the prayer book directs – without Communion (the so-called ante-communion). On these occasions its principal elements were a recitation of the Commandments, the Creed, a reading, a gospel and a sermon followed by an optional exhortation to almsgiving. There were also so-called 'altar' or 'table prayers', as we shall see an important point of friction. Second, that by default the principal Sunday service became Morning Prayer.

When there was a body of communicants, however, the intention was to gather them round the communion table in re-enactment of the Last Supper, with the minister taking the part of Christ. The bread was to be 'suche as is usual to be eaten at the table' and the intimacy placed effective limits on the numbers who could communicate in any one week. Before

Easter larger parishes might break up the congregation into groups, each one attending on a different Sunday in the run-up to the feast.

As befits such a solemn occasion, however, the communicants were expected to prepare seriously for the occasion and the prayer book gives instructions about the reconciliation of neighbours. Communion was to be distributed in both kinds, that is to say with everyone receiving both bread and wine. It was to be received kneeling with the bread placed in the hands to emphasize that it was not sacred. Some church accounts show that different grades of wine were sometimes purchased for Communion. This was presumably an arrangement that permitted people to be provided with wine according to their degree. That said, it's hard to imagine how this worked in practice.

The prayer book states that the minister should begin the celebration on the north side of the table, which suggests its lengthwise arrangement in the building (though this was not to last, as we shall see). Crucially, however, the prayer book is not explicit about the location of the communion table for these services. It could 'stand in the body of the churche, or in the chauncel, where morning and evenyng prayour be appointed to be sayd'. Canon LXXXII of 1604 does nothing to clarify this point, merely stating that the tables should be kept in repair and 'covered in time of Divine Service with a Carpet of Silk or other decent Stuff … and with a fair Linen Cloth at the Time of the Ministration, as becometh that Table, and so stand, saving when the said holy Communion is to be Administered. At which Time the same shall be placed in so

good sort within the Church or Chancel, as thereby the Minister may be more conveniently heard of the Communicants in his Prayer and Administration, and the Communicants also more conveniently and in more number may communicate with the said Minister.'

If all this seems slightly confusing, that is as it should be. By the early seventeenth century it's clear that there had come to exist an enormous variety of practices both regarding the timing of the four principal services – in particular experimental attempts to link some of them together for convenience – and the way in which they were celebrated within particular churches. At the root of this diversity lay the inherent tensions between Protestants of different temper as well as the rubrics of the prayer book that strove to reconcile them into a common church. The former point deserves particular emphasis. Catholicism remained a force in seventeenth-century English life but it was set apart from the internal controversies that wracked the established church. These were waged instead by committed Protestants who were united in their horror of 'popery'. Most accepted the authority of the prayer book but then interpreted its rubrics to create starkly contrasting extremes of practice.

One congregation of puritan persuasion, for example, might witness all its liturgy in the body of the church. In such a case, the minister would occupy a prayer desk just in front of the chancel screen for Morning and Evening Prayers. He would then also read the first half of the communion service from the same place before moving to the pulpit for the sermon. Then, if Communion was to be celebrated the table could be brought out in front of the chancel screen for use. But the rubrics also sanctioned a radically different practice of the liturgy in which Morning and Evening Prayers were read by the minister from a seat in the chancel beyond the screen, with only the sermon being delivered from the pulpit in the nave. By extension, the table also remained in this part of the church for Communion. In this case, the body of communicants passed into the chancel beyond the sight of their brethren for the re-enactment of the Last Supper. Apologists for this system insisted that it was acceptable because the chancel screen did not separate the laity from the clergy – as it did in Catholic churches – only the communicants from the non-communicants.

Upon this potential difference others were founded. One contentious and related debate, for example, concerned vestments. Those of puritan temper deeply disapproved of what they regarded as clothing that implied a priestly body. But the 1559 prayer book not only authorized the wearing of certain vestments but cleverly fudged the issue by stating that the minister 'shall use such ornamentes in the church as wer in use by the auctoritie of parliament in the second yere of the reygne of King Edward VI'. To put it mildly, 1548–9 – one of the pivotal years of the Reformation in England – is not a moment at which to look for clear direction in the statute book about vestments. Even more celebrated than this so-called Vestinarian Controversy was another incendiary debate about the treatment of the communion table. This involved the figure of William Laud, consecutively Bishop of London and Archbishop of Canterbury.

For Laud and his followers the existing arrangement of the communion table was unsatisfactory on a number of levels. Part of the problem was the table itself: a moveable and unprotected piece of furniture, it was vulnerable to misuse by having inappropriate things placed upon it. This seemed to violate its sacred purpose. But there was a perceived problem, too, in having the table set amidst the congregation for Communion. People pressed upon it and made the distribution of Communion unseemly. There were concerns, too, that high-backed pews obscured the celebration of the Eucharist and also that the irreverent could receive Communion without kneeling. What Laud wanted was an arrangement of the table that underlined its special significance and protected it from abuse.

The answer he arrived at was to place the table permanently against the east wall of the chancel and enclose it with a rail that extended the full width of the interior. This rail protected the altar when it was not in use and served for the congregation as a rest to kneel against during Communion. In August 1633 Laud became Archbishop of Canterbury and used his position to impose this solution nationally. He received a judgement from the Privy Council granting power over the position of the altar to the bishop of each diocese or his deputy, the archdeacon. Then he privately gave instruction that during the course of a general visitation in 1634 all churchwardens should be ordered to 'place the communion table under the eastern wall of the chancel, where formerly the altar stood; to set a decent rail before it to avoid profaneness; and at the rail the communicants to receive the blessed sacrament'.

The creation of enclosed communion tables generated intense controversy. To critics it seemed wrong to set up what were, in their eyes, new altars in the position of their destroyed Catholic predecessors. Quite as problematic was the fact that within the constraints of many parish churches, an altar against the east wall of the chancel was almost invisible to the congregation at large. For those unused to this removal during the Communion this was reprehensible. As an added annoyance, some ministers also began to insist that the altar prayers of the truncated communion service (the ante-communion) should be recited from the

The church of St Mary le Bow was one of the most important parishes in the city, standing on its main thoroughfare. Prior to the completion of St Paul's its 1670s spire was the highest point in London. The ecclesiastical Court of Arches originally sat in the church's vaulted crypt.

table. To those convinced of the overriding importance of clear and open prayer, these distant mutterings felt like an offence.

This debate over the placement and railing of altars, however, was reflective of a sea change that was taking place within the religious consensus of the established church. This equated inner devotion with outer reverence and placed great emphasis on the importance of Communion. Accompanying this from about 1620 there is apparent for the first time since the Reformation a widespread interest in improving the fabric and furnishings of parish churches to dignify the ceremonies of the prayer book. Ambitious church repairs, new font covers, pulpits, pews, reading desks, screens and stained glass began to appear in churches across the kingdom. The scale of this rebuilding is extraordinary and highlights the relative paucity of surviving Elizabethan furnishings. Many of the outstanding figures involved in this process were in the circle of Laud or shared his sympathies, yet this is by no means true of all. It speaks of the first maturity of Protestant worship in England. Over the same period, the design of funerary monuments underwent an important change. The most expensive continued to be conceived as grand architectural compositions in coloured marble. But besides the effigies of the deceased it became acceptable again for tombs to incorporate imagery. Particularly popular were the personifications of virtue, time and fame. But this period of creative investment was about to be violently interrupted.

The Long Parliament of 1640 expressed deep hostility to Laud's changes and accompanying riots witnessed the destruction of altar rails in some London churches. Meanwhile, 15,000 Londoners signed the Root and Branch Petition calling for the abolition of the episcopacy and condemning the prayer book as 'framed out of the Romish Breviary, Rituals and Mass-book'. From 1642 England was engulfed by civil war and Laud was led to his execution in 1645. The prayer book itself was declared illegal in the same year – as was the practice of taking godparents at baptism – and in October 1646 the episcopacy was abolished. In the ensuing chaos a fifth of all clergymen were dispossessed of their livings. Many fled abroad, where their Protestantism was tempered by experience of continental practice and exposure to Catholicism. Finally, in January 1649, the king himself, the Supreme Governor of the Church, was sent to the scaffold.

A system of Presbyterian church government was now established. The new regime disapproved of such ceremonial as kneeling during Communion, the use of the wedding ring and marking a baptized child with the sign of the cross (another long-standing bone of contention). Prayer was to be enthusiastic, i.e. extempore, rather than recited by rote, and all formal liturgical trappings were to be swept away. In the meantime, the medieval riches of England's parish churches were now subject to a second devastating attack. The scale of destruction is most famously documented in the journal of William Dowsing, who toured East Anglia destroying every vestige of superstition he could find. It's a fascinating and insufficiently acknowledged problem facing historians of the sixteenth-century Reformation that we will never really know what

survived the first iconoclasm only to be consumed by this second one.

Yet momentous as these events were, for the purposes of this narrative they represent a brief aberration. For following Charles II's return to England in May 1660 plans were set in train to restore the prayer book once more. The 1662 Book of Common Prayer was integral to the political process of the Restoration and constituted another piece of compromise. As its preface states, 'Our general aim … was not to gratify this or that party in any of their unreasonable demands; but to do that which to our best understandings we conceived might most tend to the preservation of Peace and Unity in the Church; the procuring of reverence, and exciting of Piety and Devotion in the publick worship of God.' Yet part of its authority rested in the way in which it resurrected its predecessor. For in strictly statistical terms this volume reproduced the 1559 prayer book less 4,500 original words but with the addition of 10,500 new ones. Issued with a new Act of Uniformity it constituted a new settlement based on the past and was accommodating towards those prepared to conform.

As the prayer book was reinvented so, too, in a physical sense were parish churches themselves. The destruction and neglect of the 1640s and 1650s demanded that these buildings undergo an architectural restoration. And the temper of the times determined that they be returned to their condition before the civil war. Not only were the faults of the 1630s Church now forgotten after the intervening years of chaos, but those in authority in the 1660s included many royalist gentry and clergy with a collective interest in

relegating their years of difficulty and exile to the past. In the absence of detailed documentation it's very difficult to judge the scale of such repairs, yet anecdotal evidence – for example, the large numbers of furnishings across the country that bear a 1660s date – suggests that they were widespread. In many places, too, Laudian altar arrangements with rails were restored, though this depended on local circumstances and religious sympathies. Elsewhere, the table set lengthwise in the chancel for Communion continued to serve.

The Restoration, then, did not bring about a revolution in the appearance of parish churches. Yet in returning these buildings to their former use and condition it did something that was

In 1694 a great fire consumed the town and much of the church at Warwick. The latter was splendidly rebuilt in a classicised Gothic style to designs by Sir William Wilson. The idiom owes much to 17th-century French architecture and is a reminder of how natural and admired Gothic design remained.

no less significant. It cast as normality the form and liturgy celebrated in these buildings during the 1630s. In connection with this it also reasserted the integral connections between the Church and state; public conformity remained an expression of loyalty to the Crown. Something of the strength of this association and the resilience of the established church in the late seventeenth century is reflected in the overthrow of James II's Catholic rule in 1688. In demotic mode at least, England's seventeenth-century God was patriotic and Protestant.

Yet in the consolidation of its inheritance, the established church also acquired a new foundation. Upon this it successfully developed from the 1670s a fresh character that was fuelled by confidence and Britain's growing maritime wealth. Something of this change of temper is apparent in the elaborate Baroque monuments commissioned in this period. The dead begin to appear represented not as knights in armour or ladies in contemporary dress, but as Romans, dressed as generals or in senatorial costume. The British were now involved in yet another reinvention of the Classical past to serve as a foil for their identity. In the process the tradition of English parish church architecture was to change abruptly. Church building had always been closely allied to the mainstream of secular architecture, yet in this period it ceased merely to mark time with it. Following the Fire of London in 1666 one of the wealthiest and most populous cities in the world needed to rebuild its parish churches and cathedral. Money for the work not only came from private funds but from the Crown, which also supplied craftsmen and oversight,

turning the whole project into a state endeavour.

Eighty-six churches were destroyed or gutted by the blaze and the work of reconstructing them properly got under way from 1670. Of the 51 churches that were proposed to replace them, many inherited the plot and foundations of their medieval predecessors. These plots were generally distorted rectangles, the previous buildings having developed multiple aisles. This allowed for their reconstruction as single-volume interiors. As will be discussed in the next chapter, some internal features of these buildings were a novelty, drawing on earlier architectural experiments in church design and continental example. In other respects they were relatively conservative, notably in their universal arrangement of the altar at the east of the building behind a rail.

Where these buildings did differ most strikingly from their predecessors, however, was in their Classical architectural idiom. Indeed, given their prominence within the capital, they effectively established the tradition for grand Classical church design in England. Through the figure of Sir Christopher Wren, who underpinned this rebuilding enterprise, besides the many other draftsmen, assistants and craftsmen integral to its prosecution, this was communicated into the eighteenth century. Henceforth, there came into existence through the restoration of London a distinctive Anglican Protestant architectural tradition that developed in counterpoint to that of its inherited medieval churches. The story of the evolution of the two traditions and the relationship between them will be properly discussed in the next chapter.

82 Inciting to virtue
The Church of St Leonard, Apethorpe, Northamptonshire

In 1621, a new chapel was added to the church at Apethorpe. Its centrepiece is this tomb to the courtier and ambassador Sir Anthony Mildmay and his wife, Grace. It is created of black and white marble and has been attributed to the sculptor Maximilian Colt. Certainly, the swept-back curtains and naturalism of the figures speak of the monument's exceptional quality. As an inscription explains, it was completed by the Mildmays' daughter and son-in-law to their memory and 'to excite [the viewer] to the example of their virtues'. And virtue is certainly writ large here. Supporting the canopy over the recumbent effigies are figures representing the four Cardinal Virtues: Prudence, Justice, Temperance and Fortitude. Charity crowns the entire monument, flanked by the figures of Hope and Faith, the three Theological Virtues of the Christian.

In a band around the monument are inscribed the words: devoute, chaste, charitable, just, valiant, wise. The chapel architecture incorporates further panels painted with biblical quotations and stained glass of 1621 in the east window depicts the Garden of Eden, the Crucifixion, the Harrowing of Hell, the Last Judgement and the Apocalypse. A silk tabard painted with heraldry associated with the tomb also hangs in the church.

83 Reaping in joy
The Church of St Mary the Virgin, Astley, Warwickshire

This is a detail of the choir stalls dating to around 1400 that survive at Astley. In their
original form their canopies were decorated with a series of paired figures of apostles
and prophets. Each of the apostles held a scroll inscribed with the sentence from the
Creed that they were respectively credited with having composed. And the counterpart
prophet held a related biblical quotation. Along the cornice of the canopy was painted
a vine. During the late Middle Ages the stalls stood in a grand cruciform church with a
landmark spire popularly known as 'the Lanthorn of Arden'. This building was badly
damaged following the Reformation but it was repaired in the early seventeenth century.
Its nave and transepts were demolished, a new tower begun and in 1608 a medieval
chapel was rebuilt as the chancel. These stalls appear to have been reconfigured in their
present position at this time. Remarkably, the imagery on them was also retouched
and the Latin texts over-painted with quotations from the Psalms and New Testament
in English. They constitute a fascinating instance of the careful preservation and
adaptation of medieval fittings in the seventeenth century. The scroll visible on the far
right ends the series with the optimistic statement: 'They that sowe in tears, shall reape
in ioy. ANo DMI 1624'.

84 Brothers in life and death
The Church of St Peter, Babraham, Cambridgeshire

The inscription on this remarkable marble monument states: 'Here Lie Buried Richard, and Thomas Benet; two Brothers, Both of them Baronetts: They lived together, and were brought up together, at Schoole, at the University, and at Inns of Court. They Married two Sisters, the Daughters, and Heires, of Levinus Munck esqr'. The respective dates of death are also given, as 1658 and 1667. Both men are dressed in shrouds, which suggests that they are being shown at the general resurrection. Although the inscription emphasizes their common experiences, the gestures of the figures imply an intriguing inequality of relationship: one bows to the other, who seems absorbed by a celestial vision. The elongation of the figures, a mannerism brilliantly handled by the unknown sculptor, exaggerates the poses. The viewer feels ignored in their exchange. Perhaps the younger brother, Thomas, should be understood as deferring to his elder, Richard, in death as in life. Curiously, neither man commissioned the monument. In his will Thomas simply requested to be 'buried privately by my brother' and regrets that 'I lived in hard and troublesome tymes'. It also appoints his son as sole executor. Named after his Ghent-born and fiercely Protestant maternal grandfather, a Latin inscription on the central wreath tortuously attributes the monument to him: 'These effigies of brothers, Levinus, the heir of the piety of both has therefore erected'.

85 Drowned by grief
The Church of All Saints, Barnwell, Northamptonshire

When Henry Montagu drowned on
28 April 1625, at the age of three, his
bereft parents raised this monument to
their only son. It takes the form of an
obelisk set on a base with a full-length
portrait sculpture of the infant splendidly
attired in its centre. The whole structure
stands about 15ft high and is decked
with heraldry from top to bottom. A
knotted cord connects the two shields
above Henry's head as a symbol of his
parents' marriage and further knots
in the sculpture canopy underline his
unbreakable connection to them. Within
the canopy is a blazing sun inscribed with
the word 'Jehova', suggesting Henry's
place in Heaven. Other inscriptions on
the monument refer to water – by which
he drowned – as a means to salvation. In
his hand is a scroll with the words 'Lord
give me of y[ou]r water'. Forming the
plinth beneath the figure are a pot, water
and two disembodied feet. Cut on the
rim of the pot are the words: 'Poure on
me the ioyes of thy salvation'. And carved
on the feet are Peter's words when Christ
insists on washing the feet of the Apostles
before the Last Supper: 'Not my feet
only but also my hands and head'. On the
plinth, Henry is described as a 'wittie and
hopeful child tender and deare in þe sight
of his parents'.

86 Heaven on earth
The Church of St Mary the Virgin, Bromfield, Shropshire

In 1672, the present chancel of Bromfield was created from the architectural bones of
a former priory church crossing. Raised over its interior was this splendid angel ceiling
signed by Thomas Francis. The whole is a celestial vision, a point emphasized by a
painted inscription above the threshold: 'The Lord is in His holy Temple. The Lords seat
is in Heaven.' In the centre of the ceiling is a triangular emblem of the Trinity. Circled
in cloud, this represents the person of God. Its Latin inscriptions in gold are carefully
arranged to underline visually and through alternate readings the indivisible nature
of God as Father, Son and Holy Ghost. Around it swirl winged cherubs and figures of
angels carrying long banners. Three additionally blow trumpets. Each banner is painted
with a referenced quotation from the Psalms or the Old and New Testament. All are
celebratory or laudatory in tone. On the far eastern wall are two angels respectively
holding a sprig of foliage and a sword, presumably an emblem of hope and justice.
They support an open book inscribed with a passage from Psalm 85: 'Mercy and truth
are met together. Righteousness and Peace have Kissed each other'. The whole is an
outstanding and thoughtful work of folk art.

87 Nothing finer
The Church of St Andrew, Burnham-on-Sea, Somerset

This exquisite angel is one of a pair from a great Baroque altarpiece in white marble commissioned in 1685 by James II from the Rotterdam-born sculptor Grinling Gibbons and his Flemish partner Arnold Quellin. It was made under great pressure of time for a sumptuous new Catholic chapel in Whitehall Palace. By the terms of the contract 50 men were continuously to be at work on the project (and more if the project fell behind). The diarist John Evelyn was appalled but dazzled by the chapel in 1687: 'nothing can be finer than the magnificent Marble work and Architecture at the east end' with its painting of the Annunciation and statues of Sts John, Peter, Paul and the Church. Following James II's deposition the chapel languished and in 1695 the altarpiece was dismantled and sent to Hampton Court. But in 1706 it became the high altar of Westminster Abbey. By this time it had already been stripped of its overtly Catholic elements. This angel stood on the second of its three storeys. The altarpiece was 'temporarily' dismantled for the coronation of George IV. It was then given to Walter King, Bishop of Rochester, who erected some parts it at Burnham-on-Sea (where he held the benefice). The angels have recently been restored.

88 The ways of the Lord
The Church of St Cuthbert, Crayke, North Yorkshire

Crayke enjoys an impressive situation on a hill overlooking the Vale of York. The church stands towards the summit of this prominent natural feature in close proximity to the castle. Until the 1830s, the village and its surrounds were part of Co. Durham, having reputedly been granted to St Cuthbert in 685. Hence the dedication of the church and the existence in the village of a pub called the Durham Ox. Certainly, the body of St Cuthbert was brought here for a period in the ninth century by the monks of Lindisfarne. The late medieval nave of the church preserves an unusually fine collection of seventeenth-century fittings. Its serried ranks of tightly packed pews are ornamented with finials like upturned door handles. These include to the rear elevated seats, perhaps for the churchwardens or singers. Shown here is the opposite end of the interior with the pulpit and reading desk flanking the entrance to the chancel arch, used by the parson respectively for preaching and prayer. The soundboard over the pulpit is inscribed 'shew me thy waes o lord and teach me thy paths'. It's also inscribed with the date 1637. Dividing the chancel from the nave is a simple fifteenth-century screen restored as a memorial to the dead in the First World War.

89 The house of my Lord
The Church of St Peter, Croft-on-Tees, North Yorkshire

Family pews are a common enough survival in parish churches across Britain, yet few can match the brazen self-importance of that created in about 1680 by the Milbankes of Halnaby Hall at Croft-on-Tees. Supported on Tuscan columns and approached up a generous stair with barley-sugar balusters and gates, it towers over the church interior like a theatre box. The bold three-part composition of the pew front successfully obscures the complexities of accommodating it within the medieval fabric of the nave arcade. Historically, the seating within parish churches was strictly regulated and the position, scale and comfort of pews underlined the social order of the parish. Nobody, therefore, attending Divine Service at Croft could have been in any doubt of the local pre-eminence of the Milbankes. Railed off beneath and behind the pew, and carefully accommodated by it, is a family tomb probably erected for Mark Milbanke, who was created a baronet in 1661 and died in 1680. It was, therefore, in the company of their ancestors that the living members of the family presided in formidable grandeur over the regular liturgy of their church.

Lord Byron spent his honeymoon at Halnaby in 1815 and reputedly used this pew with his new wife.

90 King and bishop
The Church of St Mary the Virgin, Croscombe, Somerset

Dividing the late medieval interior of Croscombe is this spectacular array of Jacobean fittings. The richly carved screen rises almost to the roof and is crowned by ornamental strapwork, obelisks and the royal arms. Flanking its central door are reading desks facing towards the congregation. Beside the screen is a similarly lofty pulpit decorated with the arms of Arthur Lake, Bishop of Bath and Wells. Set over it is a figure of a pelican piercing its breast. The date 1616 carved on the pulpit probably dates the two furnishings with their complimentary celebration of royal and episcopal authority. This was the year of Lake's appointment as bishop. Lake was particularly celebrated for his sermons and was exceptionally active in his diocese, preaching during his conduct of three visitations. In the old style of dating, 1616 was also the year in which a certain William Rogers, an incumbent of Croscombe, was made a prebend of Wells. The principal patron of the furnishings, however, must have been the then lord of the manor, Hugh Fortescue. His arms and those of his wife, Mary Rolle, appear in the centre of the screen. Fortescue also commissioned a remarkable ancestral monument in 1638 at Weare Giffard church, Devon.

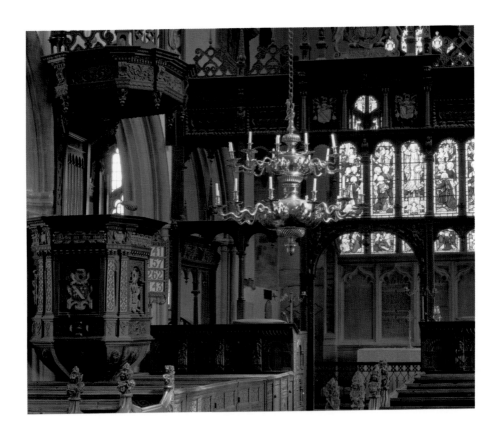

91 A widow's grief
The Church of St Mary, Elmley Castle, Worcestershire

Soon after the death of her husband, Sir Giles Savage, in 1632, Catherine Datson commissioned a striking funeral monument as an expression of her love and loss. It comprises three recumbent effigies in alabaster of herself, her husband and father-in-law. Kneeling at their feet are the diminutive figures of Catherine's four living sons, and across the widow's breast is Catherine's daughter, born, as an inscription explains, after the death of her husband.

Such is the position of the monument, tucked into the transept, that it is really this last image that dominates the visitor's view. The child is shown in swaddling bands, but with her arms free. One hand reaches towards her mother's formidably encased breast. Paired coats of arms charmingly linked by shaking hands above the tomb celebrate the dynastic alliances of the family. Catherine lived for a further 42 years and was buried at Great Malvern. This magnificent monument is one of about 60 attributed to Samuel Baldwin, a 'carver' who latterly worked at Gloucester. It was restored in 2010–11, at which time the burial vault was revealed immediately beneath its structure. The present gilding on the effigies dates from the 1960s.

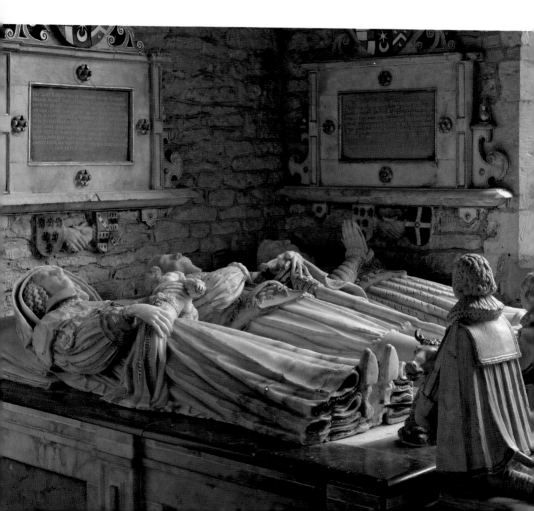

92 Black and white Baroque
The Church of St Peter and Paul, Exton, Rutland

This great monument threatens to burst the physical constraints of Exton church. It was carved as a memorial to Baptist Noel, 3rd Viscount Campden, who died on 29 October 1683, and his entire family. According to an inscription prominently placed in the central roundel it was 'punctually' erected on the order of his fourth wife, Elizabeth, by her third son and executor, John Noel, in 1686. Elizabeth consequently takes pride of place in the centre of the monument standing beside her husband to either side of a funerary urn. She and her three predecessors also appear in low-relief carvings standing among their children, all told an array of 23 men, women, children and babies. The obelisks and architectural frame of the monument speak the language of Antiquity and all the figures are shown in Roman dress. Sumptuously created from contrasting black and white marble, it was carved by the celebrated sculptor Grinling Gibbons. He was paid £1,000 for it, a small fortune. The representation of leaves, flowers and fabric illustrate the exacting and naturalistic effects for which Gibbons was so admired. Combined with the active postures of the figures, this treatment lends the whole a sense of febrile movement characteristic of the Baroque. The monument was restored in 2000–2.

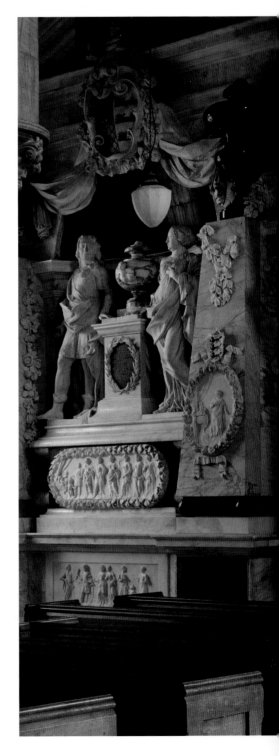

93 In defence of the King
The Church of St Chad, Farndon, Cheshire

This martial window was commissioned in about 1660 during the restoration
of Farndon church by William Barnston. The building had been garrisoned by
Parliamentarian troops in 1643–5 and was very badly damaged during local fighting. Its
imagery celebrates the siege of nearby Chester in which Barnston was involved. Around
the edges are depictions of single figures including pikemen, musketeers and musicians.
Across the top of the panel, however, are portraits of several leading Royalists involved
in the defence of the city including Barnston himself (*second figure from the right*).
These men wear the red uniform of a single regiment, rendered as brown, and their
status is indicated by the sashes they wear and, probably, also by the strips of braid
above the knee. In the central section of the window is Sir Francis Gamul, gesturing
with his commander's baton towards a scattering of military equipment. All the images
are ultimately copied from engravings. Fragments of similar windows are known in
domestic settings elsewhere in Cheshire. This may suggest that the theme was common.
The window has a complicated history. It was repaired by the Dean of Chester in 1808
(one blank quarry is inscribed as a repair of his), removed in 1869 at the behest of one
rector – who disapproved of its military character – and returned in 1894.

94 Timing the sermon
The Church of St Nicholas, Hurst, Berkshire

This is the frame for holding an hourglass, a once common fixture of church pulpits. It's made of wrought iron in the form of an oak branch with a delightful array of twigs, leaves and acorns. At the top of this stem are the lion and unicorn supporters of the royal arms and between them the date 1636. The letters EA beneath are presumably the initials of the donor, perhaps a churchwarden or vicar. Early twentieth-century photographs show the stand with an hourglass, and doubtless it survives somewhere in the building. Attached to the adjacent pillar is a separate strap of metal engraved with the inscription 'As this Glasse runneth. So Man's Life passethe'. This could be read as an encouragement to the preacher to speak briefly; to the congregation it feels more like a provocation. Hourglasses were commonly used to time sermons and images of them abound from the frontispiece of the Bishop's Bible (1569) – which shows Archbishop Parker preaching with one – to Hogarth's *Sleeping Congregation* (1736). Sermons have always varied very greatly in length from occasion to occasion and preacher to preacher. Indeed, some idea of this variety is suggested by published compilations of them. Surviving glasses likewise run for varied periods of up to an hour.

95 The eye of God
The Church of St Mary, Langley Marish, Slough, Buckinghamshire

Slough may have a popular reputation for ugliness, but nothing could puncture such preconceptions more completely than Langley Marish church. Opening off the south transept is this family pew built by Sir John Kederminster sometime after 1613 and before his death in 1631. It's timber built but painted throughout in imitation of different coloured marbles. Dense lattices – some hatched and some cut in elaborate Gothic tracery patterns – conceal the interior from the aisle and there rises above the whole a magnificent parapet of strapwork. Internally the pew is decorated with heraldry and quotations from the Psalms. There is a ledge for prayer books, seats and hat pegs. Yet its apparent privacy is disturbed by the repeated image of an eye with the simple Latin inscription 'God sees'. By itself this pew would be worthy of a visit but it's attached to a room of yet greater importance. Opening off it is a library also donated by Sir John to the church, replete with its collection of books (mainly Patristic writings). These preserve their early bindings and are set in bookcases with richly painted doors. To all intents and purposes there is preserved here in its physical totality an early seventeenth-century study. Together the pew and the library constitute two of the most complete Jacobean interiors in the country.

96 A golden weathervane
The Church of St Mary-le-Bow, London EC2

Presiding over Cheapside, the principal
east–west thoroughfare of the historic
City of London, is this astonishing
dragon. It's 9ft long and was made in
1679 during the reconstruction of St
Mary-le-Bow by Christopher Wren. Prior
to the completion of St Paul's, the spire
it surmounts was the highest landmark
in the City, so the dragon, a symbol of
London, with the arms of the city – a
red cross – beneath its wings made for
a fitting weathervane. According to
the building accounts, Edward Pearce,
mason, made an outline dragon to
determine the scale of the final sculpture
and then a full-scale wooden model of
it. This was realized in copper gilt with
a ball by Robert Bird at the substantial
cost of £60. London formerly possessed
many emblematic signposts. By virtue
of its exceptional size, however, the
dragon became popularly paired with
the commensurate golden grasshopper
over the Royal Exchange. The two were
even cast as interlocutors in *A Dialogue
Between Bow-Steeple Dragon and the
Exchange Grasshopper* (1698). In this
imaginary debate, the dragon upholds
the virtues of the Church of England in
the face of the grasshopper's dissenting
sympathies. The dragon wins, but the
grasshopper neatly returns his reproaches
with: 'Why so Disturb'd, so Scornful and
so High?/You're but a Weathercock as
well as I'.

97 Controversy and Communion
The Church of St Andrew, Lyddington, Rutland

Beneath the east window at Lyddington is this extremely rare survival: a 1635 communion table and rail that have escaped later movement and reconfiguration. The liturgical arrangements of the Protestant Eucharist after the Reformation were developed in deliberate contrast to those of the Catholic Mass. The high altar of a medieval church was conventionally built of stone and set against the chancel east wall. By the early seventeenth century the Eucharist was universally celebrated on a portable wooden table. This was normally stored on the former site of the high altar but was moved into the centre of the chancel for use. There it was rotated to sit lengthways between the seats of assembled communicants. In the 1620s this arrangement was criticized by some bishops who wished the table to be kept permanently against the east wall and enclosed by altar rails. This arrangement, it was argued, would protect the table and make impossible the practice of people receiving Communion in their seats. The changes elicited considerable opposition and the arrangements at Lyddington express a compromise sanctioned by Bishop Williams of Lincoln: the altar remains in the body of the chancel, as it would have been during the old-style service, but is enclosed on four sides by rails.

98 Celebrating ancestry
The Church of St Mary, Lydiard Tregoze, Wiltshire

Squeezed into the modestly sized church of Lydiard Tregoze is a cornucopia of monuments, wall paintings, glass and furnishings, yet one object unquestionably steals the show. To the left of the altar, rising on a low stone base to the ceiling, is a large painted board emblazoned with the family tree of the St John family. This opens out like a vast and unwieldy book to reveal further illustration of the family pedigree and a superb central image, shown here, of the life-size kneeling figures of Sir John St John and his wife, Lucy, in a spacious Classical interior. Standing to the right are the couple's daughters and, to the left, their son (who commissioned the monument) and daughter-in-law. Supporting the sarcophagus-shaped plinth on which the central figures kneel are three coffins of their dead children. The painting is perhaps by the court painter William Larkin. There are other surviving examples of seventeenth-century painted dynastic triptychs and funeral monuments, although the scale of this is exceptional. As it presently exists, the original monument – erected on 20 July 1615, according to an inscription – was augmented with genealogical panels between 1683 and 1699. These additions, which include images of ancestral tombs, reflect the research of Sir Richard St George, a herald who married a daughter of the St John family.

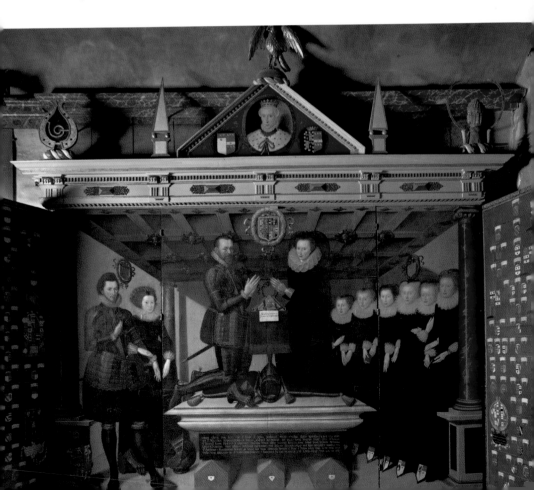

99 Offerings for a child
The Church of St Clement, Outwell, Norfolk

At the back of the church at Outwell is a wooden offering box set on a tall stand and crowned by five finials in the shape of acorns. To judge from its rugged neo-Classical detailing, the whole object probably dates to about 1600 and it may be contemporary with an unusual timber gable set above a nearby tomb. The three outer faces of the box are decorated with carved faces: one to either side and a pair in profile to the front. The faces to the side each have a horizontal coin slot in the position of the mouth, but that to the front has two vertical ones. By tradition, this remarkable object has been identified as an offering box for a ceremony variously described after the Reformation as purification, thanksgiving or churching that was held one month after the delivery of a child. Only after this ceremony did a woman return to the management of the home and sexual relations with her husband. The Book of Common Prayer stipulated an offering of the chrisom-cloth, in which the child was wrapped at its baptism, or its cash equivalent. It has been suggested that the different slits might be used to drop in coins depending on whether the new child was a boy, a girl or one of twins. More prosaically, it's probably an unusually splendid poor box.

100 Scandalous imagery
University Church of St Mary the Virgin, Oxford, Oxfordshire

This is a detail of the extraordinary porch that faces on to Oxford High Street. It was paid for by the Welsh clergyman Dr Morgan Owen, sometime chaplain to Archbishop Laud of Canterbury, and built in 1637 by the mason John Jackson. The porch cost the substantial sum of £250 and Jackson, who also worked on Canterbury Quadrangle at St John's College for the archbishop, was afterwards rewarded with a further £22 for his labours. Its swirling columns support a broken pediment inset with an image niche bearing the figures – astonishing for Protestant England – of the Virgin and Child. Reclining on the pediment itself are the figures of two angels and, between them, an open book cut with the inscription 'The Lord is my light', the emblem of Oxford University, surmounted by a pair of crowns. The porch combines Baroque and Gothic forms: the vault over the door, for example, might easily be mistaken for a late medieval creation. Such mixtures of architectural idiom have conventionally been viewed as solecisms, but they reflect the seventeenth-century admiration for Oxford's medieval buildings and the sympathies of Laudianism. At his trial in 1644, Archbishop Laud was accused of responsibility for the 'very scandalous' imagery of the porch. The statue of the Virgin and Child was later defaced.

101 The word of scripture
The Church of St Mary, Puddletown, Dorset

Painted texts – including the Creed, the Lord's Prayer, the Ten Commandments
and sentences from scripture – on the walls of churches became popular after the
Reformation. This is an unusual example at Puddletown that probably dates to the
reorganization of the church in 1634–5. It is written in Gothic script, a contrast
to the modern hand of another painted text of the 'Our Father' on the opposite
wall. This might reflect a deliberate attempt to distinguish visually between the
words of inherited scripture and a living prayer. The image represents a dialogue.
A disembodied hand at the top reaches down to offer an open book to the reader,
whose hand rises from below. Around the upper hand is a quotation from Timothy
recommending 'holy scriptures' as means to salvation. This notionally identifies
the presenter of the book as the church or minister. The reader's hand, meanwhile,
delightedly seizes upon the book with words from the Psalms that the Lord's
testimonies 'are the rejoicing of my heart'. On the open pages is a stern warning to
both parties from Revelation that neither should add nor take away words from the
book, clearly an injunction to fidelity to scripture. Perhaps the parish copy of the Bible
once stood available for public reading immediately beneath the painting.

102 Tabernacles of oak
The Church of St Edmund, Sedgefield, Co. Durham

During the seventeenth century, a number of churches in Co. Durham were provided with splendid furnishings in a Gothic idiom. One such is the screen that divides the chancel from the nave of Sedgefield. Its crown of unequally proportioned and richly decorated oak tabernacles form canopies to the stalls and central door beneath. Remarkably, the unmistakable inspiration for this furnishing is the Neville Screen at Durham Cathedral. Completed in 1380 as the reredos to the high altar, the Neville Screen exemplifies the delight of masons working in the Perpendicular idiom for creating complex visual lattices. Clearly, this virtuosic creation had seventeenth-century admirers.

Opinions differ as to the date of the Sedgefield screen, but it compares closely in both detail and form to the 1630s furnishings created at Brancepeth by John Cosin, a future Bishop of Durham. The similarities to the Brancepeth furnishings, tragically destroyed in 1998, suggests a common date. This would agree with a local report recorded by the antiquary John Loveday in 1732 that Dr Joseph Naylor, rector of Sedgefield from 1634 to 1667 (but ejected during the civil war), had 'laid out much money on the chancel'. Also, that, in 1638, a joiner called Robert Barker was involved in work to the church.

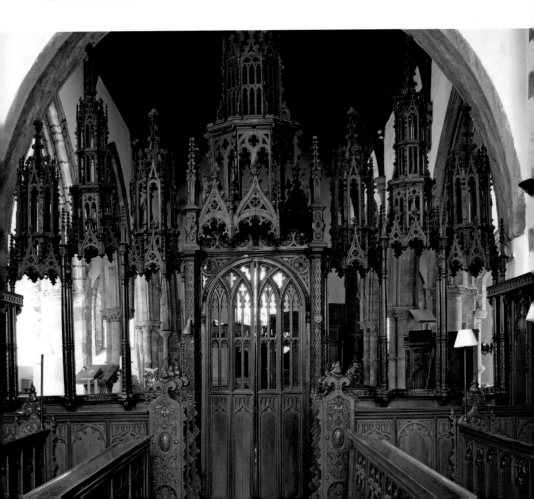

103 Stained-glass revival
The Church of St Tysilio, Sellack, Herefordshire

This is a detail of the central section of the seventeenth-century east window at Sellack. It's clearly inspired by medieval precedent and incorporates some fragments of pre-Reformation glass. In the central part of the window are four panels that relate to a central nativity scene: the Virgin and Child, St Joseph, one of the magi and the ox and ass in the stable. Each figure is set beneath an architectural canopy. At the apex of the window is a crucifixion with the mourning figures of St John and the Virgin below. The initials and date 'RS 1630' at the bottom must stand for Rowland Scudamore, owner of nearby Craddock Court who was buried in the church on 8 January 1631 (old style 1630). This work was presumably commissioned at his death by his great-nephew, John, Viscount Scudamore. Indeed, it may predate Viscount Scudamore's celebrated repair of the Cistercian church at Abbey Dore in 1632–3, one of the outstanding Laudian interiors to survive in England. The fact that craftsmen existed in 1630s Herefordshire to create a window of this complexity is almost as surprising as its iconography. It's an added curiosity – and a clear mark of admiration – that a copy of this window was commissioned by the 1640 will of John Abrahall for the nearby church of Foy.

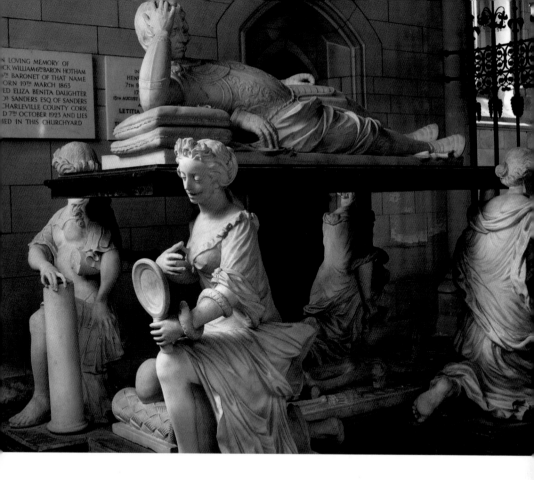

104 Protestant virtues
The Church of St Mary, South Dalton, East Yorkshire

South Dalton church, rebuilt in 1858–61, is a spectacular Victorian building with a landmark spire. Preserved within it, however, is this relic of an earlier church. It commemorates Sir John Hotham, a landowner and MP who fled abroad for his part in the attempted exclusion of the future James II from the throne as a Catholic in 1679–81. Sir John returned to England in 1688 and died a year later, in 1689. His widow, the formidable Elizabeth, Lady Hotham, commissioned this tomb. She died in 1697 and her will stipulated that her husband's memorial be 'like unto the old Cecil tomb at Hatfield'. Designed in 1609, the celebrated Hatfield monument for the 1st Earl of Salisbury comprises four kneeling virtues – Temperance, Justice, Fortitude and Prudence – supporting the recumbent figure of the Earl in robes of state. Beneath is a skeleton. Carved in black and white Italian marble, this was a revolutionary English monument inspired by sixteenth-century French and Dutch example. This copy departs from the original only in its treatment of the upper effigy: Sir John is dressed in armour and awkwardly props himself up. The name of the sculptor isn't known. As well as expressing her admiration for the original monument, perhaps Lady Hotham aimed to present Sir John – like Cecil – as the architect of a Protestant succession?

105 The Lord takes away
The Church of St Mary Magdalene, Stapleford, Leicestershire

In 1783, the Earl of Harborough replaced Stapleford church with a fine new Gothic building. He was careful, however, to preserve the memorials of his ancestors, including this extraordinary tomb to William, Lord Sherard, Baron of Leitrim and his wife, Abigail. She commissioned the tomb from an unknown sculptor sometime after being widowed in 1640 and inscribed upon it a dedication to her husband, herself and her children. It is of the highest quality and constructed of black and white marble. Around the two principal recumbent effigies, which rest their feet on a hound and lamb respectively, are the kneeling figures of their children. Above the couple's head is another figure of a swaddled baby. We know that the tomb originally stood within a railed enclosure in the south aisle of the old church, which Lady Sherard evidently rebuilt to receive it in 1650. At the entrance to the aisle was the Latin inscription 'The Lord gives and the Lord has taken away; as it pleases the Lord so let it be. Blessed be the name of the Lord'. Lady Sherard was a fascinating and redoubtable woman. She is also credited with commissioning a lavish genealogy of the family, which is represented in an extraordinary sculpted iconography on the front of Stapleford Park.

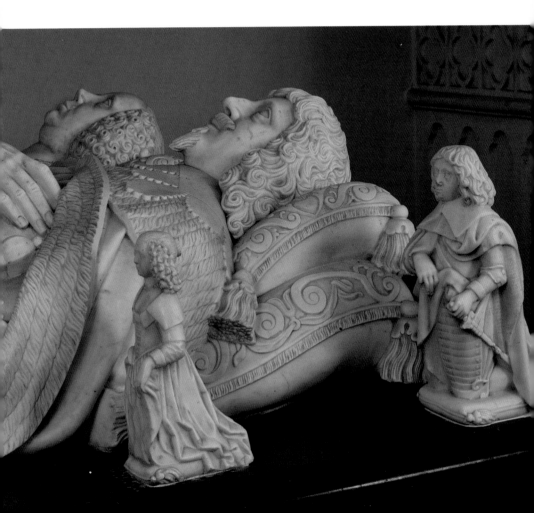

106 Baptismal splendour
The Church of St Clement, Terrington St Clement, Norfolk

The spire of timber that ornaments and seals the font in the huge church of Terrington St Clement is a magnificent composite creation. Its medieval Gothic structure was enlarged with a new Classical base in the seventeenth century and the whole externally painted to look as if it were opulently constructed in white and black marble. The inside of the cover base was decorated with New Testament scenes set in landscapes after the Flemish style and quotations in both Latin and English. During baptisms, the base could be opened out as a triptych appropriately themed for the occasion. In the centre is shown the Baptism of Christ attended by crowds and with the voice of God rending the heavens. To either side are scenes from the Temptation of Christ by the Devil (dressed as a king). To the right, Christ is shown in the wilderness, surrounded by charming wild animals, and, to the left, he is raised on to a mountain to view the glories of the world. Also portrayed are the four Evangelists. The paintings were probably commissioned in the 1630s as part of wider improvements to the church by the Laudian rector Richard Hunt. Before the civil war, the Laudian emphasis on ritual encouraged the widespread creation and reordering of font covers.

107 Loyalty and revolution
The Church of St Mary, West Malling, Kent

Since the Reformation royal arms have commonly been displayed in English churches.
Their presence reflected the religious authority assumed by the monarch and celebrated
loyalty to the Crown. This splendid wooden carving of the royal arms is a curiosity:
it celebrates the Catholic James II. A lion and unicorn support the quartered arms of
England, Scotland and Ireland, which are encircled by the Garter. Beneath is the royal
motto and above a crowned helm with a lion crest and swirl of decorative mantling. In
the frame two gilded cherubs support a coronet holding three feathers and the motto
'Ich Dien'. These emblems of the Prince of Wales probably date the panel to 1688:
James II's son was born in June and the prospect of a Catholic dynasty catalyzed the
Glorious Revolution before the end of the year. Tied with bows to the back of each
cherub are long ribbons that pass through stars of the Order of the Garter and then
intertwine with garlands of flowers. In the same manner the rose of England, the thistle
of Scotland and two shields bearing the crowned monogram of James II are interlinked
along the bottom of the frame by the rope of an anchor, a symbol – ironic in the
circumstances – of steadfast security.

108 'Dear little Tom'
The Church of St Michael and All Angels, Withyham, East Sussex

Pre-eminent among the Sackville family tombs at Withyham is this arresting marble monument. It shows Richard, Earl of Dorset, and Frances, his Countess, kneeling to either side of the recumbent figure of their thirteenth and last child, Thomas. 'Dear little Tom' – as his father affectionately referred to him – died after a violent illness holding the hand of his tutor at Saumur, France, at the age of thirteen in 1675. He was one of five children born to the couple who died in infancy. The parents look at the reclining boy, who clasps a skull and stares entranced into the distance. Both father and son had died by the time the Countess commissioned the tomb in 1677 and it is properly a memorial to both man and boy. According to the surviving contract with the Danish-born sculptor Caius Cibber, who also worked on the Monument to the Great Fire of London, it was to be produced in ten months at a cost of £350. This is many times the cost of a contemporary portrait painting. Curiously, the effigies had to be 'to the well liking of Mr Peter Lilly, his Majesty's painter, or any artist who shall be desired to give their judgement thereof'. In reality, it took three years to produce and the inscriptions were added by one Jonathan Mervin in 1680.

109 Perfection's glory
The Church of St Peter, Wolverhampton, Staffordshire

This bronze figure represents Admiral Sir Richard Leveson, who saw action against the Armada. His funeral in 1605 was an opulent affair costing £1,284 and this tomb was scarcely less lavish: it was made in 1633–4 by the French sculptor Hubert Le Sueur for £300. There is a long-standing tradition that the figure and its associated inscriptions and sculpture – including two cherubs so laid back as to be almost literally horizontal – are surviving elements from a much grander monument destroyed by Parliamentarian soldiers in 1645. Reputedly, Sir Richard's widow paid £40 to carry them away from the church. The tomb may have been damaged at this time but the story must be a romantic fiction since the widow was driven insane by the death of her only child and died in 1642. Moreover, the contract for the tomb lists all the principal surviving elements of the monument. The sole exception is the original base, which was larger than that presently existing and of black marble. Presumably the modern base was carved when the monument was moved to its present position from the chancel in 1840. The inscriptions include a triumphant elegy that begins: 'Here lyeth the bodye of Perfection's glorie; Fame's owne worlde wonder, and the ocean's story'.

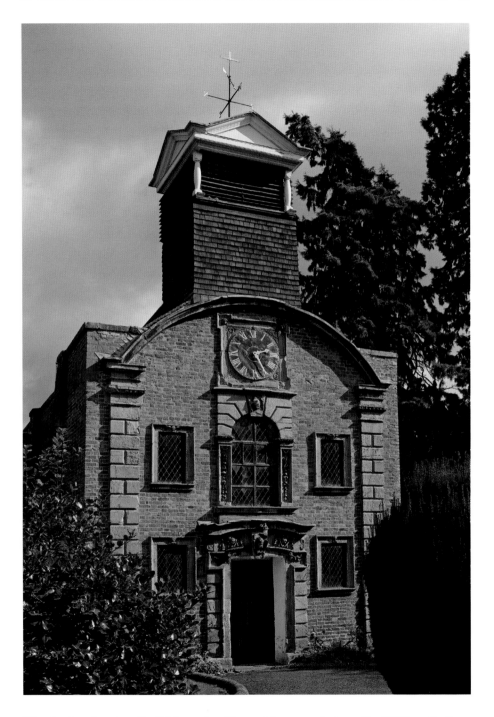

The diminutive church of Minsterley, Shropshire, was designed by William Taylor in 1688

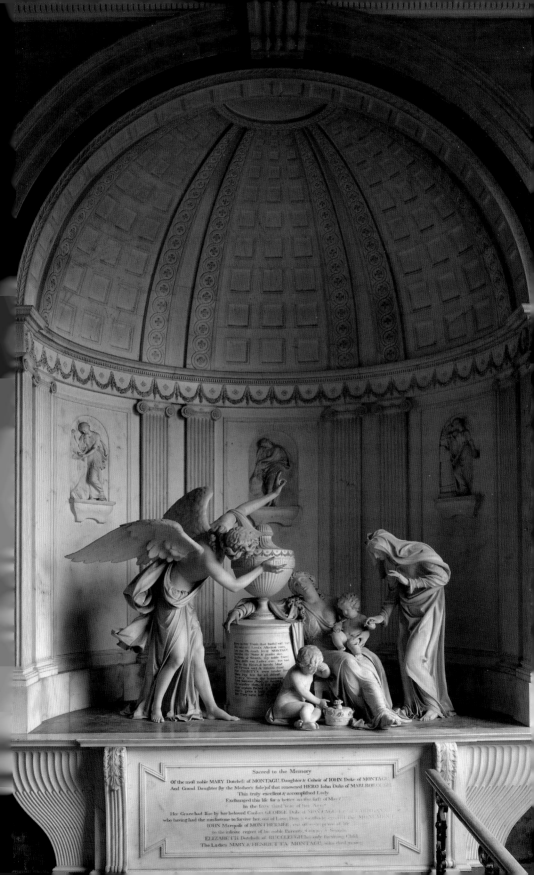

Sacred to the Memory
Of the most noble MARY Dutchess of MONTAGU Daughter & Coheir of IOHN Duke of MONTAGU
And Grand Daughter (by the Mother's side) of that renowned HERO Iohn Duke of MARLBOROUGH
This truly excellent & accomplished Lady
Exchanged this life for a better on the first of May
in the ﬁfty ﬁrst year of her Age
Her Grace had this by her beloved Consort GEORGE Duke of MONTAGU Earl of CARDIGAN
who having had the misfortune to survive her out of Love, Duty & Gratitude erected this MONUMENT
IOHN Marquis of MONTHERMER out of obedience of life
in the inmost regret of his noble Parents, Leaving & Brought
ELIZABETH Dutchess of BUCCLEUGH his only surviving Child
The Ladies MARY & HENRIETTA MONTAGU who died young

7 The Anglican Church, 1700–1799

In the early hours of the morning on 28 November 1710, following an intense storm, the medieval roof of St Alphege, Greenwich, collapsed. The damage done to the building was sufficient to provoke a demand for the demolition of much of the church and the parishioners petitioned parliament for money to rebuild it. At that time the vast shell of St Paul's Cathedral, the pre-eminent symbol of London's regeneration after the Great Fire of 1666, was at last approaching completion (at the staggering cost of £736,752). So, with Tory backing the following year, an Act of Parliament diverted the coal tax that had helped pay for St Paul's towards the intended construction of 50 new churches, including St Alphege, in London and its environs. This was, in other words, a state venture. Only 11 of these so-called 'Queen Anne Churches' were actually erected before the project was torpedoed by Whig interests in 1733, but this should not eclipse the interest or importance of what was achieved.

This initiative drew on the expertise that had already been involved in the post-fire reconstruction of the City. As a result, it served to refine and articulate, in a completely fresh set of designs (unencumbered by small building plots or existing fabric), the lessons learnt from the first generation of England's neo-Classical parish churches. Two of the commissioners involved in the new churches, Sir Christopher Wren and Sir John Vanbrugh, outlined in writing their ideas on the form and treatment of the proposed buildings. Magnificence was one crucial quality emphasized by both. In Vanbrugh's words:

> … it will perhaps be thought reasonable, that the fifty new churches the Queen has gloriously

The 1779 monument to the Duchess of Montagu, Warkton, Northamptonshire

185

promoted the building of, in London and Westminster; shou'd not only serve for the Accomodation of the Inhabitants, in the Performance of their Publick Religious Dutys; but at the same time, remain Monuments to Posterity of her Piety and Grandeur And by consequence become ornaments to the Town and a Credit to the Nation …

Both Vanbrugh and Wren identified two elements in particular as being conducive to the greatest public splendour: the steeple and the portico (the porch of a Classical temple, supported on columns). To quote Wren:

Such [church] fronts as shall happen to lie most open in view should be adorned with Porticoes, both for Beauty and Convenience; which together with handsome Spires, or Lanterns, rising in good Proportion above the neighbouring Houses, (of which I have given several Examples in the City of different Forms) may be of sufficient Ornament to the town, without great Expense for inriching the outward Walls of the Churches, in which Plainess and Duration ought … to be studied.

Wren's comments about 'spires or lanterns' deserves a brief and special digression. Of all medieval architectural forms, the spire was one in which the eighteenth century particularly delighted. These structures were objects of huge significance, moreover, to the City churches, their rings of bells not only a sign of parochial status, but a familiar sound of daily life (hence the celebrated nursery rhyme 'Oranges and Lemons' current in one form or another since at least the mid-eighteenth century). From the 1660s onwards London's church steeples were clearly intended to look as distinctive as they sounded.

The architects involved in the new churches created designs in two sharply contrasting idioms. The minority were inspired by European Baroque precedent, most famously the square-planned St John's Smith Square of 1712–32 with its four 'angle' towers by Thomas Archer. The remainder sought to cast churches in the mould of a classical temple with its enclosing screen of columns. Vanbrugh, indeed, had explicitly called for churches with 'the Reverend look of a Temple'. Rather than place freestanding columns round the entire building, those to the side and east end behind the altar were integrated within the wall to form engaged half-columns termed pilasters. These rose the full height of the building to draw its tiers of windows into a single and visually coherent external volume. In this way, the elements and proportions of the portico were echoed in shallow relief on each face of the building.

Not only did this idea of converting pagan forms to Christian usage appeal intrinsically to an eighteenth-century audience, but it played upon the perennially resonant idea that Anglican worship after the Reformation marked a return to primitive Christianity. There already was in London a parish church in the form of a temple: St Paul's Covent Garden, created as long ago as 1631–3 by Inigo Jones. The problem for the designers of the new churches, however, was how they could combine this form with a steeple, since, in an English building, the conventional position for the latter feature was on the gable end of the building,

which was also the natural location of the portico. Various solutions to this problem were proposed in the new churches. Some, for example, set the tower slightly aside or apart from the main building to leave the portico unencumbered. This decision was not generally very satisfactory, but it allowed the regular form of the temple to be read externally.

Porticos, incidentally, transformed the familiar entry into an English parish church. Visitors entered a 'temple' church on the main axis of the interior with the communion table ahead of them, rather than as formerly through side porches at right angles to it. This was not the only important contrast with earlier parish church design. Several of the churches erected after the Great Fire had substantially reduced the size of the chancel (though, confusingly, this may itself have been a legacy of the multiple-aisled medieval churches that pre-existed them, which were themselves often rectangular in plan). The new churches followed in this practice. Finally, these buildings were vaulted in imitation of stone throughout and with aisles rising to the same height as the main volume of the nave. This stood in contrast to the wooden ceilings or open roofs that had been an almost universal feature of parish churches for the previous seven centuries.

The breakthrough regarding the integration of the spire and portico came at St-Martin-in-the-Fields, the church of 1720–7 that today overlooks Trafalgar Square. This integrates the steeple behind the portico and within the volume of the temple structure. What is so satisfying about this solution is that the depth of the tower is externally expressed by a pair of full columns placed amid the ranks of pilasters. This creates a base for the steeple and counteracts the illusion that it stands unsupported on the roof. A corresponding bay at the east end of the temple creates the effect of a regimented design symmetrically bound together as if between bookends. It's notable that the spire of this building continues to follow closely in the tradition established by Wren from the 1670s onwards, a striking piece of conservatism shared by nearly all grand London churches of the eighteenth century. This paragon of Protestant English architecture – ironically designed by the Roman-trained Catholic Scotsman James Gibbs – has subsequently been copied around the globe.

In liturgical terms the real challenge facing the designers of these London churches was how to create interiors that could accommodate huge congregations within easy sight and hearing of the liturgy. Wren, for example, assumed the need for accommodating congregations of about 2,000, with everyone in earshot of a preacher with a 'moderate voice' who can be heard '50 feet distant before … 30 feet on each side and 20 feet behind': '… in our reformed Religion, it should seem vain to make a parish-church larger than all who are present can both hear and see. The Romanists, indeed, may build larger Churches, it is enough if they hear the Murmur of the Mass, and see the Elevation of the Host, but ours are to be fitted for Auditories.'

The answer, already articulated in some of London's late seventeenth-century churches, was to do away with an architecturally discrete chancel and create a tall, single-volume interior encircled on three sides with galleries. On this scale such galleries were a distinctly Protestant

architectural form. In order to create this unity of space, the chancel screen now effectively became obsolete and the rail enclosing the communion table became the only physical division in the building. By extension, communicants no longer

needed to separate themselves from the congregation during the service but came forward from their pews to receive the bread and wine kneeling at the rail. The best analogy – indeed, possibly the source – for this type of church interior is with a theatre in which the communion table, pulpit and reading desk take the place of the stage before the 'auditorium'.

But by this analogy there was an intrinsic problem, too. What should dominate the stage of a church? Because Communion by the stipulation of the prayer book was an irregular part of the liturgy, the table on which it was celebrated naturally took second place to the essential reading desk and pulpit. Some dissenting congregations and continental Protestant churches placed the towering pulpit behind the table, a massing of furnishings that worked well in practical terms.

But the Anglican tradition, with its emphasis on importance of the Eucharist, frowned on the idea of placing the pulpit beyond the table; it implied that the former was more important than the latter. So the pulpit had to be placed in front and therefore, to a greater or lesser degree, obscured the table. Nor was this the only conflict of interest. Baptisms, both by virtue of a fixed font conventionally set near the entrance to the church and the stature of the ceremony as a sacrament, required accommodation with seating for the immediate family. Consequently, many churches had a discrete baptism pew with differently orientated seating.

London's early eighteenth-century churches in the tradition of Wren were to exert a notable influence on prosperous cities and county towns across the

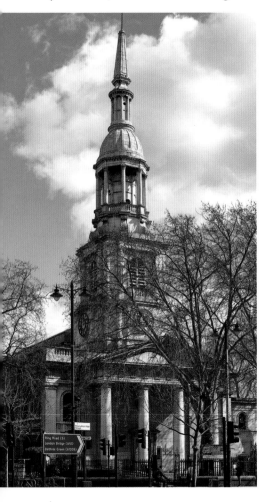

St Leonard's Shoreditch, London, was built by George Dance in 1736-40. It integrates a spire within the portico of a temple after the example of St Martin in the Fields. The debt to Wren's churches is apparent in the form of the steeple.

kingdom, where Classical churches sprang up in considerable number. In rural England, however, Classical churches are much rarer and generally much more modest. In part this was because villages usually already possessed a historic church and there was generally no need for, or interest therefore in building, a new one. No less important was the fact that most rural congregations were much smaller than their urban counterparts. Nevertheless, where the owner of a great country house rebuilt their seat, it is very common for the adjacent church to reflect this, whether it was repaired, beautified or simply made to accommodate grand new memorials. Where that happened the taste that had shaped the house touched the church and two additional idioms of Classical architecture are consequently widespread. Each deserves brief introduction.

The first of these was a reaction against the Baroque. From about 1720 Lord Burlington and his associates, including the architects William Kent and Henry Flitcroft, helped revive the English reputation both of the seventeenth-century neo-Classical architect Inigo Jones and one of his great influences, the sixteenth-century Venetian architect Andrea Palladio. Work in their so-called Palladian manner, is often deliberately austere and makes play with clear geometric forms. Ruggedly carved stonework termed rustication was particularly favoured as a means of articulating Palladian designs. In the second half of the century, the Classical style was again refined in the light of new discoveries about the Roman world as derived from direct exploration of archaeological sites such as Pompeii and Herculaneum. This second style, notably

advocated by Robert Adam, incorporated precisely observed and exquisite detailing carefully marshalled to set off the architectural frame of the design. By the end of the eighteenth century a revival in Greek-inspired architecture was also under way. This was likewise fuelled by the exploration of ancient sites.

All these different styles of Classicism are well represented in surviving funerary monuments of this period. For the very richest the tradition continued of creating large memorials with images of the deceased. These were almost without exception of marble and designed by artists working within the orbit of the capital. Just as London's mercantile connections and wealth made possible the acquisition of marble, so, too, did they draw skilled artists from across Europe. At the same time patrons on the Grand Tour saw first-hand inspiration for their tombs in France, Germany and Italy. In deference to long tradition, landowning families tended to group their memorials in the parishes located next to their principal seat. These can form almost overbearing displays of family lineage; as Laurence Sterne wittily commented of his own church at Coxwold, Yorkshire, filled with the monuments of the Belasyse family, earls and Viscounts Fauconberg, 'I can see that this is the house of my lord'.

The nobility and gentry still sometimes overhung their tombs with funeral armour, though this tradition was certainly in decline. These 'achievements' were carried in funeral processions and are evidence, therefore, of the elaborate noble funeral rites that persisted right through the eighteenth century. In the place of armour it became increasingly common from at least the mid-

seventeenth century to hang funeral hatchments. These were painted boards (apparently shaped after similar panels in Dutch churches) that represented the deceased in heraldry and which hung for a year after their death on the house they had occupied. Thereafter they were suspended in the church. Yet monuments were also now available much further down the social scale. Wealthy merchants might commission tombs on the scale of the nobility, but urban churches did not generally have the space to accommodate these great objects. The evidence of wills suggests clear preferences for the location of such monuments either in a prominent site within the building (commonly close to the chancel) or near the pew of the deceased.

Neo-Classicism in its various forms conventionally dominates discussions of eighteenth-century architecture. Yet it is worthwhile remembering that in the case of churches the example of inherited medieval building was disproportionately important. With the sole exception of St Paul's in London all England's cathedrals were substantially medieval creations. So, too, were the vast majority of parish churches across the kingdom. In purely financial terms it is clear that considerable effort was expended on maintaining these buildings. Also, that the style in which they were constructed was sufficiently admired to be imitated in repair and recreated in new buildings. Indeed, recent research into the maintenance of parish churches in the eighteenth century suggests that, contrary to popular belief, very few of these buildings were neglected. Where problems occurred it tended to be due to the legal division of responsibility between different parts of the structure. It also suggests,

curiously, that church spires were particularly singled out for admiration and maintenance.

Conventionally, recreations of medieval buildings from the seventeenth century onwards are categorized by modern scholars in terms of 'survival' and 'revival'. That is to say, early buildings in the idiom that represent the end of a living tradition of medieval building and later buildings that express a conscious harking back to the past. In addition, many twentieth-century authorities have presented eighteenth-century Gothic as essentially whimsical (in contrast to what they perceive as the morally directed revival of Gothic in the Victorian Age). Indeed, they have even given it the special name 'Gothick', its deliberately quaint spelling a reflection on the supposed character of the subject it describes. This, confusingly, departs from eighteenth-century terminology that variously categorized the accepted modern classifications of medieval architecture and gave them completely different names (such as 'Saxon'). But Gothic architecture in the eighteenth century was no more or less serious than its Classical counterpart and there are few significant architects who did not have some skirmish with it. Our understanding of it needs to be much more sophisticated.

It is to the eighteenth century that we properly owe the (false) perception of Gothic and Classical as polar opposites of style, respectively the heart and the head of aesthetic responses. The very term Gothic, indeed, was a pejorative one referring to the barbarian Goths who had overthrown Rome. As such the Gothic style had a capacity for playful fantasy denied to Classicism and this

was a quality in which the eighteenth century clearly delighted. Nevertheless, it had a more serious aspect, too, through its acknowledged antiquity. In political terms it represented England's past and its unwritten constitution, a point of intense national pride. So when, in 1740, William Kent was called to design a screen for Westminster Hall, the seat of the royal courts, he designed it in a Gothic idiom. This was not a whimsical exercise; it was an explicit celebration of English constitutional practice in the interior from which royal justice was dispensed.

In this way, England not only held on to its deep political history but it also saw in Gothic a link to the Church before the trauma of the Reformation. For the Church of England had a very complicated relationship with its own past. The Reformation may have purged and improved the established church (at least in its opinion), but the blood of its medieval predecessor clearly ran through its institutional, liturgical and physical veins. The implicit interpretation of this situation was that, while the medieval church had been riddled with errors, it was nevertheless the direct ancestor of the living church. So a positive identification with that medieval past remained a recurrent theme of Anglican architectural self-expression throughout the eighteenth century (and would burgeon in the next century). This was true not only in the repair of medieval buildings but in the creation of new ones that aped their style.

Through the prominence and architectural grandeur of its buildings, the Church of England demonstrated its continued close relationship with the established order. In reality, however, as the eighteenth century progressed it was increasingly influenced by – and in some quarters competing with – growing congregations of those who stood outside it. Dissenting Protestant groups, whose existence had been sanctioned in 1689, included the Quakers and – later – the Countess of Huntingdon's Connexion (a small but still surviving society of evangelical churches founded by Selina Hastings, Countess of Huntingdon (1707–91). She was a remarkable figure with a flamboyant past: as a young woman she appeared at a ball wearing a dress that one critic colourfully condemned as 'properer for a stucco staircase than the apparel of a young lady'). Meanwhile, the Catholic Church (still officially outlawed) began to grow, too, particularly in urban areas, although this is not to suggest that the Anglican Church was itself in any crisis or decline.

Measured even by the standards of the most remote rural parishes, the clergy of the Church of England in this period were exceptionally well educated. In rural livings, they also formed part of the established social order with a regular income drawn substantially from the land, and occupying houses that were usually second in the village only to that of the squire. This is arguably a social step higher than the clergy had ever previously attained. Many of them were also younger sons of aristocratic or gentry families, occupying family livings. In some cases this created a familial monopoly over local authority, in which both the squire and parson were brothers or close relatives. For some of these individuals serving the Church was not a vocation but a gentleman's profession, an alternative to law or the army.

Through the eighteenth century, meanwhile, the essential demands of Divine Service laid down in the prayer book of 1559 and reiterated in that of 1662 remained the same: the daily celebration of Morning and Evening Prayer, the Litany on Wednesdays, Fridays and Sundays and Holy Communion on Sundays and Holy Days. It should be emphasized that this regimen of prayer was not observed in the vast majority of parish churches. That said, the evidence of visitations suggests that the numbers of services tended to be much higher in urban churches than in their rural counterparts. This was substantially a reflection of the number of clergymen available. In this respect pluralism had a powerful impact. The medieval commonplace of senior clergy drawing the salary of several appointments and paying junior clergy to perform the necessary attendant duties did survive into the eighteenth century but it was rare.

More commonly individual clergymen acquired and served two or more neighbouring benefices, often with the help of a curate. In Wiltshire in 1783, for example, nearly half of the 262 clergy were pluralists. Such arrangements materially contributed to the fact that many rural churches only had single services on Sunday. This was true of over half the churches in the great diocese of York in 1743, for example, and of 60 per cent of churches in the diocese of Worcestershire in 1782. According to visitations in 1704 and 1806 in Norfolk three-quarters of all churches had only one Sunday service and more than half of these had only the basic minimum of three communions a year. More generally, quarterly communion seems

to have remained relatively widespread in rural parishes. Weekday services were, meanwhile, celebrated in between a quarter and a half of parishes.

Intermittent as they may have been, these services were, by modern standards, long. In 1784 the visiting Marquis de la Rochefoucauld commented that morning service without Communion lasted about an hour and a half and that evening service was a little shorter. Depending on the church, the congregation sat in a variety of pews and benches. In time-honoured fashion the position of seats was a direct expression of the social hierarchy, in which children, almsfolk, servants and other groups were usually discretely located. In towns particularly, there was intense pressure on seats and their rental constituted a major source of income for the parish. The rental of pews was regarded by many as a necessary evil. As Wren expressed it in his letter of 1711: 'A Church should not be so fill'd with Pews, but that the poor may have room enough to stand and sit in the alleys, for to them equally is the Gospel preached. It were to be wished that there were to be no Pews but Benches; but there is no stemming the Tide of Profit.'

The furniture of the church could be very variously arranged within the interior. Usually the pulpit and reading desk were integrated together as a single piece of furniture (sometimes with the addition of a clerk's desk as a so-called 'triple-decker' pulpit). In this period, it should be said, fabrics were an important trimming of pulpits and reading desks and contributed to their fine appearance. The triple-decker could be placed to the north or south side of the nave with the pews and galleries

arranged to face them. The problem with this was that the pews were then awkwardly placed to view the communion table in the chancel. The alternative arrangement of the pulpit at the east end created the problem of obscuring the communion table, as already discussed. Only in the nineteenth century did it become widespread practice to solve this problem by dividing the pulpit from the reading desk, with the improvements of sight lines that permitted.

Regardless of this problem, the altar was generally given an architectural backdrop appropriate to its importance. This usually took the form of a wooden reredos inset with the texts of the Commandments, the Creed and Lord's Prayer. The texts were in some cases placed in the centre of the reredos, but the example of cathedrals and private chapels increasingly encouraged some decorative treatment of this visual focus of the church. From the 1770s, grand historical paintings make their first appearance in parishes amid considerable controversy (that controversy has continued with the recent sale of one such painting, Benjamin West's *Devout Men Taking the Body of St Stephen* created for St Stephen Walbrook, London). In the same period fashionable artists, including West, began to explore the possibilities of making stained-glass windows depicting such subjects. As yet, however, this art form largely remained the preserve of cathedrals and college chapels.

Music was generally accompanied by a village band and the standard service setting for the period – Tate and Brady's *New Version of the Psalms* (1696) – was commonly bound up with the prayer book. Some parishes did collect their own music, usually settings of strictly

scriptural texts, as, for example, that surviving from about 1750 for the parish of Kemsing, Kent. The musical enthusiasm of particular individuals could also be important. William Hanbury, rector of Church Hanbury, Leicestershire, from 1753 to 1778, for example, can claim to be the organizer of the first parish church performance of Handel's *Messiah*. He also installed a fine organ in the church. This is an early example of the legion of such instruments that would by degrees bring about the downfall of the church bands through the course of the late eighteenth and early nineteenth century. Hitherto organs were rare instruments in parish churches and largely restricted to wealthy towns. Their widespread appearance in parishes, of course, matched their growing popularity and ubiquity as domestic instruments.

In the eyes of posterity the reputation of the eighteenth century established church has not been good. Its riches have been presented as morally suspect, its devotions lacking in ardour and its general treatment of its buildings neglectful and ignorant. The pens of writers, moreover, such as Swift, Fielding, Smollett and Sterne (two of whom were themselves clergymen), have lent vivid credibility to such criticism. Yet it is important to acknowledge that this judgement has been informed not so much by critics as hostile polemicists. For in the nineteenth century the established church was to undergo another period of intense controversy and change. And yet again – at great cost and acrimony – the reformers won. As we shall see, their victory not only changed the place of the established church in English society, but it was to leave a physical mark on virtually every single parish church in the kingdom.

110 The wrestling baronet
The Church of St Mary, Bunny, Nottinghamshire

Sir Thomas Parkyns (1662–1741) was an enthusiastic builder, designing his own bizarre seat at Bunny and inscribing himself on another house as 'his own architect & Clerk of Works'. He was also passionately interested in wrestling: he chose his servants as sparring partners, published a treatise on Cornish-Hugg wrestling in 1713 and celebrated it on his extraordinary tomb, which is made after a design described in a letter and drawing of 1715.

Sir Thomas was to be shown in a wrestling posture with hands 'fending forwards ready to receive an adversary with my elbows forwards close to my sides that he should not take the underhold or Cornish Hugg of me'. Beside this, another figure of Sir Thomas was to be shown laid prostrate by Time's scythe. The two figures are of strikingly different quality and it seems that they were carved by two brothers, a well-connected professional, Edward Poynton of Nottingham, and his brother, a friend of Sir Thomas and the vicar of Bunny.

Some visitors thought the monument inappropriate and Sir Thomas was forced to publish a verse defence of it. The criticisms continued, however: in 1790, John Throsby stated that to present anyone within a church 'in a bruising position, even to encounter Master Allbones, alias Death; to me appears unseemly'.

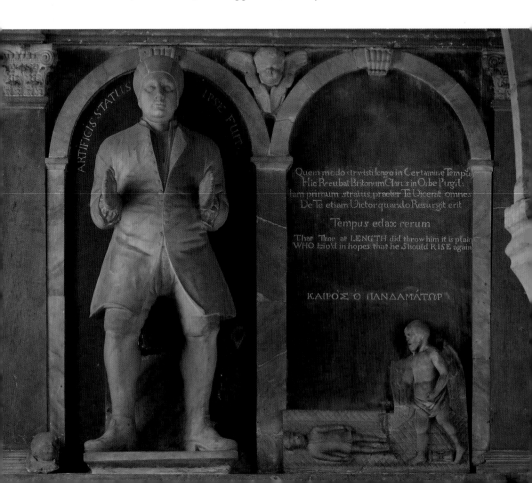

111 Mercantile Baroque
St Cuthbert's Church, Churchtown, Lancashire

In 1704, the burgeoning town of Liverpool belatedly secured for itself independent parochial rights and completed a new church dedicated to St Peter. This is a detail of the panelling carved by a certain Richard Prescot for the building. It formed part of a lavish set of choir furnishings, including a fine altar rail and virtuosic altar reredos. The latter is carved with a pelican piecing its breast to feed its brood with blood. With deeply undercut foliage, fruit and flowers, the busy carving of the panels reflects the Baroque fascination with movement. Even the figure of the cherub emerges from an architectural shaft or volute that revolves and distends unexpectedly. Flanking the principal panel are narrower vertical bands of carving. These suggest supporting pilasters and help impose visual order on the decoration. In 1880, St Peter's was chosen as the new pro-cathedral of the city and it was demolished in 1922 to make way for its leviathan successor. (Five of Liverpool's eighteenth-century churches were lost in the twentieth century.) The furnishings of the church, however, were moved to St Cuthbert's, where they remain today. St Cuthbert's, built 1730–9, must have seemed a natural home for these splendid furnishings. In the process of installation, they were carefully reconfigured for their new setting.

112 Railing for love
The Church of St Michael, Coxwold, North Riding, Yorkshire

Extending from the high altar right down the chancel at Coxwold church is this extraordinary wooden altar rail. The rail was installed in 1777 following the reconstruction of the chancel three years previously as the setting for a splendid series of Bellasis family tombs. It would not, therefore, have been known to Coxwold's most famous rector, Lawrence Sterne, the author of *Tristram Shandy*, who died in 1768. The rail is supported by elegant turned supports and was designed in such an exaggerated form in order to allow a large congregation to kneel simultaneously for the reception of Communion around the altar. It would also have been used for marriages, which, according to the Prayer Book, had to be solemnized 'before the Lord's Table'. The officiating clergyman would have read the service from within the semicircular gates while the bride and groom stood or knelt against the rail in front of him. William Hogarth depicted a similar rail used in exactly this way in his early painting *The Wedding of Stephen Beckingham and Mary Cox* (1729). The backdrop to the painting is a grand fashionable church interior, possibly inspired by the design of St Martin-in-the-Fields, London. The present high altar at Coxwold is an early twentieth-century insertion.

113 A Gothic eyecatcher
The Church of St Mary Magdalene, Croome D'Abitot, Worcestershire

The fittings of Croome D'Abitot church, consecrated on 29 June 1763, were designed by the architect Robert Adam. The new church was prominently sited as an eyecatcher in the landscape of Coombe Park, created by Lancelot 'Capability' Brown for the 6th Earl of Coventry. Work on it went hand in hand with improvements to the house. Shown here is the nave and chancel arch. The Gothic pulpit was made by John Hobcroft (or Hobcraft), a carpenter who also worked independently as an architectural designer and builder. The pulpit is hexagonal in plan and an exquisitely detailed crown of ornament surmounts its sounding board. As originally designed, it was probably integral with the prayer desk, from which the vicar read the service. The two were separated, however, during a nineteenth-century restoration. Half obscured by the pulpit in the depth of the chancel arch is a board of the Commandments. Its counterpart opposite shows the Lord's Prayer and Creed. Later in the 1760s Hobcroft produced the extraordinary Gothic furnishings of the Chapel at Audley End, Essex, in a similar idiom. The church contains an impressive array of family monuments, some of them moved from the lost medieval church into the chancel. To the left is the hatchment of George William, 8th Earl of Coventry (d.1843).

114 The use of charity
The Church of St Michael, Framlingham, Suffolk

To judge from its detailing, this two-sided bench was made in the first quarter of
the eighteenth century (perhaps in 1712). It's boldly conceived, with an alternating
pattern of 12 seats set back to back. Each is numbered – although, curiously, not in
sequence – and has a curving rear panel delicately ornamented with inlay. At both ends
is a decorative armrest that rises to a finial of wood resembling a medieval bench end.
The finials are painted with the heraldic achievement of the wealthy lawyer Sir Robert
Hitcham. He purchased the castle and manor of Framlingham, Suffolk, in 1635, and,
following his death a year later, bequeathed it with other property to Pembroke College,
Cambridge. He also endowed the town with a poorhouse, almshouses and school. This
bench was created for the almshouse community of 12 people – they wore blue coats
with Sir Robert's arms on one shoulder – and originally stood in the north nave aisle.
Beside it was a more austere bench, perhaps intended for the schoolboys. Sir Robert's
fine marble tomb, which stands in the church and was posthumously erected in 1638,
proclaims: 'The children not yet borne, with gladness shall/Thy pious actions into
memorye call,/And thou shalt live as longe as there shall bee/Either poore, or any use of
Charitie'.

115 Paradise in papier mâché
The Church of St Michael and All Angels, Great Witley, Worcestershire

In 1747, the architect James Gibbs was employed to embellish the interior of Great
Witley church, built at the expense of the widow of 1st Lord Foley in 1733–5. For the
purpose, Gibbs was presented with a group of fittings purchased from another of his
creations and one of the prodigy buildings of the eighteenth century, the chapel of the
Duke of Chandos's sumptuous mansion at Canons at Edgware, Middlesex. These
included an organ, stained-glass windows and – almost certainly – a series of paintings
on canvas by the Venetian painter Antonio Bellucci, who arrived in England in 1716.
Gibbs, who had trained in Rome, set Bellucci's paintings in a gently curved ceiling of
Italian character. As well as the three principal roundels of the Ascension, Nativity and
Deposition, there are 20 smaller medallions of cherubs, as shown here. Some carry
instruments of the Passion, in this case, Judas's purse. The detailing of the ceiling is
picked out with gilding and its writhing architectural ornament burgeons into life as
vegetation. Curiously, it is executed not of plaster, but papier mâché – then a novelty
– by Thomas Bromwich of Ludgate Hill, London. The church was the object of a
heroic restoration initiated by parishioners from 1965. In 1993–4, the interior and its
paintings were cleaned.

116 Sacred rites
The Church of All Saints, Lamport, Northamptonshire

As his marble funerary monument proudly proclaims in capital letters, the scholar and antiquary Sir Justinian Isham, Bart, left £500 towards the repair and beautification of Lamport church at his death in 1737. He was, the inscription explains, 'a zealous protector of the Church of England' and often partook here of its 'sacred rites'. Over the next six years William Smith – the son of 'Smith of Warwick' oversaw the complete renovation of the building. Among other changes he rebuilt much of the chancel, which was provided with Rocco plasterwork executed by John Woolston of Northampton. One of the fittings almost certainly associated with these changes is this communion table. It's very common for these pieces of furniture to be obscured by altar cloths and frontals. Here they conceal an extraordinary and carefully crafted object. The table is solidly built of mahogany. Its upper section is ornamented with bands of delicate detailing and supported on carved legs. These have scallop shells at the knees and terminate in distinctive scaled feet. The upper surface of the table is ornamented with inlay. In the centre of the table this describes a sunburst set with the letter 'IHS', the monogram of the name of Jesus. The name of the maker is unfortunately not recorded.

117 The lion and the unicorn
St George's Church, Bloomsbury Way, London WC1

Busy and noisy as Bloomsbury Way is, any pedestrian who looks up from the pavement is almost guaranteed to stop, stare and smile at one of its buildings. Rearing up above the street is the great steeple erected by Nicholas Hawksmoor between 1729 and 1731 to dignify his new church of St George. The spire at its summit is oddly stepped, a treatment inspired by Pliny's description of the Mausoleum of Halicarnassus in Turkey, and at the summit is the figure of George I pompously dressed as an emperor and standing on a Roman altar. Yet the eye-catching details of this curious spire are the four large-scale figures of lions and unicorns – the supporters of the royal coat of arms – that writhe around its base. Their dynamic poses perhaps suggest they're fighting for the Crown, as in the familiar nursery rhyme. The church commissioners who paid for St George's were initially inclined to refuse payment for these sculptures and, in the 1870s, the originals were judged to be unsafe and removed. But, during restoration work in 2006, the bold decision was taken to replace them and the present beasts are the work of Tim Crawley. The spire appears in William Hogarth's celebrated engraving of 1751 depicting the vices of drinking gin called *Gin Lane*.

118 Insatiated with glory
The Church of St Leonard, Shoreditch, London E1

This is an unusually splendid example of an eighteenth-century ringing board. It conveys through its enthusiastic language, bizarre punctuation and varied lettering the importance of two peals rung from the tower in 1777. The first on 18 February consisted '... of *TEN THOUSAND changes, of OXFORD TREBLE BOB TEN IN*, and was compleated in *Seven Hours Twenty Eight Minutes* the curious composition, the great Length of *TIME* and the Masterly Manner in which it was RUNG may justly entitle it, the most Excellent Performance ever *AICHIEV'D*, from the first invention of the Ingenious Art of *RINGING* to the Present Time'. After listing the ringers, it goes on to explain that '*INSATIATED* with *GLORY*', the ringers repeated the peal on 10 May, which achievement '*will be Transmitted to Posterity*'. It also notes the peal was composed by Charles Purser, who rang the fourth bell. The frame of the board is particularly fine and must be considerably earlier than the commemorated ring. It can probably be attributed to George Dance, who built the church in 1736–40 and produced very similar frames for the Mansion House in 1739–42. Might it be a recycled commandment board? One was certainly made for the church with money from voluntary subscriptions in 1740.

119 Maiden's garlands
The Church of Holy Trinity, Minsterley, Shropshire

Hung from a beam at the back of Minsterley church is a series of fragile crowns made from ribbons and paper crimped into florettes. These are maiden's garlands, or 'crantses' (literally 'crowns'), made to honour the funeral of a virgin. Each is suspended from a peg with a heart-shaped stop that's painted with the initials of the deceased and the year of their death. All date from the eighteenth century, when the making of such bonnets was widespread. In some localities, it was the custom to bury bonnets with the deceased, but at Minsterley and perhaps a dozen other English churches, they have been preserved as a display. Usually, such garlands were made for women, but some examples for men also survive. Pairs of gloves were commonly hung with them. It's not certain when and where the practice of making maiden's garlands originated, although a plausible case can be made for its great antiquity. The earliest to survive in England is a painted wooden bonnet dated 1680 at St Mary's, Beverley, Yorkshire. It seems probable, however, that the depictions of flower garlands on medieval funeral brasses to young women from the fourteenth century onwards – as at Sherborne St John, Hampshire – also testify to the custom. The practice of displaying maiden crants must have consciously echoed that of hanging armour above the monuments of the nobility and gentry. These creations, poignant and insubstantial, were the funeral achievements of extinguished youth.

120 Bluecoat boy
The Church of St Nicholas, Newbury, Berkshire

This is a replica of a painted wooden board sadly stolen from Newbury church in 1971. The original was probably executed in the first quarter of the eighteenth century to prompt charitable giving towards the corporation school that operated beside the church. This school was initially founded in 1706 for 20 poor boys. Rather unpromisingly, its first master, one Mr Mason, was sent at the town's expense to London to discover for himself the best methods of teaching. In 1715, another wealthy townsman, Richard Cowslade, made a benefaction towards the clothing, education and apprenticeship of a further 10 boys. They were to be known as 'The Blue School'. Then, in 1793, one John Kimber made a similar additional endowment. According to Samuel Perdue, the schoolmaster in 1818, clothing for all the boys in the school was issued each year at the mayoral feast. The corporation boys wore blue coats with a red shoulder knot, Cowslade's blue with a yellow shoulder knot and Kimber's green. Although the dress of this figure doesn't clearly relate to any one of these liveries, it is tempting to associate the board with Cowslade. He was buried in the church, having also given money towards the stipend of the organist, the repair of his instrument and the annual inaugural feast of the major.

121 Movement and light
The Church of St Germanus, St Germans, Cornwall

Set in the base of the north-west tower of the former priory church in St Germans, Cornwall, is this large monument to the MP and landowner Edward Eliot, who died at the age of thirty-eight, in 1722. It was commissioned by his widow and is enclosed by a fine iron railing. The monument is one of the earliest English works of the brilliant Antwerp-born sculptor John Michael Rysbrack, who settled in London in 1720. With its obelisk and animated figures, it is ultimately inspired by Roman Baroque example. It could have been designed by James Gibbs, an early associate of Rysbrack in England. The subtle lighting of the space in which the monument stands sets off its carefully arranged constituent marbles – white, veined-grey and dark grey – to superb effect. Eliot is shown reclining in Roman armour with a mourning figure at his feet. On the obelisk is a roundel portrait – presumably his deceased first wife – supported by cherubs. The relative simplicity of the architectural elements focuses the visitor's attention on the interrelationship of the different figures that is suggested by their gestures and lines of sight. Busy drapery also adds to the illusion of movement and life that Baroque artists struggled so hard to capture.

122 Roman holiday
The Church of St Martin, Stamford, Lincolnshire

On his third visit to Rome in 1700, John, 5th Earl of Exeter, was so captivated by the new tomb of Cardinal Mellini in Santa Maria del Popolo that he commissioned its French sculptor, Pierre-Etienne Monnot, to create his own funeral monument. The Earl was intensely interested in the commission and only left the city when the design was agreed. Work on it was finally finished in 1704, when the completed structure was shipped to England and erected in Stamford by the London sculptor William Palmer. It shows the Earl and his Countess, Anne, reclining comfortably in Roman costume on their vast sarcophagus. From the scattering of books around them, they appear to have been disturbed by the onlooker while reading together. To the left stands a figure of Minerva, or Victory. Her counterpart to the right is another female figure representing Art. Above them rises a great obelisk ornamented with their arms, which obscures a window. It's surmounted by a cherub clasping a hoop of gold. Neither the Earl, who died on his return to England in 1700, nor his Countess, lived to see the completed monument. Its fulsome inscription was possibly cut by Palmer.

123 Death by a pinprick
The Church of the Holy Trinity, Stow Bardolph, Norfolk

Among the series of fine funerary monuments in the Hare Chapel at Stow Bardolph is the startlingly lifelike wax head and torso of Sarah Hare. She died in 1744, reputedly of blood poisoning contracted after she pricked her finger when engaged in needlework. The figure is referred to in the inscription by the Latin term 'effigies', which suggests that it was inspired by the Roman habit of mortuary portraiture in wax. Hare's will describes the commission: 'I desire to have my face and hands made in wax with a piece of crimson satin thrown like a garment in a picture, hair upon my head and put in a case of Mahogany with a glass before … If I do not execute this in my life I desire it may be done after my death.' The effigy and its clothing were fully cleaned and conserved in 1984–6. It emerged that the arms and face were probably modelled from Hare's body, and that its features had been vividly picked out in colour. Some of the fabrics used may have been taken from Hare's own clothing and the corset had certainly been worn. The only comparable waxworks in Britain are the earlier figures made for royal funerals and which survive at Westminster Abbey. Only one of these, however, that of the Duchess of Richmond (d.1702), was intended as a memorial.

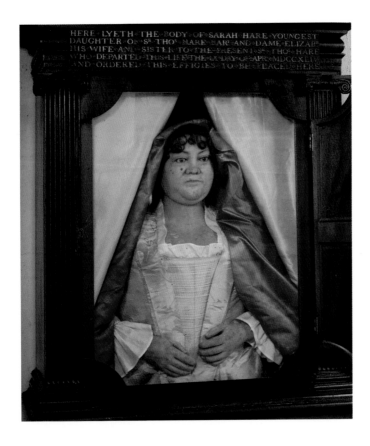

124 Palm-tree pulpit
The Church of St Peter and St Paul, Trottiscliffe, Kent

In 1775 the architect Henry Keene renovated the choir of Westminster Abbey. His new furnishings were in the Gothic style and designed 'to be removed and replaced without any apparent inconvenience', so that the interior could be cleared for coronations. The centrepiece of the choir was the pulpit, which stood in the crossing of the church. An illustration of the abbey interior, published in 1823, shows it hung with purple cloth, a fabric that also dignified the stall of the Dean and his deputy. In 1824, Keene's pulpit was removed from Westminster and presented to the church of Trottiscliffe by a distiller, James Seagar, who divided his time between Westminster and this Kent parish. The exact circumstances of its removal are obscure, but the fact that the pulpit was dismountable doubtless made it easy. Here is shown a detail of the broad wooden pulpit canopy, intended to reflect the sound of the preacher's voice down on to the congregation. This is inlaid with a wheel of tracery decoration and a decorative fringe of trefoil arches. At each angle of the canopy there formerly rose a pinnacle of iron. Its upper finial just fits beneath the roof of the chancel. The whole is improbably supported on a flamboyantly carved palm tree – a symbol of Resurrection and eternal life.

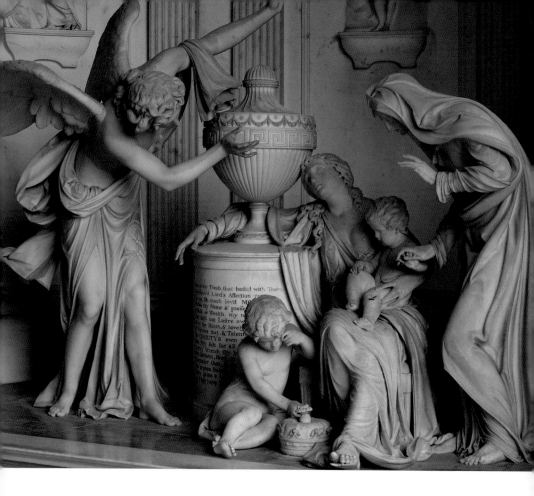

125 Bathed with tears
The Church of St Edmund, Warkton, Northamptonshire

Among the outstanding collection of memorials at Warkton is this monument to Mary, 3rd Duchess of Montagu. It was commissioned by her husband in 1779 from the Amsterdam-born sculptor Peter Mathias Van Gelder at the fantastic cost of £2,000. The expiring Duchess, with a breast exposed in the character of Charity, languishes with one arm upon the base of an urn. A child at her feet weeps over her fallen coronet while another on her lap is drawn away by a widow to the right. Orphans and widows are both referred to in the epitaph on the base of the urn as mourning her death. To the left a winged angel with billowing garments arrives on the scene. He leans forward to catch the attention of the Duchess in her last moment of consciousness and gestures upwards to indicate the future ascent of her soul. The whole sculptural tableau is raised up on a sarcophagus and recessed in a richly detailed niche. Among the background ornaments is a female figure representing death with an upturned torch. She is flanked by representations of needlework and painting, evidence of the Duchess's pastimes. The monument is a work of technical virtuosity: each angel wing, for example, is carved from a separate block of marble.

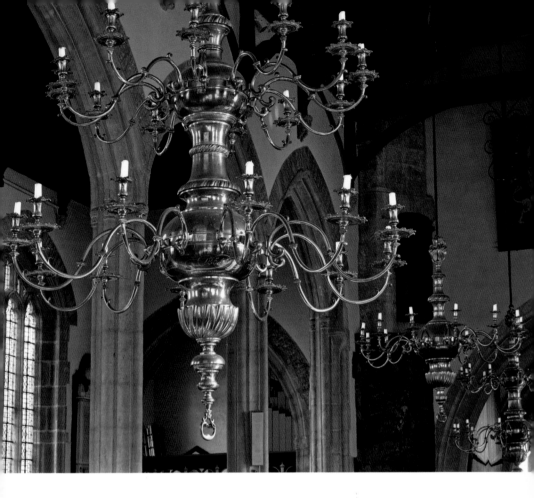

126 Let there be light
The Church of St Mary Magdalene, Wedmore, Somerset

The advent of electricity has so transformed the lighting of churches that the historic
arrangements for their illumination are easy to overlook. Yet lighting has always been
important and fine brass chandeliers with multiple arms have hung in English churches
since the Middle Ages. Each chandelier in this unusually fine series at Wedmore is
inscribed with a date and the name of its donor. That in the far distance is identified as:
'The generous gift of Mr John Tucker, of Blackford, in this parish. 1779'. Bold lettering
also announces that the two closer chandeliers are: 'The generous gift of Miss Ann
Redman of Wedmore. 1854'. They are also signed with the name of the brass founding
and clock-making company that made them, Thomas Hale of Bristol. The inscriptions
underline the expense of these fittings. St Mary's Islington, London, for example, paid
£50 for a chandelier in 1778. The arms are elegantly ornamented with flourishes and
foliage trimmings in brass. Every candle is set within a double dish. Part of the interest
of the later chandeliers is that they were clearly made to form a set with the original.
Each terminates with a bronze flourish like a flame and is hung from the ceiling with an
ornamented iron strap.

127 Nought but truth
The Church of All Saints, West Ham, London E15 (formerly Essex)

On his memorial James Cooper, Gentleman of Plaistow, stares out thoughtfully while sharing a prayer book with his wife. Cooper died a widower aged eighty in 1743. His will set aside £300 for the creation of a monument with marble effigies that was to be erected close to his grave and the chancel door. Its sculptor is unfortunately not known. The poor and his servants – including 'my poor black boy Thomas Degingoe' – were notable beneficiaries of his considerable wealth. He requested that charity children conduct his corpse to the church with singing and stated that his funeral text should be from the Psalms: 'For thou O God are the thing I long for and thro thy hand I have been holden up ever sure I was borne'. For his epitaph there should be 'writt after my name and age this that I believe in God and Jesus Christ likewise the Resurrection and while I live I then believed he was always my protection but now I lye interred here and covered o'er with dust, friends think on me that lyeth here for hereunto you must and what more my executors things proper if anything but nought by truth'. His epitaph simply adds mention of his liberal benefactions to the poor and his 'extensive charities, too large to be here inserted'.

128 A parson's throne
The Church of St Lawrence, West Wycombe, Buckinghamshire

Between 1752 and 1762, the medieval church at West Wycombe was rebuilt by Sir Francis Dashwood, a founder both of the Society of Dilettanti and the notorious Hellfire Club. This chair and lectern forms part of the unorthodox building designed for him by the architect John Donowell. Inspiration for the interior came from the Temple of the Sun at Palmyra and the church tower famously supports a large golden globe that originally incorporated seating for eight people. Commenting on this 'singular' church in 1797, the antiquary Thomas Langley noted of its furnishing: 'There are no pews but fixed forms without any distinction. The pulpit and desk are mahogany arm chairs with a reading desk before them.' There are, in fact, three raised chairs with lecterns in the building, of which this reading desk is the largest and most richly treated. It's portable and the drawers can be pulled out as steps. The lectern takes the form of an eagle on a ball, a conventional treatment rendered here with unusual liveliness. Above the seat is the hovering dove of the Holy Spirit.

The lifelike animal symbolism of this desk is echoed in the contemporary church font, which is bizarrely ornamented with doves and a snake. Reading desks of this type are known elsewhere, as, for example, at Audley End and Alnwick.

129 Civic estate
The Church of All Saints, Worcester, Worcestershire

This is a detail of an iron rest for the mayor's sword of estate when he attended All Saints' church, Worcester. It's been moved from its original position in the front of a pew but the sword would initially have been placed in the rest with the blade pointing upwards. There is no date on the rest but the inclusion of GR III in the upper section of the frame clearly shows that it was made during his reign between 1760 and 1820. It may have been erected to coincide with a royal visit in 1788, though in stylistic terms it looks earlier. The heraldry combines the two coats of arms of the city: a castle on a quartered background and a second device including three pears – the fruit of Worcester – in the upper left quarter. Swords were a mark of civic authority and were carried before the mayor whenever he moved about ceremonially. As a result, rests of this kind are quite a common feature of city churches in the eighteenth century. In Worcester another survives in St Swithun's church and a third – now lost and prosaically described as an 'iron or proper place for … [the] sword [to] be putt up' – was commissioned in 1735 for the now-redundant church of St Nicholas.

… IOSEPh YOUR BROTHER WHOM YE SOLD INTO EG…

AND SO DEATH PASSED UPON ALL MEN FOR UNTIL ONE LA…

8 Revival and Renewal, 1800–1899

No less surely than the Reformation, the nineteenth-century transformed the life and appearance of the English parish church. Interiors that had since 1540 been treated largely as functional spaces, their form subject to the liturgical prescriptions of the prayer book, now became stridently aestheticized. By the end of the century, beauty – however interpretations of the word might differ – emerged as an inspiring principle of creating, furnishing and worshipping in churches. What made this process so extraordinary was the sheer calibre of the figures involved in it. For throughout the middle decades of the century the debate over the design and decoration of churches lay at the very heart of the Victorian endeavour. Indeed, with the possible exception of Wren's church design in London, not since the Middle Ages had ecclesiastical art been of such central and formative importance to society as a whole.

Great as the changes witnessed over the course of the century were, in national terms they were the product of cumulative, creeping, and sometimes highly controversial, innovation. Bound up with them is an important but subtle shift in the emphasis and practice of the liturgy. In this respect it is important to emphasize that the prayer book remained the only authorized text of the liturgy and central, therefore, to Anglican experience and identity. Nevertheless, those at the extremes of the Church began to omit or interpolate (according to their sympathies) its text. Henceforth this volume, that in its four editions of 1549, 1552, 1559 and 1662 had encompassed the establishment of an English Protestant church, became by degrees the expression rather than the measure of Anglican practice.

A detail of the 1870s wall-paintings at Garton on the Wolds, Yorkshire

215

Meanwhile, the place of the church in British society changed profoundly, too. Catholic emancipation in 1829 broke the apparently unassailable monopoly of the established church on public life. It was followed in 1850 by Pope Pius IX's restoration of the Catholic hierarchy in England, an innocently undertaken project that provoked a hysterical response in Britain and was dubbed 'the Papal Aggression'. This was accompanied by a tide of prominent conversions to Catholicism from the ranks of High Anglicanism. It was substantially through the efforts of this highly educated group of men that the modern English Catholic church was brought into being and with it a system of parishes operating in parallel to those of the established church. These buildings and their contents now become relevant to the narrative of this book. To a large extent the new parishes served urban Catholic populations recently swelled by Irish immigration.

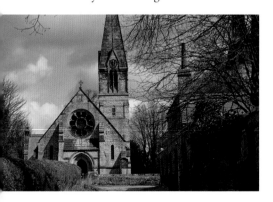

Appleton le Moor, Yorkshire, begun by J.L. Pearson in 1865, draws on a wide variety of medieval architectural sources, chiefly from 13th-century France. Its interior is strikingly polychromed, a decorative treatment that enjoyed ever increasing popularity as the 19th century progressed.

Part of the explanation for the scale of change within the church and its buildings lies in the wider social, intellectual and political context of the period. The Napoleonic Wars exerted extraordinary pressures that after 1815 demanded release. Calls for radical reform naturally touched the established church and brought into question its temporal interests. Steady industrial growth, meanwhile, created new congregations outside the historic parish system. Advances in science also radically altered the relationship between long-accepted biblical narratives and ideas about the world. Initially, at least, the Church took these changes in its stride but in the later decades of the century religious and scientific endeavour became increasingly unhappy bedfellows. In the same period the expansion of the empire had a huge impact on Christian practice. Now the world became a forum for a debate about the role of Christianity in society and the Anglican Communion became a truly global confession, competing internationally with its rival churches.

At the heart of all this change, however, there was within the Anglican Church a straightforward aggravating concern to which much of its internal dissent properly related. This was a simple question about the character of the English Reformation and the degree to which it constituted the birth of the Church of England. Since at least the early seventeenth century it had been argued by some individuals that the Reformation, and the fact of establishment under the governance of the Crown, was manifestly a secular concern. In this sense it was a distraction from the grand narrative of English church history, which ran back unbroken

through its events to St Augustine's first mission of conversion in 597. Of particular relevance in supporting this claim was the apostolic succession of the episcopacy and, by extension, of the Anglican priesthood.

This idea began to be celebrated in architecture during the late eighteenth century through the antiquarian movement. Antiquarianism, essentially the exploration of history through the study of artefacts, involved numbers of the clergy and it encouraged, as we have already seen, the promotion of the medieval 'Gothic' style in church architecture. Buildings and furnishings in this form celebrated the connection of the past with the present and lent weight to the claims of the Church to antiquity (and therefore authority). The popular appetite for the Middle Ages, meanwhile, was fed by the Romantic movement and the novels of Walter Scott in particular. In the first decades of the nineteenth century some clergy with antiquarian interests additionally turned to the Continent to supply historic artefacts for their churches. The Napoleonic suppression of religious houses placed huge quantities of Catholic glass and fittings on to the art market. These were occasionally bought up and refitted in English parish churches.

It's noteworthy that several of these restoration projects incorporated very novel configurations of furnishings borrowed from cathedral and collegiate planning, in particular the arrangement of stalls running along the lateral walls of the chancel (and sometimes even the nave, too). The former arrangement would become commonplace in parish churches after 1870, but 50 years earlier – unless they preserved medieval chancel fittings

– it was a novelty. At the same time, the elements of the conventional triple-decker with its pulpit, reading desk and clerk's desk began to be fragmented. In some cases the pulpit and reading desk were simply set to either side of the chancel arch, an arrangement that left the altar clearly visible between them.

Over the same period, however, the architectural mainstream of church building remained relatively conservative. In response to the problems of serving the ever-expanding cities the Church Building Acts of 1818 and 1819 supplied £1 million towards the creation of new urban churches not only in London but across the country. In this environment the Anglican Church found itself at a huge disadvantage. Whereas dissenting congregations could simply establish a meeting house, the creation of a new parish required an Act of Parliament. Under the Church Building Commission established in 1818 there began a massive initiative that would run into the 1850s and create around six hundred new churches. Most of the early buildings in this initiative took on a neo-Classical mantle. With their steeples and porticos, not to mention their internal arrangements with galleries, these unmistakeably followed in Wren's tradition.

During the 1830s within the established church as a whole there was an interest in reform and renewal. At the heart of this was a collective desire to increase its vitality of life and, as part of this, to create more intensive regimens of public prayer. For Evangelicals, whose sympathies graduated into nonconformity, particular emphasis was placed on preaching and also the involvement of the church in the world beyond the liturgy. Theirs was a

social as much as a religious cause and part of the crusade they led against the established order involved the reform of inherited church institutions and the redistribution of their funds.

What was important at this juncture for the purposes of this narrative, however, was the response of 'High' Anglicans, at the opposite extreme of sympathies within the church, to the need for reform. Since the status quo was by general consensus inadequate they began to look back beyond the foundation of Protestantism itself for a vision of renewal. After all, the roots of Anglicanism – as they perceived it – lay in this pre-Reformation church. Leading the field in this respect were the so-called Tractarians, who took their name from a series of tracts published in Oxford from 1833 (hence the familiar alternative name of 'the Oxford Movement'). The interest of Tractarians in the renewal of the Anglican Church did not initially extend to the furnishing and architecture of buildings. But this was about to change.

The outstanding architect and designer, the Catholic convert Augustus W. N. Pugin, was a hugely influential figure in caricaturing the medieval past to advantage. In 1836 he published the famous polemic *Contrasts*. This incorporated a series of engraved plates that juxtaposed images of modern buildings with their medieval counterparts: an almshouse with a workhouse, a medieval conduit with a water pump, a medieval city with a sprawling industrialized slum. To modern sensibilities the effect is almost absurdly partial, but the book – and Pugin's wider case – had an electrifying effect on his contemporaries. Perfection resided for

Pugin in the 'middle-pointed' period of Gothic (i.e. the decades around 1300) and for the next decade few demurred from this judgement.

It is in the context of Pugin's polemic that another group, the Ecclesiological Society (before 1846 the Cambridge Camden Society) and its journal from 1841, *The Ecclesiologist*, are important. This body began to make widely available information about the English medieval liturgy, as well as its architectural setting. The avowed purpose was to catalyse through this work a model for the appropriate restoration of churches and the reform of the liturgy. Controversially they advocated the re-adoption of ceremonial.

For Ecclesiologists – like all High Church Anglicans – the Eucharist was of paramount importance. It was essential, therefore, that the furnishing on which this re-enactment of the Last Supper was celebrated be appropriately dignified. The 'altar' as it was invariably now called once again, needed to be lengthened and raised up in its medieval position against the east window, possibly against a backdrop of images. It should be placed, moreover, as thirteenth-century example dictated, within a deep chancel demarcated by a screen or chancel arch. The chancel should in turn be cleared of all pews used by the congregation. In their place there should be a piscina for washing the liturgical instruments, a sedilia for the officiating priest and stalls ranged along the walls for the clergy or members of the church choir.

Incidentally, the late nineteenth century was also a period of enormous change in parochial music. There was an explosion in the practice of vesting church choirs

and placing them in the chancel stalls between the altar and the congregation. This change encompassed the final demise of the church band, which had been steadily losing the fight against the organ for musical control of services since the mid-eighteenth century. At the same time, clergy of all persuasions were keen to move away from the metrical psalms that had been the staple of congregational singing since the sixteenth century. In their place there emerged the hymn. For those of High Church persuasion hymns could be sung with reference to season and feast, some of them with words drawn from translated Latin texts. What was to become the standard compilation to the end of the twentieth century, *Hymns Ancient and Modern* was first published in 1861.

The architectural emphasis on the altar and its associated fittings was coupled with an effective transformation of the celebration of the Eucharist. The three receptions of the sacrament each year described by the prayer book seemed woefully inadequate. So, too, did the celebration of the abbreviated service termed the ante-communion, which did not actually involve Communion. From the 1840s the Eucharist became steadily more regular until it was the principal Sunday service in nearly all parishes. Meanwhile, vestments began increasingly to appear, an innovation justified with reference to the deliberately ambiguous text of the prayer book directing that the ornaments of the church be maintained as they existed in the second year of Edward VI's reign (the regnal year of 1548–9 conveniently spanned the effective abolition of the Mass and could therefore be interpreted very freely).

No less significant were the changes advocated by ecclesiologists to the arrangements of the nave. The pulpit was noticeably reduced in scale and the furnishings that had so long adhered to it – the reading desk and clerk's desk – to create the 'triple-decker' disappeared, the former to be replaced by a freestanding lectern. So did the eagle lectern of brass for reading the gospel in medieval churches return almost universally to Anglican buildings. All that had changed was its position: in medieval churches the lectern stood beside the altar; now it generally occupied the position of the reading desk on the nave side of the chancel screen.

There was a striking desire, meanwhile, to tidy up the internal appearance of parish churches. Galleries and box pews confused the architectural logic of the

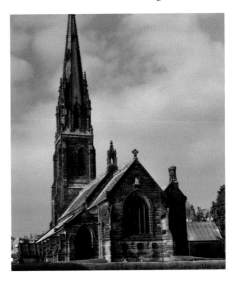

St Giles's Cheadle, Staffordshire, 1840-6 with its prominent spire is arguably A.W.N. Pugin's masterpiece; an opulently realised recreation of a church in about the year 1300

interiors they furnished. In addition, Ecclesiologists shared with virtually all other reformers a strong hostility towards the practice of renting pews in a church. To tidy up the appearance of the building and to accommodate large congregations, therefore, the naves of churches began to be entirely filled with open benches. In many churches the practice of sitting men, women and children in different parts of the interior was revived. For Tractarians there was a radical imperative behind such seating systems: they explicitly challenged the primacy of the family as a social unit. It was a striking statement that God came before all things.

Underpinning the Ecclesiologist reordering of churches was a symbolic reading of their fittings and furnishings. Influential in this respect was *Rationale Divinorm Officiorum* by William Durandus, Bishop of Mende (1286–96). Translated and published in 1843 by two founder members of the Cambridge Camden Society, Durandus' text attributed a devotional significance to every single feature of a church, its liturgy and its trappings. Even the constituent lime, sand and water of the mortar binding together the masonry did not escape attention in this ponderous and remorselessly interpretative text. These are respectively identified as emblems of charity, temporal welfare and the Spirit. Durandus offered a checklist that set out the nature, position and purpose of every item necessary for the celebration of the liturgy.

What began in the 1840s as the pure revivalism of Gothic as a means to the restoration of Anglican worship, however, quickly grew more complex under the influence of so-called 'development'. According to this idea, because art and architecture evolved in relation to the societies that produced them, a historic style could be 'developed' in a modern context to incorporate changing ideas and technology. Development, in other words, permitted the design of a railway station, a hotel or a house in a medieval idiom. It also allowed that style to be improved. Here a growing interest in architecture on the Continent, fuelled by such luminaries as Ruskin in *The Seven Lamps of Architecture* (1849) and *The Stones of Venice* (1851), came to enrich English buildings. Of particular importance in this respect was the English architectural exploration of polychrome stone and brickwork, an idea borrowed from Italy and the Baltic.

This idea of development also had a theological implication. As the Tractarian John Newman argued, for example, the Church's understanding of revelation changed over time and in response to the specific circumstances of each period. It was, therefore, pointless to try and return to a notional moment in history: the Church and the world were in continuous development and there necessarily existed, therefore, a gulf between the past and present. As a matter of fact, Pugin came to agree, as did many Anglicans. By accepting theological development, however, a new and worrying question emerged. If it was a mistake to return to the practices of the Middle Ages, what tradition best represented 'developed' Christianity? Newman famously determined in favour of Roman Catholicism and became a convert.

Meanwhile, the physical changes brought about by this reform of the church swept across the ecclesiastical

landscape like an all-consuming fire. The reaction against it was no less powerful. Then as now, churches were familiar and loved buildings and to some change appeared threatening and unwelcome. Opposition steadily grew and in 1877 the Society for the Protection of Ancient Buildings (SPAB) was famously founded in protest against the damage restoration projects were inflicting on the historic fabric of these buildings. For it must be remembered that architects were not attempting to save old churches but to turn these structures into functioning modern buildings. It is to gloss over many complications of circumstance, therefore, but all over the country church interiors were stripped out down to the masonry. Then the shell of the building was returned to a medieval idiom. Usually this was an English Gothic style more or less archaeologically accurate and 'developed'.

In their restoration, it should be emphasized, some architects could produce astonishingly convincing recreations of medieval work. In this sense an astute antiquarianism coexisted with muscular Gothic revivalism, often in the same architect. One result of this is that restored churches occasionally change architectural gear to incorporate some historic and admired feature in an idiomatic fashion. New builds rarely attempted, by contrast, any implied historic depth of development but were simply essays in one architectural style.

The internal reordering of churches was as remarkably varied in detail as it was consistent in conception. The chancel was provided with a single eastern altar and furnished with choir stalls. In contrast to medieval churches, therefore, the entire focus of the interior was on this single furnishing. Secondary altars, it should be said, remained rare in Anglican churches until the 1860s, when some urban parishes created morning chapels after the long-standing example of cathedrals. These were used for weekday services. To underline the importance of the chancel altar it was often provided with a reredos. The traditional Lord's Prayer and Ten Commandments, by contrast, rarely achieved much prominence except as wall paintings. A pulpit and lectern were placed at the opening of the chancel and the nave was filled with pews. At the same time there was a gradual intensification of the liturgy and the reintroduction of decorative trappings from vestments to flowers.

Restoration and reorganization according to Ecclesiological principles dramatically intensified from the 1870s. By that time, it is estimated that nearly 7,000 historic churches – close to 80 per cent of the total – had been enlarged, rebuilt or restored. One almost universally encountered token of Tractarian triumph is the framed lists of rectors or vicars that today hang unnoticed in so many churches. These began to be widely compiled in the 1880s as a means of articulating the continuity of the church from the Middle Ages to the present through the Reformation. Occasionally, they do significantly differentiate one figure in the list as an imposter: the incumbent during the Commonwealth. For this, not the Reformation, was the interruption in the apostolic succession of the Church of England. Some celebrations of this continuity are much more extravagant. An extraordinary display of painting and stained glass, for example, at All Saints, Helmsley, Yorkshire, sets the

church in the wider context of universal Christianity and the conversion of northern England.

The clergy were clear leaders in initiating change to parish churches in this period, though they often felt their way very cautiously in making liturgical innovations. A sequence of legal proceedings was initiated in a tiny handful of churches by hostile parishioners. There were no clear winners from these exchanges since they effectively contradicted each other, but they generated a huge amount of attention. The position of the priest facing eastwards at the altar (rather than standing to the north side of the communion table as the prayer book directs), for example, was declared illegal in 1870 and 1874, but legitimate in 1890; altar frontals and a cross illegal in 1855–6, but legal in 1857; and flowers on the altar illegal in 1847, but legal in 1870. Meanwhile, in highly ritualistic churches there was no ceremony from the past that was not revived; no liturgical utensil that was not recreated; and no opportunity to beautify the church that was overlooked. Some particularly popular urban churches established guilds that helped intensify further the celebration of Divine Service.

To a striking degree, amid this tide of restoration the tradition of local noble or gentry families creating or restoring family burial chapels continued. So, too, did the commissioning of grand new tombs to extend the collections of historic family memorials. The grandest generally incorporated full-length effigies of the deceased in alabaster or marble. These were nearly always commissioned from a cosmopolitan circle of artists and, despite an underlying tendency to medievalism,

always present modern portrait images of their subjects. Nevertheless, by the end of the nineteenth century effigies were becoming increasingly unusual. Their alternatives in parish churches included wall memorials and, more rarely, engraved brasses created in direct imitation of medieval monuments. The former were often locally produced, as had long been the case with more modest funerary memorials.

The scale of destruction of historic furnishings – predominantly post-medieval but also sometimes medieval, too – attendant on Victorian restoration was quite extraordinary. But, then, so too was the quality of the fabric and furnishing that often appeared in their stead. For stupendous sums of money were poured into both the restoration of old buildings and the creation of new. In the grandest commissions, moreover, the Ecclesiological movement ensured that there existed a deliberate overarching iconography that integrated the whole into a vast machine for prayer and praise. In such cases, all the arts from architecture to joinery and from ironwork to painting, are integrated into a compelling whole. There can have been few medieval buildings that ever enjoyed such overwhelming and coherent displays of art.

Something should be said in particular about the place of stained glass, perhaps the most familiar and ubiquitous art form of the Gothic Revival. Interest in this medium was first expressed by architects, notably Pugin, who wanted to recreate medieval glazing schemes for entire buildings. As a result the production and aesthetic qualities of early Victorian stained-glass schemes were very much dictated by the architect.

But the later popularity of the memorial window effectively overthrew this monopoly of control. Suddenly, there was a huge demand for individual windows created by established artists, each one answering the particular interests of a patron.

As a result in the later nineteenth century it was through the medium of stained glass that the world of fine art intersected with the Gothic Revival. Of particular importance in this respect was the contribution of artists within the Pre-Raphaelite Brotherhood, notably William Morris. It's worth noting, too, that the workshop system that underpinned the creation of windows also helped train up highly skilled draftsmen who transferred their skills where necessary to other media, including mural decoration or painting. In this sense, stained-glass production catalyzed new ideas and disseminated them into other furnishings.

During the middle decades of the nineteenth century other Christian denominations were swept along in the wake of the Gothic Revival. Among them was the Catholic Church, from the 1840s a major patron of new buildings. These were largely designed by a stable of Catholic architects including Pugin himself and, later in the century, the inventor of the eponymous cab, J. A. Hansom (1803–82). Yet Catholic attitudes towards the Gothic were complex from the first. The great expansion in the number of Catholics first of all marginalized the historic English members of the Church who had survived the penal years. They found their relatively modest and distinctive institution increasingly overtaken by two entirely new groups. On the one hand were large numbers of Irish immigrants, a body widely viewed with deep prejudice in nineteenth-century English society at large.

No less significant were the Anglican converts who swelled the ranks of the Catholic Church. To some old Catholics lay and clerical, the converts' enthusiasm for the institution of the Church, and particularly the papacy, seemed worrying. For, paradoxical as it may seem, England's unusual situation had created a very distinctive Catholic community which itself viewed the papacy with a degree of detachment. Certainly, allegiance to it involved Catholics in the middle decades of the century with the formidable figure of Pius IX. During the longest papacy in modern history, between 1846 and 1878, he oversaw a striking intensification of authority. This took place in the face of a battle for the Papal States against the centralizing forces of nationalism in Italy. When a French army protecting Rome was withdrawn in response to the Franco-Prussian War, the city finally fell on 20 September 1870. This event exactly coincided with the First Vatican Council, convened in 1869, which promulgated the dogma of papal infallibility. By the terms of this dogma, the Pope could speak with complete authority on matters of faith.

Burgeoning and confident as the English Catholic Church was in the later nineteenth century, therefore, its affairs both external and internal were far from uncomplicated. And these had a bearing on the chosen architectural style of its new buildings. Gothic did enjoy wide popularity, of course, but there was some reaction against it, too. In part this undoubtedly reflected a sense that building in the Gothic style

simply put the Catholic Church in an unwinnable competition with the Church of England, which possessed nearly all the real medieval buildings in the country. An obvious alternative source of ideas for Catholic churches was to be found in Italian architecture either of the Byzantine period or the very broadly defined Renaissance. It must be emphasized that the Catholic Church was not alone in breaking away from the Gothic tradition. Italianate styles also enjoyed enormous popularity in domestic and public architecture across Britain in the late nineteenth century.

There existed no established system for raising money for Catholic building (though some wealthy families did create what were in effect privately commissioned churches). Most, therefore, were dependent upon local fundraising. In these cases it was common for the land to be donated and then money raised simply for the architectural shell of the building. Finally, in a completely separate undertaking, the empty interior advertised itself as being in need of furnishing. Catholic churches, therefore, generally took shape over a period of time. The liturgical arrangements for such churches were relatively straightforward and absolutely clear. The Counter-Reformation Council of Trent (1545–63) gave its name to the Tridentine Rite of the Mass that was issued in a new missal of 1570. Its rubrics were extremely precise and admitted no variation. They were also universal to the Roman Catholic Church across the globe. One consequence of these strict directions was that there was never opportunity for the kind of imaginative exploration of the medieval liturgy found in High Anglican churches.

To accommodate the Tridentine Rite, Catholic churches required spaces dominated by a stone altar (inset with a relic) on which the priest celebrated the Mass facing the same way as the congregation. The climax of this ceremony was the elevation of the bread and wine and their transformation into the Body and Blood of Christ. For this reason the priest had to be clearly visible to everyone in the church and its interior be architecturally unified. The altar also needed to be raised up. During the celebration of the Mass the altar had to be furnished with a crucifix and burning candles. In time-honoured fashion, it was often provided with a painted or sculpted backdrop of imagery termed a reredos. By the nineteenth century it was also universal practice for the consecrated host to be reserved in a special locked cabinet, termed a tabernacle, in the centre of the altar.

In addition to this, Catholic altarpieces were usually designed to allow for the display of the consecrated host during the special subsidiary service of Benediction. During Benediction, the host was mounted in a richly decorated display case termed a monstrance so that it could be seen and venerated by the congregation. Typically, the monstrance comprised a glazed mount for the host on a pedestal, which was surrounded by a radiating pattern of decoration in the manner of a sunburst. Many nineteenth-century Catholic altarpieces incorporate towards the centre of the reredos a so-called Benediction throne upon which the monstrance could be placed in clear sight of the whole congregation. The throne generally took the form of a blind niche with a high canopy set centrally in the altar reredos above the tabernacle. To make the monstrance visible, the thrones

were often strikingly high and imposed upon the reredos a distinctive and steeply pyramidal outline.

The altar surrounds needed to be enclosed in some way, usually by a rail against which the laity could kneel to receive Communion. Communion, it should be said, usually comprised only the consecrated bread, not the wine, which was thought liable to spillage. Catholic churches might additionally possess subsidiary altars, notably one dedicated to the Virgin and another to the Blessed Sacrament. Many larger churches also possessed baptisteries with a central font. This was not a feature of medieval English churches and reflects contemporary continental influence.

Other distinctive furnishings included confessionals (enclosed stalls with grilles, for the priest to hear the confessions of his congregation) and, at the entrances to the church, stoups for holy water. Strictly speaking, however, no other architectural furnishings were necessary. The naves of these buildings were usually furnished simply with pine pews for the congregation. No attempt was made to segregate congregations or provide special pews. Large tomb monuments are very rare in nineteenth-century Catholic parishes (though many larger churches include them) and are limited to those of donor families. Confusingly, too, some Catholic gentry families did install them in family chapels attached to their local Anglican church.

As the nineteenth century drew to a close, both the Anglican and Catholic churches might reasonably have reflected upon their recent achievements with pride. The latter had established the bones of

a national parochial system as well as political equality for its rank and file after three centuries of marginalization. Over the same period the face of the Anglican Church had been completely transformed. More than 4,000 new churches had been created, many in urban areas, besides at least 8,000 historic churches that had been restored or enlarged. Not since the Reformation had most parish churches been so well maintained, so extensively ornamented or so intensively used. The liturgical changes advocated by High Church reformers, meanwhile, were now so widely observed that they were no longer controversial. The future augured well, and to start with at least, the next century answered expectations.

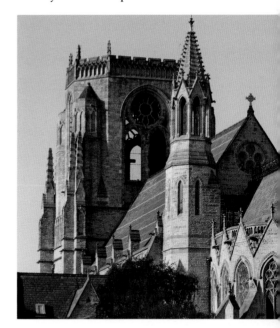

The vast outline of the Jesuit church of Holy Name, Manchester, built in 1869-71 by J.A. Hansom, one of the most ambitious 19th-century examples of an urban Catholic parish church. The tower was added in 1928.

130 Homecoming
Christ Church, Appleton-le-Moors, North Yorkshire

As a plaque in the entrance porch records, Appleton-le-Moors church was built in
1865 in memory of Joseph Shepherd by his widow, Mary. Shepherd had been born in
the village and returned there in later life, having made his fortune at sea. The architect
chosen for this ambitious memorial project was John Loughborough Pearson, who was
already well established as a church architect. Indeed, the design of the church draws
on one of his London buildings, St Peter's Vauxhall. The interior is richly ornamented
with sculpture and local stones of contrasting colours. Its fine polychromatic effects
are complemented by superb sgraffito decoration by Clayton and Bell around the east
end. In style, the decoration – as with the architectural detailing of the building itself
– is inspired by French Gothic art of the late twelfth century. This photograph shows
a detail of the high altar reredos with its depiction of the Last Supper (*below*) and the
cross surrounded by the Beasts of the Evangelists and adoring angels (*above*). On
the wall of the encircling apse are shown Christ's entry to Jerusalem and the road to
Calvary. A side chapel possesses imagery of a shipwreck and a mariner returning home.
Presumably, these relate specifically to Shepherd's career. The church cost the then
sensational sum of £10,000.

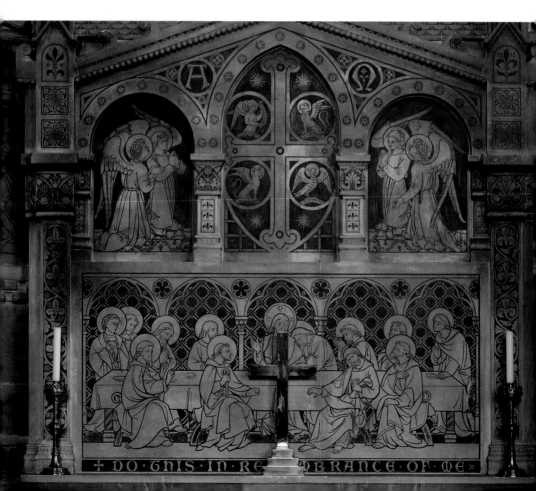

131 Historical reredos
The Church of St Aidan, Bamburgh, Northumberland

Rising up behind the altar in the unusually long thirteenth-century chancel at Bamburgh is a boldly conceived reredos of stone incorporating 16 sculptures of northern saints. The reredos was erected in 1895 by the Newcastle architect William Searle Hicks. In the previous year, Lord Armstrong had initiated his vast renovation of Bamburgh Castle. The figures and their stories are described in a contemporary printed notice entitled 'Historical Reredos' that today hangs at the back of the church. Shown here is a detail of the central section of the reredos with Sts Eata and Eadfrid flanking angels bearing a scroll inscribed with the words 'He is risen as He said'. Three lancet windows – an inheritance from the medieval interior and filled in 1847 with Flemish glass – break into the design and enliven its appearance. Hicks had earlier played with the idea of integrating a reredos with a window at the parish church in nearby Ford, although, in that case, the patron eschewed accompanying figure sculpture – probably the cost was too great. At Bamburgh, Hicks also created the canopy over the 1844 effigy of Grace Darling, the Victorian heroine who saved the lives of sailors at sea, by Charles Raymond Smith in the church graveyard.

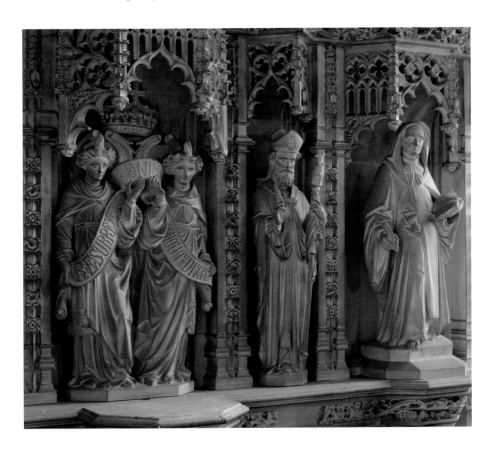

132 Anglo-Catholic splendour
The Church of St Protus and St Hyacinth, Blisland, Cornwall

Between 1894 and 1896, the architect Frederick C. Eden restored the medieval parish church of Blisland. Trained in the office of Bodley and Garner, Eden's work breathes the spirit of Anglo-Catholicism and transforms the interior of this modest building, with its rugged columns of granite and wagon roofs, into a brilliant and atmospheric evocation of a church on the eve of the Reformation. His most striking addition is the great rood screen with its crucifix that divides the building in two. Its colouring is modelled on late medieval examples with stencilled decoration imitating rich fabrics. The motifs on the lower panels of the screen reflect the dedication of the three altars beyond it. Before the high altar are scrolls bearing the word 'Alleluia' and there are Marian emblems in the panels to the left at the entrance to the Lady Chapel. Painted across the entrance to the Jesus Chapel to the right is the Sacred Monogram of the name of Jesus 'IHS'. This motif also appears across the full upper register of the screen. The unusual patrons of the church are also celebrated with flowers and 'P's. Blisland was a favourite church of the poet Sir John Betjeman and Eden himself was mentor to the architect Stephen Dykes Bower (1903–94), who followed in his tradition of Gothic ornament.

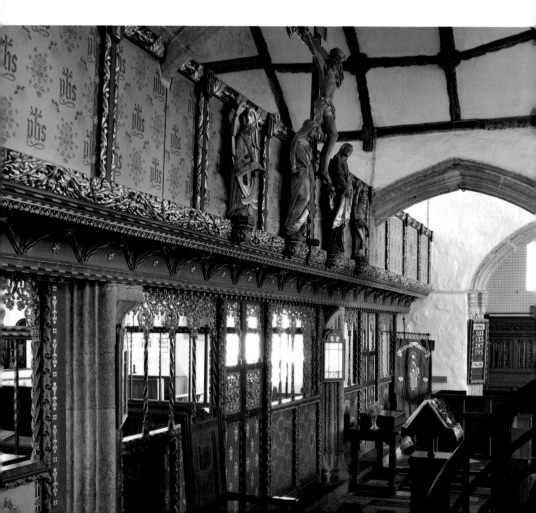

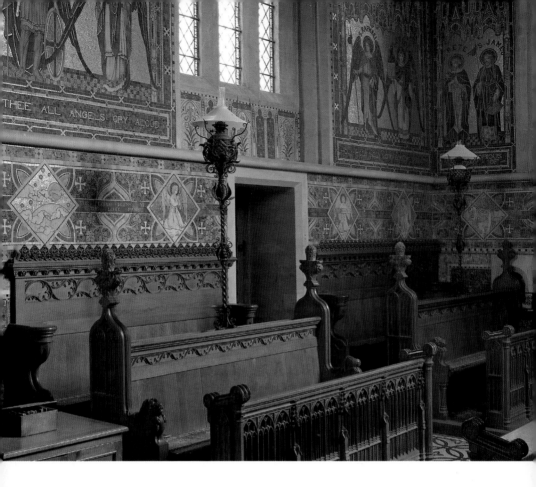

133 Memorial splendour
The Church of St Mary, Buckland, Oxfordshire (formerly Berkshire)

Following the death of his wife, Clara, in 1888, William West of Barcote commissioned this opulent chapel to her memory in the medieval south transept of nearby Buckland. The interior was designed and executed by the firm James Powell & Sons of Whitefriars in 1890. A mural of trumpeting angels presides over the entrance arch to the crossing and the ceiling is painted with golden stars on a blue ground. The walls are decorated with two registers of mosaic. On the lower is a hymn of praise – the *Te Deum* – engraved in brass and studded along its length with small illustrative panels: angels, a well, a ship and even a whale. Above this are grouped together full-length figures of archangels, Apostles, prophets and martyrs within architectural canopies. A busy mosaic decoration also extends across the floor. The focal point of the whole ensemble is a jewel-like memorial window that combines an Ascension scene with a depiction of Christ blessing the children beneath. To each side are smaller windows with exquisite foliage decoration that flood the interior with light. The facing stalls, finely detailed with architectural and animal carving, make the transept a second choir within the church. Fixed to the desks are oil lamps on splendid ironwork stands. Laid along the benches are narrow woven seat carpets, rare survivals of a once common fabric trimming.

134 The gate of heaven
The Church of St Giles, Cheadle, Staffordshire

Built in 1840–6 by the apostle of the Gothic Revival A. W. N. Pugin, St Giles's church
was intended to be a landmark in every respect. Its 200ft spire, carefully positioned
to dominate the locality, was an outward expression of the confidence of Catholics
in the aftermath of Catholic Emancipation in 1829. Backed by his patron, the Earl of
Shrewsbury, Pugin recognized in this commission an opportunity to realize his ideal:
a building that recreated in coherent and sumptuous form an English church of about
1300. To contemporaries the interior was nothing less than a revelation. Its painted
surfaces, stained glass and tiles created a symphony of colour and light that many found
overwhelmingly beautiful. John H. Newman, the future Cardinal, described it shortly
before it opened as 'the most splendid building I ever saw … The Chapel of the Blessed
Sacrament is, on entering, a blaze of light – and I could not help saying to myself "Porta
Coeli" [the gate of heaven].' No less gratifying to the Earl of Shrewsbury was the response
of the architect George Gilbert Scott. He reported to Pugin that Scott 'admired every
thing exceedingly; the Stencilling absolutely made the water run down both sides of his
mouth'. The church was one of the few commissions that Pugin regarded as successful.

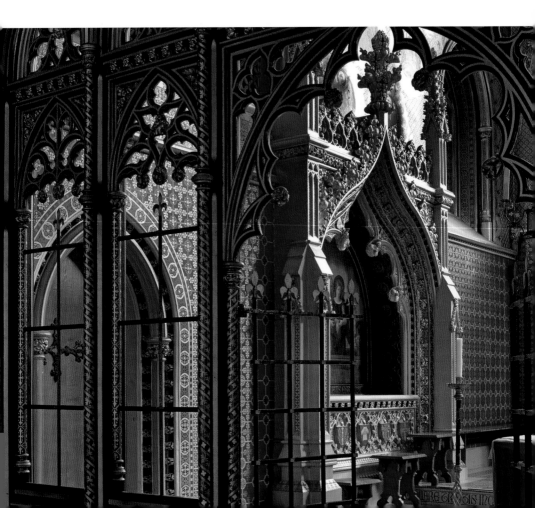

135 Renaissance revival
The Church of St Mary, Claxby, Lincolnshire

Hung in the nave at Claxby is a large painting of the Annunciation with flanking saints
– Agnes and Laurence – exquisitely rendered in the manner of a fifteenth-century
Flemish panel. This detail shows the Virgin and Gabriel separated by the radiant dove
of the Holy Spirit. The painting is one in a group originally commissioned in 1889 for
the Church of St Margaret, Burton-on-Trent in Staffordshire (demolished in 1968) by
Michael Bass, Lord Burton. The paintings can be attributed to a young artist, Charles
Edgar Buckeridge (1864–98), working under the direction of the architect G. F. Bodley,
who was frequently employed by Lord Burton. Buckeridge worked in the studio of the
stained-glass firm Burlison and Grylls, but he received several independent painting
commissions from Bodley. Despite his evident skill, he was described by Norman Shaw
as a 'poor little man ... [with] quite enough to do to keep things together' and died in
his thirties. Another painting from the set, a Crucifixion, is now at St Paul's, Burton-
on-Trent, and a third in similar format – comprising a central scene of the Agony
in the garden with flanking male and female saints – can be seen at Stainton le Vale,
Lincolnshire. How this remarkable panel came to Claxby is not clear.

136 Buying the Baroque
Church of St John the Baptist, Cockayne Hatley, Bedfordshire

When the Hon Rev Henry Cockayne Cust first entered into his estate and its living at Cockayne Hatley in 1806, the church was so ruinous that snow fell on the altar during the Christmas service. He therefore restored the building before refurnishing its interior with spectacular fittings recently made available by the spoliation of continental churches during the Napoleonic Wars. Although many contemporaries were interested by Gothic objects, Cust, informed by regular travel and with the help of his friend, the connoisseur Colonel Rushbrooke, bought up Baroque fittings that were crowded into the interior. This photograph shows a detail of the choir stalls from the Augustinian priory of Oignies, Belgium, that were installed in 1826. They are dated 1689 to 1692 and visible here are busts of Sts Guarinus, Ivo and Antonius. The purchase, carriage and fitting of the stalls cost the sensational sum of £345. Further woodwork added between 1827 and 1830, including a family pew and communion rails, absorbed nearly the same sum again. In addition, Thomas Willement was employed to oversee other improvements to the church, such as stained glass and painting the organ pipes. The organ – curiously – was purchased for its interest as a fitting, not as a working instrument.

137 The knight traveller
The Church of St Andrew and St Mary, Condover, Shropshire

Among the impressive collection of funeral monuments at Condover is the life-size figure of a kneeling man in alabaster. He leans on the hilt of his sword, his cloak thrown backwards, and stares upwards as if arrested by a celestial vision. Thomas Cholmondely-Owen inherited Condover Hall from a cousin in 1863 and died unexpectedly in Italy the following year when on tour there with his new wife. As a young man, he travelled widely and, in 1854, published an earnest reflection on the ideal society in *Ultima Thule: Or, Thoughts suggested by a Residence in New Zealand*. He served in the Shropshire Militia from 1855. This monument was commissioned by his brother Reginald from G. F. Watts, who was then trying to escape the label of society portraitist. It was Watts's first sculptural commission and was completed in 1867. The posture of the figure was apparently inspired by seventeenth-century sculpture, although its drama is wholly Victorian. By his clothing, Cholmondeley appears to be a traveller, but the sword reminds us of his chivalric vocation as a gentleman. Reginald Cholmondeley was himself an accomplished sculptor, and, with Watts's advice, later produced a monument for his wife, who died in childbirth in 1868. It stands beside Thomas's memorial and is likewise in a seventeenth-century idiom with an empty cradle at the feet of the recumbent effigy.

138 The Vault of Heaven
The Church of the Holy Trinity, Coventry, Warwickshire

The only English medieval cathedral demolished during the Reformation stood at
Coventry. Despite the loss of this great civic centrepiece, the modern cityscape is
rich with spires. That of Holy Trinity stands to the exceptional height of 237ft and is
reared up on flying buttresses embedded within the building. This external splendour
is matched by the wooden vault beneath, which was created during Sir George Gilbert
Scott's restoration of the church from 1854. With ribs rising from the vertical shafts
that define the window openings, it forms a brilliant visual resolution to the dense,
cage-like detailing of the tower. This relationship of elements is further brought out in
the coloration of the vault, with ribs that match the red stonework of the tower and the
star-studded blue webbing between. The foliage bosses enrich the central area of the
vault without obscuring the geometric logic of its design. In the centre is an octagonal
oculus with a wooden plug that allows ropes or chains to be run through. Scott's design
accommodates the peculiarities of the tower fabric so exactly that it may well reproduce
the form of a lost medieval predecessor. Note, for example, that each corner of the vault
is stone-built and reproduces within the distorting geometry of the ribs the inverted
motif of paired windows found in the tower.

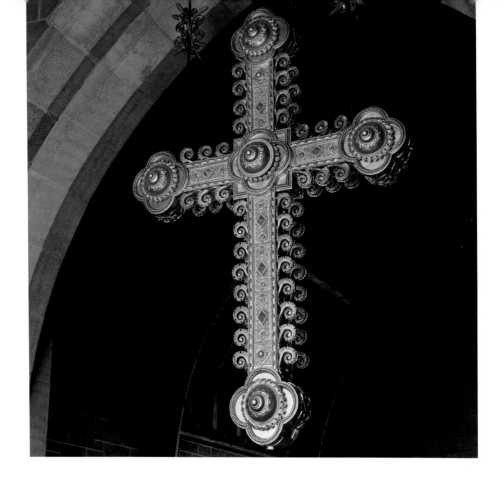

139 Restored perfection
The Church of St Luke, Dunham-on-the-Hill, Cheshire

Suspended within the chancel arch of the modest Victorian church at Dunham-on-the-Hill is this great gilded cross of brass. It was made by Francis Skidmore, one of the outstanding metalworkers of the Gothic Revival. The cross formed part of a gas chandelier in the crossing of Chester Cathedral, one of the furnishings installed by Giles Gilbert Scott during his reorganization of the choir between 1872 and 1876. According to local tradition, when the chandelier was dismantled the discarded cross was spotted by the then vicar of St Luke's, Rev Dr Griffin. His wife's family had commissioned the piece and he persuaded the cathedral authorities to relinquish it. Having been brought to Dunham-on-Hill by horse and cart, the cross was erected in its present position in 1921. Skidmore collaborated with Scott in many other commissions, including the Albert Memorial by Hyde Park in London and the cathedral screens at Lichfield, Salisbury and Hereford. A combination of perfectionism and ill health, however, led to the failure of his firm, Skidmore's Art Manufacturers & Co. of Coventry, and he died impoverished in 1896. Between January and May 1999, the cross, which is assembled on an oak frame, was disassembled and restored by Philip Irvine. All its pieces – including 72 cusps and 40 filigree panels – were burnished, gilded and cleaned.

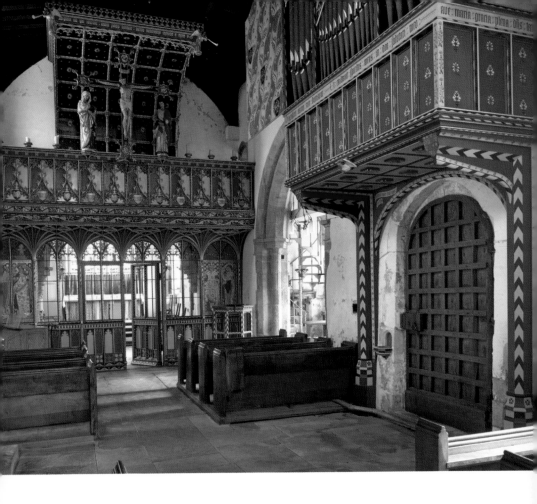

140 Living Gothic
The Church of St Mary, Egmanton, Nottinghamshire

The modest medieval exterior of Egmanton does not prepare the visitor for this interior, dominated by an organ and chancel screen (and recently restored). Above the screen is a rood loft in correct medieval form with its crucifixion scene, candle beam and canopy of honour. These are the creation of the church architect Ninian Comper, who was commissioned to furnish the church in 1897 by the Anglo-Catholic 9th Duke of Newcastle. Comper was not trying to recreate the medieval interior of the church. Instead, he drew on his deep knowledge of medieval furnishings across Europe to create a powerful and eclectic ensemble appropriate to contemporary liturgical use. Comper was in his early thirties when he received the commission for Egmanton. He had already created an interior on this scale at St Wilfrid, Cantley, in Yorkshire, but he probably came to the Duke's attention through G. F. Bodley, in whose office he had trained. Bodley, one of the outstanding figures of the Gothic Revival, had previously been employed by the Duke to create a new chapel at his seat of Clumber Park, though the two men fell out in 1890. When the Duke asked Comper to alter the chapel at Clumber – perhaps Bodley's outstanding masterpiece – he refused and in turn fell out of favour.

141 Art and worship
The Church of St Michael and All Angels, Garton on the Wolds, East Yorkshire

Between 1873 and 1880, Sir Tatton Sykes, 5th Baronet of Sledmere, transformed the interior of the medieval church of Garton on the Wolds. Sir Tatton was a reamarkable patron of church building and restoration. His desire was to create centres of 'Christian Art and Worship', and to this end he spent about £150,000 on churches across the Yorkshire Wolds, most of them on his estate. Garton on the Wolds is perhaps the most complete expression of his ideal. The work here was largely overseen by the architect G. E. Street and included an ambitious stained-glass and wall-painting programme executed throughout the interior at a cost of more than £3,000 by the firm of Clayton and Bell. This photograph shows a detail of two Creation scenes from the Old Testament iconography in the nave: the division of water from the firmament and the creation of the celestial bodies. All the paintings were executed in spirit fresco. This was a type of fresco – the admired technique of Italian wall painting – developed by the amateur artist Thomas Gambier Parry to suit England's damp climate. The paintings evoke artistic forms current in about 1200, but are unmistakably Victorian in character and of superlative quality. They were restored between 1986 and 1991 by the Pevsner Memorial Trust.

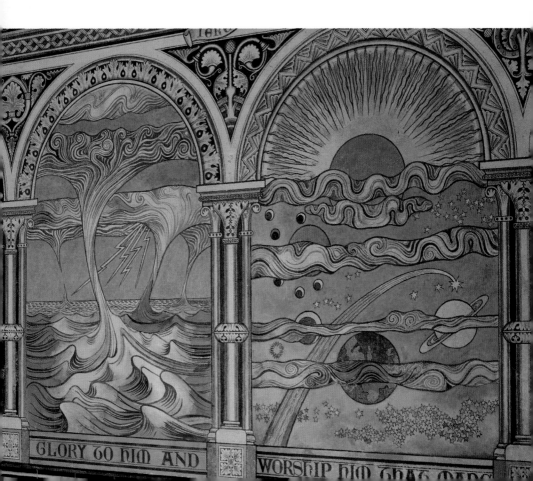

142 Church revival
St Peter's Church, Helperthorpe, North Yorkshire

In 1871–3, as part of his campaign of church construction and beautification across his Yorkshire estates, Sir Tatton Sykes of Sledmere rebuilt the medieval church of Helperthorpe. His architect, G. E. Street, created a striking building with a spire in an English Gothic idiom of about 1300. The impressive interior furnishings of the church include three richly decorated roofs over the discrete spaces of the tower (treated as a baptistery), nave and chancel. Each space was also designed with a distinct pavement. This photograph shows a detail of the chancel ceiling with panels of decoration in striking colours. It includes abstract patterns, stylized depictions of foliage and the repeated letters 'IHS' for Jesus. The painting is probably by Clayton and Bell, who also created a complete cycle of glass for the interior. Curiously, these windows were replaced within 20 years by a new scheme. Street's work for Sir Tatton on four churches in the immediate locality was published in the 1890s as a book entitled *Four Churches in the Deanery of Buckrose* by James Bayly. This is luxuriously illustrated with 'photo-tint' views of the different buildings. It also records the unexpected fact that the original church font, which was damaged beyond repair, was buried beneath its modern successor.

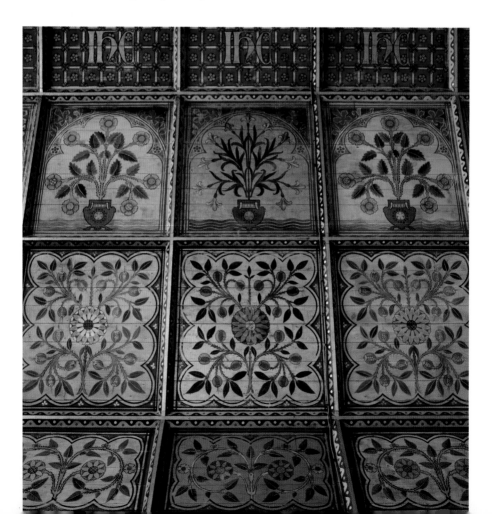

143 Memento mori
St Wilfrid's Church, Hickleton, South Yorkshire

Following his succession to the title of Viscount Halifax in 1885, Charles Wood began
the gradual transformation of the church beside his country seat at Hickleton into an
Anglo-Catholic showpiece. As the president of the English Church Union, he was
the effective lay leader of this High Church movement and the quality of the restored
building and its contents is impressive. As part of this project, a new lychgate – possibly
incorporating part of the medieval south porch of the church – was erected with an
internal niche containing three skulls and a stark inscription in Latin and English:
'Today for me. Tomorrow for thee'. The present metal grate protecting the skulls was
erected following vandalism in 1997. Lord Halifax was a collector of church antiques
and such touches as the heavy Gothic script lend this credibility as a historic *memento
mori*. He also delighted in practical jokes and lurid ghost stories, some of which were
published posthumously by his son. It would doubtless have amused him, therefore,
that the skulls have become the object of sinister and completely unfounded folklore.
Lord Halifax's sister, Mrs Meynell Ingram, commissioned another spectacular Anglo-
Catholic creation, the Church of the Holy Angels, Hoar Cross, Staffordshire. It
was designed and furnished by G. F. Bodley, the architect Lord Halifax also used at
Hickleton.

144 English Art Nouveau
The Church of St Mary and St Peter, Kelsale, Suffolk

This splendid lychgate at Kelsale was commissioned in 1890 by the rector of the church, the Rev George Irving Davies, as a memorial to his wife, Elizabeth. The rector had previously employed the architect Norman Shaw to restore the church in the 1870s. It was Shaw's pupil, E. S. Prior, however, who received the commission for the gate. Prior created a building that essentially sits in the Arts and Crafts tradition: the structure of the gate is of framed oak detailed in a late Gothic idiom with buttresses and an ornamental frieze. It sits on flint sleeper walls and a bench. The tie beam over the entrance is carved with the inscription 'Come unto me ye weary and I will give you rest'. What makes the whole design so arresting, however, is the sweeping outline of its red-tile roof. This improbable shape, like a great pointed hat, seems inspired by the Art Nouveau forms of Paris or Vienna. Inset within the gable is a covered niche for a statue on a small battlemented base, although there is no record of one ever being set up. The oval opening behind would have created a dark ground to set off the figure clearly. The gate was magnificently restored in 2014 by the parish at a cost of £37,000.

145 Missionary zeal
The Church of St Augustine, Kilburn, London, NW6

In 1867 the arrival of a new vicar at St Mary's, Kilburn, was to have far-reaching consequences. His disapproval of High Church liturgy prompted the resignation of the curate, Richard Carr Kirkpatrick. The curate, however, did not vanish from the scene. Backed by a section of the congregation, Kirkpatrick established a new mission church in Kilburn. Begun in 1870 to designs by the great Gothic Revival architect John Loughborough Pearson, this was a vast undertaking. The church was substantially complete by 1877, though its great 258ft spire was only finished 22 years later. Its austere shell encloses a cavernous interior inspired by Albi Cathedral and sumptuously decorated with sculpture and wall painting. Shown here is the choir, which is separated from the nave by a wide screen installed in 1890 by S. J. Nicholl. Carved in a thirteenth-century style with scenes from the life of Christ the screen complemented the existing imagery of the interior. Framed within its arches is the high altar, also by Nichol, and an outstanding set of embroidered processional banners. The ambition of the church expresses the scale of Kirkpatrick's foundation, the life of which was bound up with the work of two Anglican groups, the Community of the Sisters of the Church and the Community of St Peter.

146 Belief in beauty
Lanercost Priory, Lanercost, Cumbria

Beneath the east window of the former priory church of Lanercost there hangs an altar surround or dossal commissioned for the church by the 9th Earl of Carlisle from his friend and fellow artist William Morris. The design, a detail of which is shown here, is boldly conceived with the sweeping curves of stylized foliage set against an almost golden felt background. Morris drew up the pattern on a small scale and sent it off to the Earl on 29 August 1881. He wrote: 'if you approve of it let us have it back again and I will have it got out full size, materials got ready and the work started for the ladies to go on with.' For the makers of the dossal were not professionals but ladies of the parish, led by the vicar's wife and her widowed predecessor, who needed materials and an illustrative piece of completed embroidery to work from. Five years later the dossal was hung on Easter Day 1887. The full quality of their creation can now be appreciated again following a major restoration project orchestrated locally by Christine Boyce. This involved conserving, washing and repairing the dossal, work overseen by Tuula Pardoe. The dossal was rehung and dedicated in the church on 31 March 2013, 126 years after its first installation.

147 Local glories
The Church of St Mary the Virgin, Llanfair Kilgeddin, Gwent

This is a view of one of the panels illustrating verses from the hymn of praise known as
the Benedicite that run around the nave walls of Llanfair Kilgeddin. They were executed
by the artist Heywood Sumner between 1888 and 1890 in sgraffito, the technique
that involves incising decoration into layers of coloured plaster. The paintings were
commissioned by the rector of the parish, Rev W. J .C Lindsay, as a memorial to his
wife. He had already employed the Arts and Crafts architect John D. Sedding, a friend
of Sumner, to restore the church in 1875–6. Inspiration for the scene is local: it shows
the River Usk, the Sugar Loaf and the tower of the nearby church of Llanvihangel
Gobion. The full cycle reads in sequence from the figure of Christ above the chancel
arch. One critic, praising the freshness of the images in 1898, wrote that this was 'a
story which an inmate of the nursery can read'. Curiously, there is a passing similarity
to the drawings of J. R. R. Tolkein. The church was threatened with demolition in
the 1980s following pessimistic reports on its structural condition. Local opposition
ensured that it in fact passed to the Friends of Friendless Churches and was conserved
during two rounds of restoration in 1986–8 and 1994–5. The total of £23,000 for the
work came from Cadw and cost much less than its would-be demolition predicted.

148 A flight of swallows
The Church of St Martin, Low Marple, Cheshire

In 1869, J. D. Sedding began a relatively modest new church at Marple for Maria Ann Hunsdon of neighbouring Brabyns Hall (a commission inherited from his brother). Then, about 25 years after its completion in 1895–6, the church was extended by the addition of a new Lady Chapel to the north of the chancel. The architect responsible for this was Sedding's former chief assistant, Henry Wilson. Sympathetic to his former master's ideas about materials, and working in collaboration with another important figure connected to Pre-Raphaelite circles, Christopher Whall, Wilson created a spectacular series of furnishings for the Lady Chapel, a detail of which is shown in this photograph.. These include a beautifully crafted altar rail with inlaid wooden gates, and an altarpiece painted by Whall of the Annunciation. Suffusing the work is the spirit of Art Nouveau. This is particularly true of the vault above the altar. The rich blue of its surface is visually structured by a wooded landscape of golden trees, whose branches rise up to create a geometric pattern. Bringing the composition brilliantly to life is a swirling flight of silver swallows that seem to circle through the landscape and into the church.

149 Hansomly done
The Church of the Holy Name, Oxford Road, Manchester

This is the high altar of Holy Name, a church built by the Catholic architect Joseph Aloysius Hansom for the Jesuits in 1869–71. The church itself is of stupendous size, with a vault rising higher than Westminster Abbey. It's built using hollowed out hexagonal blocks of terracotta which were originally polychromed (the colour was sand-blasted off in 1973). In 1954, before the clearance of surrounding housing, the church had a regular congregation of 8,500. Its open interior allowed everyone a clear view of the liturgy and the high altar, which commands the space. The altar was carved from alabaster by Boulton of Cheltenham and installed in 1886. The pyramidal outline created by the statues' niches behind it is typical of such Catholic furnishings and in complete contrast to Anglican reredoses of the same period. The central and tallest pinnacle creates a Benediction throne above a tabernacle. The tabernacle is used to reserve the consecrated host and the throne above to display it during the service of Benediction. A ledge between the altar and the reredos supports a line of candles. During Mass it was also required that a crucifix be placed on the altar. The church has recently undergone extensive restoration.

150 A tempest's relic
The Church of St Morwenna and St John the Baptist, Morwenstow, Cornwall

This is the wooden figurehead of the *Caledonia*, a brig from Arbroath that foundered on the Cornish coast early in 1842. It was one of three local wrecks from which the long-serving rector of Morwenstow, R. S. Hawker, recovered bodies for burial in the churchyard. According to his own account, published in *The Gentleman's Magazine*, March 1867, a total of between 30 and 40 unknown sailors were laid to rest in this way. The *Caledonia* was carrying grain from Odessa to Gloucester and the cargo covered the surface of the sea when she broke up. One member of her nine-man crew survived. This ruggedly carved figurehead was recovered as a grave marker to her crew. She is dressed in armour and Highland costume with a kilt, sporran and bonnet. A thistle is pinned by a brooch to her bosom and she brandishes a sword. Her shield is likewise decorated with a thistle. In a sentimental verse on the subject, Hawker described this 'relique of the storm' as 'fair Scotland's figured form'. At the sight of it he predicted that 'many a heart of Cornish land/Will soften for the stranger dead'. The figurehead has recently been conserved and erected in the north aisle of the church. A replica of it now stands in the graveyard.

151 Windows of stone
The Church of St Michael (or St Miles), Coslany, Norwich, Norfolk

This is a detail of the exquisite flint and stone decoration that extends around the east end and south aisle of St Michael Coslany. Confusingly, the scheme is of two dates: the aisle was erected in the first decade of the sixteenth century, but the chancel was given a new skin of decoration in imitation of the existing Tudor work during the restoration of the church in 1883–4. A certain William Hubbard of Dereham was reputedly the skilled craftsman responsible for this latter work and created the finish shown here. The idea of cutting or 'knapping' flints to display their glassy inner surface for decorative effect was first explored in English fine architecture during the thirteenth century. In Norwich, the idea gained particular currency during the late Middle Ages and was ambitiously developed in the work of the Ramseys, a leading family of masons. Their work included the Ethelbert Gate to the cathedral priory precinct (under construction in 1316), which used the technique to create rose-window designs within the stonework. And it is to this building that the knapped flint windows of St Michael Coslany ultimately owe their inspiration. St Michael Coslany is currently in the care of the Norwich Historic Churches Trust.

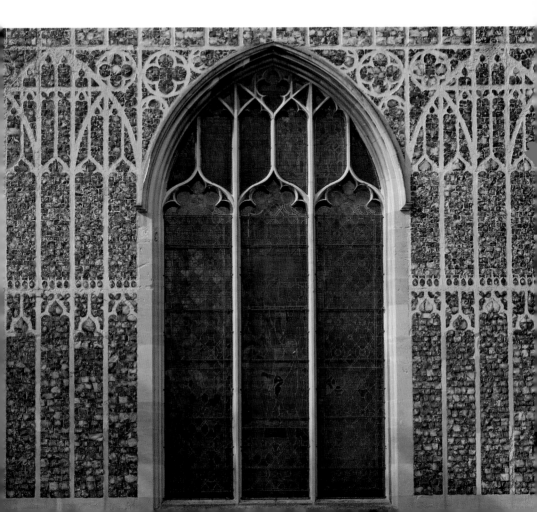

152 Fighting the cold
The Church of St Andrew, Ombersley, Worcestershire

This extraordinary object like a castle is an unusually splendid and early surviving example of a church stove. An inscription identifies its maker as 'Robert Howden, Inventor and Patentee, Old St Road, London'. A baker by trade living in Providence-row Finsbury Square, Howden received a patent on 3 July 1810 for a furnace capable 'of giving heat and a constant succession of fresh air to houses in general, warehouses, churches, theatres, hot houses, hospitals, work houses … and also manufactories'. Whether this stove is one of these machines is not quite clear. Nevertheless, by the 1830s Howden was supplying 'hot air dispensers' as far afield as Glasgow. This stove at Ombersley is original to the present church, which was built between 1825 and 1829 by Thomas Rickman at the fabulous cost of £18,000 (two-thirds of it contributed by Mary Sandys, Dowager Marchioness of Downshire). Rickman famously first established the typology of English Gothic architecture, labelling its three main phases Early English, Decorated and Perpendicular. It seems likely that he designed this stove with its buttresses, battlements and cross-loops specifically for the building, which is an extravagant essay in the Decorated style. The form of the stove as a fortification wittily suggests its importance as a bastion for the congregation in the unending fight against the cold.

153 Pre-Raphaelite masterpiece
St Martin on the Hill, Scarborough, North Yorkshire

Following the arrival of the railway in 1845, the town of Scarborough burgeoned in size. One result was the construction of a new church for its growing population. The commission for St Martin's, begun in 1861 and completed at a cost of more than £6,000, was secured by the brilliant Gothic Revival architect George Frederick Bodley through his family connections.

Bodley experimented for the first time with extensive internal painted decoration, as shown on this spectacular pulpit. Within a plain structural grid is displayed a series of panels designed by Dante Gabriel Rossetti, William Morris and Ford Madox Brown. The eight panels on the main face of the pulpit depict the four Evangelists above the Doctors of the western Church, an iconography that looks back to medieval precedent. Each of the figures stands in a densely patterned and gilded Gothic frame. The two end panels comprise a vertically arranged Annunciation with the archangel Gabriel above and the Virgin below. They are painted against a trellis of roses, a pattern that anticipates William Morris's first wallpaper design, printed in 1862. Rossetti's original cartoon for the Annunciation panels survives at the Fitzwilliam Museum, Cambridge. Confusingly, the paintings were actually executed by George Campfield, the principal artist employed by Morris, Marshall, Faulkner & Co.

154 Arts and Crafts
The Church of St Mary, Stamford, Lincolnshire

This is a detail of the ceiling added to the chancel of St Mary's church in 1890 during the course of wider alterations to the east end of the building. These were overseen by John D. Sedding, one of a group of Arts and Crafts luminaries – including Richard Norman Shaw, Philip Webb and William Morris – who had trained in the office of G. E. Street. Sedding, who died suddenly in 1891, was a passionate believer in the importance of artistic collaboration and was a founder member of the Art Workers' Guild. His engaging personality and a remarkable eye for talent enabled him to create some outstanding church interiors. The ceiling was executed by Henry Wilson, Edmund Sedding (a nephew) and R. Farrell. In the central panels are depictions of the so-called Sacred Monogram of the name of Jesus, 'IHS', and the crowned initial 'SM' for his mother, Holy Mary (Sancta Maria). Dividing them is a stylized vine scroll hung with grapes. Along the edges of the ceiling are angels with spears. The shields that appear in their hands also have monograms painted on them. At the eastern extreme of the ceiling, which oversails the altar, the panels are painted deep blue and studded with golden stars to suggest the vault of heaven.

155 Imperial Baroque
The Church of St Nicholas, Stanford, Northamptonshire

Perhaps the most unexpected of the many outstanding furnishings preserved at Stanford church is this monument to the Hon Edmund Verney. He served as a captain in the 17th Lancers and was killed at the Battle of Ulundi in Zululand, 4 July 1879. This was the last major battle in this aggressive imperial war against the Zulus. Gatling guns played an important part in the fighting, inflicting high casualties on the massed ranks of impis. The final stage of the battle involved a cavalry charge by the 17th Lancers that broke the Zulu flank. A life-size figure of a lancer lays a wreath against the monument and on its steps are placed a Zulu shield with a club, or knobkerrie, and stabbing spear, or assegai. They are all carved in white marble. The central portrait medallion fixed in the purple marble obelisk shows traces of gilding. Inscribed on its lower edge is the date 1896 and the name of the sculptor Felix Joubert, a fashionable cabinetmaker, artist and forger. The monument must be one of Joubert's first large commissions and the character of the design, which is clearly inspired by Baroque example, is very unusual for the period. According to the inscription, it was raised by Captain Verney's younger brother, Alfred, Lord Braye.

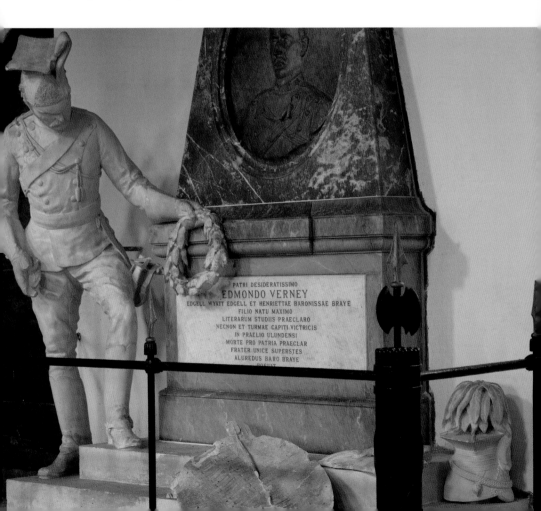

156 The colour of creation
Church of Waltham Holy Cross and St Lawrence, Waltham Abbey, Essex

From 1859, William Burges oversaw the restoration of the nave of the former abbey church of Waltham. As the focal point of the east end of the building, above the high altar, he created three lancet windows surmounted by a large rose filled with jewel-like glass. The entire glazing scheme, produced by James Powell & Sons of Whitefriars, is an early work of the Pre-Raphaelite artist Edward Burne-Jones. He painted the designs in oil so as to determine the striking colour palette. Cartoons were drawn up in 1860–1 and the rose was entirely executed by the glass painter Andrew Reid Greive (he worked on the lancets in partnership with his daughter Jessie). In the centre of the window is shown the figure of God enthroned upon a rainbow. The surrounding lobes represent, in a clockwise sequence, each of the seven days of Creation, beginning with the separation of light from darkness. This is followed by the division of the water from the firmament, the creation of land, trees and grass, of the stars, sun and moon, of birds and fish, and, finally, the animals of the earth, including Adam and Eve. Representing the seventh day of rest in the top lobe is a choir of angels.

157 Antiquarian delight
The Church of St Michael, Whitewell, Yorkshire

The simple church at Whitewell, built in 1818, possesses an unexpectedly splendid pulpit. It is set on a frame like the bell of an hourglass and looks plausibly Jacobean. As an inscription on the base reveals, however, it was 'restored' by John Parker of Browsholme Hall in memory of his brother in 1895. The pulpit is additionally signed 'Ric Alston', a craftsman who also created Jacobean furniture and panelling for Browsholme Hall. Alston aspired to authenticity in his work, reusing ancient timber in his new creations (hence the doubtful use of the word 'restored' on the pulpit). He worked with sufficient skill, moreover, to make it very hard to tell where his own work began and ended. The rim inscription of the pulpit, for example, may be partly recycled because it begins mid-sentence: 'eth and forsake them shall have mercie happy is the man that feareth al way but he that hardeneth his heart shall fall in to mischief'. Whatever the case, the pulpit is testimony to late Victorian antiquarian tastes. Behind the pulpit hangs another curious object probably gifted from the hall, a coarse patchwork tapestry of Rubens' *Descent from the Cross* (1611–12). Along with Holman Hunt's *The Light of the World* (1853), Rubens' image is one of the most copied images in English Protestant churches across the world.

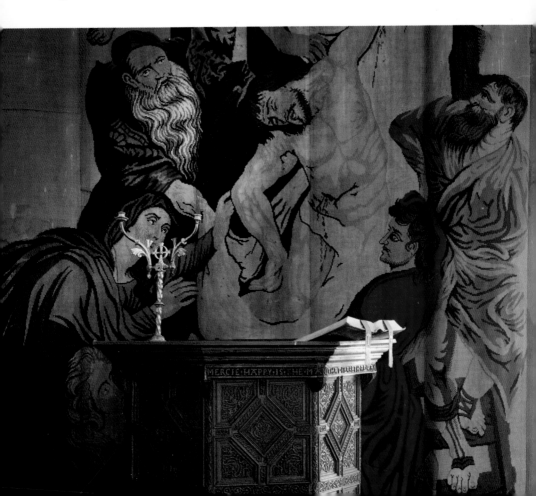

158 Thy pale image
The Church of St Mary at Wreay, Cumbria

Entering the ruggedly built mausoleum in the churchyard at Wreay, the visitor is confronted by this figure in white marble looming out of the darkness. It represents Katherine Losh, who died in 1835, and was taken from a drawing of her overlooking the Bay of Naples during a continental tour in 1817. The sculptor was David Dunbar, but the figure directing the work was Katherine's sister, Sarah Losh. A Latin inscription at the foot of the statue expresses her loss: '… sweet sister, loving and pious, thou wilt ever be most dear to me; dear is thy pale image now'. Beside the mausoleum stands a family burial ground where the two sisters lie buried together and beyond this a copy of the Bewcastle Cross (c. AD 700) erected in memory of their parents. Yet even more remarkable than these is the wonderful parish church completed by Sarah in 1842. This is richly decorated with the imagery of animals and fossils. Two other recurrent images are the pine cone and the arrow. A friend – or possibly lover – of Sarah's was killed on the North-West Frontier by an arrow and before his death sent her a pine cone, from which she successfully germinated a seed. The tree stood in the graveyard. A cone also lies on Katherine's lap; an emblem here of renewal and hope?

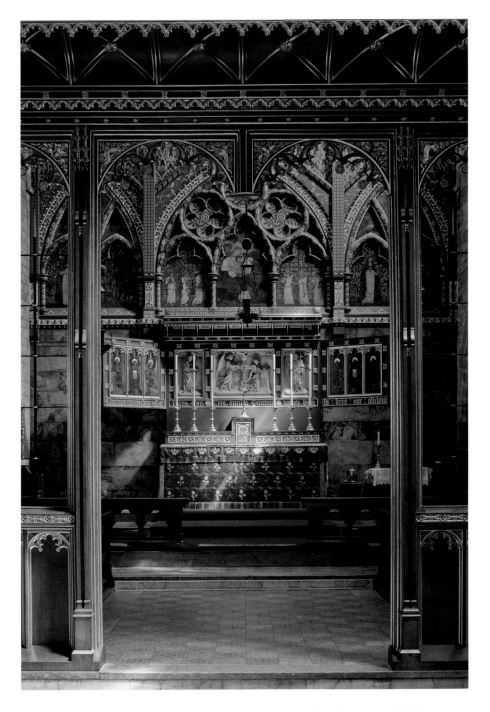

The chancel of St Martin's Scarborough, North Yorkshire, begun in 1861 by
G.F. Bodley

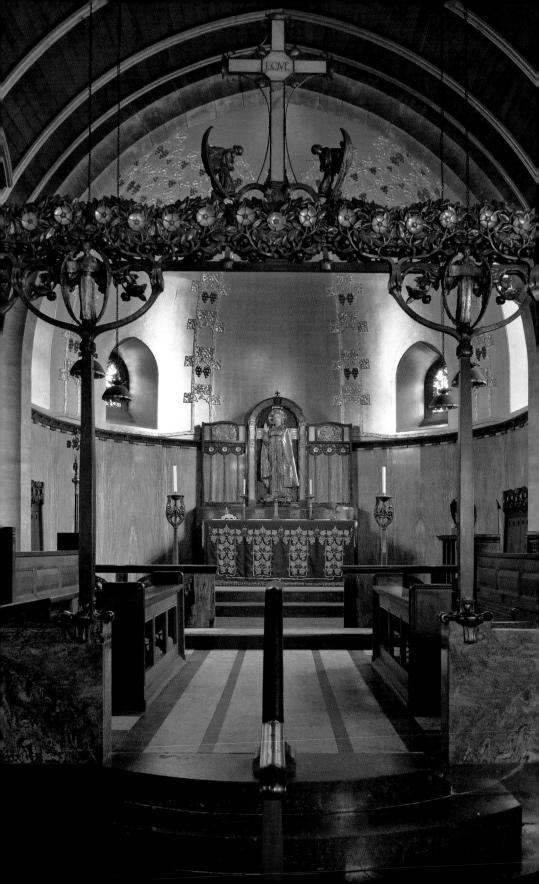

9 The Twentieth Century and the Millennium, 1900 to the Present

In the years immediately before the First World War my grandfather made tours by bicycle through England, many of them in his native East Anglia. He was a keen photographer and took pictures of the sights that caught his eye. There are several photographs of picturesque rural scenes such as 'Harvest 1911', showing a cart piled high with hay with two nervous looking farmers supporting the load. Another series of pictures relates to steam locomotives, photographed with their proud drivers and firemen. But the lion's share of the pictures record churches (and their organs, which he loved), from the cathedrals of Ely, Peterborough and Norwich to the parishes of Woolpit, Stebbing and Hatfield Broad Oak. For he was one of the legion of amateur enthusiasts for medieval church architecture and a collector of such popular illustrated books on the subject as Francis Bond's weighty *Gothic Architecture in England* **(1906).**

The first impression given by his church photographs is that – to a quite striking degree – the buildings he saw remain almost entirely unchanged to the present. This fact drives home the extent to which the picturesque churches that were his interest have enjoyed, since their Victorian restoration, a period free from substantial physical alteration. As will already be apparent from this narrative, it's hard to

point to another period in the thousand-year history of these buildings when they have stood so still for so long. What any regular visitor to parish churches today will also be aware of is that this situation is now changing very fast indeed, and not always inappropriately or for bad reasons.

But the continuity implied by these photographs is also deceptive. In part,

The fabulous 1902-11 interior of Great Warley, Essex

this is because the physical changes undertaken since these images were recorded have generally respected the shell, fabric and furnishings of the inherited Victorian interior. In other words, they don't tend to register very clearly in images that are predominantly axial views of the buildings. Of particular importance in this respect are the memorials to the dead of the First World War. The sheer scale of the casualties, combined with the strict insistence that no bodies should be returned from the front, encouraged communities across the full extent of the kingdom to erect public war memorials. As well as outdoor crosses, often on the bounds of the graveyard, there are remarkably few churches that don't possess at least a plaque, book or a board of remembrance bearing the names of the dead. These often stand at the west end of the church (rarely in the chancel), a position that makes them prominent to the entering visitor.

Yet war memorials could also be considerably more elaborate. Particularly popular were the gifts of screens to create side chapels and of altarpieces. In general, these fitting were executed in a Gothic idiom, though often reflecting the influence of the Arts and Crafts Movement. Another popular medium for memorials was stained glass. This varies enormously in artistic quality but abounds in intriguing background detail. Sometimes it suggests a specific reference to the circumstances in which someone was killed. In other cases, portrait images appear amid the faces in the window; on occasion these are evidently copied from a photograph. Overall, this desire to memorialize the dead drove forward into the early 1920s a final stage in the

renovation of parish churches initiated by the Victorians. Catholic churches were likewise touched by this desire to record the dead from the war.

The medievalized Christian imagery of so many parish church war memorials, however, also elicited a strong counter-reaction. There was a sense that the tragedy of the war manifestly transcended creed. This was a perspective clearly articulated in the national war memorials in London, none of which was designed in a Gothic idiom. Indeed, only Scotland plumped for a Gothic war memorial in Robert Lorimer's masterpiece at Edinburgh Castle. Underpinning this rejection of Gothic was a feeling in some quarters of the church that the war had revealed the Church of England to be patrician and aloof in its concerns. In fairness, the issue of reaching every section of society had long troubled the established church. The Victorian reflex had been to rear up large and richly furnished buildings in city suburbs to attract congregations. From the late 1920s, however, splendour was as out of fashion in new churches as it was in domestic fashion.

Yet the continuity suggested by my grandfather's picture is deceptive, too, because the greatest changes undergone by parish churches over the last century are invisible to the camera lens: the life of their congregations and the character of the liturgy celebrated within them. The seeds for this revolution in practice were sown by the First World War and initially developed in parallel to the mainstream of religious practice across the whole of Europe (indeed, it's worth emphasizing that debates about church design became to an unprecedented degree both pan-European and interdenominational

through illustrated books in this period). At the heart of this new thinking were profound questions about the role and practice of Christianity in an industrial society. Invoking the example of the early church, some clergy wanted to reject rich ceremonial and liturgical dressings. The buildings they used were deliberately austere and some new churches were erected that made use of industrial building techniques.

For both the Anglican and Catholic churches, however, the architectural mainstream of the interwar years is well represented by Liverpool's Anglican Cathedral, erected, following a competition in 1903, by Giles Gilbert Scott. This astounding building perpetuated through the war one highly eclectic tradition of Gothic Revival architecture that adapted the style to modern building techniques. Revivalist buildings of this kind grew increasingly minimalist in time, delighting in volume and texture above detail. For this reason it was perfectly adapted to serve for industrial buildings such as Battersea Power Station in London, begun in 1929. It was also used, however, as a model for many parish churches.

Another parallel model for development, but evocative of early church architecture, was meanwhile popular among church architects. This is represented by another leviathan masterpiece: J. F. Bentley's Catholic neo-Byzantine Westminster Cathedral, designed in 1895. The wide influence of this building is in stark contrast to that of the neo-Classical Catholic cathedral in Liverpool begun in 1933 to the designs of Sir Edwin Lutyens. Despite the scale and importance of this latter building,

surely one of the greatest churches never built (or at least not nearly completed, largely because of the Second World War), neo-Classicism hardly found expression in Catholic parish architecture in the middle decades of the twentieth century.

There were, however, interesting experiments taking place against this grand backdrop. The High Church Anglican Ninian Comper was an Aberdeen-born architect who saw sources for his designs and furnishings not only in native Gothic art and architecture but the entire Christian tradition. In the light of fourth-century churches in North Africa he pursued the idea of creating parish churches in which the altar sat within the centre of the church. The Catholic Church was concurrently playing with similar ideas. As early as 1935 the Church of the First Martyrs, Bradford, was designed in the round with an altar in the centre of the congregation. Executed in a Romanesque idiom, the form of the building echoed its resonant Early Church dedication. The priest in charge was Monsignor John O'Connor, an inspiration for G. K. Chesterton's priestly sleuth Father Brown.

In the second half of the twentieth century, reformers would recognize in such experiments a new formula for church design. Nevertheless, they came categorically to reject the process of distillation from historical example on which they were based. They would look instead to continental explorations of centralized planning premised on an industrial model. At Notre-Dame du Raincy outside Paris, for example, Auguste and Gustave Perret famously created a new church in 1922–3 at

minimal cost. Built in the form of an industrial space using industrial materials such as concrete, this machine for prayer placed the altar in the centre of the building. As we shall see, the idea of developing a building that drew so explicitly from the present – not the example of the past – would come to dominate late twentieth-century architecture. It still remains a dogmatic principle of much contemporary architecture, and not just churches.

These architectural developments took place against a background of wider liturgical change. Within the Anglican Church there was an attempt finally to revise the prayer book and bring it into line with modern practice. The modest revisions, which aimed to accommodate High Church sensibilities, provoked uproar and in June 1928 were the subject of an impassioned debate in the House of Commons. Despite an embarrassing rebuttal here, the bishops authorized the revised version. From this moment onwards the Anglican liturgy has diversified gradually to the present. On a much more modest level the Catholic Church was also engaged in modernizing the texts it used in this period, commissioning, for example, a new translation of the Vulgate Bible in 1936. It was an unhappy project if only because by the time it was completed, the emphasis of biblical scholarship had moved on beyond this Latin text to the analysis of its Greek and Hebrew sources.

One other interwar fashion with a direct impact on the furnishing of many Anglican churches also deserves mention. This was a small area or chapel set aside within the church for the use of children. It is hard to better Peter Anson's slightly

waspish reminiscence on their former appearance in 1960: 'Tiny tables and chairs were mass-produced. Hangings of a rather sickly shade of blue were almost obligatory, likewise framed reproductions of watercolours by Miss Margaret Tarrant. Lots of little flower vases and statues of the Christ Child, his Mother Mary and very often St Francis of Assisi (because he loved animals).' In fact some children's corners were very beautiful indeed. One of the most marvellous is to be seen at Little Braxted in Essex, created in the 1880s by the hand of its Tractarian rector, Ernest Geldart, in the aisle beside the women's benches in the church.

The outbreak of the Second World War marked yet another watershed in parochial history. As well as damaging domestic buildings, enemy action inflicted terrible destruction on many churches. The vast majority of these were in an urban setting – the principal areas of Victorian church expansion – though there were occasional rural casualties, too. The tower and much of the north arcade of the nave of Coggeshall in Essex, for example, collapsed as a result of bomb blast in September 1940. Several great cities, including London, Liverpool, Coventry and Bristol preserve to this day church ruins created during the war. They stand as testimony to the huge quantities of ecclesiastical architecture, furnishing and glass lost to this assault from the air.

Yet, for some, the sadness felt at such wanton destruction was tinged with a sense of relief; for all this demolished splendour made manifest a truth that was both liberating and intoxicating. To priests and congregations of every denomination who had celebrated services in the field, in prison camps

or the ruins of their former churches at home, with no vestments or proper utensils, the established trappings of Christianity had been proved at one level to be irrelevant to the practice of their religion. Such experiences, and the release it offered from tradition, were to shape profoundly the post-war reaction to churches and their fittings. There was no desire for clutter and the accoutrements of beauty. Some clergy and congregations wanted to get back to basics.

This determination to renew the church formed part of a much grander utopian vision to rebuild the nation socially and physically. Central to this endeavour was the complete reordering of Britain's cities and towns to accommodate new roads, new shops, new houses and new churches. We continue to live with the consequences of such projects, both good and bad. The curious thing is that in Britain today there remains a popular reluctance to admit that this change was not precipitated entirely by the bombs of the Luftwaffe, but by its own ideologically driven politicians, town planners and architects. In the process of reconstruction, churches remained an important – perhaps even the outstanding – emblem of architectural renewal. And the desire for change gave an edge to those within the Church who wished to break free from the constrictions imposed by the past.

With material shortages it was not really until the 1950s that the great rebuilding of churches began and it was carried through to a crescendo of activity in the following decade. This took place against a background of high levels of church attendance and growing prosperity. For the Anglican Church, the spirit

of this new beginning was powerfully expressed in its first major architectural commission of the post-war era: the rebuilding of Coventry Cathedral from 1951. Apart from its astonishing spire, the great medieval parish church that had served as the cathedral since 1918 had been completely gutted during the bombing of the city. Sir Basil Spence designed the new building as an addition to the ruins, setting it out at right angles to its predecessor and oversailing the connection of the two buildings with a great porch. Here was expressed as architectural reality a powerful idea: the old church as an anchor to its living present through the cataclysm of modern conflict.

The new building made clear reference to the traditions of English cathedral design. That said, it was also a conscious and radical new departure. This was a church conceived in a Modernist idiom as a functional space that made full use of modern building materials and displayed them for aesthetic effect. It was, in other words, pre-eminently an architectural manifestation of contemporary industrial prowess. No less remarkable was the extraordinary quantity and quality of the new fittings commissioned for the interior from contemporary artists. This proclaimed itself a cathedral for a modern age in a modern idiom. Coventry was of defining importance in setting the tone for new Anglican building projects across the country. Over the following decades these adopted the language and manners of mainstream contemporary architecture.

To the Catholic Church in England, Modernism seemed initially less beguiling. As late as 1955 a popular book

by the parish priest Joseph O'Connell, *Church Building and Furnishing: the Church's Way*, cited the authority of the Council of Trent in rejecting art that was not obviously sacred or informed by the Christian tradition. His view was ultimately informed by Cardinal Newman's thinking: while the Church continually evolved and therefore

responded to contemporary ideas and needs, its central teaching and identity were nevertheless transcendent. New architecture, therefore, needed to respect and relate to that of the past. There was, in short, '... a certain traditional idea of a church, based on its purpose and its needs, which has gradually taken shape and been handed down'. This should not be lightly abandoned.

As a result, the idioms of Byzantine or Romanesque architecture (or a combination of both) initially remained the staple of English Catholic church architecture. By the end of the 1950s, however, things were definitely changing. There was a growing sense that the Catholic Church had much to gain by engaging with contemporary architecture. Radical buildings, moreover, promised to signal its status, relevance and involvement in the modern world. As a final encouragement to make the leap there was a deep-seated and ever growing desire for radical liturgical reform. Pressure was building for a massive new departure that was bound up with concurrent changes in the Anglican Church.

This church in Harlow New Town Essex, designed by Gerard Goalen in 1953, is an early English Catholic modernist experiment. Its open interior directly inspired the Catholic Cathedral in Liverpool.

From 1957 an interdenominational group of clergy, architects and artists called the New Churches Research Group (NCRG) set out an agenda to drive forward the Modernist cause in the ecclesiastical sphere. Functional need, they argued, rather than tradition or symbolism, should shape the form of a church. And the central function of the church was as a setting for the liturgy. This in turn needed to be a genuinely communal experience, not just a performance put on by the clergy for the benefit of the congregation. They were, in other words, propounding a simultaneous case for reforming

architecture and the liturgy according to a new ideal. This influential group began to make headway, but its total victory came when their case for reform was given endorsement by the Catholic Church through the Second Vatican Council.

This council of bishops gathered in Rome between 1963 and 1965 was a defining moment in the history of modern Catholicism. In so far as buildings were concerned, it reversed the established position on the importance of tradition. According to its *Constitution of the Sacred Liturgy* of December 1963: 'The art of our own days, coming from every race and region, shall … be given free scope in the church, provided that it adorns the sacred buildings and holy rites with due honour and reverence.' In liturgical terms, the same document also stated that 'the full and active participation by all the people is the aim to be considered before all else'. This intention underlay the complete reform of the Mass that ensued over the following years and was finalized in the new rite of 1969.

Henceforward the Mass was always to be celebrated in the vernacular language, not Latin, and it was to take the form of a dialogue in which people and priest responded to one another. Like so much that Vatican II promulgated, the so-called dialogue Mass was not a new invention. Nevertheless, England had generally been much slower to adopt it than many countries. What had been a choice for those moved by circumstance or sensibility now became a universal imperative. The priest, meanwhile, was instructed to celebrate Mass facing the people. And the congregation were now encouraged to focus solely upon the actions of the priest. (Hitherto, it should

be explained, it had been common to perform private devotions such as the recitation of the Rosary while the Mass was being celebrated.)

Every Catholic church now needed an altar that accommodated the priest on its eastern side, facing the congregation. The position of the priest in turn required that everything on the altar be reduced in size to avoid obstructing the view of his actions. The statutory six candles on the altar, for example, were now reduced in size and sometimes in number. Shrunken, too, was the cross that had to stand on the altar. It was also required that the tabernacle in which the host was reserved be removed from its long-standing position behind the altar. In historic buildings the most common solution to this problem was to preserve the old altar with its candles and tabernacle as a backdrop to the new. Of course, the scale of the original altar and the way in which it was designed into the building often made it, anyway, impossible to remove. The consequent duplication of altars is so widespread in Catholic churches today as to seem liturgically intended.

In new churches, none of these problems applied. And the Catholic Church was building astonishingly fast. Its congregations peaked in the early 1960s and in the same decade around six hundred new Catholic churches were built in England and Wales. To all intents and purposes, however, liturgical reform effectively swept away any physical contrast between these buildings and their modern Anglican counterparts. Architects were free to create buildings of any shape they chose, bearing in mind the imperative that the congregation must be able to see, hear and be involved

in the liturgy. Prominence within them, therefore, was given to the principal liturgical fittings, notably the altar, the font and the lectern. To underline their importance, these objects were often individually conceived with great care. Their arresting appearance was also intended, in an open church interior, to hold the eyes of the congregation. The pulpit, meanwhile, with its overtones of authority, seemed increasingly outdated. In many churches erected over the last 50 years it has often completely disappeared.

The architectural decoration of these buildings was no less striking. In rejecting traditional forms – and also symbolism in architecture – Modernists were confronted with the problem of how to make their industrial buildings read as churches. The answer lay in decoration. Modern construction techniques made possible the creation of huge windows that became the setting for stained glass. Murals, mosaics and sculpture were also disposed around the church to denote its sacred character. These often appear over or around the altar, the entrance and the font. In Catholic churches they include panels of the Stations of the Cross, fourteen numbered images that recount the principal events of Christ's Passion.

Since the heady days of the 1960s the recent experience of Catholic and Anglican parish churches has been very similar. Most importantly they have both shared in the decline of church attendance and numbers of clergy. New churches continue to be built but many more have recently been subject to internal reorganization. It's hard to point to any recent examples of such buildings that aspire to architectural grandeur, though that is not to deny their quality. A growing concern for the conservation of the built environment has contributed to this. Nevertheless, the reality is that there do not presently exist patrons prepared to spend the sums of money necessary to create landmark parish churches (the same does not presently apply, however, to private chapels and institutional church buildings).

In the field of fine arts the situation is very different. A huge amount has been commissioned over recent years for parish churches including furnishings, glass and sculpture (the millennium prompted a particular surge). Anglican cathedrals have recently led the way in commissioning contemporary work from the cultural mainstream rather than from artists who profess any religious belief. Monuments to the dead, in the historic sense of large tombs, were last to be seen inside churches in the 1930s. Since that time, this tradition has entirely given way to lettered plaques and memorial commissions of art. John Bunting's magnificent effigy of Hugh Dormer (killed in 1944), wearing battle dress and heavy treaded boots in his 1950s War Memorial Chapel at Scotch Corner, Yorkshire, is an outstanding and – to my knowledge – unique exception to this rule.

There exist, meanwhile, deep-seated contextual and cultural differences in the treatment of parish church buildings by the two denominations that maintain them. Most Catholic churches remain in use exclusively for private prayer and the celebration of the liturgy and are furnished accordingly with pews, multiple altars and at least one chapel or tabernacle for the reservation of the Blessed Sacrament. With the exception of an ever-diminishing number of special feasts, worship is increasingly falling on a

Sunday with the sole liturgical emphasis on the celebration of the Mass. The laity is involved in the management of church buildings but to a much lesser degree than their Anglican counterparts.

Catholics themselves often speak in jest about the terribly quality of the modern churches they use and the furnishings they contain. This is sometimes completely justified, but, as this book contends, it's also occasionally spectacularly wrong. Indeed, many of the 1960s churches in particular are the products of a period that in the cycle of taste is presently at the nadir of its popularity. The care and time expended on the design and furnishing of these buildings virtually demands that they and their contents will soon enough come to be appreciated. Indeed, there are already some Catholic parish churches where a guidebook for interested visitors would not be at all out of place. Not to mention some individual works of art that could fairly be considered absolutely outstanding.

Among Anglican churches there is a much greater diversity of use and circumstance. In broad terms there is a distinction between the treatment of buildings in remote rural areas – where congregations generally lack the resources to change (or sometimes even to repair) churches – and those in towns and cities. The former usually preserve an essentially nineteenth-century aspect and normally attract relatively small congregations, except for occasions such as weddings, funerals and christenings. Churches of this kind are now normally gathered together in multiple benefices with a single member of the clergy (or sometimes a small group of clergy) serving as many as seven or

eight (or more) buildings in what were historically discrete parishes.

Various working models have developed for sustaining the liturgy in these situations. In some cases there is a rota of services that moves between the different churches. Elsewhere, one church is used for regular worship and the others operate as chapels of ease for occasional services. The latter system is particularly kind to the historic furnishings of churches simply because to some extent it allows particular uses to be assigned to the buildings that can best accommodate them.

There is a growing sense within the central organization of the Church of England that the future of these buildings is unsustainable, a view that, in my own anecdotal experience, is shared in a qualified way in the parishes themselves. Qualified, because those who look after these churches acknowledge the problems of maintaining the fabric but nevertheless feel an intense pride in the particular building for which they take responsibility. These people are in many ways the unsung heroes of the modern English rural parish church, not least because their care is unconditional and unpaid. The final failure of their care for a network of rural churches that bears little relationship to modern patterns of population has been confidently predicted for decades. Nevertheless, to date, and against all the odds, the relationship of these buildings with the locality holds good.

The recent history of town and city churches is very different. These buildings generally witnessed some attempt at deformalization in the 1970s or 1980s. This commonly involved a new coat of paint, both to refresh the interior

and to obscure Victorian decorative schemes of polychromed masonry and coloured stencilling. It already seems surprising that these finishes could ever have fallen so far from fashion as to be treated in this way. At the same time, a portable altar was often created for the nave. Where necessary, a block of pews might be removed to accommodate this. As a background to these changes there was a universal modernization of basic facilities, including heating, lighting and sound systems. The last made possible even more informal liturgies since speakers could move within the building and still be heard.

More recently, and usually on the initiative of the congregation, an attempt has been made to clear a social space at the west end of the nave, again by the removal of blocks of pews. Commonly connected with such works has been the installation of a kitchen and a lavatory. Underlying these changes is a pragmatic need to create space for informal mingling and conversation. The reinvention of the church as a social as well as a liturgical building has also encouraged other innovations borrowed from domestic life. Fitted carpets, for example, are now an increasingly common feature of church interiors. Meanwhile, disability and health and safety legislation have been factors in making hitherto temporary reorganizations of space – such as the setting of the nave altar – effectively permanent.

Across the country such changes have been done well in some places and badly in others. In this respect, a hugely important factor is the quality of the advice offered by local Diocesan Advisory Councils (DACs), the bodies which authorize alterations to Anglican churches. Sometimes this advice is of the very highest quality. In other extreme circumstances it can seem bureaucratic, inconsistent and uninspired. At the heart of the problem is the essential character of most churches since their Victorian restoration: that is as unified spaces designed solely for liturgical use of a particular kind. The art of sensitive reorganization usually involves adapting that space so as to enable it to operate in different ways while preserving its dignity. Often the solution requires a subsidiary internal structure or some element of partitioning.

Reorderings that fail usually do so for the same reason: they impose upon the particular church a solution that compromises its character. It should be said in this respect that there are no universal panaceas for the revival of these buildings, such as the removal of pews or the installation of new heating. These may be part of the answer for a particular church but – to state the obvious – they will not of themselves reverse the decline of a congregation. To make changes of this kind without proper reflection is simply to engage upon the wilful destruction of historic fittings. The cost of failure, too, is shockingly high. This is true not only in financial terms, but in the despoliation of a building that should be in the forefront of local life and consciousness. Disasters are rare but they do happen.

In my experience, successful reordering projects are often dependent at least as much on intangibles as on physical change. Well-conceived proposals are generally informed, for example, by a clear understanding of the objectives of the work. Those planning them,

moreover, have often looked at alterations to other churches and have offered their plans for discussion not only among the congregation but the wider local community as well. These are all terribly obvious things, but that doesn't mean that they are easy to do. Navigating the difficulties they present, however, lends the ensuing project real purpose and integrity. In this sense, indeed, the successful transformation of a church is usually a direct comment on the health of the congregation and the local community.

Change always receives attention, but in an account of this kind it is also important to acknowledge that the vast sum of energy invested in church buildings and their fittings today is expended in – effectively – keeping them as they are. Minor repair, maintenance, cleaning and beautifying absorb huge amounts of time, money and goodwill. So, too, do the requirements of conservation. There is a growing awareness of the historical and artistic importance of the contents of parish churches. One result of this is that, whenever a historic object needs repair, it is now widespread practice for specialists to be called in to work on them. Informed conservation of this kind does not come cheaply, yet over the last 30 years or so literally scores of objects illustrated in the pages of this book have benefited from it. Hopefully, too, some solution will be found to the notorious – and scandalous – problem of bats.

In this sense, local people have time and again shouldered a considerable burden to do the right thing by their parish churches and their contents. One of many reasons that we should be so grateful for such efforts is that there is really no safety net either for these buildings or the objects they contain. Indeed, unless these buildings are used and loved, they will disappear. In this respect the recent example of the treatment of national monuments is salutary. These are henceforth to be managed not by the state but a self-funding charity. To all intents and purposes the Ancient Monument – the transfigured memorial of the past maintained at public cost for the benefit and edification of society – has gone. Stonehenge and Dover Castle may pay their way in the market place, but what hope for the modest parish church? To survive these buildings have to live and the only choice they have is to cling on.

If this seems a bleak note on which to end a celebratory book, it's worthwhile setting the present in its full historical context. If it were possible to travel back in time and visit one historic parish church in England at different moments in its millennium or so of existence, the likelihood must be that it has undergone at least four complete changes of appearance. The first involved its probable transformation from wood to stone around the years of the Conquest; the second its late medieval enlargement to accommodate a formalized liturgy; the third the Reformation, when its interiors were stripped bare and the parish left destitute; and the fourth its reordering in the nineteenth century. To this chronology we must now add the fifth and current period of change. Like all the others its outcome is unknowable. Yet the fact that it is happening at all should be encouragement that future generations will continue to savour the click of the latch and the yielding door that herald what must surely be the most unpredictable, compelling and distinctive of English encounters: the visit to a parish church.

159 A new millennium
The Church of St Mary, Acton Round, Shropshire

This picture shows a detail from a sculpted panel, or tympanum, internally set over the door of Acton Round church by Andrew Pearson to celebrate the millennium in 2000. The vicar of this tiny church, Hugh Patterson, was keen to create a sculpture of its patroness, the Virgin Mary. Rather than make a freestanding figure, however, the example of the Romanesque church doorway at nearby Aston Eyre suggested to him the idea of a modern tympanum. It was agreed with Hew Kennedy, a driving force behind the commission, that this should present scenes of contemporary Herefordshire life arranged around an Annunciation scene. In designing the tympanum, Mr Pearson was particularly inspired by the carved scenes on the misericords of medieval choir stalls, with their exaggerated perspectives and foreshortening. He also wanted to make the sculpture eye-catching by creating an object that appeared old, but incorporated such modern imagery as a tractor and a quad bike. The figures projecting at regular intervals from the frame evoke the decorative sprigs of foliage termed crockets that often ornament medieval furnishings. Among the specific details visible here that refer to village life at Acton Round is a depiction of a trebuchet, a type of medieval siege catapult, built by Mr Kennedy. Mr Pearson is presently working on another local church project, making misericords for the stalls of Leintwardine church in neighbouring Herefordshire.

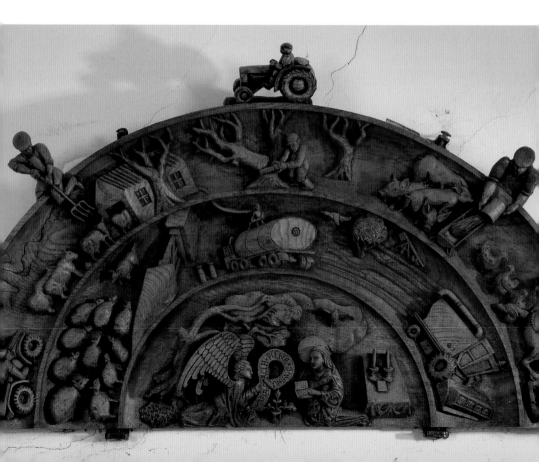

160 Modern sgraffito
The Church of St Columba, Anfield, Merseyside

This font bowl and matching ewer decorated in sgraffito were made in 1993 as a memorial to Linda Lester. Sgraffito involves coating a pot with layers of different coloured clay and cutting through them to create contrasts of colour. The lustre of the glaze emphasizes the uneven texture of the ceramic surface. Here the decoration appropriately suggests an underwater world for fishes (one has swallowed all but the feet of a man, presumably Jonah) and mermaids. The foliage swirls downwards towards the plug at the bottom of the basin. This font is one of several ceramics produced for St Columba's church by Julia Carter Preston, who died in 2012. She was the daughter of the celebrated sculptor Edgar Carter Preston, who worked at Liverpool's Anglican Cathedral from 1930. As a girl she modelled for her father and appears several times in the cathedral sculpture. So, too, does her mother, Marie, a watercolourist and dressmaker. Julia trained – and later taught – at the Liverpool College of Art. She was first recommended to do ecclesiastical work as a student and was subsequently involved in work at numerous churches in and around the city from about 1960 onwards. St Columba's was completed in 1931 and contains an impressive collection of twentieth-century art, some of it removed from other buildings.

161 Flaming colour
St Oswald's Church, Ashbourne, Derbyshire

This dazzling window was created by the stained-glass artist and craftsman Christopher Whall and installed in 1905. It is a memorial to Monica and Dorothy Turnbull, two sisters who died of burns after a tragic domestic accident with a candle. The flanking saints in this central detail are Sts Barbara and Dorothea. Their faces are respectively represented by portraits of the two dead sisters. Both are presented with their conventional attributes and stand against the background of a vine. The roses of Dorothea's garden are particularly sumptuous. In the centre of the window is St Cecilia, who is shown falling asleep at the organ. Angels assume her playing at the keyboard and birds take up her song. Celestial light descends from the upper register of the window and suffuses the whole composition. In the lower section of the window are smaller panels with inscriptions and a central image of the approach to New Jerusalem choked with briars, a reference to worldly ensnarement on the journey to Heaven. The palette of colours employed is strikingly varied and powerful. It reflects Whall's debt to the Pre-Raphaelites, who were an early influence on his career. The frustrations Whall experienced in trying to realize his early designs encouraged him to learn the craft of stained-glass manufacture.

162 Crowned with dignity
The Church of St Mary and St Peter, Barham, Suffolk

This compelling sculpture in Hornton stone of a Madonna and Child was carved by Henry Moore as a memorial to the dead of the Second World War from Claydon, Suffolk. It stands on a base inscribed with their names. The sculpture was commissioned in 1948 by Sir Jasper Ridley, trustee of the National Gallery, whose son had been killed in Italy in 1943. It derives directly from an earlier sculpture of the same subject commissioned from Moore for St Matthew's church, Northampton, by its vicar, Canon Hussey, a noted patron of contemporary art. Moore struggled to imbue the Northampton figures with satisfactory character. 'The Madonna and Child,' he explained 'should have an austerity and a nobility, and some touch of grandeur (even hieratic aloofness) which is missing in the everyday "Mother and Child" idea.'

Sir Jasper saw a series of maquettes for the Northampton figures displayed for inspection by Kenneth Clark, Moore's friend and the director of the National Gallery, and was determined to commission one. In this final sculpture, Moore dignified the Virgin's head with a crown. It was originally erected at Claydon, which became redundant. In 1978, it was then moved to nearby Barham, where, by coincidence, it stands close to another extraordinary transported sculpture: a tomb brought from Limerick in 1640.

163 'Altar of Fire'
The Church of St Bartholomew, Brighton, East Sussex

This photograph shows the high altar of St Bartholomew, the largest of about 15 so-called 'Wagner Churches', built or restored around Brighton in the nineteenth century by Henry Wagner and his son, Arthur, both clergymen. It was designed by the architect Edmund Scott in the idiom of a north German brick church with a cathedral-like interior rising a staggering 135ft.

The building was begun in 1872, but work faltered two years later. In 1897, the brilliant architect and designer Henry Wilson became involved with furnishing the incomplete building, creating the baldachin above the altar, its enamel and brass rails, altar frontal and bronze candlesticks set on Italian marble columns. Created at the sensational cost of £2,000, the ensemble created for Wilson 'an altar of fire'. Wilson also proposed a mosaic figure of Christ as King to fit within the baldachin and to create a Lady Chapel beyond the high altar with its own 30ft-high mosaic Madonna. But these proposals were frustrated and the present high altar with mosaics of archangels was designed by F. Hamilton Jackson. Had it been completed, Wilson might well have created what he described as 'the noblest church of modern times', yet enough of his vision was realized to stagger any unsuspecting visitor.

164 Memorial window
The Church of St Mary, Cumwhitton, Cumbria

This is a detail of a small memorial window of the Virgin and Child set low in the nave aisle wall at Cumwhitton. It is a beautifully conceived panel with a central mosaic of colours creating an immediate focus for the viewer's attention. The face of the Virgin and the figure of the Christ child are executed in clear glass so as to stand out clearly against this background. Subtly underscoring the visual structure of the panel are the lines of the leads that knit it together. The panel was made by Leonard C. Evetts, a versatile artist who spent much of his professional life in the department of Fine Art at King's College, Newcastle upon Tyne. Among his more surprising professional undertakings were consultation with the War Office on camouflage during the Second World War and the design of cartons based on nursery rhymes for the Milk Marketing Board. Nevertheless, Evetts became particularly celebrated for his stained glass and his most important single creation is the complete glazing scheme for the church of St Nicholas, Bishopwearmouth. This panel is a reminder of the restrained dignity and beauty that some post-war church art achieved. The panel is signed and inscribed 'Given by Catherine Elizabeth Hetherington in gratitude for her parents Ann and Thomas Bowman Hetherington. 1962'.

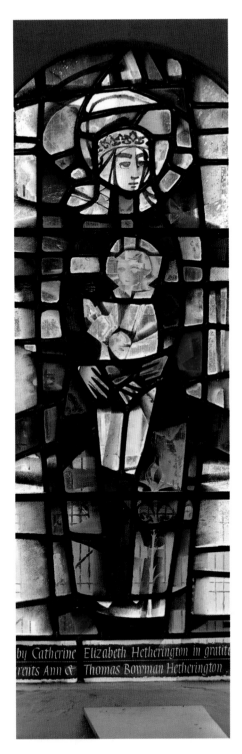

165 Fruits of the Spirit
The Church of St Mary the Virgin, Great Warley, Essex

This externally modest church, built in 1902, opens up to reveal an extraordinary Art Nouveau interior. It was gifted to the parish by the stockbroker Evelyn Heseltine as a memorial to his brother, Arnold (the father of the composer known as Peter Warlock), and was the collaborative creation of the architect Charles Harrison Townsend (also architect of the Whitechapel Gallery and Horniman Museum in London) and Sir William Reynolds-Stephens, who designed most of the interior fittings. According to an *Explanatory Memorandum* of 1911, the aim of the coherently planned internal decoration was 'to lead the thoughts of the worshipper onward through [the] decorations to the glorified and risen Christ, whose form, in the centre of the reredos is the key to the whole'. The aluminium finish of the apse, which is decorated in relief with vines, was intended to underline the importance of the altar. Its rail is decorated with motifs inspired by the Crown of Thorns. The chancel screen is comprised of brass trees springing from a marble base. Framed within each tree are angelic figures representing the Fruits of the Spirit: Joy, Peace, Patience, Faith, Meekness and Temperance. In addition, the kneeling figures of Goodness and Gentleness – attributes of Christ – flank the central crucifix symbolizing Love.

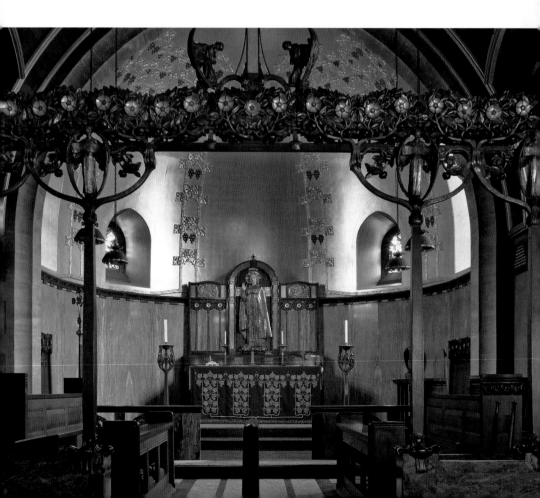

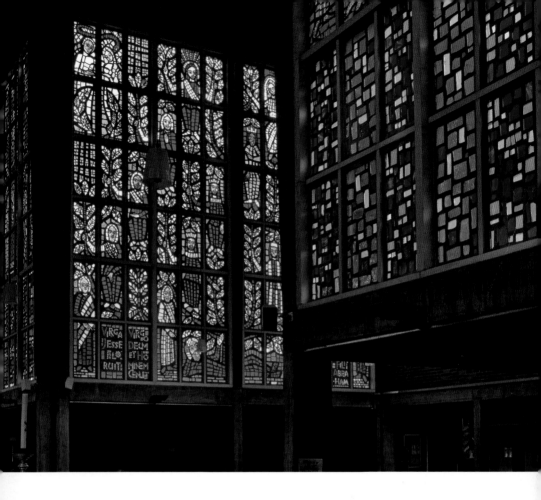

166 Walls of Glass
The Church of Our Lady of Fatima, Harlow New Town, Essex

In 1953 the architect Gerard Goalen was commissioned to design a Catholic church for Harlow New Town. The building, completed in 1960 and inspired by Auguste and Gustave Perret's celebrated 1920s church at Le Raincy, north of Paris, made use of a concrete frame that allowed for the creation of huge windows. Boldly conceived with coloured glass set in a concrete matrix – a technique termed *dale de verre* – the windows were designed by the Benedictine monk of Buckfast Abbey, Charles Norris. Visible here is a representation of the ancestry of Christ, known as the Tree of Jesse. There are also images of the visions of the Virgin at Fatima and the Mysteries of the Rosary. The windows help unify the interior, which is laid out on a T-shaped plan with the altar at the crossing. This arrangement was intended physically to bring the congregation into the liturgy and represented a radical departure from the norms of Catholic worship at the time: prior to the reforms of Vatican II from 1962 the Mass was celebrated in Latin with the priest facing the same way as the congregation. Curiously, this building was known to the architect Frederick Gibberd, who worked on the new town and it inspired his successful design for the Liverpool Metropolitan Cathedral competition in 1960.

167 A Great & Noble Calling
The Church of St Deiniol, Hawarden, Flintshire

This monument stands in the centre of a specially constructed chapel attached to
Hawarden church. Represented with great realism beneath the protecting figure of an
angel are full-length effigies of the Victorian statesman William Ewart Gladstone and his
wife, Catherine. The couple are in fact buried in Westminster Abbey. This monument
was created posthumously by Sir William Richmond in 1906. Richmond was a friend
of Gladstone and is celebrated today primarily as a portrait painter. On this monument,
however, he reveals his considerable powers as a sculptor. Laid between the two figures
and just visable in this photograph is a large brass crucifix. Bronze panels decorate the
sides of the monument table. They include a nativity scene and Christ's deposition from
the cross to either end. At each corner stand the figures of Aristotle, David, Homer and
Dante, expressions of Gladstone's formidable literary interests. The inscriptions include
several quotations by Gladstone. One begins: 'Be inspired with the belief that life is a
great and noble calling not a mean and grovelling thing.' Every detail of the monument is
suffused with such confidence. Even the figures seem asleep rather than dead. Gladstone's
portrait in particular forms a striking contrast to that captured by Richmond's own pencil
in 1898, when he drew the cadaverous face of the statesman on his deathbed.

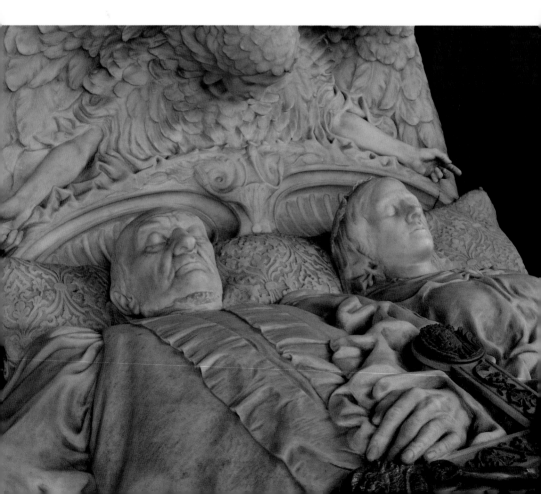

168 Mosaic of colour
The Church of St Mary, Hound, Hampshire

The east window of the small medieval church of Hound contains an arresting
stained-glass window made in 1958–9 by the artist Patrick Reyntiens. Its three
unequal lights present the figure of the Virgin and Child flanked by angels. The
palette of colour – with an overwhelming predominance of blue and green glass
(but with touches of yellow and red) – is both unexpected and serene. With its thin
leading lines and relatively large constituent panels, the overall effect is of a bold and
abstract mosaic of light. Never precisely defined but suggested within this by folds
of drapery and contrasts in colour are the forms of the figures. Their ghostly reality
is part of the appeal of the window. The Virgin faces the viewer, while the two angels
seem almost to be walking around her. The only clearly defined figure is that of
Christ, who is represented with his arms and legs splayed wide. Reyntiens made this
window while working on the stained glass of Coventry Cathedral (1957–61) with
John Piper (with whom he collaborated for over 30 years). Some of his later windows
are in a very different idiom, however. A magnificent case in point is the large west
window of Southwell Minster in Nottinghamshire, completed in 1996 with the
architect Martin Stancliffe.

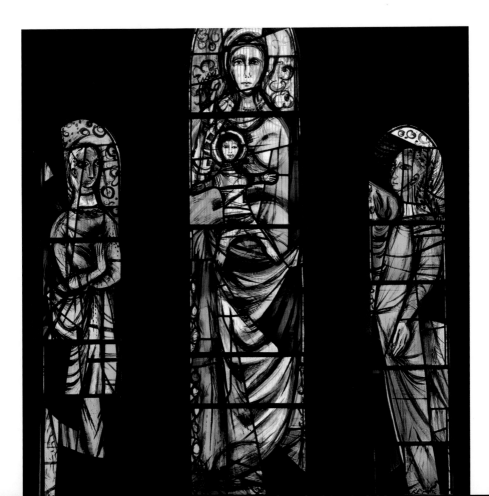

169 A pilgrim's progress
The Church of St Anselm, Kennington, Lambeth, London SE11

This is a detail from one of two large canvasses executed by Norman Adams in 1969–70 for the interior of St Anselm's church. Their theme is the narrative of John Bunyan's *Pilgrim's Progress*. The images read from left to right – up the full length of the church towards the altar and then back down again. This is the scene of paradise that concludes the narrative. The paintings, which are executed on canvas, were commissioned to try and improve the interior of a church with a peculiar history. St Anselm's was begun in 1911. The original intention of its architects, S. D. Adshead and S. C. Ramsey, was to create a large centralized building with a dome. Unfortunately, however, the First World War intervened and construction was interrupted. In 1933 the original footprint of the church, which had already been laid out, was cannibalized to create a huge longitudinal basilica in loosely neo-Byzantine style. At the time of its completion this vast interior was highly praised for its austerity, but the appeal of this gradually waned. Norman Adams responded to this grand space on a scale to match. The colours he used extend across a broad palette and the scenes blend into one another.

170 Spanish majesty
The Church of St Cuthbert, Philbeach Gardens, Kensington, London SW5

In 1887, work was completed on a grandly austere parish church in the developing London suburb of Earl's Court. The new building rapidly established a reputation as a centre of Anglo-Catholic worship and, under the direction of its dynamic priest, Henry Westall, acquired an outstanding collection of sumptuous furnishings. They include this spectacular wooden reredos above and behind the high altar. Inspired by late medieval Spanish example, the reredos was conceived by the clergyman-designer Ernest Geldart in 1899–1900, but only completed in 1914, when funds became available. The carving was undertaken by the sculptor and architectural carver Gilbert Boulton. He was assisted in his work by two craftsmen named as Taylor and Clifton. The central panel shows the crowned figure of Christ standing on a rainbow surrounded by figures of angels holding censers. At his feet are the Beasts of the Evangelists and in the curving frame above his head is a quotation from the *Gloria*: 'You alone are the Lord'. To either side of this central panel are tiers of canopies filled with saints. The largest figures represent the Doctors of the Church. Visible here is St Gregory with his papal tiara, quill and book. To the top left is a panel depicting the sacrifice of Noah.

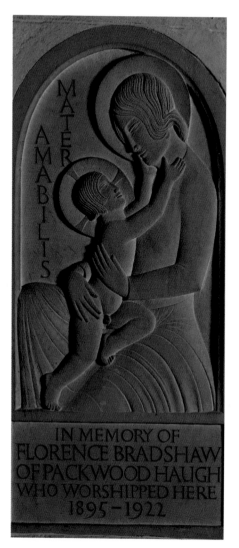

171 Lettering and line
The Church of St Mary the Virgin, Lapworth, Warwickshire

This is a detail of the Portland memorial to Florence Bradshaw, which was carved by Eric Gill and erected at Lapworth in 1928. Gill produced his first commissioned inscriptions in 1901 and, three years later, in 1904, was elected to the Art Workers' Guild as a 'letter cutter and sign writer'. By the time he produced this tablet, his workshop was producing an average of one inscription every fortnight. Gill was also intensively involved in wood engraving: perhaps his most famous work in this genre is *The Four Gospels*, published by the Golden Cockerel Press in 1931. This low-relief carving of the Virgin and Child shares many similarities with his woodcuts, in particular the command of line that simultaneously imbues his images with life and serenity. The infant Christ kneels on his mother's lap and holds her face in a return of the tender affection expressed by their exchange of looks. The exquisitely cut vertical inscription translates as 'Mother deserving of love' and is arranged to fill the space created by the figures. The free organization of text in this way is a hallmark of Gill's lettering. Gill also produced the headstone for Florence's husband, J. G. Bradshaw, at Radley, Oxfordshire. He was the founder in 1892 of Packwood Haugh School, formerly about a mile distant from the church.

172 The shadow of our night

The Church of St Andrew, Mells, Somerset

This equestrian monument commemorates Edward Horner, a lieutenant in the 18th Hussars, who died on 21 November 1917 of wounds received in action at Noyelles in France during the Battle of Cambrai. It was intended to stand in a specially built mausoleum designed by Sir Edwin Lutyens – a plan that never came to fruition – and was erected instead in the Horner Chapel at Mells, a more enclosed space than its present position in the nave aisle (to which it was moved in 2007). The tall, compact base by Lutyens evokes in reduced and simplified form the Cenotaph in Whitehall. Inset in one end of the monument is Horner's temporary grave marker from France, a painted wooden cross. Visible here at the opposite end is a family armorial and the side inscription 'he hath outsoared the shadow of our night', a quotation from *Adonaïs,* Shelley's elegy on the death of Keats (1821). The bronze sculpture, entitled *A subaltern of cavalry,* is by Sir Alfred Munnings and inscribed from his workshop 'Dedham, Essex 1920'. The bowed head of the horse and bare-headed figure remove any sense of triumphalism from this imposing and moving monument. A wooden board records that Horner had previously been seriously wounded at Ypres and the location of his grave near Etrecourt. In order to avoid distinction in death, it was forbidden to bring the bodies of soldiers home.

173 A portal of pity
The Church of St Mary, Nottingham, Nottinghamshire

These magnificent bronze doors were designed by the Arts and Crafts metalworker and architect Henry Wilson in 1904. They were made as a memorial to his father-in-law, Francis Morse, a former vicar of Nottingham. The inscription commemorating Morse across the top of the door describes him simply as 'father, pastor, friend'. Wilson wanted the iconography to suggest 'the idea of pity' through the portrayal of Christ's life in relation to that of his mother, Mary. A deposition scene fills the triangular head of the medieval doorway in which they are fixed. Below, the two leaves of the door are divided into panels with inward looking angel bosses at the intersection of each. With one exception, the scenes run in chronological order from the Annunciation to the Crucifixion and the empty tomb in the lowest register. The exception is the Resurrection, which appears out of its originally intended position beside the Annunciation. These were the second of four sets of bronze doors made by Wilson in the course of his career. The last and largest were the vast pair installed in the cathedral church of St John the Divine in New York in 1936, two years after Wilson's death.

174 Seaside sensation
The Church of St Andrew, Roker, Sunderland, Tyne and Wear

In 1906, work began on a new church for the expanding seaside resort of Roker. The new building, largely financed by a local shipbuilder, was designed by the architect Edward Prior with the assistance of Randall Wells, who acted as clerk of works. It's a grandly conceived building in a Gothic idiom that attempts to integrate the ideals of workmanship born of the Arts and Crafts Movement with modern industrial construction methods. Combined in the structure, for example, is locally quarried magnesian limestone and concrete. The vast and austere nave is supported on arches that spring almost from ground level and span the full breadth of the interior. Opening out of this imposing space is the chancel, shown here, with a concentration of colourful decoration. It sits beneath the church tower. The chancel carpet is designed by William Morris and over the high altar hangs a Burne-Jones tapestry of the Adoration of the Magi. In the window is a depiction of the Ascension by H. A. Payne of Birmingham. Covering the vault and upper walls is a mural by Macdonald Gill that was completed in 1927 using egg tempera technique. It represents the Creation. In the centre is an alabaster light with gilded shafts of radiating light. The blessing hand of God appears on the vault above the apex of the east window.

175 A provocation to iconoclasm
The Church of St Hilary,
St Hilary, Cornwall

On 8 August 1932, a motley group of
vehicles improbably delivered a band of
iconoclasts from Plymouth to the Cornish
village of St Hilary. Their object was
to enforce a consistory court ruling to
remove some of the furnishings installed
in the church by its Anglo-Catholic
rector, Bernard Walke. At the time
Walke enjoyed some celebrity, having
written plays for his parishioners that
were broadcast by the BBC from the
church (the first outside broadcasts in its
history). Meanwhile, along with his wife,
Annie, he worked to fill the church with
art. She had trained as an artist and had
connections with the Newlyn circle, many
of whom she persuaded to contribute
work to the church. The image shown
here is a detail of the Visitation in the
Lady Chapel painted by Ernest Procter.
Other contributing artists included Annie
herself, Dod Procter and Laura Knight.
Particularly striking are the choir stalls
with scenes from the lives of local saints.
Another interesting contributor was Joan
Manning Saunders. At the age of 11 she
was asked to contribute a series of six
scenes depicting the life of Christ for the
Lady Chapel screen. Despite the work of
the iconoclasts, an impressive collection
of paintings survives in this remarkable
church.

176 Blinded to botany
The Church of St Mary, Selbourne, Hampshire

While out hunting partridge on the morning of 21 September 1741, the young Gilbert White found his dogs 'blinded and hoodwinked' by an extraordinary quantity of dew-covered spiders' webs in the vegetation. The experience kindled in the keen huntsman a fascination with the natural world that later culminated in his classic work *The Natural History and Antiquities of Selbourne* (1789). Selbourne was the village in which White was born and spent most of his life observing and recording the world around him. He also acted as village curate and lies buried beneath a simple ledger stone in the chancel of the church. This is a detail of another memorial to him in the building: part of a three-light window showing St Francis preaching to the birds by Horace Hinckes from the Nottingham firm G. F. Gascoigne & Son. As an inscription notes, it was installed in 1920 'by lovers of nature and the man ... as a mark of admiration and esteem'. The exacting and naturalistic depiction of birds within the design of the window is enthralling. All 82 species shown are mentioned in White's writings and are depicted in vibrant colours. The window also includes depictions of the church and the rectory. In 1993, a second memorial window to White was created in the church.

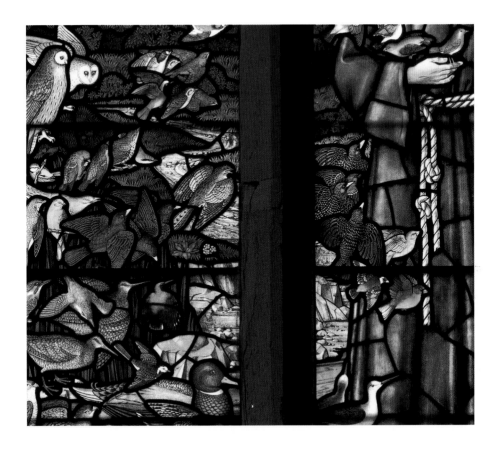

177 An artistic congregation
The Church of St Joseph, Burslem, Stoke-on-Trent, Staffordshire

The foundation stone of St Joseph's church by J. S. Brocklesby was laid on 17
September 1925. As is typical of Catholic churches in this period, it was designed in a
loosely Early Christian idiom. What distinguishes the relatively austere architectural
shell is its internal decoration. This was produced by the congregation itself, which
was drawn from the potteries of Stoke-on-Trent. It included, therefore, large numbers
of skilled draftsmen and artists. There can be few churches so directly shaped by
the parishioners who worshipped there. The process of decorating the church was
orchestrated by Gordon Forsyth, Principal of the Burslem School of Art. He organized
groups, including children, to work on the glass and the decoration of the main roof.
All the work was complete in time for the opening of the church on 14 June 1927.
Subsequently, Mr Forsyth's daughter, Moira (or Maura), completed a very accomplished
figure of Christ in majesty in the semi-dome of the apse. This work is executed in a
neo-Byzantine style. Meanwhile, the parish priest travelled in Europe and collected
further art for the interior. An ambitious and richly deserved restoration of the building
is currently being planned.

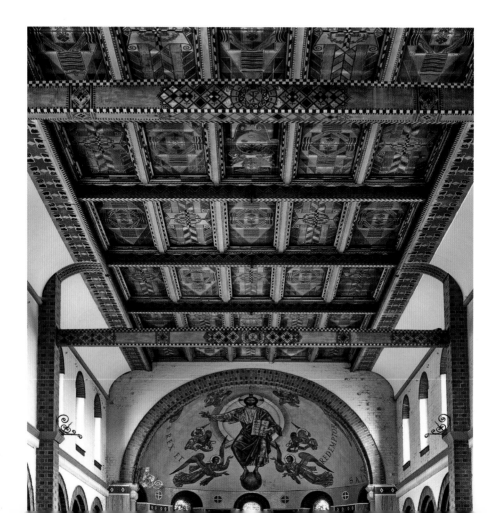

178 War memorial
The Church of Our Lady and St Thomas of Canterbury, Wymondham, Norfolk

This is a detail of the altar table that dominates the vast interior of the former priory church at Wymondham. Designed by Ninian Comper in 1913, this ambitious wooden furnishing was realized as a war memorial between 1919 and 1928. The work of colouring and gilding was only completed in 1934, following a large anonymous bequest. Dominating the composition is the central figure of a youthful Christ. Beneath him are the Virgin and Child flanked by Thomas of Canterbury, joint patrons of the church, and St Alban, protomartyr of England. The monastic cell at Wymondham was originally founded from the Abbey of St Albans in Hertfordshire. On the lower register, there also appear the figures of Sts Peter and Paul as well as representations of the Annunciation and Visitation. Much of the decoration is inspired by the history of the town. Depicted in the upper register are the patron saints of its medieval guilds: George, Margaret of Scotland, John the Baptist, John the Divine, Andrew and Michael. Above these are miniature figures of East Anglian saints and the arms of local notables. Projecting over the altar is a canopy showing the descent of the Holy Spirit in the form of a dove. It's surmounted by trumpeting angels and a large-scale crucifixion.

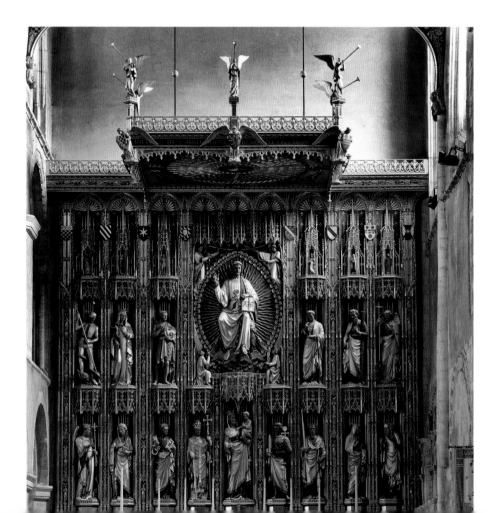

ACKNOWLEDGEMENTS

This book has from its outset been a joint venture with the photographer Paul Barker. As its pages show, his ability to capture the atmosphere of churches and their marvellous contents is second to none. With his wife, Tracey, who processes the pictures he takes, they make for an outstanding team. For myself, producing the book has not been hurried, but it has taken place under intense pressure of time. That it could be written at all, therefore, is due to the help of many people.

First are the incumbents, priests and churchwardens (not to mention the Churches Conservation Trust) who have – either through the regular regimen of opening or through special arrangement – generously given access to churches. No less important has been the contribution of *Country Life*. Mark Hedges, the editor, first accepted the idea of an illustrated column on parish churches in the magazine. Meanwhile, Phil Crewdson, Grace Cullen, Heather Lock, Octavia Pollock, Vicky Wilkes, and Annie Walton and Jane Watkins have helped produce this column week by week. In addition Kate Green and Rupert Uloth have suggested improvements and corrections in the circulating proofs. And readers have, as ever, proved unnervingly sharp in pointing out my own errors. The literary agent Jonathan Conway helped develop the idea of this book – a history of the English parish church – from the column and found the right publisher for it. Justin Hobson in the Picture Library has kindly helped in the practicalities of assembling pictures for the book.

The team at Bloomsbury have been a great pleasure to work with in creating the volume you hold. Caroline Chartres, my commissioning editor, has showed enormous enthusiasm for the project from the outset – first writing to me about the possibility of a book soon after the *Country Life* column began – and has accommodated its gradual growth in ambition and size. I'm very grateful to her and also Jamie Birkett, the assistant editor, James Watson, the designer, and Richard Collins, the copy editor, who have brought it to fruition.

There are many people whose enthusiasm and knowledge has fed my own both in selecting treasures and in compiling and writing this book: Clive Aslet, James Bettley, Marcus Binney, Alixe Bovey, Roger Bowdler, Stephen Brindle, Carol Cragoe, John Crook, Ptolemy Dean, Anna Eavis, Anthony Geraghty, Loyd Grossman, Steven Harding, Richard Hewlings, Simon Jenkins, Philip Lankester, John McNeill, Linda Monckton, Jeremy Musson, Alan Powers, David Robinson, John Robinson, Nigel Saul, Gavin Stamp, Roy Strong, Tim Tatton-Brown and Roger White. To this list I must add especial thanks for help with sections of this book to Jeremy Ashbee, James Carleton-Paget, Richard Halsey, Michael Hall, Stuart Hay, Sally Jeffery, Mary Miers, and Andrew Wareham. Also to those involved in *Country Life*'s two Village Church for Village Life Awards of 2008 and 2009, initiated by Roy Strong. In addition to those listed above are Sue Clifford, Rev Nigel Done, Fred Hohler, the late Candida Lycett-Green and the competition organiser Susannah Glynn.

Finally, of course, there is the immediate family, both Campbells and Goodalls, to whom real thanks – if spelt out – would overwhelm the book itself. Several of them have read the manuscript and made very helpful corrections to it. But ultimately the book is dedicated to my wife and two children. For the latter, it is written in the hope that they will one day take considerably more pleasure in visiting churches than they – sometimes – do at present.

SELECT BIBLIOGRAPHY

There is an enormous literature dedicated to parish churches – indifferent, bad, good and excellent – and there seems no purpose in listing it here. What follows is a select bibliography of books, most of them published in the last twenty-five years, that usefully offer overviews of subjects or themes relevant to the study of these buildings and their contents.

Addleshaw, G.W.O. and F. Etchells, *The Architectural Setting of Anglican Worship* (London, 1948)

Anson, P.F. *Fashions in Church Furnishing* (London, 1960)

Baker, A. *English Panel Paintings 1400-1558. A Survey of Figure Paintings on East Anglian Rood Screens* (London, 2011)

Berg, M. and H. Jones, *Norman Churches in the Canterbury Diocese* (Stroud, 2009)

Bernard, G.W. *The Late Medieval English Church. Vitality and Vulnerability Before the Break with Rome* (New Haven and London, 2012)

Bettey, J. H. *Church and Community*, (London, 1987)

Blair, J. *The Church in Anglo-Saxon Society* (Oxford, 2005)

The Book of Common Prayer. The Texts of 1549, 1559 and 1662 ed. B. Cummings (Oxford, 2011)

Chadwick, W.O. *The Victorian Church* (London 1966-70)

Daniell, D. *The Bible in English* (New Haven and London, 2003)

Davies, J.G. *The Secular Use of Church Buildings* (London, 1968)

Draper, P. *The Formation of English Gothic. Architecture and Identity* (New Haven and London, 2006)

Duffy, E. *The Stripping of the Altars. Traditional Religion in England 1400-1580* (London and New Haven, 1992)

Duffy, E. *Voices of Morebath* (New Haven and London, 2003)

Fincham, K (ed) *The Early Stuart Church 1603-1642* (London, 1993)

Friedman, T. *The Georgian Parish Church. 'Monuments to Posterity'* (Reading, 2004)

Friedman, T. *The Eighteenth-Century Church in Britain* (London and New Haven, 2011)

Goodall, J.A.A. *God's House at Ewelme. Life, Architecture and Devotion in a 15th-century Almshouse* (Aldershot, 2001)

Hall, M. *George Frederick Bodley* (London and New Haven, 2015)

Hill, R. *God's Architect. Pugin and the Building of Romantic Britain* (London, 2007)

Knight, F. *The 19th-Century Church and English Society* (Cambridge, 1995)

Kroesen, J. and Steensma, R. *The Interior of the Medieval Village Church* (Louvain, Paris and Dudley, 2004)

Little, B. *Catholic Churches since 1623: A study of Catholic Churches in England and Wales from Penal Times to the Present Decade* (London, 1966)

Maccullough, D. *Reformation. Europe's*

House Divided 1490-1700 (London, 2004)

Marks, R. *Stained Glass in England During the Middle Ages* (London, 1993)

Nockles, P.B. *The Oxford Movement in Context: Anglican High Churchmanship 1760-1857* (Cambridge, 1994)

Parry, G. *The Arts of the Counter-Reformation* (Woodbridge, 2006)

Pevsner, N. et al. *The Buildings of England Series*

Proctor, R. *Building the Modern Church. Roman Catholic Church Architecture in Britain, 1955 to 1975* (Farnham and Burlington, 2014)

Rodwell, W. *The Archaeology of Churches* (Stroud, 2012)

Saul, N. *English Church Monuments in the Middle Ages* (Oxford, 2009)

Spurr, J. *The Restoration Church of England, 1646-1689* (London and New Haven, 1991)

Stevenson, C. *The City and the King. Architecture and Politics in Restoration London (*New Haven and London, 2013)

The Twentieth-Century Church, *Twentieth Century Architecture, 3* (1998)

Walsham, A. *The Reformation of the Landscape* (Oxford, 2011)

Whiting, R. *The Reformation of the English Parish Church* (Cambridge, 2010)

Yates, N. *Buildings, Faith and Worship. The Liturgical Arrangement of Anglican Churches 1600-1900,* (revised edition Oxford, 2000)

USEFUL WEBSITES FOR RESEARCH

Anglican texts: http://www.anglican.net/

British History Online: http://www.british-history.ac.uk/

Churches Conservation Trust: http://www.visitchurches.org.uk/

Church Monument Society: http://www.churchmonumentssociety.org/

Corpus of Romanesque Sculpture: http://www.crsbi.ac.uk/

Corpus Vitrearum Medii Aevi: http://www.cvma.ac.uk/index.html

Ecclesiological Society http://ecclsoc.org/

Historic topography: http://www.visionofbritain.org.uk/

Society for Church Archaeology: http://www.archaeologyuk.org/socchurcharchaeol/

Friends of Friendless Churches: http://www.friendsoffriendlesschurches.org.uk/

Monumental Brass Society: http://www.mbs-brasses.co.uk/

The Chapels Society: http://www.chapelssociety.org.uk/

The Digital Atlas of Great Britain: http://www.digiatlas.org/

There are historic churches trusts for most English counties, such as the **Oxfordshire Historic Churches Trust:** http://ohct.org.uk/

Other society websites:
Ancient Monument Society: http://www.ancientmonumentssociety.org.uk/

British Archaeological Association: http://thebaa.org/

20th Century Society: http://www.c20society.org.uk/

Georgian Group: http://www.georgiangroup.org.uk/docs/home/index.php

Historic Chapels Trust: http://www.hct.org.uk/

National Churches Trust: http://www.nationalchurchestrust.org/

Society of Antiquaries of London:
Society of Architectural Historians of Great Britain: http://www.sahgb.org.uk/

Society for the Protection of Ancient Buildings: http://www.spab.org.uk/

Victorian Society: http://www.victoriansociety.org.uk/

INDEX

Page numbers in *italics* refer to illustrations